THE NUECES RIVER

RIVER BOOKS

Sponsored by

THE MEADOWS CENTER
FOR WATER AND THE ENVIRONMENT
TEXAS STATE UNIVERSITY

Andrew Sansom,
General Editor

The Nue

RÍO ESCONDIDO

ces River

Margie Crisp
with artwork by William B. Montgomery

FOREWORD BY ANDREW SANSOM

TEXAS A&M UNIVERSITY PRESS · COLLEGE STATION

LIBRARY OF CONGRESS CATALOGING-IN-PUBLICATION DATA

Names: Crisp, Margie, 1960– author. | Montgomery, William B., 1953– artist,
 illustrator.
Title: The Nueces River : Río Escondido / Margie Crisp ; with artwork by
 William B. Montgomery ; foreword by Andrew Sansom.
Other titles: River books (Series).
Description: First edition. | College Station : Texas A&M University Press,
 [2017] | Series: River books | Includes bibliographical references and
 index.
Identifiers: LCCN 2016039264| ISBN 9781623495152 (flexbound (with flaps) :
 alk. paper) | ISBN 9781623495169 (e-book)
Subjects: LCSH: Nueces River Valley (Tex.)—Description and travel. | Nueces
 River Valley (Tex.)—History. | Natural history—Texas—Nueces River
 Valley. | Nueces River (Tex.)—Pictorial works.
Classification: LCC F392.N82 C75 2017 | DDC 976.4/883—dc23
LC record available at https://lccn.loc.gov/2016039264

A list of titles in this series is available at the end of the book.

For Elijah, Davis, Louella,
Haley, & Tula:
the next generation.

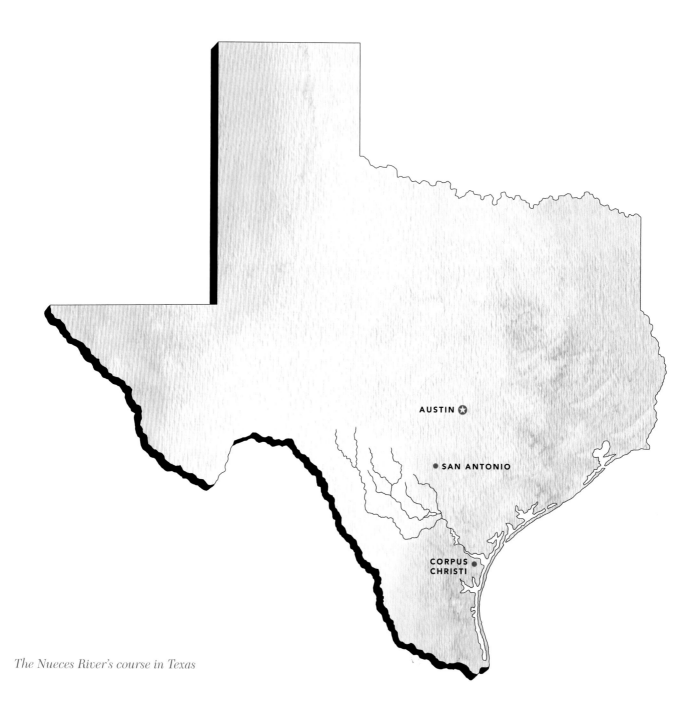

The Nueces River's course in Texas

CONTENTS

Mimosa pods

FOREWORD

I remember the first time I saw the Nueces River, below where its east prong meets Hackberry Creek and it forms part of the boundary between Edwards and Real Counties. It then flows through one of the most beautiful canyons on the Edwards Plateau before meeting its west fork in Uvalde County. Throughout this reach, its aquamarine yet crystal-clear waters are among the loveliest streams in Texas, and its peaceful, cooling character here is in sharp contrast to its nature and appearance on other stretches as it makes its way to the Gulf Coast.

The rich diversity of the Nueces is eloquently captured in this volume of the River Books series, a publishing partnership of Texas A&M University Press and The Meadows Center for Water and the Environment at Texas State University. Through remarkable artistry and prose on the pages to follow, author Margie Crisp and artist Bill Montgomery treat readers to a luxurious, delightful, and informative tour of one of Texas' most interesting, naturally diverse, and historically significant rivers. It should be no surprise that Crisp's eloquent writing is of the highest quality. Her previous book in this series, *River of Contrasts*, is about Texas' Colorado River and won the non-fiction book of the year from the Texas Institute of Letters, which is perhaps the most prestigious acclaim an author can achieve in Texas. Her words are illuminated by the art of her talented husband, Bill, whose work is not only handsome but often haunting and truthful, and sometimes whimsical, never failing to capture the spirit and many contrasts presented by Río Escondido.

To a great extent, the spirit of the river is reflected in its cultural history as well. The Nueces was claimed by Mexico as Texas' southern boundary, though it is significantly north of the Rio Grande, which early Texans insisted was the border with Mexico. It was this dispute that sparked the Mexican American War and changed the history of the Southwest—from present day Colorado and New Mexico through Texas to the Gulf of Mexico.

I know Margie and Bill join me in profuse thanks to Tim and Karen Hixon, two of the most distinguished conservationists in Texas, whose ranch along the Nueces near Cotulla helped inspire their work. Tim and Karen, who I actually met many years ago while running another great American river, are among the most generous, unassuming, and instrumental leaders in defense of America's fish, wildlife, and parks. It is fitting that the two of them made this book possible as their love of fine art is equal to their love of the lands and waters of our country.

And so, as you treat yourself to the written and illustrated delights and insights on the pages to follow, celebrate the contributions of two remarkable talents (and their benefactors) and relish the river itself. Like many of our great Texas rivers, the Nueces will need all the help it can get as the population of Texas continues to explode. Sadly, due to impoundments and withdrawals along its journey, its cooling fresh water no longer nourishes the once prolific estuary of Nueces Bay. Hopefully, *The Nueces River: Río Escondido* will help to ensure that it flows on for our children and grandchildren.

—Andrew Sansom
General Editor

PREFACE

A parade of oil refineries blocks my view of the Nueces River delta and Nueces Bay as I drive along Up River Road in Corpus Christi, the industrial-gothic stacks rising into the sky. Multicolored series of pipes snake through the towers. Metal tanks as large as office buildings squat by the road, my favorite emblazoned with "FIREWATER" painted so it reads as one word. A machine with a mechanical head like a giant yellow lobster claw sits inside the walls of one such rusted behemoth, curling the steel walls down onto itself like the involution of a retreating sea anemone.

I pull over to watch. I try to hold this river in my mind, to see it as one creature: a hydra with its many heads hidden in the rough limestone hills and canyons of the Hill Country, its body curving through the brush of the South Texas Plains, and here, where decades ago the river would have split into myriad roots watering a delta and estuary, is a channel straight and deep. Instead of the tidal ebb and flow of Nueces Bay lacing marshlands with brackish water, the Nueces is tidily compressed into a polite passage that bypasses the splayed delta to the north. For the last seventeen miles while it still looks like a river, it is more salt than fresh, more bay than river. It is nearly impossible to equate this manufactured riverscape with the spring-fed, clear waters of the upper Nueces.

And yet they are one and the same.

One of the first Spanish maps of the Gulf of Mexico named it the Río Escondido, or "Hidden River," for its secretive bays protected by barrier islands. In 1689, Alonso de León, marching from Mexico in search of the Frenchman La Salle's settlement, declared it the Río de las Nueces for the pecan and walnut trees that flourished along the banks.

The riverbed of the Nueces and its tributaries runs broad and distinct through hills and coastal plain carved by its path to the sea. Yet can a river that only sometimes has water truly be a river? Along the edge of the Edwards Plateau and the eroded Balcones Escarpment, commonly referred

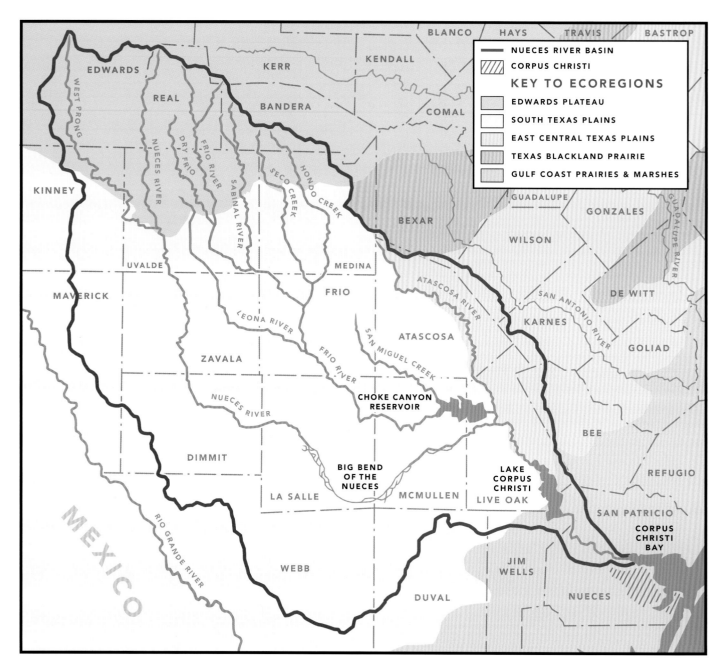

The map shows the Nueces River Basin with the following labels:

BLANCO / HAYS / TRAVIS / BASTROP

KENDALL

EDWARDS

KERR

REAL

BANDERA

COMAL

WEST PRONG

NUECES RIVER

DRY FRIO

FRIO RIVER

SABINAL RIVER

SECO CREEK

HONDO CREEK

KINNEY

BEXAR

GUADALUPE

GONZALES

WILSON

GUADALUPE RIVER

UVALDE

MEDINA

ATASCOSA RIVER

DE WITT

MAVERICK

LEONA RIVER

FRIO

SAN ANTONIO RIVER

KARNES

GOLIAD

ZAVALA

FRIO RIVER

SAN MIGUEL CREEK

ATASCOSA

NUECES RIVER

CHOKE CANYON RESERVOIR

BEE

DIMMIT

BIG BEND OF THE NUECES

REFUGIO

LA SALLE

McMULLEN

LAKE CORPUS CHRISTI

LIVE OAK

SAN PATRICIO

MEXICO

RIO GRANDE RIVER

WEBB

DUVAL

JIM WELLS

NUECES

CORPUS CHRISTI BAY

KEY TO ECOREGIONS

— NUECES RIVER BASIN

▨ CORPUS CHRISTI

EDWARDS PLATEAU

SOUTH TEXAS PLAINS

EAST CENTRAL TEXAS PLAINS

TEXAS BLACKLAND PRAIRIE

GULF COAST PRAIRIES & MARSHES

The Nueces River Basin extends from the Edwards Plateau to the Gulf of Mexico and encompasses more than 17,500 square miles of Hill Country, Brush Country, and Coastal Plains.

to as the Hill Country, the Nueces demonstrates its sea serpent–like nature, rising above and then plunging below its bed, leaving pools like tracks on the surface and hints of the aquifer where the Nueces dwells for much of the time. Oases of fern-clad banks, crystal-clear water, and preternaturally aware bass alternate with stretches of blinding limestone washes as white and forbidding as sun-bleached bones.

The Nueces enters the gently rolling swells of the South Texas Plains, meandering south through spiny brushlands of mesquite, huisache, and prickly pear. The dense thornscrub and coarse pastures overlay the Eagle Ford Shale geological formation where a resurgence of oil and natural gas production has profoundly altered land and water use yet again. The river idles alongside new wells for oil, natural gas, and water. Curling east, then south, only to swing up in a lazy dip, the Nueces slowly makes its way toward the coast. Drought and demand turn the river into a series of small stagnant pools that, while not looking particularly refreshing, provide refuge and sustenance for wildlife. Below the Frio River's Choke Canyon Reservoir, the carefully calibrated flow from the dam converges with the Nueces, and then the river winds its way down the steep-banked channel until its waters are impounded into Lake Corpus Christi. Below the lake's dam, as the Nueces nears the coast, it broadens into a slow and dignified waterway lush with trees. Housing developments perch along its edges as the river flows into the Corpus Christi city limits. A last park and a saltwater barrier dam are the dividing line between freshwater and salt, between the river and the estuary.

Can a river have an identity crisis? Or is it a failure of my imagination that I have trouble holding this river in my mind? In the Spanish language, rivers, as well as roads, oceans, and mountains, have a masculine gender, but I found myself thinking of the Nueces as "her" and "she." The Nueces was, then wasn't, an international border. Her winding course traced a disputed boundary that included New Spain, Mexico, the Texas Republic, and finally the United States. Yet even after the 1848 Treaty of Guadalupe Hidalgo established the Rio Grande as the international border in Texas, the land between the Nueces and the Rio Grande was a wild and untamed land, the residents uncertain of their allegiance.

In Texas, with our extremes of terrain and climate, we know our rivers can never be defined solely by the presence or absence of water. The Nueces seems to be a series of contradictions: a body of water flowing to the sea and a dry river channel; a geographical demarcation of a history both noble and egregious; a river whose name hasn't changed in three hundred years but whose ownership has been contentious for nearly the same length of time; and a hidden river that both flows and is stagnant, a river that flows from our past and into our future.

False day flower

ACKNOWLEDGMENTS

Working on this book has been both a privilege and a joy. We simply could not have created it without the vision and generous support of George C. "Tim" and Karen Hixon. Special thanks to Andrew Sansom, executive director of The Meadows Center for Water and the Environment, whose belief in this project turned an idea into reality. Shannon Davies's enthusiasm and encouragement kept the project on track and moving forward.

We have numerous people to thank for their help during the creation of this book, but Con Mims, executive director of the Nueces River Authority, and his staff went out of their way to answer my many questions and teach me about the river. Every river should have such a team working to protect the resource. Rocky Freund, deputy executive director, Sam Sugarek, director of the Water Quality Program, and Mary Bales, education, were extremely helpful. The Nueces is lucky to have an advocate as passionate as Sky Jones-Lewey. After rains finally returned water to the upper Nueces, Sky invited me to join her on several kayaking trips, for which I am grateful.

We are fortunate to have a number of remarkably talented friends who helped us by patiently answering many questions. Robert Kier did his best to teach me about the geology of Texas and the Nueces River basin in particular; William R. Carr, botanist extraordinaire, identified plants from questionable snapshots; Michael Forstner answered questions about turtles up and down the river; and Dean Hendrickson cheerfully answered all piscine questions. Martha Doty Freeman generously shared tidbits of Texas history that changed the way I looked at the natural history of the Hill Country.

We owe thanks to a number of people in the Nueces Canyons for their hospitality and generosity. Diana and Terry Hibbitts not only gave us a place to stay but shared their knowledge and enthusiasm for the natural history of Texas with us. Special thanks go to James Holder for introductions, railroad history, and his friendship. Milburn Wooldridge,

Suzanne and Wright Friday, Mary Lou and Tommy Ward, Meagan and Jan Prather, Forest "Junior" Hatley, Tom Stoner, Leanne and Kyle Read, Bill Rickey, Kay and Les Breiden, and Ron Sprouse shared river stories and history with me. Marcus Gary, Edwards Aquifer Authority; Susan Hughes, executive director, Green Spaces Alliance of South Texas; Janey Hopkins, Texas Water Development Board; and Joel Pigg, executive director of the Real-Edwards Conservation and Reclamation District, helped me understand the hydrology of the Edwards Aquifer. Joyce Moore and Brent Ortega of the Texas Parks and Wildlife Department, Jude Sandoval of the USDA Wildlife Services, Beryl Armstrong and Shane Kiefer of Plateau Land and Wildlife Management, Troy and Marla Hibbitts, Toby Hibbitts, Jackie Poole, and Chuck Sexton deserve thanks for answering questions and sharing their insights regarding the natural history of the canyonlands. Russ Walker and Carol Miserlian, longtime friends, invited us to join them on a fly-fishing trip and introduced us to the upper canyons of the Nueces more years ago than any of us will admit.

On the West Prong we owe thanks to John Taliaferro and Malou Flato as well as Katy and Ted Flato for our magical time at Kickapoo. Scott Fleming went out of his way to help us. Alma Smart was as candid and honest as anyone I've ever met; I am humbled by her trust. Paula and Ernest Smith generously gave us the run of Dobbs Run while Bryan Fisher made sure we didn't get lost and patiently answered our questions. J. David Bamberger's breadth of vision still astounds me. I owe him, along with Joanna Rees and the Snowbell Team from Selah Bamberger Ranch Preserve, thanks for letting me tag along.

In La Brasada, I was lucky to meet the Marquez family of Crystal City. Rosalinda, Alejandro, and their daughter, Andra, shared their family's history with me and helped me understand the drastic changes the area has undergone, both environmentally and socially. The Nueces' Bermuda River Park does indeed have lots of water as well as Doris Jackson, owner, former teacher, and local historian, who cheerfully shared her memories and knowledge. Downstream of Cotulla, the Hixons, George "Tim," Karen, and Timo, gave us a memorable weekend on the river. Special thanks to Mike Hehman, manager of the Hixon Ranch; Eric Grahmann, director of game bird research at Texas A&M University–Kingsville; Ed Walker, Wintergarden Groundwater Conservation District; Lawrence

Gilbert, University of Texas at Austin; Francis Rose; Daniel Walker, David Rios, and Sarah Resendez, Texas Parks and Wildlife Department; and Virgil Alexander, Gus Canales, Jim Willingham, and Jim Stout for their help. Forrest Smith, director of South Texas Natives of the Caesar Kleberg Wildlife Research Institute, took the time to tell me about exotic grasses. Jon Paul Pierre and Michael Young shared their research about aboveground impacts of the Eagle Ford Shale with me. Gerald Daub and William Lindemann each loaned me their master's theses about the geology of the Nueces River and the possible connection with Baffin Bay. Travis LaDuc, curator of herpetology for the Biodiversity Collections at the University of Texas, invited us to join his class at The Chap. We owe him one.

Hershall Seals invited us to the Rocky Reagan Campground in Oakville, where his parents, Jack and Evelyn, and his brothers and cousins welcomed us and treated us like family. Craig and Connie McIntyre supplied us with bed, birding, and great company. Pat and Joe Garland rescued me with friendship, food, and extra kayak straps. While I relied on the Coastal Bend Bays and Estuaries Program's published research about the Nueces estuary, Ray Allen brought the information alive when he took the time to show me the delta and taught me how to see beyond the huisache. W. Scott Bledsoe III, Nueces River Authority Board of Directors; Joel and Vicki Simon, HawkWatch International; Tim McWha, Nueces River Preservation Association; Aaron Baxter, Center for Coastal Studies, Texas A&M University–Corpus Christi; Bill Brooks, Horned Lizard Conservation Association; and William "Ski" Zagorski, San Patricio County, all helped immeasurably. Dawn and Ross Carrie loaned Bill their diamondback terrapin for photographs.

A tip of the hat goes to the libraries and their staff who helped me with my research. Special thanks to the staff of Baylor University's Texas Collection, where I spent a number of days reading Anna Stoner's original letters. Lois Myers's book *Letters by Lamplight* first introduced me to Anna's story. Virginia Wood Davis, archivist at the Archives of Southwest Texas, El Progreso Memorial Library in Uvalde, was an inspiration and helped me locate a number of unique sources.

William Reaves and Sarah Foltz of William Reaves|Sarah Foltz Fine Arts gallery deserve special credit for their continued enthusiasm for

our artwork and the project—even when we missed gallery deadlines. Peter Williams at AgavePrint scanned all the artwork, including Bill's largest paintings, so they could be accurately reproduced. Rob Story miraculously turned my scribbles into beautiful and legible maps.

On a personal note, we must thank our family and friends for their encouragement and support. We simply could not have completed this work without the help of Austin Moline and Melissa Swenson.

The amazing team at Texas A&M University Press took our sometimes haphazard work and transformed it into a book. Magic indeed. Special thanks to Shannon Davies, press director; Patricia Clabaugh, production editor; Laurel Anderton, copyeditor; Mary Ann Jacob, design and production manager; Kevin Grossman, prepress manager; and Gayla Christiansen, marketing manager.

Finally, in memory of James R. Dixon. His passion for Texas herpetology and zest for life will always be an inspiration.

I : El Cañón

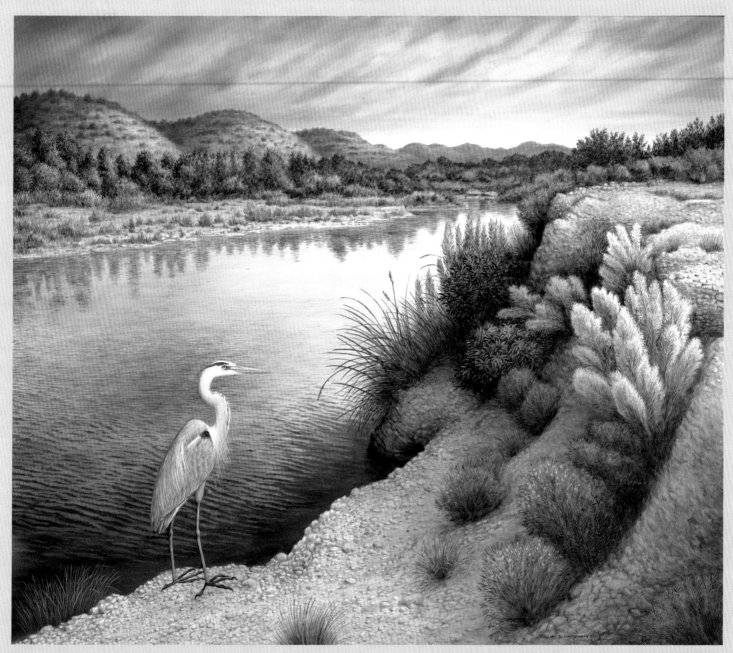

Camp Wood Crossing

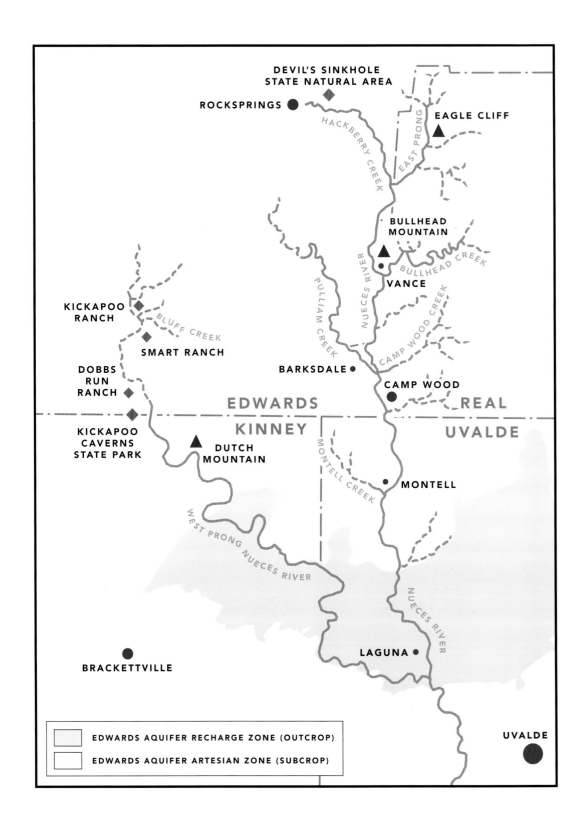

DEVIL'S SINKHOLE
STATE NATURAL AREA

ROCKSPRINGS

EAGLE CLIFF

HACKBERRY CREEK

EAST PRONG

BULLHEAD
MOUNTAIN

VANCE

BULLHEAD CREEK

PULLIAM CREEK

NUECES RIVER

CAMP WOOD CREEK

KICKAPOO
RANCH

BLUFF CREEK

SMART RANCH

BARKSDALE

DOBBS
RUN
RANCH

CAMP WOOD

EDWARDS

REAL

KINNEY

UVALDE

KICKAPOO
CAVERNS
STATE PARK

DUTCH
MOUNTAIN

MONTELL CREEK

MONTELL

WEST PRONG NUECES RIVER

NUECES RIVER

BRACKETTVILLE

LAGUNA

UVALDE

EDWARDS AQUIFER RECHARGE ZONE (OUTCROP)

EDWARDS AQUIFER ARTESIAN ZONE (SUBCROP)

El Cañón

I stand on the divide. Behind me the windswept curves and uplands of the Edwards Plateau roll northward. Dark soil and white limestone rubble alternate with closely cropped winter grasses. Thickets of shin oak, persimmon, and cedars tangle in dense stands that clog the plains. Beneath me the caprock of the plateau, a continuous sheet of hard Cretaceous limestone, extends across the heart of Texas.

The Breaks of the Balcones fall away in front of me. The parallel canyons of the Nueces River and her tributaries dig into the slopes, gouged into the edge of the Edwards Plateau like claw marks left by a great beast scrambling to grab hold of the edge. The water-sculpted gullies, draws, and streambeds of the West Prong, Nueces, Frio, and Sabinal Rivers, plus Seco and Hondo Creeks, cut through layers of limestone, creating the long slopes and eroded canyons of the Balcones Escarpment. In the distance the jagged landscape levels out, the canyons worn down into the South Texas Plains and La Brasada, the brushlands.

Immediately before me the blue-gray haze of cedar and oak woodlands fills the drainage of the East Prong of the Nueces and Hackberry Creek. To my right runs the West Prong of the Nueces, the desert edge of the Breaks where the Chihuahuan Desert slips its plants and animals into the Hill Country. A hint of pale green clings to the slopes, the buds and first leaves barely perceptible against the bare limbs and trunks of the deciduous trees. Nearer, male cedar trees are tawny with pollen cones, and I wonder whether the atmospheric haze turning the hills multiple shades of blue and gray is drifting clouds of cedar pollen. Somewhere in the steep canyons below me, the many springs of the Edwards Aquifer reach the surface and slip above the ground long enough to be called seep or spring, then creek, and finally river.

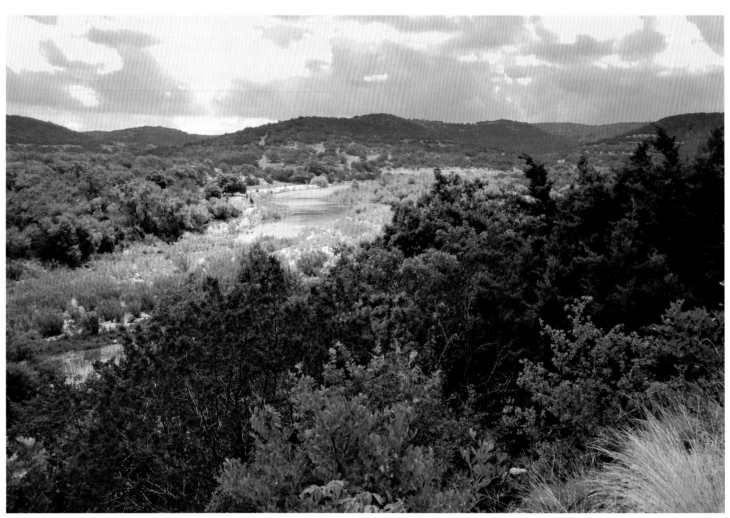

View of the Nueces canyon,
Edwards County

1 *Breaks of the Balcones*

EAST PRONG OF THE NUECES

Hackberry Road balances along a crest between slim canyons, no more than steep gullies at this point. Stunted cedars, yellow grasses, and a few gnarled piñon pines border the road. Patches of rock-strewn pasture appear from behind and between the trees.

The road tips over the edge of the plateau and dips down into the shade of a live oak leaning over a dry wash. No water, just stones jumbled and stacked in the language of gravity, sudden hard rains, and flash floods. There is evidence of water: a small sycamore rattles its brown leaves at me, dusty maidenhair ferns cling beneath a boulder, and vanes of dried grass droop between the cedars. Behind the thicket, the water-stained ledges of a small limestone bluff wait.

I am not in a land of gentle soaking rains, of deep drenching fogs and year-round trickling creeks. This sere cut is filled with tumbled river stones too large for the canyon. Where, I wonder, is the water that tossed limestone boulders around like dice in a game of geological chance and carved this canyon with its abrupt steep sides? I can imagine a flood of rainwater leaping down the canyons, crashing off the sides of the steep draws and rushing toward the river valley below.

There is something unmistakably wild about these small canyons snaking through the Breaks of the Balcones. I've left behind the close-cropped grasses of the upland pastures and the herds of cattle. Tall, eight-foot wire game fences turn the road into another kind of canyon.

The road crests a ridge, and I look over the tan fingers of the plateau combing through the blue-gray haze of cedar and oak slopes. It is a dusty sea lapping at the edge of the caprock and running down its flanks to an end obscured by dust and distance.

I drive on, stopping at every low-water crossing to peer upstream and down. Hoping to see water; wishing for access. Perhaps unrealistically

optimistic, but I am, after all, a Texan. The ridiculous grape Kool-Aid scent of a blooming mountain laurel wafts down the canyon. Agarita perfumes the air with streams of honey gold. Around a turn and a redbud flames from a ledge, pink flowers sprouting along its trunk and branches. Bees work the flowers in a nectar-drunk frenzy. These canyons are home to a number of endangered and rare species. Some, like the golden-cheeked warbler and black-capped vireo, formerly lived throughout the Hill Country and are making a tentative comeback. The Tobusch fish-hook cactus, a small, low-growing, single-stemmed cactus found only in the western Hill Country, still lives on dry limestone slopes in the Nueces canyons. And the Texas snowbell, a slender-trunked tree with leaves reminiscent of a redbud, dangles pearly white flowers over limestone ledges somewhere behind the tall fences.

A green kingfisher flashes across the road and over the net wire, out of place in the dust-choked cedar canyon. The bird's rattling proclamation of water and fish and the tantalizing smell of river weeds draw me out of the truck. Sunlight flashes off water from behind the screen of trees. All that stands between me and the oasis is an eight-foot-tall game fence and my goody-two-shoes need to obey the law. I walk down the road to a river crossing. The banks are thick with cedar and thorny brush. I wonder if I'm imagining the kingfisher and the cool river fragrance. The fence across the bone-dry low-water crossing has a gap left for floodwaters. I could easily duck through the space and walk upstream, and I'm on the verge of crawling under the fence when sense prevails over the siren song of the river; I prefer my skin unperforated by buckshot. Sitting on the tailgate I sip tepid metallic water from a canteen. A cloud of gold-green oak pollen drifts into blazing sun, and the luminous dust settles onto the trees, bushes, and my truck. I think of the cold shock of immersing sunblasted skin into green and blue spring-fed river water. I can almost feel the spongy water-saturated moss and spiny sedges under my bare feet.

My daydreams are interrupted by the sound of a 4×4 somewhere on the other side of the tall game fence, heading in my direction. I panic, even though I haven't physically trespassed. Do the owners have cameras or surveillance equipment along the road? I slap the oak pollen off my jeans and scramble into the truck.

As Hackberry Road descends, the canyon bottom begins to broaden

into terraces along what the maps grandly call the East Prong of the Nueces River. I cross the dry river on broad shelves of water-smoothed limestone tinged gray with dried algae and silt. Clearings appear where the dense cedar forests or brakes are pushed back to the slopes of the canyon walls.[1] The ongoing drought is evident here with grasses bitten back to the quick and ground into the powdery dirt. Black pebbles of sheep and goat dung pepper the limestone rubble of the pastures. Stunted prairie verbena hugs the ground with clusters of purple flowers.

Golden-cheeked Warbler

Headwaters

Greenwood Valley Ranch, of the many KEEP OUT and NO TRESPASSING signs, has a crew clearing cedar and brush. They are cutting everything but oaks and grass, scraping the unwanted trees and brush into burn piles. Ash pits smoke and slashes of dark soil mark the heavy machinery's tracks. Tall cedar posts set in concrete mark the property boundary. The crew's trucks nearly block the road, and as I inch past, I watch the brown faces of the men whose eyes slide over the truck. A foreman stands at the edge of the road scowling at his crew, me, and the ground at his feet.

Just over the dusty hood, a miraculous sight appears. Water pours over a low dam in a shimmering curtain that flows over the road and into pools that gleam in the afternoon sun. Sycamores wave pale green leaves in welcome, and I spy the brilliant red flags of scarlet penstemon growing along a limestone ledge. After the miles of wire and warning signs, the unfenced river seems illusory. The sound of cascading water nearly overwhelms the foreman's barked orders. The county road curves up out of the river and past a sign welcoming me to Camp Eagle. I look back. The foreman is staring at me, squint eyed and lemon mouthed.

I drive on, sending wavelets of river water lapping downstream and leaving a trail of water and tire tracks on my way to the camp's office. Flurries of cars arrive and depart from the welcome center, each vehicle bracketed with racks of knobby-tired bicycles. Inside, a cheerful young woman wants to sign me up for tomorrow's race but listens seriously when I ask permission to walk the river. She disappears into the back office, and I find myself staring at a stuffed juvenile golden eagle with frayed primaries and tattered tail feathers mounted over a fireplace and a plaque

proclaiming "Love one another as I have loved you." Its six-foot-wide wings are half opened as if it is about to spring aloft. Yet the bird's expression is not the fierce stare of a top predator; indeed, something about the way the taxidermist set the eyes gives this bird a bemused gaze. A young man suddenly appears at my shoulder, startling me. "We have a permit," he says.

Matt Reed has the healthy good looks of a happy young man. As we walk toward the river he tells me, "The eagle and the permit came with the property when Camp Eagle purchased the Eagle Ranch in 1999 with the goal of creating a Christian camp to develop both spiritual and physical skills in people of all ages." He follows the camp's mission statement with anecdotes about the ranch's history that include tenure as a boys' home in the 1950s, a possible stint as a brothel, a vacation ranch owned by defense contractor Ling-Temco-Vought, and a time-share resort. One story he tells me (and that I will hear repeatedly from canyon residents) involves clandestine visits by Lyndon B. Johnson, then the vice president of the United States, to the Ling Ranch to plan the assassination of President John F. Kennedy. Matt reminds me, as I scribble furiously in my notebook, that these are just rumors.

We walk along boardwalks installed between former condominiums, now guest and staff housing. New dormitory cabins, surrounded by the unfortunate choice of St. Augustine grass sod, sit under shady live oaks. Sprinklers hysterically fling water, and rivulets seep out from under the sod and run downhill.

Camp Eagle is designed for outdoor adventure: mountain biking, rock climbing, and, of course, swimming and recreation in the river. The property includes a mile and a third of river and extends into the surrounding hills. From our vantage I look downstream and see slides, giant rubber rafts, and other gear filling the river. Matt points out the decommissioned USGS gauging station and leads me down to the river crossing and their property line. We look upstream. On one side of the impounded river, limestone ledges sprout ferns, last year's dry switchgrass, and bushy bluestem. The river curves away behind blue oaks, Mexican persimmons, mesquites, buttonbush, and thickets of cedar. Greenwood Valley Ranch's bank is raw dirt and scraped limestone down to the water's edge. "The springs produce over a million gallons of water a day," Matt tells me. "But

just a quarter of a mile upstream it is completely dry." Turning downstream he points out Eagle Cliff rising over the river. "That is where they shot the eagles," he says. I turn sharply to look at him.

"They wrote a book about it," he adds, his voice trailing off. He gives the binoculars looped around my neck a swift sideways glance.

"Really?" I ask. "Eagles in these canyons?"

"Not much anymore," he says quickly. I jot a note to look up eagles in the area and wonder whether their stuffed bird once soared over the limestone bluff.

<div align="center">✦ ✦ ✦</div>

Matt leaves me, and I climb up to stand on the shoulder of the dam. From my vantage point I look across the camp. Away from the pools of river water, it is dangerously dry. Again. The drought persists. On the slopes the brown of dead and dying trees counters the pale optimism of spring leaves.

Not that there is much rainfall here in the best of years. The Nueces River canyons, including those of her sister the West Prong, are considerably drier than the eastern Hill Country canyons like the Medina or Guadalupe. Average annual rainfall measures about twenty-eight inches per year in the Nueces River canyon. But over the entire river basin, rainfall averages start at thirty to thirty-four inches per year on the eastern edge with Hondo Creek and get progressively drier moving westward to Seco Creek, then the Sabinal River, the Frio River, the Dry Frio, and the Nueces River canyon, and ending with less than twenty-six inches of annual rainfall in the arid country bordering the West Prong.

Indeed, some people refer to the Nueces and her canyons as being in West Texas. In the midst of this drought the dry landscape certainly feels like the Chihuahuan Desert. Yet how can this river suddenly appear in a dry canyon in a near-desert land?

The springs at Camp Eagle are locally referred to as the headwaters of the Nueces but are otherwise unnamed.[2] I find it remarkable that such a volume of water isn't uniquely named, but it illustrates the abundance of springs in the Breaks of the Balcones. Springs seep from limestone ledges in nearly every draw along the length of the canyons.

The nameless headwater springs have, however, been consistent. The

earliest land surveys clearly mark this spot and these springs as the headwaters of the Nueces (even though Hackberry Springs at the head of the tributary Hackberry Creek produces more water). The description of the survey section (640 acres or one square mile), measured for the Gulf, Western Texas & Pacific Railway Company in 1876, describes the north line of Survey No. 51's perfect square as crossing the "dry bed of the Nueces." Yet the south boundary crossed a running Nueces. An even earlier description by Spaniard Nicolas Láfora, engineer for the Marqués de Rubí expedition, describes what could be the headwaters springs (but could just as likely be Hackberry Springs) in July 1767: "At 2 leagues we came to a place called La Cabecera. There, at the foot of a tall hill where the canyon ends, two arroyos with two springs join to form the [headwaters of the] Río del Cañón" (Jackson 1995). Looking downstream, I wonder whether Eagle Bluff could be the same tall hill that Rubí and Láfora describe. As tantalizing as the written record is, I know that an older history exists. The proof is scattered beneath my feet.

I step off the dam. In 1975, an archaeological team spotted three burned rock middens just off the road (possibly where the crew is clearing cedar). I scuff my feet in the dry soil and kick a few pieces of limestone and chert chips around. I might be able to spot camouflaged birds in trees or cryptically colored lizards basking on rocks, but I never see arrowheads, points, or tools, much less the worked fragments and chips left behind by the tool makers. To me it all looks like bits of rock. This lithic blindness keeps my head up and looking for creatures, but I feel like a foreigner who doesn't speak the language.

The Texas Parks and Wildlife Department's 1975 archaeological survey of the Devil's Sinkhole State Natural Area included an informal cataloging of sites along the upper Nueces. Though the archaeologists had problems gaining access, which resulted in "a survey peering out the window of a pickup truck while driving down a county road," they were invited onto the Eagle Ranch (much of which is now Camp Eagle), where they located multiple burned rock middens, or hearths, on the river terraces near the springs. As generation after generation returned to these springs, debris accumulated, building circular or oval mounds of burned and cracked limestone, charcoal, and ash-stained soil. At the time of the survey, most of the middens had been destroyed by road construction,

altered by land clearing, or extensively collected. I look around; the gently sloping river terrace along one side of the river still makes a fine camp. Upstream the clash of gears and sound of metal scraping limestone announce the work crew's progress.

The river pools before me, the spring water slowed and then held downstream by a series of low dams. Layered limestone shelves frame both sides of the river with one side rising to small bluffs crowned with trees.

The bright primary colors of plastic slides, blobs (giant air-filled pillows), and other recreational equipment reflect off the water and the pale limestone backdrop. The spring air is still cool, especially as the afternoon light turns to gold and a chilly breeze runs down the canyon.

Camp Eagle is all about recreation. And while enjoying nature is part of outdoor recreation, it isn't the main goal. The wear and tear on the area is evident. Riparian vegetation is crumpled or gone. Playing fields are closely cropped grass. The surrounding hills are dense with cedar brakes. A former quarry is filled with a ramshackle structure designed to look like old mining equipment that is, in fact, a giant jungle gym.

Yet the limestone cliffs capture the sound of excited voices calling and

Camp Eagle at the headwaters, Real County

laughing. Young men and women stream across the camp on bicycles getting ready for tomorrow's race.

I sit on a limestone ledge and barely dip one big toe in the water before I shriek. The deep, still water is too cold for my pale feet. The water stretches smooth and dark in the shadow of the bluffs. Azure damselflies alight on slender reeds. Last fall's sawgrass blades arc from the bank, turning into heart shapes when twinned with their reflection. Spiderwebs shine, tangled in the drooping seed heads. Bright spears of new reeds point skyward, arrow-sharp in the thickets of shadow.

Just across the river, a live oak leans toward the river, as if peering over the limestone ledge to see its own image. Maidenhair ferns cluster and dip toward the water where springwater flows from under the stone shelf. An eastern phoebe calls from a branch of the oak. Cardinals flash through the shadows. The world smells like springwater, ferns, black soil, and sunbaked stone.

I walk, then drive, down the series of impounded river pools in Camp Eagle. Jumping from limestone shelf to boulder along the shore, I suddenly realize why this place feels so different from the headwaters of the Frio and other Hill Country streams I know. It isn't the open, arid feeling of the camp with broad swaths cleared for playing fields. Or that the river terraces, long cleared of undergrowth, have only scattered oaks, cedars, and other trees to shade the camp's buildings. Or that trees grow streamside only along the steepest banks and bluffs. I look around again. I haven't seen a single cypress tree along this stretch of spring-fed river.

Eagle Cliff

I drive over the last river crossing on Camp Eagle. Water trickles over a dam into tall clumps of bushy bluestem and switchgrass. The bare stems of seep willow and the trunks of sycamores and pecans cast a latticework of shadows. Signs direct campers to the rappelling, bouldering, and other rock climbing courses on the bluffs above. The slender river skirts the base of the limestone, disappearing from sight.

I drive a short distance through a corridor of cedars and dry brush, certain that the river runs just out of sight. Yet when I emerge from the trees I am confronted by a bare-bones expanse of limestone riverbed.

Flouting the "No Trespassing" signs, I pull over and walk upstream to a low dam. In the open expanse of limestone bedrock I find fissures, cracks, and areas filled with dirt, gravel, crispy grass, and even a puny cedar seedling. The dam is less than two feet tall and the water behind it, while clear and still, is well below the lip of concrete. On the far end water seeps under the concrete and gently pools in the riverbed's contoured surface. I follow the ripple of water across the stone until it disappears, circling and pouring down a hole in the limestone. I can hear the water splashing as it disappears underground. This must be the swallow hole where, according to local lore and the aforementioned team of archaeologists, the entire river's flow can and will disappear, leaving only dry riverbed downstream. As dry as the rocks before me now.

<p style="text-align:center">✦ ✦ ✦</p>

It is easy to comprehend a series of dammed pools in a mostly dry riverbed while in the midst of a drought. But the earliest maps show the Nueces and the West Prong as a series of pools alternating with long stretches of dry gravel bed—long before ranchers built concrete dams. The map symbols for springs, sperm-like squiggles, point their tails toward the blue-inked pools on broken lines of the rivers. And those symbols are the key to the "now you see it, now you don't" nature of the Nueces in the canyonlands of the Balcones Escarpment.

The springs and spring-fed pools, rivers, and creeks of the Edwards Plateau canyonlands are the external manifestations of the Edwards Aquifer. After more than a century of study, and even with all our technological advances, much of the aquifer remains unknown, and possibly unknowable.

It is tempting, when considering an aquifer, to look at surface water and compare the two. After all, an aquifer is nothing more than an underground layer of sand, gravel, or rock that holds water. In this canyon I'm surrounded by the evidence of water and gravity. Water flows downhill or down a swallow hole. It seems like plain old common sense. In the 1920s, Jesse Grinstead, in his popular magazine *Grinstead's Graphic*, rakishly explained the springs in the canyonlands:

The head of the Frio, where the stream breaks forth from its rock-bound prison a full-fledged river at its source, is another wonderful sight; also the famous Kickapoo Springs on the West Nueces, and scores of others. Then you naturally ask, where does all this water come from? Who knows? The elevation in Edwards County as stated is 2496 feet. Evidently this flood of water comes from a source much higher. Probably it finds its way underground from the melting snows of the Rockies.

As humorous and simplistic as the idea of water flowing downhill from the Rocky Mountains seems now, it makes sense to me—unlike the capricious nature of groundwater, which stumps me at every turn. The thing to remember about the Edwards Aquifer is that what you see on the surface—the hills, draws, and riverbed—can have little or nothing to do with what is happening below ground. In the aquifer water can, and does, run uphill. The underlying principle of groundwater is that water goes from an area of high pressure to an area of low pressure. But how does a hidden process—with such lackluster terminology—result in seeps and springs of freshwater along these canyons and draws? To fully understand the springs of the Edwards Aquifer, you have to know about karst, the heart of the aquifer. But to understand karst you have to accept that water is stronger than stone. And that stone is limestone, the accumulated remains of marine creatures.

✦ ✦ ✦

Once upon a time, the land we call Texas (and most of what we know as North America) was beneath a shallow sea. This was a period in the earth's life when the continents were not settled into the outlines we recognize today. Waves lapped at a shoreline roughly where the Rocky Mountains rise out of the lower forty-eight states today. The shallow sea flooded over the existing layers of sediment (including the silt, clay, and calcium carbonate that would become the Glen Rose Formation) and gradually, layers upon layers of marine creatures with calcium-rich shells built up on the bottom of the sea. The deposits of limy shells would in time become the Edwards Limestone formation. Meanwhile dinosaurs roamed, leaving footprints and bones. Flowering plants flourished, birds

evolved flight, and early mammals staked their territories in the forests. Eons passed and the seas gradually receded. The Edwards Limestone, now exposed to the air and rain, began eroding. Slowly our continent's current shape became recognizable, but the seas again covered the land, depositing additional layers of chalky Cretaceous marine sediments on top of the now-eroded layers of Edwards Limestone. The Rocky Mountains popped up and massive erosion from their slopes sent soil cascading all the way to the Gulf, covering just about everything. The weight of the sediments caused the earth's crust to slip, jostle, and crush, ultimately creating the assemblage of fractures we call the Balcones Fault Zone. About ten million years ago, along the Balcones Fault Zone, something shifted and either the limestone layers of the Edwards Plateau heaved up or the coastal area dropped. The end result, either way, is that the top of the Edwards Plateau sat more than two thousand feet above the coastal plains. Over time, water and wind washed away the upper layers of younger, softer limestones and sedimentary stones, leaving the plateau with a hard cap of Edwards Limestone. Runoff from rainstorms nibbled away at the abrupt edges of the plateau and softened its profile. Water-

Eagle Cliff, Real County

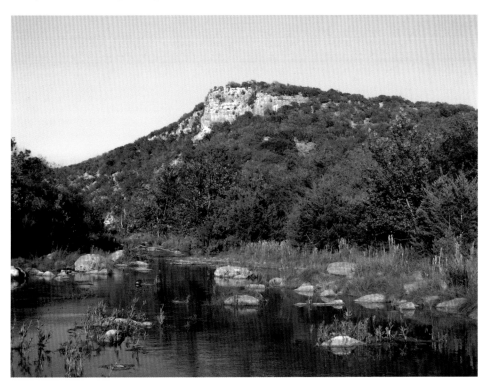

sculpted gullies, draws, stream ways, and canyons cut down and across the older layers of limestone, dolostone, shales, and clay, ultimately creating the Balcones Escarpment or canyonlands that now separate the edge of the plateau from the fault zone.

Eagle Cliff, two hundred feet of cream and white Cretaceous limestones, glows in the late afternoon light. I look up at one hundred million years of history set down in layers as neat as chapters in a book. The cliff's secrets and its stories are spelled out in an alphabet of marine animal and plant fossils. The bedrock of the river stretches before me, water-smoothed stone with irregular patterns of rough rock on smooth rock. It looks like someone dabbed thick, sticky paint with a giant household sponge. The expanse of streambed has layers that are eroded, broken into massive slabs, and pierced by fissures like the swallow hole and the rubble-filled hollows. Where does the water go when it flows down the swallow hole? Is there an underground river siphoning off the surface water and flowing though subterranean caverns deep into the heart of the Edwards Aquifer? I scuff my feet and kick a loose rock. A small cloud of dust puffs up and then settles. So how do you get water *into* stone, much less *from* a stone? The secret is karst.

Despite its rude-sounding name, karst isn't something you cough up. It is a region of limestone, dolomite, or gypsum rocks that have been partially dissolved into a porous network. Around here that ranges from the ubiquitous honeycombed rock scattered on the surface of the Edwards Plateau to sinkholes, caves, springs, and, in this case, an extensive aquifer. Karstic limestone is created by rainwater, naturally acidic, leaching into normal fractures in the rock and slowly dissolving the alkaline calcium carbonate of the limestone. Drop by drop, the rainwater creates a matrix of tiny passageways and gaps in the rock. A few of the pathways enlarge and become conduits, the pipelines of the underground plumbing system. Most of the water is stored in the matrix (about 95 percent), but the majority moves through the conduits. Over time, as more water flows through a conduit, more of the surrounding mineral matrix is dissolved, thereby creating larger passageways and ultimately, caves, sinkholes, springs, and swallow holes.

The Edwards Plateau is one of the largest continuous karst regions in the United States, so it stands to reason that it is also one of the big-

gest karst aquifers. No one knows exactly how much water is stored in the water-bearing strata of the Edwards and Glen Rose limestone formations or, more importantly, how much of that water is accessible. At this time, more than two million people currently depend on the Edwards Aquifer for water. And that number is skyrocketing as the population of central Texas booms.

A few hundred yards downstream, water seeps out from between layers of limestone at the base of Eagle Cliff. It slips across the flat limestone bedrock, pooling briefly. With the river's flirtation with the aquifers, it isn't clear whether I'm looking at surface water or groundwater. Rainwater or springwater. The "now you see it, now you don't" nature of the Nueces in the canyons is confusing. When there is rain—well, that is another story. In these steep canyons, rain rapidly soaks into the relatively thin soils overlaying the uplands. Some of the rainwater soaks into the porous limestone, but a significant portion runs off and briefly fills the riverbed, until it encounters a swallow hole or sinks beneath the gravel of the riverbed.

✦ ✦ ✦

As I drive away from the low-water crossing, the road curves behind a line of trees and brush. In the shadow of Eagle Cliff, trees are budding out, and new leaves flutter quietly in the breeze. I break from the tree cover to discover yet another face of the Nueces. This one is gentle, with clear water flowing over and between limestone cobbles. Somewhere upstream a spring is pouring into the river. The waterway is bordered by clumps of grass topped with last fall's russet seeds and stems. Backlit by morning light, green shoots glow in dark green sedges. Feathery spikerush crowds the river's edge. Small fish dart away. A turtle basks upstream, and as I scan with my binoculars, my eyes are drawn from its red ear patch to a brilliant red cardinal splashing upstream. Above the russets, browns, and greens of the grasses, little walnuts and sycamores flaunt newly unfurled leaves in a band of yellow green. Behind the spring green there is a backdrop of dark cedar, brown and gray tree trunks and branches, and the dark gray of limestone bluffs in shadow. A Texas mountain laurel flashes its purple flowers in the midst of the somber tones.

Every crossing on the East Prong of the Nueces reveals another

glimpse of the mysterious river. I see shallow pools stretching across solid limestone riverbeds under sloping white bluffs with little or no streamside vegetation, rushing water curving through seep willows, sycamores, and tall grasses with heavy cedar slopes on either side. A dozen or more stone cottages ring a river terrace. The flat ground before them is drought-burned to dirt, shattered limestone, and struggling clumps of grass. Behind the cottages, the tops of tall trees contrast with the dry, brush-covered slopes beyond.

The river valley broadens as I descend. I pass East Rose Draw, then West Rose Draw before the hills fall back at the mouth of Sanchez Draw and the confluence with Hackberry Creek. Local history and place names focus on the Anglo settlers that arrived after the Civil War, so where did this Hispanic name come from?

HACKBERRY CREEK

When the East Prong reaches the confluence with Hackberry Creek, it is clear that you have reached the main canyon. The riverbed is an enormous gravel wash with a few stagnant pools of water. The banks have been pushed back and lined with massive blocks of limestone in preparation for future floods.

Turning north onto Ranch-to-Market Road (RR) 335, one of the Three Sisters scenic drives, you look down into Hackberry Creek. But it looks like a quarry, not a creek. The landowner has stripped the banks of all vegetation and dug enormous pits in the creek bed. The escaping water flows downstream surrounded by barren white gravel.

Keep going and the road twines along Hackberry Creek through deep canyons and finally climbs up onto the divide. The road clings to limestone bluffs and drops down to the creek with little or no room to spare. As he drives us up the canyon, I torture my husband, Bill, by pointing out the flowering trees clinging to the slopes—mountain laurels, escarpment cherries, Mexican buckeyes, yellow buckeyes, and redbuds—and then I squawk if he glances away from the road. We pass piñon pines and chinquapin oaks, Spanish daggers with full heads of creamy white blossoms, and spring-fed pools below us. I recite a nonstop list of birds and wildflowers spotted from the passenger seat. We pass the remains of

AT RIGHT: *Tropical Parulas on Hackberry Creek*

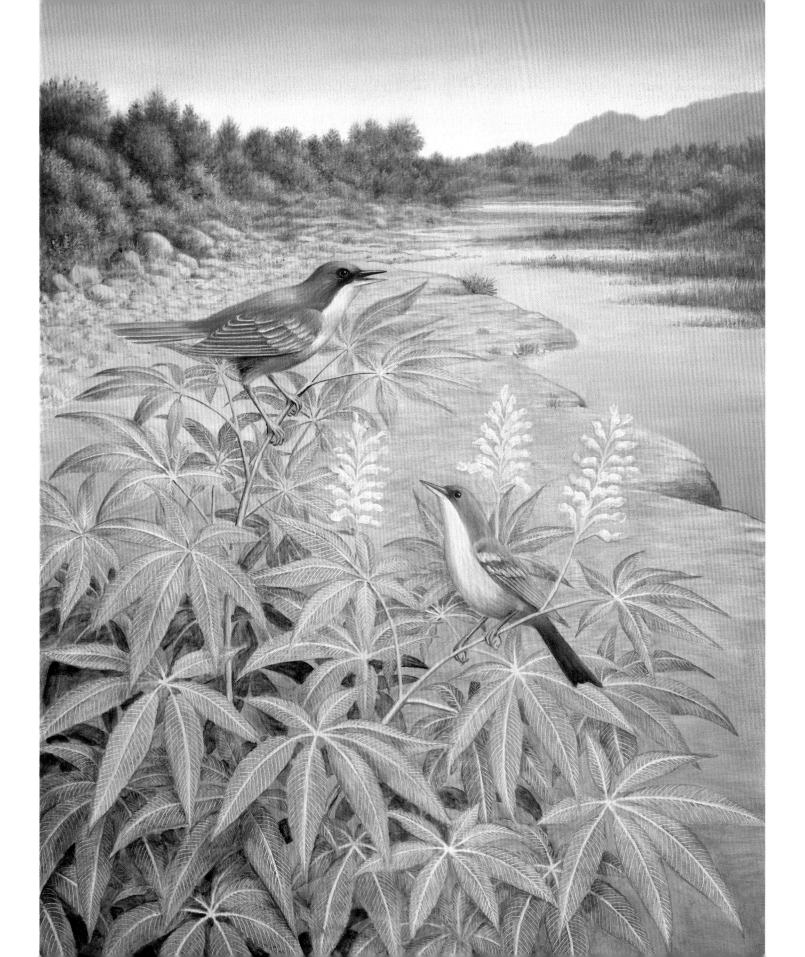

Hackberry Community, a restored one-room schoolhouse and Hackberry Cemetery. Motorcyclists stream past and impatiently cluster behind us. I look down at the stream flowing over bedrock. Hackberry Creek flows stronger than the East Prong and has always done so. To further complicate matters, the big springs at the head of Hackberry Creek are often called the headwaters of the Nueces. In 1861, W. W. Heartsill, a Confederate soldier stationed at Camp Wood, the abandoned US Army post, described reaching what is likely Hackberry Springs:

> Upon looking around and close examination I have come to the conclusion that this is no ordinary place, This is the source of the East fork of the Nueces, the Springs rising up through round holes in the rocks, the water then running off in channels in the rocks, these channels are rounded out and as smooth and as precise as if done by a skillful workman, these natural channels extend for fifty or sixty yards down the river; the bed of which is some thirty or forty feet wide and perfectly smooth except where these channels exist: the water is as clear as crystals and nearly as cold as Ice-water, this is certainly the wildest, yet the pleasantest place I have ever seen. (Heartsill 1954)

Then why isn't Hackberry Creek called the river and the smaller stream coming in from the east called a creek? In 1962 a US Geological Survey district engineer drove out to the canyon. It seems that an early topographical map labeled the main river as the East Fork of the Nueces, which could make sense seeing that there is a West Prong. But the engineer found that the local viewpoint was very clear: the Nueces is formed in the headwaters by Hackberry Creek and the East Prong. The engineer noted that Hackberry Creek is "much the larger water course," and that there is no East Nueces River or East Fork of the Nueces—except that people continually use the name. In fact, even the Texas Water Development Board's catalog of springs calls Hackberry Springs the headwaters of the East Fork of the Nueces River.

Driving down the twisting canyon, I find it hard to believe that anyone would drive cattle through the steep and winding waterways of the upper Nueces. Yet after the Civil War a feeder trail of the Great Western Trail

pushed cattle up through the headwaters and over to Rocksprings on the divide. According to Frank S. Gray, an Edwards County rancher, the trail drivers dreaded the headwaters canyons. To get the herds through the narrow canyons, thousands of cattle were strung out for miles. After pushing the main herd through the rough terrain, the cowboys still had to search the plentiful ravines for strays and move them back into the main herd. Then there were the rustlers who took advantage of the situation to rush in, cut a few cattle out, and push them into side canyons.

I say to Bill, "Imagine thousands of cattle strung out from one end of the canyon to the other." He raises an eyebrow. "But supposedly there were herds of wild cattle in the canyons too," I say and then tell him about W. W. Heartsill and his fellow Confederate rangers' scouting mission on either Hackberry Creek or the East Prong in 1861. On the first night, the scouts heard the sound of hundreds of hooves pounding up the canyon. The rangers hid, squatting in tall grass with drawn guns. Concluding that they'd narrowly missed discovery by a band of marauding Indians on horseback (likely returning to a camp somewhere upstream), at first light, the rangers crept up the canyon to surprise the Indians. They sneaked up to an old Indian campground, certain there would be bloodshed. Instead they found a herd of wild and wary cattle stamping their hooves and switching their tails. No Indians, no horses. Just cows.

As we drive down the main canyon on RR 335 toward Bullhead Mountain and Bullhead Creek, I can imagine cattle pastured on the cleared broad flat terraces lining the river. Runs of cedar-covered hills on the edge of the valley look like a chain of miniature mountains. In the headwaters behind me, the hills are long, dissected fingers of the plateau. From above, the connected ridges look like fern fronds reaching toward the river, with the many canyons, draws, and washes sculpting the eroding plateau into a lacy pattern. Many of the hills have a flat cap of limestone with stair-stepped sides of alternating scarps or ledges of stone and slopes of rocky soil. In outline they look like a crumbling ziggurat or the stepped mountain design used in Navajo rugs. Bill pulls over at a low-water crossing. No water. We were fooled by the flood gauge and the signs warning us to look for high water.

Just upstream from the low-water crossing (where the river becomes the dividing line between Edwards and Real Counties), the Nueces

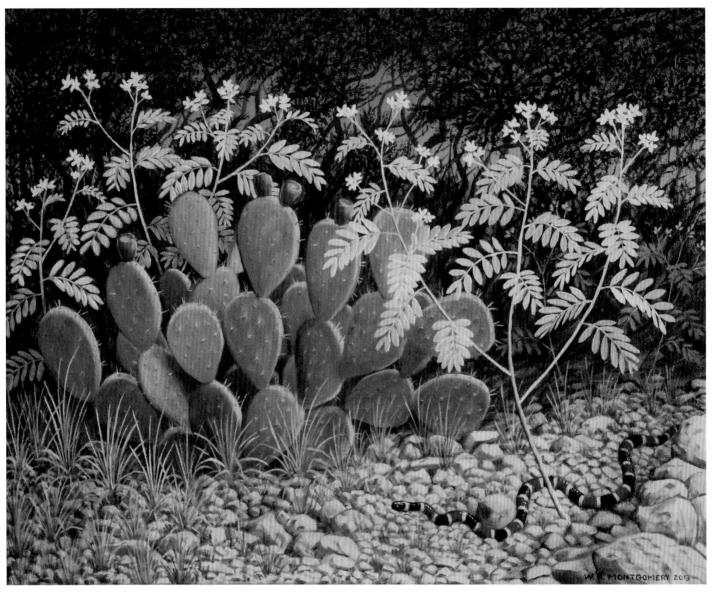

Senna with Coral Snake

becomes a public river with all the access rights accorded a navigable waterway.[3] (The East Prong and Hackberry Creek are private property, even though public roads wind along and across the streambeds.) In Texas, stay in the main streambed—whether or not there is water—and you are fine. The banks and beyond are NOT public property and should be treated with all the respect and deference accorded Texas landowners.

I look upstream to where the south- and west-facing slopes of the hills are thinly covered with cedar and gray-green brush. The ground

shows nearly white from the shattered and exposed limestone between the thin vegetation. Downstream the north and east slopes are clothed in a thicker carpet of trees that mingles the evergreens of live oak and cedar with the browns, grays, and yellows of trees just beginning to leaf out.

As we move down the canyon, the long, convoluted ridges break into distinct hills and mountains bordering the river. Bullhead Mountain raises its craggy profile above the confluence of the Nueces and Bullhead Creek. A church and cemetery along with a few scattered houses sit in the shadow of the mountain, remnants of the Bullhead Community, now called Vance.

A Real Mountain Home

Anna Wellington Stoner and her husband, William Clinton Stoner, were among the wave of settlers that flooded into the Hill Country river canyons after the Civil War. After arriving in the lower Cañón and camping in the Montell area for several months, they moved to the upper Nueces (somewhere between Bullhead and Hackberry) in 1882. With two children, a herd of five hundred Angora goats, and assorted livestock they set out to make a new life on a recently vacated piece of land. While the house was rustic—Anna describes it as a "real mountain home"—she was happy with the rough cabin after living in a tent. She wrote to her mother:

> You must expect to see the roughest kind of house when you get here. The room I use for a kitchen has no floor in it & the house is log hewed on the inside & the cracks are boarded up with clapboards, and this is one of the "*finest*" houses in this part of the cannion. I am very much pleased with this place so far & think it can be made a beautifull & plessent home.

In the same letter Anna describes the river and garden:

> The river Neuesses runs close by the yard fence, just under the hill there, you know, & is about half as big as it was where we camped. The principal part of it here comes out of our field as the largest spring I have even seen rises in the middle of it & runs along the

side of my garden, the garden can be irigated from it. . . . There are more shalots & onions in the garden than I ever saw in one garden before & plenty of raddishes and lettuce to eat, lots of cabbage plants, beet plants & some tomatoe plants too.

While Anna tended their two children and the garden and ran the house, her husband, Clinton, looked after their livestock, fields of corn, and bee-hives; hunted for game; and made regular trips to Bullhead for mail and supplies.

A *stranger* visiting this place would think Clint was an old setler from the looks of things about here. The cows he milks, his goats, hogs, sheep & chickens are all the gentlest I ever saw & he has three stands of bees, two of them two story high. He took off the upper story of one of them filled full of the nicest honey I ever saw & with what he got out of one of his bee caves, filled a five Gal. keg full & put it in the Spring house for safe keeping.

In Anna's letters to her mother and brother in Anaqua (on the San Anto-nio River), I'm surprised by a reference to a Mrs. Sanches. Could this be the same Sanchez from the draw and springs on the East Prong? Anna, attending a rare party in Bullhead, was approached by the elderly woman. While Anna didn't remember her, Jerusha Sanches recognized the young woman from Anaqua. Anna wrote to her brother that "they call them-selves Indian instead of Mex [*sic*]."

At the junction of Highway 55 and RR 335, Bill and I stop in the vil-lage of Barksdale to read a Texas Historical Commission marker. To my surprise, the marker for the Dixie Settlement (forerunner of Barksdale) claims, "First civilian settler Jerusha Sanchez, midwife for Nueces Can-yon area, widowed by Indians in the 1870s." With help from Janet Vernor, widow of Jerusha's great-grandson Calvin, Jerusha's story unspools.

In 1844, in Nacogdoches, the already thrice-widowed, thirty-four-year-old Jerusha married Francisco Sanches, a Creole born in Loui-siana to Spanish parents from the Canary Islands. The family, includ-ing Jerusha's children, followed the moving frontier, living in Navarro, Hill, Parker, Eastland, and other counties before settling in the Nueces

canyon in 1857 near the newly established Camp Wood Army Post. While she is most often referred to as a midwife, Jerusha was hired as Camp Wood's post doctor in 1861, and numerous accounts survive of her treating the arrow wounds and illnesses of both soldiers and settlers. The Sancheses lived in Dixie and, like other settlers, ran cattle in the upper river canyon in the grassy flats between the river's tree-lined corridor and the dry slopes of the hills. I wonder whether the wild cattle that frightened Heartsill and his Confederate companions were, in fact, the Sancheses' herd. According to family lore, black-haired half-Cherokee Jerusha and her Creole husband lived companionably with the Lipan Apache, but in 1867 Comanche arrows mortally wounded Francisco. Jerusha remained in the canyon, continuing to work as midwife and doctor for the canyon's settlers until her death in 1884, two years after Anna wrote about meeting her. Jerusha's grave lies at the far end of the Vance Cemetery, her name scratched into the simple concrete marker. While a few of Jerusha's descendants still live in the canyon, the Sanchez name remains on the springs and the draw up on the headwaters of the Nueces.

OLD-TIMERS

Milburn Wooldridge, a retired Real County commissioner, meets me at a local restaurant in Camp Wood. He's been pressured by friends into giving the "lady author" a quasi-official tour of the Nueces canyon. Lean, fit, and wearing his Sunday hat, he has a weathered face that doesn't reveal his age, but I know he is older than fifty and younger than eighty. I get into his work truck, a 1970s-era GMC Sierra pickup. A dense web of cracks spiders over the windshield, a wedge of dusty paperwork and discarded sunglasses fills the cracked dash, and the floorboard is covered with a worn rubber mat. I suspect there is not much metal beneath my feet. I struggle to pull the seat belt out and Milburn looks at me in surprise, blue eyes glinting. "Don't know that anyone's ever used that thing," he grins. I manage to fasten it, suspecting that the frayed nylon isn't worth the effort. "Now," he says, "that door is a little hard to catch—give it a right hard yank." I slam the door and the bang reverberates through the cab and probably up and down the entire canyon. We roar north out of Camp Wood with the windows down and yell over buffeting wind and

the ancient muffler's roar. Once through Barksdale, we turn onto RR 335 to follow the river.

"Before the Highway Department built the high bridges," he yells, "folks would be stranded whenever there was a big rise." I had already heard that the low-water crossings, massive slabs of concrete or piles of gravel situated in naturally broad, shallow fords, washed out regularly.

"Worst flood?" I yell.

"The 1950s. The river cut off Barksdale and Camp Wood. The army dropped bread from airplanes for the families that couldn't get out. The river reached from one side of the canyon to the other. Course it was all open then." He nods toward the wooded bottomlands hiding the river and then shakes his head.

We pass an estate surrounded by tall white walls crowned with broken glass. "Drug lord?" I yell. He barks a laugh and nods toward what can only be described as a villa on the far side of the valley. Lombardy poplars stand at attention around the massive house and bright green irrigated lawns and pastures. "They raise some nice horses there. Or they did," he yells. We pass zebra, ostrich, a giraffe, and other exotic animals grazing in high-fenced pastures.

"Everyone kept a few cows along the river," he yells in answer to my question about cattle in the canyon. "But no one bothered to put up fences since they'd just get washed out in the next rise." We roar down and up a low-water crossing. "All this was open," he yells again. "Grass up and down the whole canyon with none of this willow brush and sycamore." He points to the riverbank in disgust. "There were pecan trees back from the river. Thousands of pounds of pecans used to come from this canyon. We'd pick and shell pecans on a percentage but no one harvests pecans commercially anymore." He pauses. "No one ever cut the pecan trees until the subdivisions came in. They don't like the mess pecan trees make."

"River bottom was good soil for crops too. Corn, cotton, and vegetable gardens." Milburn yells.

I look across the river bottom, a broad gravel plain crowded with brush and trees. "Farming cotton, here? Doesn't cotton need water?" I'm getting hoarse from yelling. Milburn laughs, a short bark, and grins at me. "There was a cotton gin in Barksdale. But it's not just the drought," he

yells back. "It's the cedar, mesquite, persimmon, agarita, and other brush growing up and taking water."

"Did the river ever run constant?" I yell. "From the headwaters down?"

"Only in flood times," Milburn yells. We pass the confluence of Hackberry Creek and the river and then turn off onto Hackberry Road. On the gravel road, the truck clatters and rattles more but we don't have to scream over the wind and muffler.

"Now," Milburn says as we rattle across the white rocks of a dry low-water crossing, "this is the Nueces and we're on our way to the headwater springs."

The river, he tells me, has always had long dry sections where it runs under the gravel. But, he continues, there used to be more water, especially on the main river below the Hackberry Creek confluence. "It's the brush," he says. Again. "Plus all the new subdivisions. Everyone comes out here, builds a house, and digs a well. Too many straws drinking from the same glass."

As we drive up the East Prong he continues to point out which ranches look good to him (mostly-open rangelands) and which places have grown

Empress of Silence

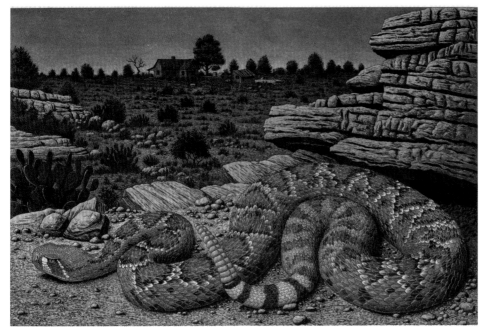

up into dense cedar brakes, brush, and oak woodlands. The cedar is out of control, he says, and then gives me a quick history lesson: Government-funded brush eradication programs began in the 1930s as part of a drive to improve native rangelands for grazing and water conservation. The cedar brakes and brush in the canyons were bulldozed, chained, and poisoned. The land was too steep for cattle but perfect for sheep and Angora goats. The sheep cropped the grasses short and the goats browsed the tender twigs and leaves of the brush. What he doesn't say is that all that open land with short grasses must have hastened the flow of rainwater and runoff down the steep rocky hillsides—water that hurried out of the canyons nearly unimpeded, stripping topsoil and shifting mountains of gravel on its way.

"You could make a good living with goats," he states. "Now the new owners put up game fences and let the land go wild and grow up in cedar." With absolute certainty, he tells me, "The predators put the sheep and goat ranchers out of business. We didn't have trouble with predators before all this land went wild."

Milburn tells me about fishing for fat catfish in river pools and meeting friends after school and during the summer at deep swimming holes. Now, he says, the river is all fenced off and the only places people can get to the water are at county road crossings and the highway bridges. He waves his arm at a thick stand of cedar stretching beside the road. "This was a pretty ranch," he says. "No brush except in the header canyons. You could see the river from here." He shakes his head mournfully. It is a lesson in land use and aesthetics. The places we've passed that he approves of look bare and bleak. As the road passes under Eagle Cliff, Milburn tells me, "Big controversy over eagle killing here. Ranchers were sent to jail."

He drives me up to Highway 41 and then loops back down RR 335. He calls out the names of tributary creeks as we pass: Bullhead, Dry Creek, Pulliam, and Camp Wood. As we rattle back into Camp Wood, Milburn points out the site of the Spanish Mission. The town, he tells me, gets its city water from Camp Wood Springs (now called Old Faithful Springs). "That spring," he yells, "is the reason the Apaches camped here and the Spanish set up their mission here. And the reason the army put Camp Wood here."

Milburn Wooldridge pulls up next to my truck on Main Street and

shuts off the engine. My ears ring in the sudden silence. "So did you learn what you needed about the river?" he grins. I open my mouth to thank him but all that comes out is a hoarse croak. I smile and nod vigorously. Before he drives off, I ask for a photo. He poses by his truck, leaning on one elbow, the shadow of his hat cutting across his face, smiling broadly at the camera.

The next morning I'm invited to meet Junior Hatley, a retired ranch manager, and his friends for breakfast. First they tell me about Camp Wood's 1924 brush with celebrity. Pilot Charles "Lucky" Lindbergh and his friend Leon Klink, en route to California, goofed and mistook the Nueces River and the railroad from Uvalde for their planned route along the Rio Grande. Lindbergh landed his plane safely in a pasture outside of Camp Wood and drove the plane into town, but on takeoff he clipped a telephone pole with a wing and crashed into the hardware store. If Lindbergh was embarrassed by his mistakes, it isn't remembered. The townspeople were thrilled (and still are) with the celebrities. Lindbergh Park, Leon Klink Street, and the damaged propeller (proudly hanging in the local museum) memorialize the aviators' blunders.

The conversation veers to favorite swimming holes, yellow cats, and polliwogs. They laugh when I look confused. To me a polliwog is a tadpole; to them, it is a mud catfish. "But all the swimming holes are filled in with gravel now." "No good fishing holes either." "There is too much gravel in the river." I scribble, head down, trying to keep up with the three men. "Well," Junior says slowly. We look to him. "The river—land along the river—has gone way up in price but people don't use the river the way they used to. I guess they just want to sit and *look* at it." His friends join in with comments about scoundrels selling land in the floodplain and newcomers building homes next to the river. They scoff, agreeing that unless you've seen—no, *heard*—the Nueces come rolling down, you have no idea how big and destructive the river can be during flood. The three men nod their heads, memories whisking them away from the noisy restaurant.

I pull them back by asking them about changes in land use in the canyon. "You could go anywhere on the river," Junior says. "Now everyone has a 'my land' attitude." He pauses. "We all used the river and depended on the river, so we took care of it." They agree unanimously that

the country was in better shape when browsing herds of goats controlled the brush and the riverbanks were clear. They look at me until I write it down. The comments start rolling over each other and my pen skitters across the pages. Too much cedar. City people come up and leave trash everywhere. The best fishing holes were on private property but no one minded. You could drink straight out of the river. A family could make a good living raising goats. Then one of Junior's friends looks at me and says, slowly and clearly, "Until the government killed the Angora goat business by stopping the program." This sets off a tirade that starts with the federal government, veers to the Texas Parks and Wildlife Department's policies, moves on to bitter complaints about the law prohibiting driving in the river, and ends with griping about the new ranch owners letting the land grow up in cedar so the predators take over. One of Junior's friends shakes his head, tucks his chin down so that the weathered skin of his face crumples and his lips disappear between nose and chin. When he speaks, the bitterness surprises me, though it shouldn't have. "The ranches are nothing but playthings," he snaps. "Just toys for rich folks from Dallas or Houston. They don't give a damn about their neighbors."

2 El Cañón

MISIÓN DEL CAÑÓN

I am floating in the Nueces just upstream of Camp Wood. The river rushes through a narrow, rock-strewn channel behind me, the running water masking the sounds of traffic on Highway 55. The swimming hole is a pale turquoise darkening into deep green shadows near the base of an alluvial bluff in front of me. Evening light gilds the tops of the live oaks, already gold with pollen tassels. The slender sycamores bow in the evening breeze, the soft new leaves nearly silent. The air is brisk but the water feels warm, so I stay submerged. The gravel wash of Camp Wood Creek is upstream, while Camp Wood Springs, or Old Faithful Springs, flows into the river just downstream. On the east shoulder of the river,

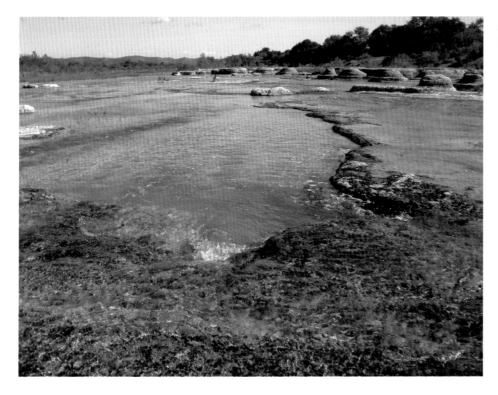

River near Camp Wood, Edwards-Real County line

out of sight, are the ruins of the Spanish Mission, San Lorenzo de la Santa Cruz, or the Misión del Cañón. Established in 1762 in the northern borderlands of New Spain, it was short-lived, not lasting even a decade before being abandoned. Less than two weeks after founding San Lorenzo, the missionaries and soldiers established another mission twelve miles south at another large spring. A sign in the village of Montell marks the general location of the Nuestra Señora de la Candelaria del Cañón mission. Franciscan missionaries and Spanish military built the missions for Lipan Apache in hopes of pacifying and converting the tribes to Christianity and European ways as well as offering protection from the hostile Comanche Indians. The missions, however, soon attracted the attention of the Comanche. The Apache promptly decamped. The Comanche began an ongoing siege of the missions. Candelaria mission residents fled north and huddled in San Lorenzo as the Indians attacked again and again. By 1767 Candelaria was abandoned, and San Lorenzo was reduced to a stopping point for pack trains on their way to the short-lived San Sabá presidio. By 1771, just nine years after it was founded, the mission was burned and abandoned.

Visitors continued to camp at the ruins between the springs and river, and in May 1857, Company G, First Infantry Regiment, established a temporary US military outpost. The commanding officer named it after a fallen colleague, Captain George W. F. Wood. In 1861, at the onset of the Civil War, the US military abandoned Camp Wood. Just a few months later, W. W. Heartsill and his Confederate compatriots arrived. Yet the town of Camp Wood was not founded until 1920, and it was founded on cedar.

CEDAR BRAKE BOOMTOWN

Yes, cedar. The villain in an evergreen cape. The scourge of the Hill Country that sucks up groundwater, hoards rainwater in its needles until the water evaporates, and crowds out other native trees, shrubs, and grasses while taking over hillsides and bottomland.

But is cedar just a bad citizen? The more people I ask, the murkier the picture becomes. One naturalist tells me that the old-growth cedar trees are essential habitat for golden-cheeked warblers and a valued part

of the canyon ecosystem. A bulldozer operator eagerly tells me that clearing cedar will restore springs depleted by the greedy trees. I am told, repeatedly, that the Nueces is running lower than it did during the 1950s drought—the drought of record—because of cedar taking over the valleys. Wildlife biologists insist that the trees serve as cover and the berries are a favorite food of deer and many birds. Some tell me that cedar and mesquite invaded from Mexico, others that the trees are native to the Edwards Plateau and canyonlands. Historian Martha Freeman tells me that at the turn of the century, tracts of Hill Country land with cedar brakes were valuable. Investors speculated, buying and selling land with the sole purpose of harvesting the cedar posts.

Today many botanists, rangeland specialists, and ranchers believe cedar was originally restricted to the high draws, steep canyon walls, and crowns of hills in the Hill Country. Wildfires, both naturally occurring and intentionally set by native people, kept cedar and other brush suppressed and promoted extensive grasslands. If this is true, how and why did cedar creep over the landscape forming cedar brakes? The historical record is inconsistent and, at times, contradictory about the vegetation the early settlers found on the Edwards Plateau and in the river valleys.

The earliest written descriptions of the Nueces are from the soldiers and missionaries dispatched by the Spanish king to control and settle the northern regions of his colonial empire. These men, like the later Anglo explorers, were interested in establishing settlers. Hence, the accounts of landscape, wildlife, and natural resources focused on their potential uses. Would the grasses support livestock? Was water nearby? Soil and vegetation were viewed with an eye toward agriculture. Later reports often exaggerated a region's benefits and minimized its problems in order to entice settlers. The written accounts are valuable pieces of the puzzle regarding Texas' historical environment, weather, plants, and animals, but they are by no means complete. And, sadly for us, the Native Americans who lived and traveled through these canyons left no written records.

Franciscan fathers Jiménez and Baños did leave a vivid picture of the El Cañón area in a 1762 deposition sent to their superiors:

The fields are extensive and easily irrigated from the river. There are many types of wood in this area, for example, cedar, British

oak, cottonwood, walnut, evergreen oak, mesquite and others for all types of construction. (Tunnell and Newcomb 1969)

A hundred years later, Heartsill described an overland trek between the Camp Wood Army Post and Bullhead Mountain as "winding through a gorge, around huge rocks and through dense Cedar-brakes" before returning to the open bottomlands in the river valley. Mrs. Henrietta Motes, a longtime resident of the canyon, remembered traveling to the Camp Wood area as a child in 1877 and recalled it as a huge wilderness with cedar brakes so heavy that people were known to have been lost in them. And in 1899, geologists Robert T. Hill and T. Wayland Vaughan

Scarlet penstemon

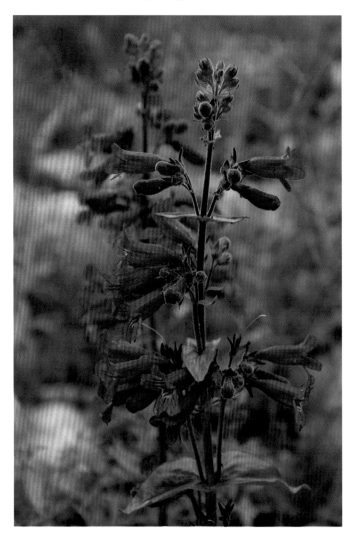

described the rocky canyons and mountains of the canyonlands as "rugged evergreen hills" but also described the same mountains as having "dark evergreen shrubs, juniper and Sophora [Texas mountain laurel], extending like garlands around the brows of the circular hills."

Clearly cedar has been a natural part of the landscape in the Nueces River's valleys since the 1700s, and likely earlier, but the location and density of growth have changed—as have people's perceptions of the tree. Over the last 150 years, there has been an ebb and flow to the tide of cedar as it flows out of the canyons and across the bottomlands, lapping at the slopes of the hills and retreating, only to swell back and over the same areas again and again.

On the southern and western edge of the Edwards Plateau, there is a profusion of the evergreen *Juniperus ashei*, or Ashe juniper. First of all, it is not a true cedar (we do not have true cedars in the United States), but it is in the same family as cypress trees and redwoods. This mountain cedar, or formerly, Mexican cedar is a shrub or small tree that tops out at about twenty feet. Given space, it develops into the ubiquitous army-green flame-shaped tree, but it also happily grows in crowded forests called cedar brakes. The brakes are forbidding, with dense foliage creating deep shadows, sound-deadening mats of needles covering the ground, and tangled branches making travel difficult. Older trees develop the distinctive shaggy gray to reddish-brown bark that the endangered golden-cheeked warbler uses in its nests. But it is the heartwood, infused with natural oils, that makes cedar resistant to rot, disease, and pests—the characteristics that made it, for a time, surprisingly valuable.

Today we spend enormous sums to temporarily rid our land of cedar, yet in the last quarter of the nineteenth century, cedar's value skyrocketed. Mountain cedar is unequaled as a fence post; it is durable, grows straight trees in conveniently dense forests of hundreds or thousands of acres, and regenerates quickly. Cedar's value rose as timber resources were depleted in central Texas and as settlers moved onto the mostly treeless plains of the Edwards Plateau, the Llano Estacado, and farther west. Farmers and ranchers valued Hill Country cedar posts for building post-and-rail and stacked fences. But the heyday of cedar harvesting (and cedar choppers) began with the mass production and wide distribution of barbed wire in Texas in the late 1870s. Across Texas, ranchers set posts

and strung wire, sometimes around land they didn't own, to keep cattle and horses in—or to keep the neighbors' stock or wild cattle and horses away from prime grazing or water sources.

Cedar, always valuable, now became a commodity. Land was bought and sold on the value of the cedar timber it held. In 1917, William Foster, the Texas state forester, lamented the incursion of timber onto the grasslands of the Edwards Plateau. But while he despaired of the stands of "mixed cedar, mesquite, mountain oak and live oak, with a ground covering of prickly pear" occupying vast areas of rolling uplands, he also noted that the mountain cedar was spreading to new areas on steep slopes where no other species except perhaps sumac had gained a foothold. He was quick to point out that

> they are of decided commercial importance and for ten miles or more back from transportation points are cut for posts and poles and shipped to all parts of central and west Texas. Cedar cutting has been going on for many years and since the brakes are usually not cut clean, they tend to renew themselves except where fires burn through the brakes, and even then a return to cedar is not unusual. (Foster 1917)

In the canyon of the Nueces, businessmen eyed the cedar brakes around Barksdale as potential profits just waiting for extraction. While individual landowners chopped posts and hauled them out of the canyon by oxcart and wagon, in 1914, the Uvalde and Northern Railway Company was chartered with the purpose of hauling cedar and kaolin clay from the canyon down to Uvalde. The railroad was originally planned to go through to Rocksprings and then on to San Angelo, but feisty landowners in Barksdale refused to sell easements. The railroad's owners designated the terminus of the rail line, thirty-seven miles north of Uvalde, as a town site, and Camp Wood was created. Investors purchased or secured options on fifty thousand acres of land around the new town.

Camp Wood became a boomtown. Crews cleared land along rights-of-way and cut an estimated ten thousand live oak trees into railroad ties. A tent city popped up in the new town for the hundred-plus cutters and haulers hired by the newly formed Uvalde Cedar Company. By 1929, the

company was said to be the largest cedar shipper in the United States, with three trains per week hauling loads of up to forty thousand posts at a time. And not just cedar. One out of every three train cars carried fuelwood for heating and cooking to cities across Texas. Walnut trees with girths over five feet in diameter shipped out to distant lumber mills. The land around Camp Wood was clear-cut for miles in every direction. Local ranchers took advantage of the cedar boom as well. W. O. Prentiss and his wife moved to Silver Creek Ranch (near Montell) in the early 1920s. In his words, "There was lots of cedar on that ranch and I cut cedar posts and ties for a cedar company, enough to pay for that ranch."

All told, over 7.5 million cedar posts were harvested from nearly forty thousand acres of land by the time the railroad made its last run in 1941. A photo of the south end of Camp Wood in 1942 shows a collection of buildings on a treeless expanse. In the foreground, a lone mesquite casts a pale shadow. Yet it wasn't a lack of cedar that closed the company and eventually shut down the railroad. A 1933 article pleading for a massive public works project (financed by federal money) to rid the Edwards Plateau of cedar estimated that there were another ten thousand carloads of cedar posts remaining to be harvested around Camp Wood. But by 1930, demand for cedar fell. Posts made of iron, steel, and treated pine competed for fencing dollars. The shift from firewood to natural gas for heating and cooking further eroded the demand for cedar.

✦ ✦ ✦

Maybe those early ranchers and landowners didn't revile cedar. It was, after all, a cash crop that grew without expense, expertise, or labor. What if, I wonder, ranchers had let the hills and bottomlands grow up into cedar intentionally? After the Depression hit and the market fizzled, they would have turned and looked at the cedar brakes not as greenbacks waiting to be harvested but as trees in the way of a profit. Specifically, the grass-eating and browsing kind.

ARNOLD CROSSING

Along the Nueces canyon are a number of spots where the highway and county roads cross the river and tributary creeks like Hackberry, Bullhead,

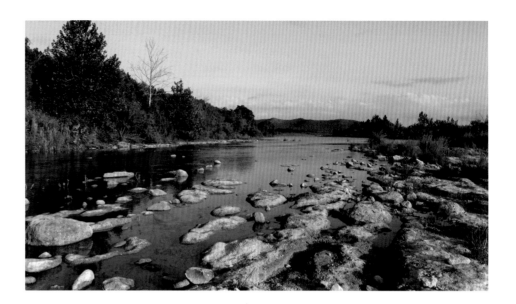

Pulliam, and Camp Wood. With no public parks along the river, the only way that most people can enjoy it is to either rent lodging that offers access, or stop at one of these crossings. Anyone with a map can find these spots, but because many of the low-water crossings are surrounded by private property, the only reliable access spots are the Highway 55 high bridges: Barksdale, Arnold Crossing, and 19-Mile Crossing.

At Arnold Crossing, south of Camp Wood, the highway bridge soars over the old concrete low-water crossing. A modest dam impounds Nueces Lake just upstream. Cooksey Park offers access to a short section of lakeshore, for a fee, but the majority of the lake is private. At the far bend of the river downstream, I see a trio of fishermen casting lines into the current.

I'm looking at sycamore saplings and sawgrass at the river's edge, thinking about thin-soiled hills grazed and browsed to the quick, and rampaging floods, when someone touches my arm. I yelp and flinch like I've been burned. A young woman stares at me wide eyed, frozen with her hand still out. She apologizes; I flush deep red and wait for my heart rate to return to normal. Tentatively she asks whether I know how to rig a fishing rod. "My parents took me fishing," she explains, "but they always set everything up for me. We thought it would be fun to go fishing with our daughter."

Her husband sits in the backseat with their daughter, a toddler who

looks at me doe eyed and reaches to her father for reassurance. Together the young mother and I pull the new gear out of shopping bags and assemble it. I surprise myself by attaching the hook with a tidy clinch knot. We add the split-shot weights and bobber. All those years of watching Bill rig my lines has paid off. When I start to thread a big red wiggler worm onto the hook (something I am skilled at), her husband lifts the little girl out of the car seat and they stroll down the old low-water crossing. As I leave I take a photo of the family, the daughter holding her father's hand as she leans over to watch the river flow downstream while her mother tosses a line into the deep water upstream.

ROCKS AND CEDAR

Not long ago, I was wedged into a middle seat in the cattle section of a commercial air flight. Two businessmen sat on either side of me and spent much of the hour-long flight cheerfully deriding Texas, Austin, and especially the Hill Country. "Why do they call those measly bumps mountains?" asked one in mock exasperation. "Why, they aren't even really hills!" The other gentleman sagely nodded his head. "And did you see what they call rivers? Nothing but creeks." "No forests, just those stunted cedar trees." "And the deer, I've seen Labrador retrievers bigger than those scrawny bucks." I said nothing, keeping my retorts to myself and my nose in a book while they went on to disparage the weather, the distances, Texas drivers, and—unbelievably—Tex-Mex food. Clearly they had missed something vital about Texas, and in particular about the canyonlands of the Edwards Plateau.

In some places, beauty is easy. Obvious scenery with no subtlety and little mystery. Possibly awe inspiring, but grandeur can be mistaken for beauty. The Texas Hill Country, I've discovered, is both a mystery that needs extreme patience and curiosity to unravel and, at the same time, an in-your-face profusion of heart-stopping wildflowers, hidden canyons, vistas, and other scenes of defiant loveliness. But to appreciate this unique enclave, you must be willing to take on the challenge of flash floods alternating with droughts, rocky soils, thorny plants festooned with abundant flowers, cedar trees, endangered songbirds, and invasive species.

The Hill Country isn't the rangeland or the Wild West of Texas

mythology; in fact it is in many ways the antithesis of the open range-lands preferred by cattlemen. As one Hill Country rancher told me, "It is mighty easy to overgraze this land. And once it is overgrazed, it is nearly impossible to bring it back." The Nueces River valley is a contradiction: a hardscrabble land full of rocks and cedar that feels rough and untamed, yet, as history illustrates, its hills and bottomlands are surprisingly vulnerable.

MONTELL

By the time Anna and William Stoner reached the Nueces Canyon in 1881, it was still considered the frontier (the last Indian raid took place in 1882 in the Frio Canyon), but ranches were already well established in the lower canyon. Away from the rivers, Edwards and Uvalde Counties[1] were surveyed into vast checkerboards of square miles of railroad land alternating with state sections—all of it for sale. Waves of settlers moved into the canyonlands after the Civil War, eager to claim the land as their own.

Surprisingly, overgrazing was already a concern when the Stoners arrived in Montell, only twenty years after the first settlers staked legal claims. Ranchers like Jerusha and Francisco Sanches had been running cattle in the bottomlands of Hill Country canyons for decades. As early as 1861, a German living near the Camp Wood post grazed a herd of one thousand sheep. In 1876, S. J. Arnold and Brothers leased land near Montell, establishing what would become one of the major sheep and Angora goat operations in Texas during the 1880s. In 1884, William Landrum moved his entire herd of purebred Angoras from California to a ranch near Good Luck (now Laguna), south of Montell. Upon first arriving in the canyon, Anna Stoner wrote her mother and brother saying the only land suitable for cattle was in the river bottoms and at the mouths of the creek canyons along the river. In December 1881, not long after arriving, she wrote home with the alarming news that "a man came here not long ago & bought 100 acres of land & then brought 1000 head of cattle here on it, & will bring more next spring & everyone is talking now of this cannion being overstocked & the cattle dieing next summer."

The fertile soil and abundant water in the valleys also inspired the settlers to clear the river and creek bottomlands for fields. The stream-

side forests of the Nueces fell before the axes of the settlers, converted into cabins, fences, and cash. Anna details the trees as "pecan, oak, cedar, cipress, cotton wood & others common to our river bottoms."

——I'm surprised to see that Anna listed cypress among the trees, but so did Spanish explorers Rubí and Láfora when they traversed the canyon in 1767. Geologists Hill and Vaughan remarked in 1899 on the absence of cypress along the Nueces, noting that the other trees that usually accompanied it were found in abundance around the water holes even on the drier West Prong. I've seen a few slender cypress planted near homes but nothing like the avenues of tall, straight trees on the Frio, Sabinal, and Seco. When the Spaniards encountered these rivers, the trees were ubiquitous enough that they bestowed their word for cypress, *sabino*, on one of the headwater rivers of the Nueces. If there were any cypress on the Nueces, they were likely harvested by settlers. By 1875 most of the large cypress trees were gone from the Hill Country rivers, cut down for lumber and roofing shingles. The trees have since rebounded and now line the banks of the spring-fed rivers of the eastern Balcones Escarpment. But not the Nueces. In this rocky canyon with intermittent running water, why am I surprised by the absence of a water-loving tree usually found in tupelo swamps and eastern rivers?

✦ ✦ ✦

The canyon around Montell opens up into a flat valley nearly two miles wide filled with rich alluvial soil and ancient gravel deposits. The river curls from one side and back, bouncing off high bluffs of stratified limestone to linger in the alluvial plains. Mesquite, infrequent in the upper canyon, is abundant here. Candelaria Springs, just upstream from Montell, supplied water to the Nuestra Señora de la Candelaria del Cañón mission. The missionaries dug ditches, still visible in the 1870s, from the river to irrigate their fields. The settlers followed suit, digging their own ditches and likely appropriating the missionaries' work, to water hundreds of acres of cotton, sweet potatoes, sorghum, corn, johnsongrass, and tobacco. To anyone looking at the dry slopes and brush-choked pastures along the river, farming in this drought-stricken valley would seem improbable. But it was the river that made it all possible. Descriptions of the Nueces and her creeks in the canyons invariably mention three

things: crystal-clear water, the stream disappearing under the gravel, and the river reduced to pools of water separated by stretches of gravel during the summer.

> The water is spring, creek, well and river, which is all clear as cristall, we campt near the bank of Montell Creek; in some places you can walk over on dry gravel for yards. At such place the water runs under the gravel instead of over it. here at the camp it is 3 or 4 ft. deep but you can see the bottom so plain that you would think it was very shallow. We can see the perch & trout swiming as plain as if they were in a glass cage when they are near the bottom. the river dries up in summer to only pools here & there in it, but still they say it is enough for stock. The creeks dry entirely up in summer. (Anna Stoner to her mother, Martha Wellington, November 16, 1881)

I'm standing hip deep in the Nueces just upstream of Montell. A local property owner has given me access to the river. The water is cool enough to make me gasp as I wade in, but with an early-morning breeze running

Montell Crossing, Uvalde County

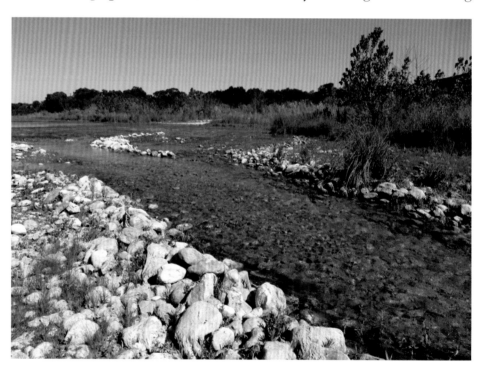

down the valley, the water soon feels warm. I'm in my amphibious outfit: long quick-drying nylon pants, long-sleeved nylon shirt with pockets big enough for my notepad and waterproof camera, and large floppy hat. The material around my legs billows in the current. The water is so clear that I can critique my lack of pedicure and examine my sandals' brightly colored nylon straps. I turn and plow upstream, the current pushing against my thighs as my feet slip over smooth stones. Piles of white gravel border the river and as I haul myself out, my feet slide in the loose cobble. Sun diffuses through the gray clouds, softly illuminating the river. Birdsong ricochets across the water. Morning has arrived.

Following a wildlife trail across the gravel terrace, I wind through young sycamores and clumps of tall brown grass shot through with new green blades. Pulling my sleeves down over my hands, I elbow my way through thick stands of sawgrass, arriving at the water's edge with only a few scratches. I kick through a riffle and turn over a few rocks looking for dragonfly naiads and mayfly larvae with no luck. Upstream the river slows, broadens, and spreads thinly over gravel. Minnows flit and splash around the leafy water willow growing in the shallows. Dodder twines its parasitic, leafless stems through a cluster of water willow, obscuring the bright green foliage in an orange tangle. Tall clumps of sawgrass line the river's edge along the gravel shore on the low bank side. The red heads of last year's bushy bluestem stand at attention in the ranks. Behind the sawgrass, sycamores and little walnuts colonize the loose gravel. Dark green cedar and oak woodlands grow on the river terrace that butts against the river.

All of this lush riparian vegetation (the sycamores, grasses, and other plant life in and along the river's edge) is relatively recent. According to Terry Hibbitts (biologist, author, and Camp Wood resident), prior to 2010, the riverbanks were mostly bare gravel and were regularly scoured clean by rises and floods. Mary Lou Ward, lifelong resident of the Nueces canyon, told me, "It used to be so pretty." Her husband, Tommy, added, "Clean and clear without all that brush." They blamed the sycamores and grasses for the low river flow and then took turns describing a river running over bedrock with only short sections of gravel. Many of the old swimming and fishing holes are now filled in with gravel, the river has altered course, and now, they say, there is significantly more gravel in the riverbed. And less water. In their minds, it is all linked.

John Hicks, a local real estate agent, summed up one of the prevailing attitudes. "The problem," he tells me, "is too much gravel. If Texas Parks and Wildlife Department would let property owners take *their* gravel out of *their* river, the problem would be solved." I think about Hackberry Creek and its rock quarry aesthetic.

The question remains, is there more gravel in the Nueces riverbed now? The answer sits in front of me in the low bluff next to the river. The property owners of these narrow strips of land, each wanting a view of the river, have cleared away the brush and tall grasses from under the pecan trees on the terrace, leaving a lawn-like expanse of mowed grass that ends at the ragged edge of the bluff. Chunks of soil and turf have slumped off into piles of loose dirt and gravel on the narrow cobble beach below. From the river it is clear that the bluff is actually an exposed cross section of the river terrace: the accumulated layers of alluvial soils and gravel deposited by the river that form the valley bottomlands. Upstream and downstream sycamores, sawgrass, switchgrass, and other riparian plants crowd the river's edge, digging their roots into the dirt and cobble, literally holding their ground and ready to deflect the river's currents. Because the property owners cleared the trees, shrubs, and bunchgrasses from their beach, it is likely that any river rise will eat away at the bluff, cutting into the property and adding more dirt and gravel to the river. It is a natural process, to be sure, but one aided and abetted by property owners who try to reengineer the riparian landscape into a manicured view. I'd been told, by more than one person, that the main cause of the excess river gravel is that droughts and overgrazing let rocks from the valley's slopes roll down and fill the riverbed. I look at the river cobble beneath my feet; it is all smooth and round, burnished by years of tumbling through water, not the sharp-edged limestone from the hillsides.

Carrizo Cane

While cutting down streamside plants can aggravate erosion problems along the river, too much of the wrong plant can also wreak havoc with the river. In the spring of 2010, local landowners, including Sky Jones-Lewey, the education and resource protection director for the Nueces River Authority and fifth-generation rancher, had watched in alarm as

patches of Carrizo cane sprang up along the river. Thickets grew around Montell and downstream for more than seventy miles.

Arundo donax, a.k.a. giant reed, Carrizo cane, Georgia cane, or just plain arundo, is a giant grass that can reach heights of thirty-plus feet and grows in dense riverside thickets. Tenacious doesn't even begin to describe it. Often confused with bamboo, arundo has a variety of uses including roof thatching, fences, baskets, stakes for vineyards, and brooms. Giant cane is used for musical reeds for woodwind instruments such as oboes and clarinets, as well as supplying many a fisherman young and old with cane poles. The long stalks also make fine thrashers for whacking

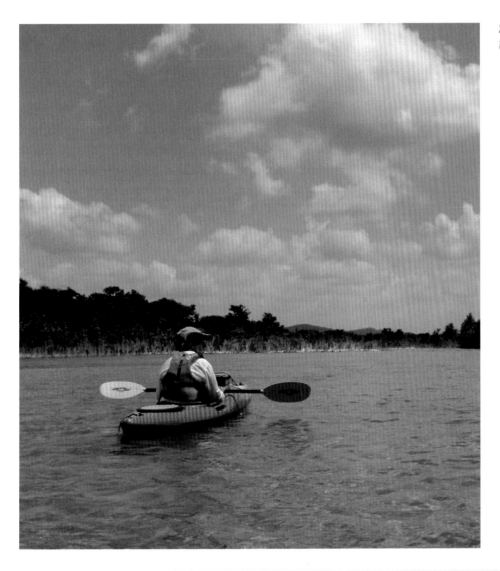

Sky Jones-Lewey paddling the Nueces, Uvalde County

pecan trees to knock down nuts. But arundo has a nasty side. On the Rio Grande it has taken over miles of riverbank, destroying food, shelter, and nesting sites for wildlife as it crowds out native vegetation. Jones-Lewey knew that the cane consumes a prodigious amount of water: an acre of arundo could and would use up to forty-eight acre-feet of water per year—eight times as much water as native riparian plants.[2] Arundo grows at stunning rates, more than two inches per day, and an acre of the stuff can produce more than sixty tons of stalks and leaves by the end of a growing season. Its staggering growth rates are attractive for potential biofuel production but lousy for rivers. Luckily it doesn't sprout from its prolific seeds, but instead from roots and sections of stems. Where a stalk falls over, it can—and will—root along its length at each leaf node. Every stalk that floats downstream holds the potential for creating a new thicket of the stuff.

✦ ✦ ✦

The arundo along the Nueces rapidly formed dense monocultures, with some patches several acres in size. Ominously, it was altering the river's flows by blocking the river channels and slurping up enormous quantities of water. Nearby property owners noticed that every morning and evening the river's level would rise and fall. Jones-Lewey heeded the calls and noted the quirk in the reading from the US Geological Survey (USGS) river flow gauge at Laguna. She contacted the Edwards Aquifer Authority (EAA) to investigate. Because the Nueces River basin is one of the primary sources of recharge for the Edwards Aquifer, and the aquifer is the primary source of water for more than two million people (especially the city of San Antonio), the EAA was curious to know just how much of the precious resource the cane was siphoning away.

Dr. Marcus Gary, a hydrologist for the EAA, and his team set to work studying the Nueces and her idiosyncrasies. Just upstream from Montell and Candelaria Springs, the team began investigating whether arundo was causing the odd fluctuations.

Sky Jones-Lewey and the Nueces River Authority started contacting landowners up and down the river, ultimately developing an alliance of 126 landowners along the Nueces (with more landowners along the Frio and the Sabinal) who treated miles of Nueces River frontage and 179

acres of arundo. With the work and enthusiasm of the landowners and the support of the Texas Parks and Wildlife Department, the "Pull. Kill. Plant." campaign is a remarkable success. Landowners pull new shoots of the invasive cane, spray the established plants with herbicides, and finally plant the area with natives that will benefit the river and its wildlife. Yet with a tenacious foe like arundo, the campaign is likely the first salvo in a long and protracted battle.

+ + +

I'd paddled from Montell downstream with Sky Jones-Lewey and Luci Cook-Hildreth, a Texas Parks and Wildlife aquatic biologist, after rains filled the river. I tagged along as they looked to see how much arundo had survived. We stopped in an inlet where springwater flowed into the river. Feathery dark red plants waved softly beneath the surface. A live oak leaned over the steep bank, dangling clusters of ball moss from its branches. Kidneywood thrust its spikes of tiny fragrant flowers toward the water. The urn-shaped flowers of a leather flower tangled in a stream-side sycamore sapling. Sky and Luci started off while I snapped photo after photo. When I looked up, they were moving downstream fast. I stowed my camera and, without thinking, tried to cut across the swift river current. I was in a small sit-in kayak, not my usual buoyant sit-on-top boat. I leaned over a fraction of an inch too much and watched in slow-motion horror as water slopped into the kayak and gracefully filled the boat. I kicked free, grabbed onto my kayak leash, and wrestled the boat first to a snag, then to the gravel shore where Luci and Sky stood watching me. Luci helped me dump the water out of the boat. Shaking with a combination of adrenaline and mortification, I checked my gear. My notebook and I were equally soggy, but there was no damage. Except to my pride. I hopped back into my kayak and followed Sky and Luci's path downstream.

Now, tall rattling clumps of dead arundo crowd the riverbanks. Occasionally a few bright spears of new growth peek through the brown stalks. Clumps of knotted roots look like tangled ginger roots.

We pass "Big Momma," the former three-plus-acre stand of arundo. Dried stalks layer sections of the riverbanks, preventing anything from sprouting until the plants decompose. Yet every dead clump is a triumph,

American Bitterns

a step forward to a rejuvenated river. Sky points out the gravel bars sprouting with sycamore, sawgrass, and switchgrass that off-road vehicles had stripped bare. She points out the cypress trees planted to help stabilize eroding banks. We slip past a small subdivision and Sky puts down her paddle to look at a stretch of riverbank. "Oh, that looks great!" she calls out, pointing to clumps of native vegetation between the river and the mowed lawn. "They used to cut everything down. I'm so glad to see that."

We round a bend and face a bleak, bulldozed riverbed. The county maintenance crew has repaired the road—a pile of loose gravel with a couple of culverts—by scraping the riverbed and turning it into a sul-

len, silty stretch. And all for just a few landowners who could reach their ranches using other roads. We drag the boats across the road and back to the now-cloudy river. After rounding a few bends, the river has cleared and Sky is back to pointing out the stretches of rejuvenated river. The river valley is wide open, and distant hills loom over the low banks. A spring flows from beneath a cluster of little walnuts, winding its way through tangled grasses and grapevines to pour into the river.

<center>✦ ✦ ✦</center>

Dr. Gary and his graduate student Jenna Kromann continue to collect data about the river and its flows and to look at how much water the aquifer and the river trade back and forth. Ultimately the arundo study concluded that the rhythmic rise and fall of the Nueces was not related to the presence of the invasive plant. The river's daily rises, one in the morning and one in the evening, continued through the winter, even when all the riparian plants—not just the arundo—were dormant and not using water. Dr. Gary has not been able to explain the river's enigmatic and steadfast rise and fall each day. It isn't equipment error, and the phenomenon has been constant since 2008, so it is unlikely that it is from someone pumping from the river or tributary creeks.

It isn't at all scientific, but I feel certain I know what causes the anomaly: the heart of the Aquifer, mysteriously, slowly, and steadily beating.

GOOD LUCK

I think of Anna Stoner and her life as I drive out of Montell down Highway 55. She and her husband, Clinton, had a good life on their land in the upper canyon but it exacted a physical toll. In January 1884, not even two years after settling near Hackberry, her husband died. Five weeks later Anna gave birth to their third child, a son she named after his father. Despite pleading from her in-laws to move, Anna held on to the land as long as she could. Ultimately her "mountain home" proved too remote, with abundant thieves and outlaws ready to take advantage of her situation. In September 1884 she sold the land near Hackberry and a month later purchased 320 acres south of Montell near the town of Good Luck. I pass Round Mountain with its long talus slopes crowned with a distinctive cap

of Edwards Limestone and the Stoner Ranch gate at its foot. Anna's description of this area still fits:

> The mountains instead of being covered with trees is covered with grass, rocks, brush, cats-claw, pricly-pare, dagger choto or soto, or whatever they call it with cedar breaks & timber between them—the mountains—with flats of grass every where. (Letter to Thomas Wellington, December 4, 1881)

At twenty-seven, with two young children and a newborn, she lived in a tent on her property. She survived by trapping animals for hides, shearing her herd of five hundred Angora goats, harvesting pecans, and growing corn in the bottomlands around Miller Creek and the Nueces. Eventually she and her children flourished, although the demands of ranching meant little or no school for the children.

I think about all I learned about ranching from her letters. Angora goats were (and still are) lousy mothers because the best mohair comes from the youngest animals; every season many of the does are first-time breeders. The newborn kids, unlike sheep, aren't strong enough to follow the herd, and Anna staked out each kid until it was strong enough to run with the herd. And a pen full of staked kids was a nearly irresistible invitation to feral hogs, vultures, coyotes, and other predators. During warm weather, screwworms were a menace, and every day, every animal on the ranch needed a complete going over for any nick, scrape, or injury—no matter how tiny—where the screwworm flies might lay eggs. Wormy animals were penned and treated daily by removing the worms and slathering the open wound with any of a number of noxious remedies including tar, kerosene, and pine tar. Without treatment an infected animal (e.g., goat, sheep, or deer) could die in five to ten days. As one of the pioneer Angora goat ranchers, Anna had to learn through experience which local plants were toxic or harmful. On top of all her ranching duties, Anna was a mother, cook, dishwasher, laundress, gardener, pecan harvester, and farmer. And all without electricity and its labor-saving devices until the 1940s.

I turn off the highway onto a gravel road, on my way to the Friday Ranch. I cross the river on a low-water crossing that is high and dry, but the river—perfectly clear—is flowing through the big culverts. Next to

the concrete crossing, a black pickup is backed up to the very edge of the river and a woman with hair as flamboyantly red as a vermilion flycatcher's crest stares at me from the tailgate. Her look is so confrontational that I abandon my plan to stop and keep driving. One of her tattooed companions raises his beer in a salute; the other continues to stare at the river flowing past his feet. The road takes me through green bottomlands with grass, pecans, and oaks before lurching up onto a terrace thick with mesquite. The road continues uphill until I am on a broad, rocky terrace. Away from the river and its moisture, the plant life changes abruptly.

I stop the truck to photograph the blooming shrubs and wildflowers. Opening the door, I'm nearly knocked over by an intense perfume. I track it first to the tiny waxy flowers of a Mexican persimmon, then to the pink powder puffs of fragrant mimosa. Following my nose, I walk down the road and visit a blackbrush acacia so covered in blooms that its stems and vicious thorns are obscured by innocent soft white flowers. Catclaw acacia's perfumed puffs are dangerous to sniff, with abundant recurved thorns along each branch. Its other name, wait-a-while, is painfully illustrated when I try to unhook a stem from my shirt. By the time I'm free, my hands look like I've been playing with a rambunctious kitten. Huisache, decorated with tiny gold pompons, curves its limbs over shorter shrubs with a tentative shade. Guajillo's creamy white flowers look like those of the other acacias, but its distinctive long, narrow leaf fronds gracefully arc around the flowers. Cenizo, dusty looking in its silvery foliage, waits for rain to produce lavender flowers. Purple prairie verbena and orange pincushion daisies add splashes of color to the roadside. Prickly pear cactus and tasajillo (also called pencil cactus or turkey pear) crowd next to the fences along with a few dagger-like lechuguilla agaves. I'm stunned and entranced by this wanton display of blooming desert. The variety of acacias and other thorny plants is proof that I'm nearing the mouth of the canyon where the oak woodlands of the canyonlands give way to La Brasada, the Tamaulipan thornscrub of the South Texas Plains.

The Ranching Habit

Suzanne and Wright Friday welcome me into their home on the bluff overlooking the Nueces. They explain, modestly, that it is new. A flood in

1913 washed the original ranch house off the bluff and the lumber was used to build the house in the center of the ranch where the Friday family worked and lived for nearly a century. Suzanne shows me the house. It is, she says softly, their dream house. The view from their porch of the river and mountains is breathtaking. We sit in their kitchen and they are stunningly honest with me, a trait I encounter over and over in my visits with the longtime ranchers along the river. Wright tells me that everything on a ranch runs in cycles. Suzanne nods in agreement. His father was born on Montell Creek in 1902 and grew up riding horses everywhere but lived to see a man on the moon. "From horseback to the moon," he muses. He continues, telling me that they are in an extreme drought—just like the one in the 1950s—with the main difference being the amount of livestock on the river. He goes on to explain that at the time, no one fenced off their river pastures so livestock ate all the grasses along the river. (I make a note: here is another reason for the historically bare riverbanks preferred by some.) Now there is less livestock but more demands on the river's water. Suzanne and Wright talk quietly in level voices about floods, predation, goats, sheep, and feral hogs. They both grew up ranching and Wright tells me, with a grin, that they both had full-time jobs to support what they refer to as "their ranching habit."

"Has ranching changed?" I ask. Suzanne and Wright look at each other, and then Wright answers, "In all the years we've worked the ranch, until we sold the conservation easement I can only remember two years when we were out of debt. Honestly, without the easement, I don't know that we could have held on to the ranch." The Fridays, along with other ranchers in the area, have had to adapt to economic changes as well as the natural vagaries of drought and flood. The trials and changes the Friday Ranch—and Suzanne and Wright—have gone through are typical of ranches along the Nueces. For years, Wright says, the old-time Mexican cowboys, the vaqueros, made goat and sheep ranching possible. He says they were skilled, loyal, hardworking, and affordable. Professional shearing crews, mostly Mexican, came in to shear the Angora goats four times a year and sheep twice a year. But then the border with Mexico, fluid for decades, was closed and ranchers were fined for hiring illegal immigrants. The vaqueros and ranch hands who'd worked on the ranches along the Nueces and the West Prong for generations lost their livelihoods. Even

with the absurdly generous government wool and mohair subsidies (first instituted in 1954), increased labor costs made it difficult to make a living solely on ranching. Luckily, by the late 1970s, screwworm flies and their devastating worms were eradicated by a brilliant and thorough government program of broadcasting sterilized male screwworm flies to suppress and finally exterminate the flies throughout the United States. As a result, the native white-tailed deer population suddenly and dramatically rebounded across Texas, especially in the southern and southwestern parts of the state. Deer, already prized, became a valuable commodity, and hunting leases saved many a ranch and rancher. In the 1980s, a change in the Texas Property Tax Code allowed property owners to transfer their valuable (and essential for working ranches and farms) Agricultural Exemption into a Wildlife Exemption and manage their ranches for native game species such as white-tailed deer, turkey, quail, and dove. Then the wool and mohair subsidies ended in 1996. Even with hunting supplementing the slim income from ranching, holding on to family ranch land became increasingly difficult. Family ranches, split among children, were further burdened by inheritance taxes. Often the only recourse a family had was to sell off land. In the 1990s, the Wrights, like the neighboring Stoner Ranch, turned to recreation and opened their ranch

to the public for camping, bird-watching, and river recreation. Finally, they were approached by a nonprofit working with the City of San Antonio and the Texas Nature Conservancy about establishing a conservation easement on their ranch.

San Antonio is a hundred miles away, yet the city is strangely dependent on the Nueces River and her flows. As Highway 55 travels south out of Montell, not only does the valley broaden and thicken with mesquite and other thorny brush, there is a significant and unseen geological transition from what hydrogeologists call the Contributing Area of the Edwards Aquifer to the Recharge Zone.

The Contributing Area, or drainage area, encompasses the upstream river and stream watersheds of the Balcones Escarpment. These rivers (West Prong, Nueces, Frio, Sabinal, Medina, Guadalupe, Blanco, and Colorado) formed the Balcones Escarpment by cutting down and across the edge of the plateau. On the southern and eastern edges of the plateau, the resulting deeply dissected, steep slopes are known as the Hill Country or canyonlands. In the Contributing Area, the exposed Edwards Limestone formations are eroded, in some valleys down to the harder and older Glen Rose formations. Where the porous Edwards Limestone is on the surface, it absorbs rainfall directly through sinkholes, fissures, and openings in the stone (as near Eagle Cliff). What I find surprising is that the water doesn't filter into the aquifer right away. Instead, some is stored while the rest runs off into the streams. Many of these Hill Country rivers and streams flow long after rain has ceased as the limestone gives up its stored water into the waterways as springs and seeps. Whether you call this area the Escarpment, the Hill Country, the canyonlands, Contributing Area, or drainage area, it ends at the Balcones Fault Zone, the original edge of the plateau uplift ten million years ago.

In the Balcones Fault Zone, massive layers of Edwards Limestone breach the surface along the 1,500-square-mile jumbled assemblage of faults. The limestone outcrop creates the Recharge Zone, which swoops from Del Rio (on the Rio Grande) eastward to pass north of San Antonio before curving northeastward through Austin and toward Waco. When it rains, water dramatically flows into the aquifer through Edwards Limestone solution features such as caves, sinkholes, and swallow holes. But the majority of the water recharging the Edwards Aquifer comes from

the rivers and streams that start in the Hill Country. And the Nueces River basin is one of the primary sources of recharge. As the Nueces and her tributary rivers and streams cross the layers of honeycombed limestone, much of their flow percolates down through the streambed into the aquifer. Below the Fault Zone, the Edwards Limestone dips down, subsiding deep beneath the South Texas Plains, pulling the rainwater, river water, and springwater underground into the 2,300-square-mile rock storage matrix of the Edwards Aquifer Artesian Zone. The water in the aquifer isn't static; it follows roughly the same curve as the Fault Zone and flows eastward toward San Antonio and then northeastward. Springs erupt along the edge of the curve, from San Antonio and Pedro Springs in the city to Comal Springs, the largest springs in the state, and then to San Marcos Springs.[3]

The cornerstone of the City of San Antonio's water policy is the Edwards Aquifer and its Artesian Zone. In 1998, with the ever-growing metropolis dependent on the aquifer's water, a group of citizens started pushing for protection of the irreplaceable resource and its easily damaged recharge zone. By this time, San Antonio had already consumed most of the nearby recharge zone in Bexar County. Homes, roads, and businesses covered the sensitive area, increasing the volume of pollutants flowing into the aquifer and reducing the amount of land available to catch water. The first Aquifer Protection Initiative passed in 2000 and the city purchased lands within Bexar County. The second initiative, in 2005, expanded the area to include Medina and Uvalde Counties and allowed the city to purchase conservation easements (development rights) as well as make outright purchases.

The Friday Ranch with its Nueces River frontage was a natural fit for the program. In addition to the obvious recharge features (the creeks, arroyos, river, and riverbed), the city recognized that all areas in the recharge zone are sensitive. The Fridays, as well as their eastern neighbor, the Briscoe Ranch, sold conservation easements to San Antonio through nonprofit partners, the Nature Conservancy and Green Spaces Alliance. These landowners, along with other ranches in the recharge zone (totaling over 120,000 acres) have permanently relinquished their right to divide their property into five-acre ranchettes or other development schemes. In exchange they received a cash payment and reduced federal

taxes for a number of years. Like other conservation easement sellers, the Fridays still run cattle and goats, but with the burden of debt removed, they regard the livestock as management tools to keep the range in good shape. The conservation easement not only protects the recharge zone and the aquifer but also means that the Friday Ranch will stay in the family and not fall prey to fragmentation. In the not-too-distant future, these ranches may be some of the only large open spaces remaining in the area.

Standing on their porch, Suzanne, Wright, and I look down at the river and the low-water crossing. The black truck is still parked at the river's edge. I ask Wright and Suzanne how they feel about people using the river. I add, "and driving in the river." Wright answers equably, "By and large people have gotten better trash-wise." But Suzanne leans forward to answer my second question. "It is so much better now!" she says. "It was just terrible. Nearly every weekend 4×4 clubs from San Antonio and other cities would come up in groups of twenty, fifty, or even more 4×4 trucks, SUVs, all-terrain vehicles, even motorcycles to drive around in the river." With a flash of anger, she points to the river. "They would *try* to get stuck. They'd spin their wheels and dig enormous holes into the river so they'd have to pull each other out!" They describe routed tracks in the river that churned the clear water into mud and destroyed plants, gravel riffles, and the beds where fish spawned. Drivers cutting over and across the streamside bluffs destroyed the erosion-preventing trees and grasses; sections of bank slumped off into the river. The river shifted new mountains of gravel and silt from spot to spot. The off-roaders roared through the river, even driving at night, oblivious to the destruction and disruption they caused. Wright shakes his head. "How they could take a pristine treasure belonging to all the people of Texas and treat it like it was just a toy to play with is beyond me." The Fridays joined the Nueces River Authority, a host of river advocates, environmental groups, and other property owners to help pass Senate Bill 155 through the Texas legislature in 2003. The bill made it illegal to drive a motor vehicle in the bed of a navigable Texas river or stream.[4] The newspaper articles I look up describe a long and vocal struggle that split the communities along the river, pitted neighbor against neighbor, and alienated lifelong friends. The ill feelings survive yet. Suzanne sighs and tells me that the group worked hard to make the law equitable but also limit the damage to the river. "People

Laguna

don't understand," she says. "They think we tried to block property own-
ers from driving across the river. It just isn't true. Any landowner can
drive along the river to access their property. We just needed to stop the
destruction by people who didn't care about the rivers."

✦ ✦ ✦

As I drive out of the Friday Ranch gate, I see the vermilion-haired woman
trudging up the road. She waves me down. I stop, feeling wary. Standing
at the window, she smells like sun and stale beer. Could I, she asks hesi-
tantly, come give their truck a jump start? In addition to her flamboyant

hair, she has an impressive array of visible tattoos. I say "sure" and then ask if she wants a ride back down. She pulls back in surprise. "You don't mind?" she says. "You don't mind me being in your truck?" I shake my head, flummoxed by her question. She perches on the edge of the seat and as we drive she tells me that she came up with her boyfriend and brother from Uvalde to visit the river. "I got to get back to pick my kids up from school," she says. I look over and notice that each inked forearm bears a child's smiling face. She notices my glance and thrusts her arms toward me, fists clenched and wrists bared. "My kids." She slumps into the seat, looking down at her arms. I pull onto the gravel bank and we get their truck started. As I'm pulling away, she runs over and thrusts a wad of dollar bills at me. I pull back and shake my head no, speechless. For a second time, she looks at me, surprised and wary. "Are you sure?" I nod my head. I want to say something but I say nothing. As I watch her walk away, sunlight reflecting off the river turns her hair into a flaming halo.

3 West Prong of the Nueces

The town of Rocksprings (which no longer has springs) is high on the divide. It is a dusty place with a long history closely linked to cattle, goats, sheep, and the rise and fall of the wool and mohair industry. We pass the visitor's center for the Devil's Sinkhole State Natural Area. A magnificent example of karst in action, the Devil's Sinkhole is the state's largest one-chambered cave and its fourth-deepest cave. During the summer

Last Waltz of the Coppery Dancer

and fall, volunteers escort groups out to the site to peer into the depths or to watch the nightly spectacle of millions of bats streaming out of the collapsed cavern. Down the street, the Priour-Varga Wool and Mohair warehouse looms, its dark interior empty. We turn southwest on Ranch-to-Market Road (RR) 674 toward the West Prong of the Nueces. On the arid western edge of the Edwards Plateau, the West Prong slices its canyon from the edge of the plateau down to the Balcones Fault Zone.

Unlike her sister tributaries, the West Prong is not really in the Hill Country. This landscape is arid, a collision between the plants and animals of the Chihuahuan Desert, Edwards Plateau, and Tamaulipan thornscrub (South Texas Brush Country). Just a few miles away is the water parting, where springs, creeks, and runoff turn away from the Nueces River basin and flow west to feed the Rio Grande. We round a curve and the road sinks into the depths of the canyon, hugging the curves of the river. Cactus and spiky lechuguilla grow on the rocky slopes next to the road. Lean shin oaks, ever-present cedar, and occasional mountain laurels give the hills a dark green, though thin, mantle. The wide, deep canyon and limestone hills remind me of driving Interstate 10 and the landscape where the Edwards Plateau merges with the desert Trans-Pecos. We dip down and cross the dry bed of the West Prong and just as quickly roar up and out of the wash. My stomach lurches. Two Mile Draw at fifty miles per hour provokes the same stomach-churning roller coaster effect. The undulating roadbed swerves in and out of the mouth of Flat Creek, another water-carved draw with hard-edged river cobble and a forlorn river height gauge. I get a glimpse down the main canyon, but there is no water in sight, despite the abundant spring rains.

KICKAPOO RANCH

From the entrance gate on RR 674, the Kickapoo Ranch driveway plunges down to an open, remarkably flat terrace punctuated with thick clumps of prickly pear cactus. Each fleshy paddle is crowned with rows of buds or bright, tender new pads. Purple clusters of prairie verbena bloom, surrounded by four-petaled yellow mustard flowers, tangled grasses, and leafy plants.

We crunch through the field and then the road turns sharply. Ahead, a

dense band of trees arches over the road. Descending through the green shadows, we emerge into another world. Upstream, a pool of pale jade water ripples. Tall cypress trees line the shores. A breeze wafts across the water, cool and seductive. Downstream, the West Prong of the Nueces glides between slabs of limestone bedrock and boulders. We inch the truck out onto the dam, stunned and slack jawed. Bill sets the brake and turns the engine off. We step out of the truck, leaving it blocking the road with doors open wide. The air is saturated with birdsong and the sounds of water rippling and lapping against stone. Bewitched, we walk down the gravel bank toward the river, where I can see fish moving in the shadowy pool. A rattling cry rings out, startling me, and we spin. A ringed king-fisher is flying straight toward us, on a collision course with our heads. We duck. The big bird veers over us, yelling, as an equally enraged, smaller, belted kingfisher follows in hot pursuit. They fly upstream to perch on cypress limbs and hurl insults back and forth. I grab Bill's hand. "Honey," I whisper, "I think we've gone down the rabbit hole and through the looking glass." He nods slowly as he turns to look up, then down the river. "Oh my," he finally says.

We are not the first to be entranced by the waters of Kickapoo Springs. A century ago, long before the springs were dammed, geologists Hill and Vaughan rhapsodized, "Here enormous springs break forth, creating a wide, running stream of clear water that continues 4 miles. In places it is 100 yards in width, is bordered by exquisite forests, and teems with aqueous vegetation and game fish." A US Geological Survey topographical map from 1892 shows Kickapoo Springs at the head of a four-mile-long pool that dissipates into the dotted line of an intermittent stream. On the old topo, the next pool is Dobbs Run, about eight miles downstream. Many miles beyond lies Silver Lake.

As we walk along the West Prong, it doesn't feel like a desert environment. The sky reflects blue off pale green water and I think, yes, it is a looking-glass land. Big cypress trees line the riverbed. I would have guessed the majestic trees to be over a hundred years old, but they were planted as saplings fifty years ago. Multiple generations of cypress offspring stand slender and tall, roots clenching gravel. Water gurgles, splashes, giggles, and whispers nonsensical but lovely syllables. Clumps of tall switchgrass and sawgrass live beside buckeyes, sycamores, elms,

Tasajillo cactus at Kickapoo Ranch, Edwards County

hackberries, little walnut, buttonbush, and wafer ash. I walk uphill, through the first ranks of plants lining the river and onto the first terrace of the river. In the alluvial soils deposited over eons, tall pecans sway in an afternoon breeze. I look up, hypnotized by the shifting patterns of the leaves against the sky. The limbs of the pecan trees clatter above me; I notice the piles of broken branches on the ground. A very steep, thirty-foot-tall bank marks the edge of the river's channel. I notice something white and walk over, expecting flowers. Instead I find that I'm standing beneath a wild turkey roost. The ground is littered with feathers and splattered with white droppings. I laugh; I've discovered a Rio Grande turkey Jackson Pollock painting of bright white drips and drizzles over a canvas of oak leaves and feathers.

Above the tall bank is a broad alluvial terrace like the field we crossed

on our way into the ranch. At one time, the three big terraces on Kicka-poo Ranch were treated as fields, planted with grass and irrigated with river water. But it has been years since the land was leased for grazing; most of the planted nonnative grasses are gone. Now the land along the river is held in a conservation easement while the rest of the property is managed for wildlife. Hunters lease the majority of the ranch for white-tailed deer, exotic animals (including axis deer, aoudad sheep, and oth-ers), and feral hogs. Kickapoo has a total of four endangered species: two songbirds, one cactus, and one reintroduced plant, the Texas snowbell, but the owners are not currently restoring habitat.

The ranch has been in the Flato family since the 1930s. The oft-repeated story is that on Jane Flato Smith's eighteenth birthday, her grandfather, banker Louis Schreiner, gifted her the eighteen-thousand-acre ranch. Jane's daughter, artist Malou Flato, laughs when I ask about the story. "Almost true," she tells me. "The ranch is eighteen thousand acres." She goes on to recount the factual story, but later all I recall is the embellished version. The ranch is intact, but the family uses only a small part of it—just the area along the river—and not as often as they'd like. There are a number of houses near the river including one of the ranch's original wooden farmhouses, which was moved and restored by Jane's son, architect Ted, and his wife, Katy. While neither Malou nor Ted lives at the ranch, when I look at their work I can clearly see the influence of Kickapoo and its juxtaposition of river, wind, and stone.

I leave the pecan bottom and catch up with Bill and our friend Terry Hibbitts. Terry is a gifted naturalist who has taken up the study of the Odonata, or dragonflies and damselflies. We wade up the river while he points out damselflies: violet Kiowa dancers and blue Comanche dancers. I jot down the names Aztec, spring, dusky, and powdered. The dancers fly erratically, literally dancing over the water while the bluets (which, de-spite the name, are not always blue) fly straight, darting from rock to rock. Coppery dancers with metallic iridescence on the back, azure bodies, and brilliant red eyes are an exciting find; they live only in the Nueces River drainage. Bill and Terry crouch in the riffles, water splashing around their legs as they focus cameras on the damselflies. Overhead a male vermil-ion flycatcher throws himself skyward with a mercurial flash of reddish-orange feathers against the blue sky. Light and air moving through the

feathers create an aura of reflected color around the bird's small body. How do you paint a creature that is mostly air and insect and only part feather, blood, and bone? If only I could paint air, then I would capture the flurry of a column of midges shimmering in the late afternoon light and the beat of the flycatcher's wings.

The river flows continuously from the spring lake to where it disappears into its gravel bed near the Kickapoo fence line. Swift water over gravel riffles alternates with deeper pools. We pass where Bluff Creek joins the river. The channel narrows and the river flows beneath solid limestone bluffs to quiet pools where big dragonflies patrol. Bill and Terry stalk the Odonata while I poke around, photographing flowers, watching the patterns of leaves against a blue sky, and generally dawdling.

I walk downstream alone. The river slips from its channel to flow across a wide limestone ledge. Furrows and channels course across the stone, all the edges rounded, smoothed, and slippery. The river channel is tucked under a tall creamy bluff. Jumbled house-sized boulders capped with lichens, ferns, flowers, and plants create an island in the stream. What caused the cliff to shear? And when?

I sit on a boulder, a dead-end channel curving into a quiet backwater on one side and flowing river on the other, and I put my feet into the water. Maidenhair ferns arc from rocky edges. Red flags of cedar sage blaze in the shade of tall sycamores. Bass, catfish, and bream swim through the dappled light in the river. Brightly colored dragonflies fly in tandem. Damselflies flit above the current. Minnows nibble at my toes. Over the gurgle of the river, a wash of buzzing bounces off the rock cliff. There must be a beehive in a crevice or cave in the limestone face. The sounds ricochet between the rocks and I let the nervous energy of the working bees flow over and around me. A green heron flounces up a tree limb hanging low over the water. He glares at me from behind a screen of leaves. Finally deciding that I'm not a threat, he hops out of the tree to saunter upstream. While I watch, he stalks a minnow, lifting and placing each foot in painfully slow movements. Even though I never look away, his strike is so fast that I miss it. He flips his head back, tosses the minnow up in a shower of silver, and slides it headfirst down his throat.

When we return to the truck, a pair of variegated meadowhawks hover in tandem over the hood of the truck, dipping down and touching the

hood with the tips of their tails. I look closely at the dark green paint; tiny oblong pearls—dragonfly eggs—speckle the surface. A pair of sandhill cranes glides silently overhead, following the river downstream. (Later I will e-mail Terry and pester Bill: Did we really see sandhill cranes on the West Prong? The answer: yes.) A few minutes later we see an adult bald eagle in the top of a sycamore. Bill and Terry take photo after photo of the bird perching over the river as late afternoon sun gilds its white head. Terry tells me that it is the second eagle he has seen in a decade of living in the Nueces canyon.

I wander off, leaving Bill and Terry while I follow a road (likely the canyon's original wagon road) up to the top of a bluff. When I reach the top, I look down over the last pool of water, the end of Kickapoo's nearly four-mile-long water hole. It is still, shallow, and thick with algae. I can see duck tracks and trails, and the pattern of punctuated dots where a pair of deer walked into the water. Below the pool, the river disappears, dissolving into a pale gravel wash. Hill and Vaughan wrote, "Toward its lower end the streamway narrows; the bold flow which up to this point has rushed through the rocky banks suddenly ceases and is succeeded by a whitened pebble bed. We were informed that the gravel drank in this water; but, suspecting that its disappearance was too rapid for such imbibition, cleared away a thin layer of gravel and discovered that it escaped down a large fissure into the underlying limestone rocks."

Mexican prickly poppy

Beyond the white gravel a thick stand of sycamores takes over the riverbed. Just downstream of the trees a fence cuts across the dry river valley, marking the property line between Kickapoo and the Smart Ranch.

THE SMART RANCH

I'm standing with Alma Smart on the road high over the first water hole on the river below Kickapoo. On the slopes above the river, she's got an excavator yanking cedar trees out of the ground. A skid loader chugs back and forth, piling up the trees for burning. The process, brush sculpting, is remarkably tidy compared to clearing or chaining with a bulldozer. The end result will be a mosaic of persimmon, blackbrush, cedar, and other woody species in irregular groups alternating with open areas for grasses and leafy plants. The trees and shrubs provide food, nesting, and cover

River Sentinel

for deer, birds, and other wildlife, while the irregular edges of the mosaic encourage plant diversity.

Alma has a head of gray curls, a frank gaze, and a quick laugh. I doubt much slips past her keen eyes. She is a recent widow, and her husband's dachshund keeps close tabs on her, brazenly hopping into the front seat of the Ranger 4×4 and barking commands whenever he thinks she needs to hurry or change direction. She dumps the dog into the back of the ve-

hicle with a touch of exasperation. The dog glares at me with a haughty expression; clearly I am in his seat. In addition to the brush sculpting, the crew has ripped the sycamores and grasses away from the banks of the spring-fed pool. It looks desolate to me—bare gravel and piled brush. She tells me that the water, essential for her livestock and deer, has already risen a couple of inches.

Alma is a lifelong rancher born and raised on the Pecos River. She met Neville Smart, her husband-to-be, when they were both in college. For over fifty years they ran the ranch together, first with Neville's parents and then, as Neville's mother gradually deeded the ranch to them, on their own. In turn, the majority of the ranch is now deeded to Alma's children and grandchildren. There aren't many large ranches left in what Alma Smart refers to as "old-time rancher's hands." Most of the family ranches have been chipped away, diminished by selling off parcels to pay inheritance tax or debts, or fragmented by heirs unable or unwilling to continue the lifestyle. "Nowadays," she tells me, "it is impossible to survive as a rancher without hunting leases or oil and gas wells." It strikes me that adaptability is the key to surviving as a rancher. That and water. The Smart Ranch is fortunate to have a number of spring-fed pools dotting the river's length through the twelve-thousand-acre property.

In the past the Smart Ranch ran sheep, Angora goats, and cattle. Alma and her son Tres (Neville Smart III) still run goats, but they've switched from Angoras to a sturdy Boer-Spanish cross that thrives in the near-desert area. "Better mommas," Alma tells me matter-of-factly. Then she adds, "I can hardly raise a crop of kids for all the predators." Her goats browse on the tender twigs and leaves of persimmon, blackbrush, catclaw, and, she adds, on young cedar sprigs but also have a tolerance for coyotillo and lechuguilla, plants that are deadly to animals unused to their toxins. Alma rotates the goat herd from pasture to pasture but limits the time the animals spend in each area. The trick is to let the goats stay long enough to control the brush but not so long that they consume all the preferred wildlife plants. White-tailed deer browse on woody brush during the winter—or drought—but prefer the weeds and wildflowers that ranchers regard as pests in grass pastures. Yet the ranch doesn't survive on domestic livestock anymore; it depends on the money paid by hunters for white-tailed deer and exotic hunting leases. Alma is quick to give

Tres credit for managing the ranch's game. She says he keeps track of the whitetail population and monitors the exotic game animals.

As manager, Tres makes sure the axis deer and other exotics don't overwhelm the native white-tailed deer. Axis deer, sika deer, fallow deer, blackbuck antelope, aoudad sheep, and other imported hoofed stock (ungulates) are having a serious, albeit unadvertised, negative impact on habitat and native wildlife throughout Texas, but especially in the canyonlands. Exotics were first introduced in the 1930s onto private ranches; now the Exotic Wildlife Association estimates that there are over seventy-six species and 250,000 exotic animals in Texas. Some of these animals live in closely managed herds on high-fenced ranches, but large numbers roam freely across the state. Whether they were intentionally released for sport or whether they are escapees, the exotics are established and are competing with native wildlife for food and habitat. Axis deer (imported from India) in particular are remarkably adaptable, and their biology gives them a distinct advantage over the native deer. While white-tailed deer are solitary or live in small family groups, axis deer congregate in large herds, nibbling on brush and grazing on grass and herbs until they've eaten everything possible before moving to a new site. Our native deer prefer to eat forbs (leafy herbs other than grass) and turn to browse woody shrubs only when forbs are unavailable. White-tailed deer cannot, however, live on grass. In a field of abundant mature green grass, a whitetail will starve. Meanwhile the exotics thrive, moving on to happily eat grass after the forbs and browsable twigs and leaves are depleted. Native deer cycle once a year, with fawns born in summer. Axis deer, on the other hand, reproduce all year long, so there is never a shortage of sexually mature females popping out fawns. Wildlife biologists continue to study the competition between whitetails and exotics, but ranchers like the Smarts know that if left unmanaged, axis deer and other exotics can overpopulate and devastate a ranch, especially on the arid western edge of the Hill Country.

The Smart Ranch has an eight-foot-tall fence running the length of the ranch on RR 674. I ask Alma whether the entire ranch is high fenced. She starts to laugh, but an expression of grief flashes across her face. "My husband put up that fence," she tells me. "There were a couple people in the subdivision across the highway that would sit up on the ridge and

Caracara

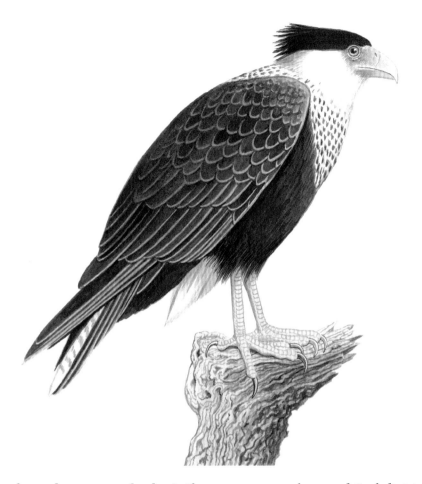

shoot deer at our feeder." She pronounces the word "subdivision" with discernible scorn. Then she grins. "Those deer were like pets. At first my husband would just go out there to sit and read next to the feeder. The deer were so tame they'd just stand and eat corn next to him. But he couldn't be out there all day every day and we finally put up the fence. Even if someone poaches a deer, they can't get to it." She waves her hand at the land across the road. "They got a bad deal," she says. "No creeks and you can't drill deep enough to reach good water. Plus, the properties are too small to hunt. Some of them do pay for predator control though."

"Predator control?" I ask. We bump down a gravel road along the river canyon. Abundant spring rains have greened up the ranch, though the river is not flowing. "I sure wish you could be here to see that river running," she tells me. Pools of water shine like jade beads in the white gravel bed. The channel skews from one sheer bluff to the next. We get out and walk through tall grasses to overlook Wiley Waterhole and the beginning of neighboring Dobbs Run Ranch. "Do you have eagles?"

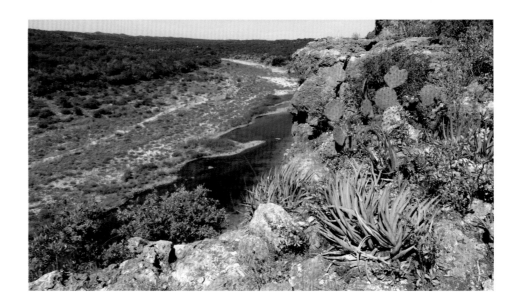

View of the West Prong, Edwards County

I ask. Not anymore, is her response. She tells me that during kidding season, caracaras and vultures prey on newborn kids. The main predators, according to Alma, are coyotes and feral hogs. A few years back, she saw feral hogs attack a pregnant ewe. "They shredded her, just tore her to bits and pieces." She grimaces and looks downstream, squinting into the distance. Pointing to a line of nearly invisible fence posts, she says, "We put up snares for coyotes on that fence line, but my neighbors, the Smiths, got a little upset with me. We don't put snares on our joint fence line anymore. But there has to be a balance; the coyotes are getting worse. We can't afford to have predators eating all our kids and fawns."

Unspoken is the reality that few landowners in the West Prong canyon depend on their ranches for a living. While most of these property owners expect their ranches to cover expenses (property taxes, fences, feed, and labor), their primary income comes from elsewhere. Indeed, ranching is rapidly becoming a hobby of the well-to-do. That the Smarts have been, well, smart enough and adaptable enough to keep their ranch in the family is a testament to their devotion and love of the ranching life.

DOBBS RUN RANCH

If Alma Smart and her family's ranch represents what she called the "old-time ranchers" on the Nueces, then the owners of Dobbs Run Ranch are

stellar examples of a new type of ranch owner. Paula and Ernest Smith, along with their son Carter, purchased Dobbs Run after splitting from a family ranch in the Coastal Prairie region. The Smiths knew they wanted a ranch where they could focus on habitat restoration and wildlife management. They found what they wanted in Dobbs Run.

The ranch is small by West Texas standards (a third the size of Kickapoo Ranch), but it was the diversity of the habitats and the potential for wildlife that entranced the Smiths. Dobbs Run is a surprising mash-up of regions and plant communities. Plants typical of the Chihuahuan Desert grow side by side with species unique to the Edwards Plateau and the South Texas Plains. The Smiths manage the ranch for wildlife and have placed the property under a conservation easement to protect its future. The hunters at Dobbs Run followed the Smiths from the family ranch; they've worked together for over forty years now.

The best part of being out on the ranch with Paula Smith is her unrelenting curiosity about the natural world and her infectious passion for Dobbs Run. We are driving along in a Mule, an all-purpose four-wheel-drive vehicle. My stepdad, J. David Bamberger, and his friend Joanna Rees are driving another Mule behind us. Paula points out that the southern and western slopes of the hills are drier and have less brush than the slightly cooler and more heavily timbered northern and eastern sides. It turns out, she tells me, that the endangered black-capped vireo prefers the slopes with less brush and the golden-cheeked warbler (also endangered) makes its home on the northern and eastern slopes. We try to identify the abundant wildflowers along the road as we drive past. Billowing clusters of pale blue-star flowers demand a closer look and Paula stops. Joanna jumps out to join us. Each five-petaled flower looks like a shooting star and every cluster like a fireworks explosion. Blue-gray gnatcatchers flit around an oak tree above us. One discovery leads to another. Wild garlic flavors the air when I trample a cluster of pale pink flowers. Persimmon blossoms perfume the air. Growing in the midst of prairie verbena and blue-eyed grass are thick flexible stalks of leather stem or jatropha, a plant I associate with rocky deserts. Leaves sprout from the dark red stems and tiny urn-shaped flowers cluster near the tips of the stalks. I'm telling Joanna that it's also called dragon's blood because the clear sap turns red when exposed to air, when we hear David clear his

throat. "Okay, little Joanna, let's get this show on the road!" We pop up from our botanizing, startled and guilty, and jump back into the vehicles. We are on our way to inspect the Texas snowbells.

The road rises and falls as we wind our way down to the river. Paula points out deadfall cedars—when they cut cedar, they leave it in place to create cover for animals and prevent erosion. Since purchasing the ranch in 1997, the Smiths have worked to create a mosaic of grasslands and woodlands in the canyons and on the hills. The goal, Paula tells me, is to support and encourage the diversity of plants and wildlife by developing niche habitats. Paula laughs. "Restoration requires taking the long view *plus* hard work. You celebrate the small achievements but hang on to the grand goals. Oh look, there is one of the quail sites!" She is pointing to a bright piece of surveyor's tape tied in a persimmon tree. A graduate student from Texas A&M University–Kingsville is conducting research on Montezuma quail on a number of ranches along the West Prong and upper Nueces. Montezuma quail, once abundant on the Edwards Plateau and Escarpment, are now so rare that most property owners are unaware of their presence. Little is known about the secretive quail's preferred habitat, foraging, or response to brush and cedar removal. The Smiths are happy to have the researcher working on the ranch. Indeed, Paula and Ernest repeatedly remark that one of the best aspects of owning the ranch is being able to share it with others. They work with researchers, school groups, master naturalist groups, and their favorite, the Texas Parks and Wildlife Department's Youth Hunts.

We cross Antelope Flats, a river terrace once used, astonishingly, for growing crops. A sheer limestone cliff rises above us as we rumble across gravel to stop next to Wiley Waterhole. In the distance I can see the Dobbs Run–Smart Ranch fence line running across the riverbed and pool. According to historical accounts, the West Prong doesn't run except in times of flood. It isn't, however, a river that has dried up from drought, agricultural overuse, or groundwater pumping; it has always had spring-fed pools separated by long dry stretches. This is a flood-lashed riverbed, cut into the limestone, thrown up against steep bluffs where floodwaters have tossed boulders to cut and crush a path downstream. The bluffs along the West Prong are, at first glance, as mechanical and contrived as a highway cut. But the human hand did not create these precipitous cliffs.

Geological faults, fractures in rock where one side shifts up or down, created the beautiful scarps, bluffs, and cliffs. While erosion from wind and sudden downpours has influenced the shapes of the hills, it is the incremental growth of fractures and fissures in the limestone layers that finally shears off slabs and slices of limestone as neatly as a knife cutting layer cake.

As I burrow through a thicket of buttonbush and scramble over large boulders to get to the pool, I hear David reminding Joanna that we are in rattlesnake country. Small fish dart away as I walk along the edge, every step sending another cricket frog or leopard frog splashing into the water. Birds sing unseen and unrecognized in the thicket. Crevices in the stone face hold moist soil and bouquets of grasses, flowers, and ferns. Water eases down the stone to the pool, leaving a trail of moss and algae. Bunches of grass spill off a ledge and down the rock face. I look closer and realize they are growing in a channel with water seeping around their roots down to the pool. "Oh Margie! Where are you?" Joanna calls, and I follow her voice to the mouth of a small canyon. She and Paula stand smiling next to a sign announcing "Recovery Site Texas Snowbells (*Styrax texana*)."

Dobbs Run, like the rest of the upper West Prong and upper Nueces canyon, is home to at least four federally listed endangered species: two songbirds, the black-capped vireo and the golden-cheeked warbler; and two plants, the Tobusch fishhook cactus and the Texas snowbell. Unlike many property owners, the Smiths don't mind having endangered species on their ranch. So when David called up the Smiths to talk about his proposed Texas snowbell project, they were willing partners—especially since Texas Parks and Wildlife botanist Jackie Poole had already located four of the small trees on Dobbs Run Ranch.

But before David Bamberger even put a snowbell seed into a pot, he was a man on a mission. He knew that with the majority of Texas lands held in private hands, the ultimate responsibility for an endangered species and its habitat falls on the shoulders of the property owners. If you have a federally listed endangered or threatened animal or plant on your property, you do not get any specific tax benefits or financial incentives to protect the species or its habitat. David wanted to demonstrate that private citizens could—and should—take the work of saving endangered

species out of federal hands. His plan was to find ranchers, botanists, naturalists, and volunteers who would be active participants in the management and recovery of an endangered species. Setting out to save the Texas snowbell from extinction, he networked, cold-called property owners, and knocked on ranchers' doors up and down the Nueces and Devils Rivers. Often the ranchers were unaware of the existence of the Texas snowbell, much less the possibility that the small trees survived in the canyons and stream cuts of their ranches. Many of his first overtures were met with outright suspicion. Landowners in Texas, particularly ranchers, have viewed the Endangered Species Act as a license for government infringement on their rights. David's courtship of property owners relied on his experience as a fellow Hill Country rancher along with abundant helpings of charm and infectious optimism. Gradually he won the grudging respect and even enthusiasm of a number of ranch owners who joined the snowbell project.

If you are going to pick something to save, the Texas snowbell is a lovely choice. A slender, multitrunked tree with rounded leaves, it is found only in the southwestern corner of the Edwards Plateau along the Nueces River, West Prong, and Devils River. It can be easily mistaken for a redbud tree except in the early spring, when clusters of small white bell-shaped blossoms hang beneath the branches. Only thirty-nine plants from seven populations were known when the federal government listed the plant as endangered in 1984.

In 2003, David, Paula, and Ernest along with a group of volunteers planted Texas snowbell seedlings at Dobbs Run. They surrounded each young plant with fence posts and heavy fence wire to protect the tender leaves from browsing deer and aoudad sheep. Today the trees stand nearly ten feet tall and are covered with snowy white flowers. Bumblebees and honeybees buzz from flower to flower. David stands and looks up at the blooms with a grin splitting his face. After twenty years of work, thousands of volunteer hours, and a little support from state and government agencies, he has planted more than nine hundred trees. Of those, at least five hundred have survived drought and flood, substantially bumping up the wild population. The Endangered Species Act says that recovery is achieved when a species can exist and reproduce on its own without human intervention. Has J. David saved the Texas snowbell? Some would

say not. Since no seedlings survive around the caged trees, they are not successfully regenerating. Only time will tell, but in the meantime, hundreds of Texas snowbells are planted on ranches along the Nueces and West Prong. Bamberger has proved, once again, that a single person can achieve extraordinary things.[1]

While the others sit on a shady ledge near the snowbells, I scramble up the side of the canyon toward the bluff. At the first exposed rock ledges, I find sedums, their fleshy, succulent leaves incongruous next to ferns. A piñon pine dusts me with pollen as I duck under its limbs. Red *Salvia greggii* flowers tremble while anonymous asters dip in the warm air rising off the cliff face. I take photos of half a dozen different ferns, some with the coriaceous surface of a desert plant, others tender and slick. Miniature pocket gardens of cacti and succulents, including

Bluffs along the West Prong on Dobbs Run Ranch, Edwards County

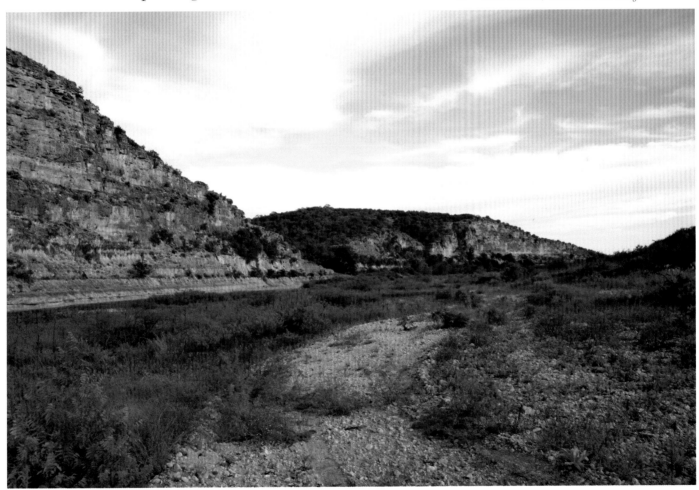

Spot-tailed earless lizard

Tobusch fishhook cactus, crowd into fissures. The vermilion petals of a claret cup cactus on a ledge catch fire in the late-morning sun. Cat-claw acacias, lechuguilla, leather stem, and prickly pear cactus squeeze into the thin pockets of soil. Dry moss crumbles underfoot and the smell of crushed sage surrounds me. A canyon wren pours out its liquid song from somewhere below me as I look out over the dry canyon of the West Prong. I try to imagine water flowing down the river channel but the West Prong has rarely, if ever, flowed continuously, at least not in the span of remembered human history. Geologists Hill and Vaughan called it "an intermittent stream of gravel flowing away from the Edwards Plateau and spreading over the Rio Grande Plain."

And I thought water was what made a river. The wren's liquid notes end, as always in a series of ridiculous buzzing squawks. I laugh and scramble down to join the others.

TULAROSA ROAD

If my map is right, I'm looking up at Dutch Mountain from a bone-dry crossing of the West Prong on Tularosa Road, a winding road north of RR 334 between Brackettville and Laguna. Silver Lake, a deep, spring-fed pool in the river, is just a few miles downstream. One is the site of a Civil War skirmish, the other a battle site from an ongoing conflict.

On the night of August 9, 1862, a group of Union sympathizers set up camp next to the West Prong under the shadow of Dutch Mountain. Most of the armed men and boys were German immigrants from Comfort and the surrounding Hill Country. They were on their way to Mexico, determined to avoid conscription into the Confederate Army. By the next night nineteen were dead, killed by Confederate and Texas troops. Was it a battle or a massacre? Descendants and historians still hotly debate the controversial Civil War episode that pitted Texas citizens against each other.

The Silver Lake battle in the winter of 1975 was an incident in the Hill Country ranchers' so-called war on predators. Today, that conflict rages on—and contentious doesn't even begin to describe the situation.

In the canyons of the Nueces, I've found the name "predator" to be a remarkably flexible term that in its purest form identifies any animal that

preys on livestock. Nowadays that means coyotes and feral hogs (more about those pests later). But not that many years ago golden eagles were, according to the old sheep and goat ranchers, on the verge of putting them out of business by eating up the profits. Literally. Looking at the cedar-clad hills around me, I have to ask, why would a golden eagle come to this river valley? Historically the big birds migrated and overwintered in the wide-open deserts of West Texas and New Mexico, preying on jackrabbits and rodents before returning to northern nesting grounds in early spring. Today they are rarely seen east of the Trans-Pecos. There are some open terraces along the river, but most of the land has a covering of brush and cedar. But it hasn't always been so. And therein lies the story of cedar, sheep, goats, and river.

The dramatic early changes in the landscape of the Edwards Plateau and canyonlands follow a narrative that most historians and biologists generally agree on: Early settlers came in and, seeing the abundant grasses (possibly the result of an extended period of cooler and damper climate), misjudged the resiliency of the land and promptly overstocked and overgrazed large swaths with cattle, sheep, and Angora goats. The war on predators began; wolves, mountain lions, coyotes, and other carnivores were systematically exterminated to protect valuable livestock. Meanwhile, because the settlers suppressed the wildfires previously set by the Native Americans, the existing brush—and cedar—began expanding, creeping down from the hilltops, out of the steep canyons, and into the grasslands.

But the story doesn't end there. At first, this incursion of brush might not have been considered all bad. Recall that timber, especially cedar, was a valuable commodity until the 1930s. By then, sheep and Angora goats were the profitable combination on the marginal land.

Ranchers, with help from the government, bulldozed, chained, and poisoned the cedar brakes and brush-covered hills in an attempt to transform the canyons into rangelands: grasslands with a smattering of brush for browse. Even with goats and deer nibbling on the brush, maintaining the Hill Country as open rangeland required reclearing the same land every ten to fifteen years.

Meanwhile the ranchers joined wolf clubs and predator clubs and paid trappers to take aim at any carnivore deemed to be a nuisance or

a potential threat to the lambs and kids. Counties hired private trappers or arranged for government trappers to shoot, snare, and poison coyotes, mountain lions, and bobcats. Even animals not normally considered threats, like raccoons, ringtails, and javelinas, were trapped and shot—often for their pelts. The war on predators likely had the same unintended result here that it had in other parts of Texas—the populations of jackrabbits, cottontails, rats, mice, and rodents grew. The open hillsides and abundant small prey enticed a group of migrating tourists to stop by the Hill Country and stay awhile.

<div align="center">✦ ✦ ✦</div>

Let me be clear: golden eagles can and do prey on very young lambs, kids, jackrabbits, and bunnies. But because eagles also eat carrion, they are often blamed for any carcass they happen upon—even if the lamb died of exposure, parasites, abandonment by the mother, or other natural causes.

I count myself lucky to see one bald eagle at Kickapoo Ranch. In ten years, Terry Hibbitts has seen two bald eagles in the canyons of the Nueces and knows of no reliable golden eagle sightings in the area. Yet during the winter of 1975, one pilot working for South Texas Helicopter Services arrived to fly a government trapper and a group of sportsmen around the Silver Lake Ranch to gun for coyotes. Instead they went after eagles, shooting the big birds out of the sky. The final tally for one afternoon's shooting was more than a dozen golden and bald eagles. The pilot kept a log of his flight hours along with lists of the eagles and other predators shot during each flight. That log became part of the government's prosecution against a number of Nueces canyon ranchers and the first enforcement of the Bald Eagle Protection Act of 1940 (amended to include golden eagles in 1962). And it all started at Eagle Cliff, at the headwaters of the Nueces, when a ranch foreman watched someone in a helicopter blast an eagle out of the sky. Outraged, he called the local game warden.[2]

The trial was controversial. Ranchers believed the eagles were ravaging their livelihood while the government meddled, hiding behind laws that defended birds over people. Scott Campbell, a photographer for the *San Angelo Standard-Times* (later a state representative), staked out a lone bleating lamb on a bare hillside and then hid in a blind to photograph an eagle striking and killing the easy target. To this day the pub-

lished photographs are touted as unequivocal proof that eagles were decimating lamb crops. The San Angelo paper's special insert, "The Eagle and the Lamb," had a few moderate voices, but the general tone was summed up in one uncredited quote: "Ranching is tough enough without the losses to rampaging federal eagles."

During the trial, information from the pilot's logbook listed more than one hundred bald and golden eagles shot from his helicopter alone (the company had several aircraft and pilots) during the winters of 1975–76 and 1976–77.

While the sheer number of eagles shot is jaw-dropping, what I really want to know is, *Where did all the golden eagles go?* In 1977 writer Donald Schueler counted over fifty eagles in one afternoon on a single ranch and estimated the ranch's total could be as high as eighty or ninety of the big predators.

It's been nearly four decades since the trial, and the number of sheep and goat ranches in the Nueces canyons—as well as the rest of the Hill Country—has plummeted. Likewise, the number of eagles spotted in the Nueces canyons has dropped from an extraordinary abundance to essentially zero.[3]

Retired ranch managers, like the gentlemen I had breakfast with in Camp Wood, were quick to tell me that the eagles left when the government put the sheep and goat ranchers out of business. No lambs, no eagles, they told me. Yet in the same breath I heard about the canyons changing. There has been a shift from the arduous mechanical maintenance of open rangelands to more and more brush and woodlands in the canyons. Screwworm eradication, the increasing trend of managing ranches for wildlife instead of livestock, and the end of the wool and mohair subsidies resulted in many of the open pastures surrendering to brush. There are still goat and sheep ranchers in the canyons, but woody shrubs and trees have crept across the Hill Country, blanketing many of the former ranches.

Did the golden eagles leave because, as the old-timers told me, there were no more lambs to prey on? Or was it the habitat shift away from the easy hunting of open hillsides and bottomlands with short grass, to slopes and valleys clothed with shifting mosaics of cedar, persimmon, agarita, and scrubby oaks?

I look up the West Prong at the cliffs over the river. Turkey vultures spin in lazy circles, held aloft by thermals flowing up the cliff faces. Just for a moment, I replace the soaring rusty two-toned black chevrons with the golden brown color and long, broad wings of eagles.

I turn my truck around and head downstream. I cross the river—no sign of water, just the broad gravel stream on its way down to the Rio Grande plains. But just because there isn't water now doesn't mean that there won't be someday soon. Alma Smart told me stories about floods that stranded them on their ranch. In 1935, a flood on the West Prong produced the highest discharge ever recorded from a watershed of its size. At the time, there were no standard rain gauges in the West Prong. People normally estimated rainfall totals in cans, buckets, and troughs, and in the three weeks prior to the flood, sixteen to twenty inches of rain fell in the canyon. But on June 14, 1935, all the containers overflowed. An estimated ten inches of rain fell over the canyon north of Kickapoo Ranch. The saturated ground shed water and it roared into the canyon. No river gauges recorded its depth or speed. Instead, after the waters receded, the US Geological Survey sent out engineers to measure the high-water marks on the cliffs.

The engineers chose a section of riverbed south of Silver Lake, next to where Tularosa Road crosses the river. The high-water marks showed that the river had rushed downstream at over fifteen miles per hour, in

a single channel over seven hundred feet wide and up to forty-five feet deep. Since I'm used to measuring speed from the interior of a car or truck, fifteen miles an hour doesn't seem all that fast. Until I scribble a few numbers on a scrap of paper and realize that a person would have to run faster than a four-minute mile to outrun the river. I'd never make it.

I'm thinking of this when, a week later, in May 2015, a weather system moves over the canyons, dumping enough rain to make the West Prong flow. I visit the USGS website several times a day to check river gauge heights and precipitation totals. Paula Smith sends me photos of the West Prong with flowing water and a short recording of the sound of the river rolling stones downstream. The river flows and then within days disappears again, only to reappear when more rain soaks the dry canyon.

II : La Brasada

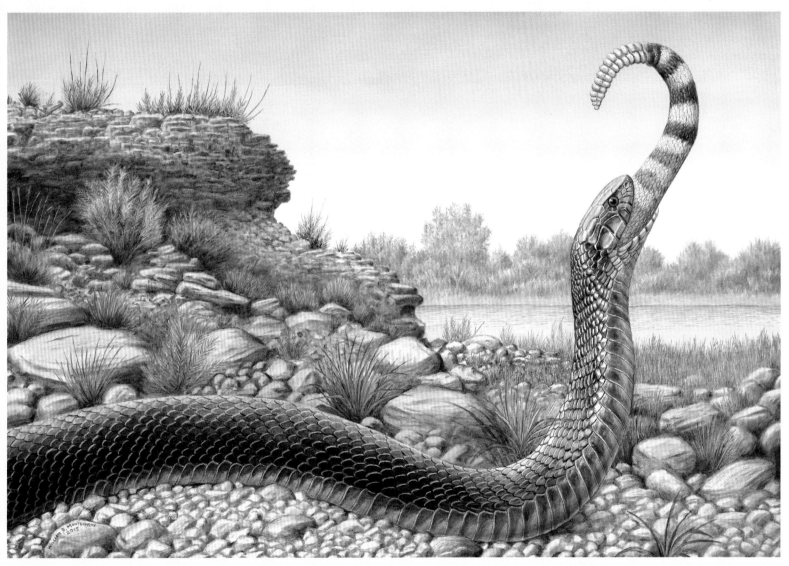

Indigo Snack

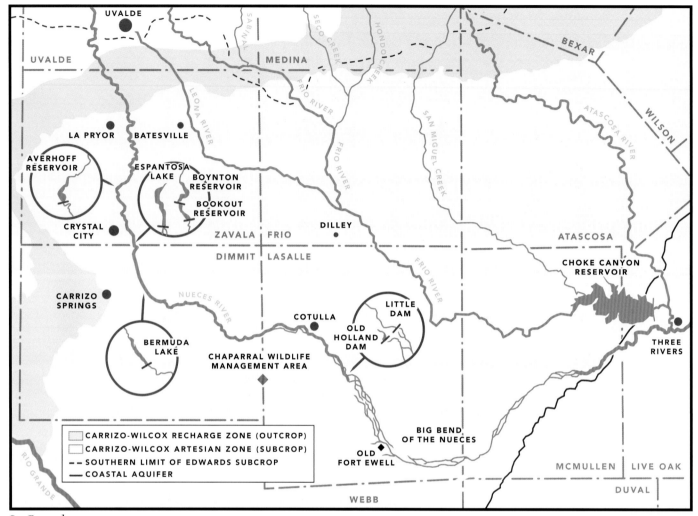

La Brasada

When the West Prong flows, it runs across broad gravel washes in an open valley with widely spaced hills on its way to join the Nueces River. Along the way it runs across the Edwards Aquifer Recharge Zone where, if there is water, much of it sinks underground. But not all. Just below the confluence of the West Prong with the Nueces, the river leaves the Recharge Zone and the combined waters of the Nueces and her tributaries swiftly move downstream. The canyon opens and the hills disappear into a fan of river sand and gravel that spreads over the plains and leads to the Gulf of Mexico. As the river leaves the Balcones Fault Zone, the plants and animals of the Edwards Plateau meld into the prickly thickets of La Brasada, the South Texas Brush Country.

Beneath the changing landscape, the water-filled matrices and channels of the Edwards Limestone begin their sloping descent. The layers of subterranean Edwards Limestone form a vast underground reservoir known as the Artesian Zone. The 2,300 square miles of the Artesian Zone, sometimes called the subcrop of the Edwards Aquifer, extend from its western limit, near Brackettville, and run east and northeast, following the curve of the Balcones Escarpment and Balcones Fault Zone through San Antonio. There the Artesian Zone narrows but still ascends below the Interstate 35 corridor from Bexar County northeast through Comal, Hayes, Travis, Williamson, and Bell Counties. Water flows through the conduits and matrices of the limestone, moving north and northeast. Fault-zone springs like the Leona, Cline, and Soldier's Camp Springs erupt where the waters are forced to the surface through crevices from deep underground.

The Nueces River bypasses Uvalde, slipping to the west of the city. Uvalde, after all, was settled around Leona Springs and the Leona River. The springs, actually four groups of springs, surfaced along a nine-mile stretch of river extending from the heart of the town south to the grounds of the Fort Inge historical site. Now hidden beneath a series of small impoundments, the springs flow little if at all. According to all accounts, the Leona was a beautiful river, but now it runs only when rain and runoff fills the channel.[1]

I drive south on Highway 83 from Uvalde heading to the river crossing where we'll launch our kayaks. Gravel mines spit out a steady stream

of overflowing semitrucks on their way to the Eagle Ford Shale Play or to construction sites. Mesquite trees crowd the fences, their leafy fronds overshadowing the brush, cacti, and scattered grasses below. I pass cabbage fields and trucks loaded with the heavy green and purple globes. Even at a distance I notice that the leaves are outlandishly blemish-free. Then the brush stretches out over the land until, abruptly, a pivot irrigation rig hovers over fields of shorn grain only to disappear behind another stretch of shaggy mesquite.

This is a land of disparate personalities and a place of many names and identities. It is cattle country and farmland and Tamaulipan thornscrub dancing cheek to cheek with tender vegetables. It has been called, at one time or another, New Spain, Mexico, the Republic of Texas, Coahuila, Coahuila y Texas, the Nueces Strip, the Wild Horse Desert, and the Winter Garden. But above all, it is La Brasada.

The Brush Country is the northern tip of the vast dry plains extending from deep in Mexico, over the Rio Grande, and into the southwestern part of the state. Bordered on the north by the Balcones Escarpment, it extends eastward to the Atascosa River (and the edge of the Nueces River basin) and then melds into the Coastal Prairies. The land is made up of fans of soil and gravel deposited by rivers, creating rolling plains cut through with the arroyos and valleys of the Nueces and Rio Grande and their tributaries.

4 *The Winter Garden*

BEE BLUFF

As we unload our kayaks, I look up at the tall concrete pilings of the Highway 83 bridge overhead. Mesquite, huisache, catclaw acacia, and other thorny brush surrounds us. I drag my boat through grass and across river cobble to the river's edge thinking what a difference a few weeks and ten inches of rain can make. I'd visited the crossing in early May when the

Buttonbush and European honeybees

drought, in its fifth year, seemed unending. The river was nothing but an ankle-twisting gravel wash. There was evidence of water: a slender young cypress standing over a dry pool; lines of sycamore saplings defining former shorelines; and an undercut stack of rust-red sandstone shading a few parched ferns. But no water. A week later it started raining in the upper canyon, and when I returned a week after that, a muddy brown torrent obscured the riverbed. The current stripped the sycamore saplings, baccharis, and buttonbush of their leaves and piled driftwood and debris along the edges. Even so, a family of five people bobbed in the rushing silt-filled water next to the bridge. Their laughter and infectious joy ran across the surface of the water, and we waved our arms at each other across the churning brown river.

Since then, the water has slowed and cleared. The river is half as wide, slower, and clear with the pale turquoise tint peculiar to the limestone Hill Country rivers and springs. Cliff swallows dip into the river to drink and then spin up to mud nests plastered to the bridge high overhead. The tall, slender pilings soar above us, supporting the roadbed. Less than two miles upstream, the colossal remains of the former highway bridge lie canted sideways, pushed out of the river channel almost exactly eighty years ago to the day. It was the same flood that crested at over forty feet in the canyon of the West Prong. The floodwaters rushed into the Nueces and headed downstream. The only river gauge washed out, so there is no accurate record of the river's height or flow on the fourteenth of June 1935. The US Department of the Interior's report *Major Texas Floods of 1935* has a pair of photos taken about thirty minutes before the destruction of the highway bridge and the railroad bridge just upstream. Sightseers crowd the concrete railings, watching the water churn around the pilings just below the steel trusses and roadbed. Sky Jones-Lewey's mom and sisters were among the people on the bridge watching the floodwaters come down. She tells me that her grandfather came down and got them, and others, off the bridge moments before the river took it. The river would rise another ten feet, rip the trusses off the concrete pilings, and slam the railroad bridge into the highway bridge. The force of the water cracked the bridges into pieces, lifting and carrying the massive pilings and roadbed downstream. The Missouri Pacific Railroad quickly built a replacement low-water trestle bridge while the fledgling

Texas Department of Transportation moved the highway crossing downstream to the current site, completing the present bridge in 1947.

As we unload the boats and stow our gear, we chat and ask questions about each other, slowly introducing ourselves. Sky Jones-Lewey is the trip leader. Linda, a local landowner interested in riparian ecology, is new to kayaking and a little nervous. David, a wildlife biologist, slathers a thick layer of sunscreen onto his arms and legs, explaining that he burns easily. We stow our gear and push off into the current.

The water is Nueces clear. I can see each individual river cobble and pebble beneath the rippled surface. A surprisingly zippy current grips the boat and demands attention and respect. No idly floating backward and fiddling with cameras and memo books on this river. The saplings that had reclaimed the dry riverbed during the drought turn the river into a sycamore slalom course. Luckily the trees are pliable, my kayak is made of durable heavy plastic, and I don't mind hugging a few slender trees along the way.

The river narrows; the water shades to a blue green that is an exact match to a green-winged teal's iridescent wing patches. As the low gray morning clouds break up, the sky reveals itself a powdery ultramarine, a cloak of Madonna blue decorated with puffy white clouds as innocent as lambs. On this gentle river my mind balks at the idea of floods that rip apart steel and concrete.

The cobble and gravel along and under the river is no longer the bone white of the upstream limestones. In the current, the dusty stones come alive in shades of cream and tan limestones, red and yellow sandstones, and occasional dark gray, green, and black stones. The river performs an unparalleled optical feat, washing the reds and browns with translucent blue greens. If I attempted the same with my watercolors, I'd end up with opaque shades more akin to sullen bayou water than limpid river.

On the banks, the thorny mesquites, huisache, catclaw acacias, and guajillo of the Brush Country mingle with riparian standards: buttonbush, hackberries, ash, little walnut, willow, and sycamores. The current snags the kayak and I rush through a little rapid, spinning off into a side eddy that pushes me under a blooming buttonbush. European honeybees, bumblebees, and tiny metallic green bees spin like satellites around the spiky flower globes. Puffs of perfume from blooming Texas kidney-

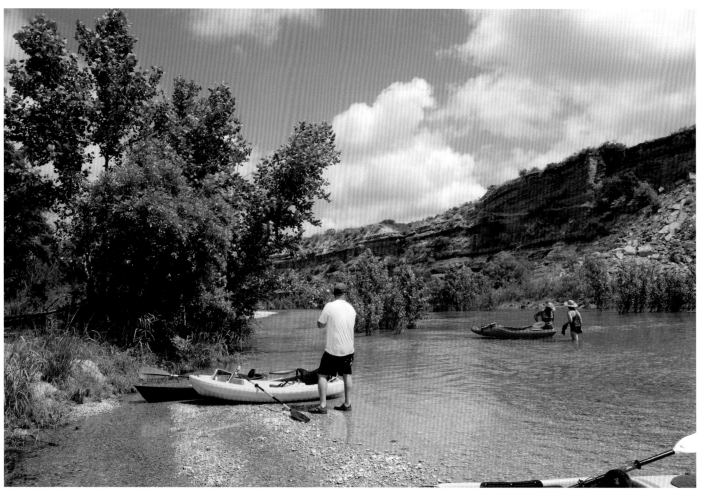

Kayakers below Bee Bluffs, Zavala County

wood explode into sweet olfactory fireworks as I hurtle downstream, the tiny white flowers barely visible from the boat. We pass bluffs of layered yellow-brown sands, streamside forests of dark live oaks festooned with clumps of ball moss, groves of tall wild pecans, and gravel bars dotted with sycamore and grasses. The sandy bluffs and red stone outcrops are proof we've left the Edwards Aquifer Artesian Zone and entered the recharge zone for the Carrizo-Wilcox Aquifer.

Sky Jones-Lewey spent her childhood on this section of river. She's seen it transition from a wild river with a narrow, swift channel to a bare, devastated gravel roadway with muddy water during the years of abuse by off-road vehicles and four-wheelers. Now, eleven years after the passing of Senate Bill 155 outlawed driving motor vehicles in riverbeds, the river is regenerating. Every bend reveals another triumph as nature re-

claims the ravaged river. The redefined stream alternates broad, shallow riffles with deep, swift channels. The formerly bare gravel bars sprout native plants like the sycamores and sawgrass that dig roots in to hold themselves and the terrain in place. Without the constant shifting and moving of gravel and sediment in the disturbed bed, Sky tells me, the water has cleared again.

Bee Bluff rises pale gold on the east bank, stretching downstream long and low. We pull the kayaks onto a pebble beach and lounge in the shade cast by sycamores, willows, and hackberry trees. We eat lunch and with full bellies sprawl in the shade, trying to make witty conversation. I'm lucky to put together a coherent sentence. We're startled out of our torpor when a young aoudad sheep scampers diagonally across the bluff on a nearly invisible trail, disappearing over the top.

We load back into the kayaks. The river spreads before us in a shimmering riffle with a thicket of young sycamores stretching from bank to bank: a strainer. Tangled in the saplings are downed trees and limbs pushed downstream by the drought-busting rains. Drowsy and lazy, I quickly give up trying to pinpoint a clear path through the trees and debris. Instead I abandon the paddle and pull myself through the thicket from sapling to sapling until I reach open water and the current pushes me to the base of the bluffs. Leaning back in the boat, I scan the bluffs. Thousands of thin layers of sand and clay create alternating bands of buff, white, brown, red, and pink. A few dark brown and black layers stain succeeding levels. The dark red of iron oxide drips down and paints lower strata. A cap of durable stone on the top prevents the softer, friable layers from disintegrating in the elements. I see an anomalous dark patch high up under the caprock. "A wild beehive!" I call out and dig into a dry bag for my binoculars. Sky looks up and quietly suggests we move downstream. Pronto. By 1992, Africanized "killer bees" had arrived in South Texas and began changing formerly benign hives into more aggressive colonies. She and David paddle away with alacrity while Linda and I take turns looking through the binoculars. The hive is quiet, the bees still. Concentric arcs of pale comb peek out of the dark mass of bees. If foraging field bees are returning with loads of nectar and pollen, I can't see their movement.

When settlers pushed into the frontier they found cash crops theirs

for the taking. Not only were there the semimythical herds of wild horses, but pecan groves in the creek and river bottomlands, timber growing along the river, and European honeybees building hives in hollow trees, along bluffs, and in the limestone caves of the Hill Country.

The honeybee is another successful European immigrant to North America. While there are a few species of native honey-producing bees in northern Mexico (and one wasp in Texas), the first colonies of European honeybees, *Apis mellifera*, arrived in the Virginia Colony in 1622. The bees went feral and quickly spread down the Eastern Seaboard and westward. No one knows exactly how long it took for what the Indians called the "white man's fly" to make its way to the land we call Texas. We will also never know what native bees—if any—were displaced by the fecund interlopers. And, although the Spanish were skilled beekeepers and imported hives to Mexico, no evidence (as of yet) indicates that they brought honeybees to their missions in Texas along with their herds of cattle, horses, pigs, sheep, and goats. Yet by the early 1800s, honeybees were established in Texas and producing hives and honeycombs. Historical accounts and relict names describe the massive hives and honey reservoirs in the karst landscape of the Hill Country. Early explorers and settlers enthusiastically sought out bee trees and caves so they could supplement their diet with wild honey. In 1834 Jean Louis Berlandier described the unique skill of beelining: "The people of the countryside have the ability to follow, on horseback, a single bee flitting from flower to flower, until they find the hive where it collects its honey." The Devil's Sinkhole had hives in the open crevices between the strata of the rock wall. The honeycombs were visible and just out of reach in the throat of the sinkhole. Hungry cowboys shot the combs off the walls and watched the honey fall to the floor of the cavern. But they didn't risk lowering themselves on ropes to harvest the honey. Even today, anyone walking along the canyons can hear the walls vibrate with the buzzing of wild hives.

For the early settlers, honey was a valuable cash crop. Beelining to locate bee trees or caves took some skill, as did collecting the comb and packing it into kegs for sale, but the bees did the majority of the work. Before the introduction of portable hives with movable frames, beehives were routinely destroyed to collect honey, but by the 1880s, the improved hives were widely available and nearly every farm and ranch kept

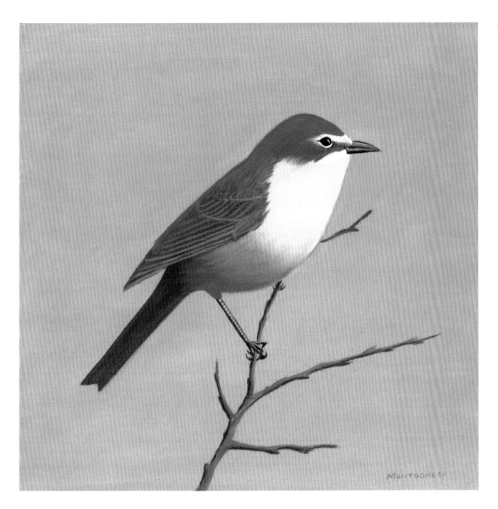

a few hives. Uvalde County quickly became the most important section of Texas for beekeeping and honey production for two reasons: thorny brush and water. While the flowering plants of the thorny brush were considered an impediment to good rangeland, the guajillo, catclaw, mesquite, bee brush, blackbrush, and brasil provided abundant light nectar and protein-rich pollen. But nectar alone doesn't supply enough water for bees to survive. The hives thrived along the Nueces, her tributaries, springs, and creeks. In 1900, judges at the World's Fair in Paris awarded a gold medal to Uvalde honey (as well as to Remington typewriters, Garland woodstoves, and Baker's cocoa and chocolates) and catapulted guajillo honey onto the international stage. The explosive development of the Winter Garden region of the Brush Country created thousands of new farms, each with a few hives to pollinate crops and supply honey.

According to local beekeeper Jim Willingham, beekeepers and bee-men shipped tons of the gold liquid from railroad terminals in Uvalde and, after rail lines extended north and south, Laguna, Crystal City, and Carrizo Springs. By 1913 Texas was the leading honey-producing state in the United States, with an annual yield of over three million pounds of honey.

I look up at the wild hive and wonder whether the bees are fanning their wings, creating small honey-scented maelstroms to cool the hive. As the current pushes my kayak downstream, I lose sight of the hive. I grab my paddle just in time to avoid crashing sideways into Linda's boat and a low-hanging willow.

Red Rocks

Downstream we bail out of the boats to swim in a deep green pool under the layered iron-red bluffs of Chimney Rock. No one can find a chimney-shaped rock, so we speculate that one of the many eroded cuts and gaps in the rock face might form a natural flue for a fire pit. The red Carrizo Sandstone next to the river is undercut and carved into nooks, bridges, and hidden passageways between the river and the shoreline. The water burbles and speaks low words as it weaves through the rocks. A yellow-breasted chat releases a long, jumbled cascade of notes, nearly melodic, then pauses. It sings a single, mellow-toned "bob." I hold my breath, knowing it is a chat yet yearning for the follow-up—the concluding, ascending "white." The chat pours out its glorious messy song again.

At our takeout spot, an old low-water crossing with a wide gravel bar and jumbled concrete riprap, families are enjoying the river. I pull my boat through a shallow riffle where three grown-ups sit in lawn chairs. A little boy and a small girl float in the current, holding on to the chair legs to keep from drifting downstream. On the bank a screen tent shelters a young mother and her sleeping baby while a young father and his son throw fishing lines into a deep, swift channel. Sky pulls one of the Nueces River Authority's bright yellow Up2U net trash bags out of her kayak and we start picking up cans, bottles, and juice boxes. I untangle a plastic grocery sack from a buttonbush. The young father comes over and collects it while his son watches the exchange. "Sorry," he tells me. "No problem," I

reply, and we agree that we are lucky to have the river running again. Sky, David, Linda, and I drag our boats over the gravel to load into the truck. I look back and see the man and boy downstream, filling the grocery sack with trash.

When I tell Sky, her face lights up. "That's the way it's supposed to work!" she says. The Nueces River Authority's Up2U campaign is based on a simple premise: people want to do the right thing and, given the opportunity, will do so. The Nueces River Authority believes that shame and guilt just aren't effective motivators, whereas what does seem to work is giving away free trash collection bags with the short, sweet message that Sky says "empowers the individuals." Sponsors donate money to buy the bags, which are handed out at recreation sites along the Nueces, Frio, and Sabinal Rivers, all the way from the headwaters to the Gulf beaches. With few public parks for river access, and even fewer trash bins (or trash collection), litter is a problem along the Nueces and her tributaries. It is up to the river users to clean up after themselves. Some people are conscientious; others are unaware of the environmental, aesthetic, and health costs of discarding used diapers, bottles, cans, and food wrappers along the river.

<p style="text-align:center">✦ ✦ ✦</p>

The low-water crossing, as far as I know, has no name. It is on an unmarked road (some maps designate it as County Road 4008) off Farm-to-Market Road 1436. The roads follow the rigid conformity of section roads: straight lines and abrupt right angles marking off square miles. According to Sky, this particular grid of roads north of La Pryor and a few man-made ponds are all that remain from a land development scheme from the 1940s.[2] It wasn't the first time that developers set out to convince a hapless public that the thorny brushland just needed a little irrigation (and sweat equity) to make the near-desert land yield up harvests of fruits and vegetables. We drive past an outcrop of red sandstone boulders with mesquites growing between the jumbled rocks. Sky points it out as a rattlesnake haven. Yet the dusty rocks harbor more than reptiles. Like the bluff along the river, this iron-rich reddish stone is an outcrop of Carrizo Sandstone, a small piece of a red belt that crosses the entire state. The distinctive reddish sands and sandstone ridge that peek above the

American Bison

surrounding soil are the leading rim of an underground formation. Layers of sand, sandstone, gravel, silt, and clay up to three thousand feet thick and a hundred miles wide curve from beyond the Rio Grande, under the state, to Arkansas and Louisiana. As the waters of the Nueces and her tributaries cross the outcrop (or recharge zone), they seep into the depths, feeding and sustaining the Carrizo-Wilcox Aquifer, the source of water that turned the Brush Country, La Brasada, into the Winter Garden.

AGRARIAN DREAMS AND ARTESIAN WELLS

The Winter Garden sounds like an imaginary place. I envision it as a secret walled oasis protected from the harsh Texas extremes of drought and flood, blistering summers, and unexpected northers. A place with fountains, verdant and riotous with tropical plants and blooming flowers of all colors. Above all, a place rich with flowing water from springs, artesian wells, creeks, and rivers.

That is the image promoted by the speculators and developers who advertised thousands of small-acreage farms for sale in the first part of the twentieth century. They were selling a myth and a dream. The Winter Garden improbably combined elements of the western frontier with the nearly impossible premise that a family could—or should—support itself on a small freehold farm. Land agents across the country (selling on commission) presented the rough land as an opportunity for those with the vision to imagine the thorny brush transformed into tame row crops. They tempted midwesterners and northerners with newspaper advertisements listing outlandish annual yields and potential profits made by established Winter Garden farmers (often the land developer). The ads sidestepped the oppressive summer heat, instead crowing about extra long growing seasons. They also failed to mention the enormous irrigation costs or the heroic labor needed to turn the thornscrub into productive cropland. Thousands of new residents were lured to the original Winter Garden area (Zavala, Dimmit, and eastern Maverick Counties) as well as other counties in the Nueces River basin including La Salle, McMullen, Atascosa, Frio, and Live Oak.

The Winter Garden all started with a single well and then a single crop, not even by the same men or in the same county. In 1884, outside Carrizo Springs, the Frazier brothers used a hand-operated drill to dig a well tapping into the Carrizo Sand, an upper level of the Carrizo-Wilcox Aquifer. At the time, the aquifer's layers of sand and gravel were so completely saturated that water flowed up out of the ground, no pumps needed—a magical fountain in a near-desert land. The brothers irrigated a few acres and then continued, like the rest in the region, to run sheep and a few cattle. Ten years later, some bright fellow decided to put in

a crop of Bermuda onions near Cotulla in La Salle County. When the first railroad car of Bermuda onions shipped out of Texas in 1900—a full month earlier than any from growers in other states—people took notice.

Texas loves a land developer. Always has. From Moses Austin's first scheme to settle a chunk of New Spain and acquire a sizable slice of land for himself (carried out by his son Stephen F. Austin with support of the Mexican government) to today's luxury gated communities, men have been chopping Texas up into tasty morsels for the masses. With the success of the Bermuda onion crop and with artesian wells spouting up like a pod of whales surfing through the brush, dozens of land developments sprang up in southwest Texas. Ike Pryor divided up his ranch and platted the town of La Pryor on the west side of the Nueces. Crystal City sprang from the dreams of the Cross S Farming Company.

Río de las Nueces

On the drive to Crystal City, there is scant evidence of the Winter Garden's heyday of annually producing tons of vegetables for the nation. South of La Pryor, Bill and I turn off onto FM 1025 in search of Averhoff, or the Upper Nueces Reservoir. We drive down unmarked roads through what was once a massive pecan orchard. The land is divided into lots, some with houses, most with dead or dying pecan trees marching in rigid ranks. In 1928, a crop of more than four hundred thousand pounds of pecans from the "world's largest native pecan orchard" earned Ike Pryor the title of Pecan King (it is, of course, quite likely he bestowed the honorific upon himself and then notified the newspapers). This drought-parched land seems an unlikely place for pecan orchards, yet before the groundwater dropped out of reach of the trees' long taproots, native orchards thrived along the river.

Early explorers noted abundant pecan trees on the east side of the Nueces River. William C. Foster, author of *Spanish Expeditions into Texas, 1689–1768*, pinpointed the regular crossing point for the Spanish *entradas* as just north of the Averhoff Reservoir. Most of the early explorers and missionaries noted the presence of mesquite prairies and thickets on the west side of the river and then a valley of pecans, oaks, elm, and mulberry trees on the east side.

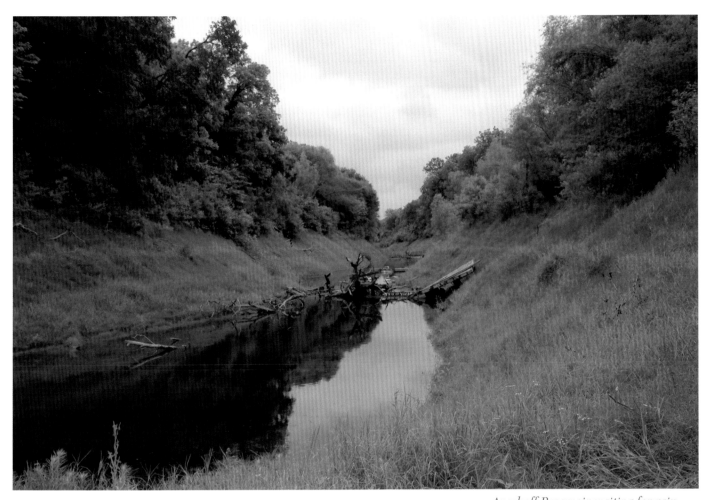

Averhoff Reservoir waiting for rain, Zavala County

In 1689 Alonso de León, on his way to find René-Robert Cavelier, Sieur de La Salle's French settlement, bestowed the name "Río de las Nueces" upon the river. Yet two years later, despite acknowledging de León's name for the river and describing abundant pecan woods, Domingo Terán de los Ríos renamed it San Diego. Fellow traveler Fray Damián Massanet called it San Norberto and recorded "Chotilapacquen" as the Coahuiltecan Indian name for the river. But no one had connected de León's Río de las Nueces with the river flowing into the bays behind Padre Island. Indeed, while the rest of the state's rivers were explored early on, the Nueces was a mystery. For more than a century many believed that the Nueces and Frio Rivers were tributaries of the Rio Grande. Martín de Alarcón, governor of the province of Coahuila, was so taken with this idea that in 1707 he planned an expedition to

paddle down the Nueces in dugout canoes to the Rio Grande, float downstream, and then paddle up the Frio River. Even Captain Zebulon Pike's 1807 map of the provinces of New Spain, famous for its annotation "Immense Herds of Wild Horses," skipped the Nueces River (and her bays), drawing only a single slender tributary labeled "Cold Creek" down to the Rio Grande.

Despite the confusion, the name "Nueces," as well as the names of surrounding rivers, streams, and landmarks, has been remarkably steadfast for over three hundred years, even if the many springs, flowing creeks, and water holes the early explorers relied on are long gone.

<center>✦ ✦ ✦</center>

We drive over a bridge, past a dam and a dark, tree-filled spillway. The wide gravel washes I saw upstream are gone, replaced by steep-sided troughs in the deep soil. As if feeling constrained by the high banks, the river begins a fevered twisting and turning as it flows south.

Another road (also unmarked) leads us straight through more distraught pecan orchards to the reservoir. A small, mostly tidy, village perches on the edge of the lake, its streets optimistically named after fishing lures and their targets. Bill and I walk to the concrete boat ramp and look down the grassy slopes to the strip of water in the bottom of the deep V-shaped canyon. I pull out bottles of insect repellent and we slather our ankles, knees, and waists. No blood donations to the Nueces today. We wade into the hip-tall grass, slipping and sliding down the steep trail to the water. Yellow-breasted chats sing, tossing ribbons of song back and forth across the green canyon. Floating docks lie stranded above our heads. A green kingfisher hunts and calls, flying from one cluster of logs to another. A thrasher or mockingbird repeats the kingfisher's rattle and then trills like a drunk finch. I laugh and the kingfisher flies away. The water is thick with aquatic plants but clear and surprisingly deep. Snarls of ancient trees block the channel, so paddling up and down would be impossible—assuming I could convince Bill to drag the kayaks down and up the steep bank. Spotted gar, bass, and bluegill rise from the depths and then disappear back into the maze of aquatic plants. A diamond-backed watersnake hangs vertically in the water with only its red eyes above the surface, watching us watch him. The river channel twists away

from us, vivid green, forlorn and yet beautiful. Shaggy woods crest the rim of the reservoir, dipping and creeping down the sides. Bobbers, lures, fishhooks, and tangles of monofilament line dangle from the branches far overhead. We trudge back up to the truck. I stop and pat the hull of my kayak, promising it—and myself—a river paddle someday soon.

A week later, the drought-busting rains finally arrive and Averhoff fills after eight long, dry years. I wait another week and then drive out and park in the same spot. Brown swirling water fills the channel, nearly reaching the very top of the concrete boat ramp. I walk down the road, stopping at a property designated by a fancy metal sign as the spot for "Old Hippies and Honky Tonk Angels." I learn from the not-quite-friendly group drinking beer that Averhoff filled with runoff ten days prior. Then the water from upstream flooded into the reservoir and turned it muddy and turbid. A guy casts a line off the roof of a flooded shed. His friend, standing in a skiff, teeters next to him. I leave and pass their neighbor, who spins his riding mower in concentric circles on a narrow island of lawn. He is surrounded on three sides by swirling, chocolate milk–colored water. My kayak stays put in the bed of the truck a second time.

Popeye's Green Gold

Crystal City is a dusty, sun-bleached town neatly laid out in tidy grids, with the railroad center stage, running through the heart of downtown. A statue of the cartoon character Popeye surveys the old plaza from a sheltered pedestal. The Cross S was a cattle ranch of more than one hundred thousand acres bordering the Nueces when two men, Carl Groos and E. J. Buckingham, acquired a trust deed in 1905 for the ranch (guaranteeing they would pay for the acreage as it sold to others). Like other developments, the ranch was surveyed into ten-acre lots. They platted Crystal City, its name inspired by the artesian water, near the Old Spanish Highway between the Rio Grande and San Antonio. The Cross S Farming Corporation, as was common at the time, offered the railroad a bonus of $345,000 to build a line from Uvalde to Crystal City. An army of land agents across the country advertised in their local papers and waxed rhapsodic about the land of possibilities. Anyone buying a ten-acre or larger tract of farmland received a lot in town. One Cross S Ranch ad

described the ranch as free from "malaria, insects and Negros." The agents arranged excursions to see the mythical land (even throwing in special train fares, meals, and side trips to Mexico as additional enticement), sold lots, and collected their commissions. Buyers flocked from the north and Midwest, believing that the thornscrub was an agricultural paradise just waiting for the right touch to bloom.

On my first trip to Crystal City, I stop by city hall. A second statue of Popeye stands in front on a white pedestal. In the 1920s Crystal City started switching from Bermuda onions to spinach (and cotton), ultimately claiming the title "Spinach Capital of the World." It still holds an annual festival and crowns a Winter Garden Queen. In the office foyer yet another Popeye stands next to two interpretive panels with text and photos about the World War II Crystal City Internment Camp. The site of the former camp is now listed in the National Register of Historic Places and I am curious to see what remains. I ask the clerk for information about the location. She gives me a blank look and shrugs her shoulders. "Hey," she yells over her shoulder to the back office, "there's a lady here asking about the Japanese camp." Silence. Someone calls back to her, laughing, but I can't hear what they say. She shrugs again and stifles a giggle. "Sorry," she says, not meeting my eyes.

I find a carved granite block by the high school. The incised text frankly states "World War II Concentration Camp" and is intended to be a reminder "that the injustices and humiliations suffered here as a result of hysteria, racism and discrimination never happen again." A maintenance man hops off his mower and walks over to point out interpretive displays put up by the Texas Historical Commission.

I remember a line from an article stating that the camp officials "often granted requests from the detainees for picnics by the Nueces River." Picnics outside the ten-foot fence, guard towers, and floodlights. Beyond the censored letters, head counts, guards, and forced labor in the camp's vegetable fields.

I can't imagine. And I get in my truck to go find the Nueces for myself.

Espantosa Lake

What I find is the Rock Quarry Crossing on Espantosa Slough or Lake. There is a little roadside park and I pull in and hop out of the truck. Not a drop of water flows under the bridge or over the rounded and water-sculpted rock formations. Originally called Rock Falls, it is a natural formation although it looks out of place in the heavy bottomland soils. A partially submerged television bobs in a dark and scummy pool at the end of the run. I'm walking around taking photos when a pretty young woman walks down the hill. She is lecturing two young boys (her nephews, I learn) and a friend about the place's history. I eavesdrop for a minute and then introduce myself and ask whether she knows anything about Espantosa's history. She inhales, but before she utters a word, her friend rolls his eyes with a groan and her nephews plop down on nearby rocks with exaggerated sighs. She ignores their dramatics, shakes my hand, and tells me rapid-fire that her name is Andra Marquez ("like Sandra without the S") and she grew up next to Espantosa; her family owns the land along the slough and the dance hall, El Campestre; the song "La Llorona" ("The Weeping Woman") was written about one of Espantosa's ghosts; no one has ever seen Espantosa or the river so dry; her nephews have never seen water flowing through the crossing or had a chance to swim there; over the years many people drowned in the Rock Quarry, plus there were drug overdoses, suicides, and dead bodies. But at the park, not at El Campestre, the dance hall. We walk over and look at the pool that Andra calls the *tinaja*. "Nasty," says one of her nephews. The other asks, "You used to go swimming in there?" Andra grins. "People say there are alligators in there!" This gets the boys' attention. She continues, "The floods used to bring down big alligator gar and they'd live here until someone caught them. The water used to be clear. I remember water flowing that was as blue as her eyes." She points to me. One of her nephews turns and steps up close to me. I can feel his soft exhalations on my face as he looks at the color of my irises. Andra laughs and I smile as the boy quickly steps back, his cheeks flaring pink. She turns to me. "My mom is the one who really knows about Espantosa since she grew up here." She nods to the house up the hill. "I know she'd be happy to talk to you." We make plans to meet and she and her entourage walk away, her words and nephews trailing behind.

Long before J. Frank Dobie spooked the public with his tales of the haunted lake with murderous mermen and lost wagonloads of treasure, Laguna Espantosa was a reliable source of water for travelers on the Camino Real or the Old San Antonio Road (OSR).[3] Established by the Spaniards in the late 1700s, the OSR was not a single track but a network of trails that varied according to season, weather conditions, the state of the rivers, and the presence or absence of hostile Indians. There were several routes connecting the Spanish frontier missions with colonial settlements south of the Rio Grande. The Upper Presidio Road led from the Presidio del Río Grande crossing (modern Guerrero, Coahuila), passing by Espantosa and present-day Crystal City, and then going on to San Antonio and points east.

By the time Jean Louis Berlandier, a French naturalist, traveled the

Espantosa

OSR in 1834, the laguna's reputation was firmly established. Berlandier referred to Espantosa, which means "haunted" or "horrible," as "Lake Dread" and recounted a tale of a monstrous animal that would emerge from the lake at night, sometimes attacking the people and animals camped on the lake's banks.[4] He also noted that when the Nueces rose, the river would split itself in two and send its waters down Espantosa, with any overflow turning the surrounding low-lying spots into vast swamps where alligators roamed. Along with Espantosa, there were a number of other long, narrow, and deep lakes in the area. Soldier Slough and Alligator Slough (as well as Espantosa) are abandoned river channels that run roughly parallel to the river. Caimanche Lake (also called Comanche), northwest of present-day Crystal City, gathered water from a large spring-fed drainage that reaches nearly to the Rio Grande. The overflow ran down Turkey Creek to Espantosa, which in turn flowed into Soldier and Live Oak Sloughs until finally returning to the river. It sounds confusing, but on a satellite image it is possible to trace the original—though now dry—twining tracks between the river, lakes, and creeks.

Curious to see the river, I visit Triple R Resort and RV Park on Highway 65 just outside Crystal City. Unlike the many "man camps" and new RV parks (usually a gravel lot with former federal disaster relief trailers) that have popped up to house oil field workers from the Eagle Ford Shale Play, Triple R is well established and maintained. I check in at the office and then take off down the three-mile-long nature trail. On one side stately oaks and pecans shade RVs and expanses of closely mowed grass; on the other side a wooded precipice drops twenty feet or more down to the river. Whole trees crisscross the deep, narrow channel, their roots torn loose from the dirt bank. From my vantage point I spy on spotted gar, bream, basking soft-shelled turtles, red-eared sliders, and fat diamond-backed watersnakes in the dark, still pools. A Cooper's hawk cruises along the river below me. Cardinals, sparrows, and a red squirrel dive into foliage, wrens and vireos clamp their beaks shut, and a wave of silence crests before the hawk.

A few trails skid down to the water but the thickets of poison ivy deter me. From the shelter of the woods next to the channel, I look across the RV park onto fields and pivot irrigation rigs blazing in the sun. I make a list of the trees: mulberry, cedar elm, hackberry, a buckeye with pink

flowers along its branches, ash, pecan, oak, willow, and chinaberry. All
the riparian standards plus a few thornscrub representatives: brasil, its
thorns hidden by soft new leaves, mesquites, and a lone sweetly bloom-
ing guajillo. Before I leave, I return to the office and ask the park's man-
ager, Rashell Keene, if the river ever flows enough for kayaking. She looks
doubtful. "I don't think so. Even when we're not in a drought," she says,
"there isn't that much water. What we need, though I might regret saying
this, is a hurricane to come through and bring enough rain to flush out all
the dead trees." She shakes her head. "No, I really don't wish for a hurri-
cane. But some real rain would be nice."

La Llorona's Tears

Rosalinda Marquez, a vivacious woman with a head of dark curls threaded
with silver, leads me into El Campestre to a table where Andra works
on a laptop. Bathed in light from the dance hall's opened doors, she tells
me stories learned from her parents, grandparents, and relatives. Tales of
Mexican general Santa Anna's lost gold, of strange flames burning in the
woods at night, of her uncles finding pieces of wagons when they dug for
the treasure—the same folktales J. Frank Dobie recorded. Her eyes spar-
kle and she taps and shuffles a stack of photos like they are playing cards.
Her husband, Alejandro, quietly joins us, taking measured steps by the
entrance, listening to his wife, and nodding in agreement. When she tells
me that the folk ballad "La Llorona" ("The Weeping Woman") was written
about Espantosa, Alejandro clears his throat. He is trim, dignified, with an
aura of gentle authority. We turn to him. My pen is poised over my note-
pad. He walks slowly past the table. "A fellow asked me," he says gravely,
"if it was true that La Llorona could be heard crying at Espantosa." Ale-
jandro pauses and turns. "I told him yes!" Another pause as he crosses the
room. I sneak a peek at Rosalinda, who has her head down, propped on
her hand, her curls covering her face. I scribble madly. "Yes! But there
are really five *lloronas*! He was shocked!" He paces back. "And I tell him I
hear them weeping and crying all the time." He turns and faces us. "And
their names are Andra, and . . ." His daughters' names are lost as Andra
protests, "Not fair!" Rosalinda shakes her head and groans while I laugh.
Alejandro smiles to himself and makes another circuit around the table.

Rosalinda lines up a series of photos in front of me. Espantosa flooding the Rock Quarry with angry muddy water. Espantosa flowing a startling blue green through the Rock Quarry. Family and friends swimming in clear water. A photo of Rosalinda with her father standing under the old bridge.

<p style="text-align:center">✦ ✦ ✦</p>

The Marquez family's chronicle is interwoven with the larger history of the Winter Garden's successive booms and busts. Rosalinda's grandparents arrived in Crystal City in 1926, during the region's second of many agricultural booms.

The first agricultural explosion was a sixteen-year period of exuberant optimism fueled by the abundant artesian water and inexpensive Mexican labor. Thousands of new people moved into Zavala and Dimmit Counties between 1900 and 1916. Carrizo Springs and Batesville were established before the Winter Garden's land rush but grew rapidly. Bermuda Colony was the first planned town, and Asherton, Big Wells, Brundage, Catarina, Crystal City, Dentonio, La Pryor, Palm, Winter Garden, Winter Garden Ranch, and Valley Wells all sprang into being seemingly overnight, the product of land developers' agrarian dreams. Homesteaders bought into the Winter Garden vision and arrived to build a new life, yet many abandoned their land immediately. Faced with the realities of months of backbreaking labor grubbing and clearing thorny brush, brutal heat, rattlesnakes, and the cost of drilling wells, they fled. Nevertheless, the developments flourished for over a decade, fueled by a steady inflow of new settlers, inexpensive labor, and the outflow of groundwater and river water onto the fields.

What doomed the first Winter Garden land rush was lack of water (though falling onion prices didn't help). When the Frazier brothers drilled the first artesian well, springs still steadily seeped along the edge of the Carrizo outcrop feeding creeks that flowed into the river. Carrizo Springs wasn't a fanciful name invented by a developer; the springs had been a regular stop on the Old Spanish Highway long before the invention of the Winter Garden. In 1909, when the railroad trunk lines reached the Winter Garden (coming in from both the north and south) and land developments were popping up all across La Brasada, the aquifer still

had a hydrostatic head—enough pressure to push the water up to the surface. Dig a well and water magically flowed out. No expensive pumps or engines needed. By 1910 at least 250 irrigation wells in Zavala and Dimmit Counties tapped into the water-filled layers of sand and gravel. When some of the original artesian wells faltered and then stopped flowing, few people paid attention. Wells were fitted with pumps—or abandoned. A few people noted that small springs stopped flowing and creeks dried up before reaching the river, but no one was unduly concerned.

And then, beginning in late 1916, the seasonal rains bypassed the Garden. It was the Winter Garden's first nosedive on the roller coaster of boom and bust. Rains and higher market prices briefly revitalized the Winter Garden area in 1919, but subsequent droughts, disease, and changing market conditions plunged the farmers into debt and despair. The homesteaders and farmers sold out or abandoned their land, leaving the fields to grow up into mesquite brush. Crops withered—even with irrigation.

Artesian wells slowed to a trickle and then stopped. The hydrostatic head of the aquifer retreated farther. Although during drought, little rain or river water percolated down to recharge the aquifer, the Carrizo-Wilcox still held plenty of water. But to reach the water and pull it up to the surface, big expensive pumps were needed. Espantosa and other sloughs were dammed to hold irrigation water. Applications of tons of arsenic-based pesticides ensured bountiful harvests but killed honeybees and native insects and birds. In the mid-1940s farmers switched to DDT. Beekeepers hauled bees in to pollinate crops, often losing multiple hives when nearby fields were sprayed with poisons. A ready supply of labor tended, harvested, processed, and packaged the fruits and vegetables.

The local springs, such as the formerly robust Carrizo Springs, water holes, and creeks were gone, dried up and filled in with eroded soil. The river slimmed down, its base flow reduced as the springs ceased. Swamps and alligators along the Nueces disappeared, remembered only in folklore.

By the big drought of the 1950s, most of the small farms were gone, replaced by corporations like the California Packing Corporation (now the Del Monte Corporation). The California Packing Corporation purchased thousands of acres, built a plant to process vegetables, and se-

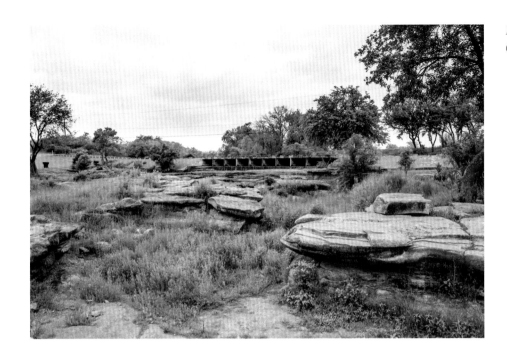

cured water rights from the Upper Nueces Reservoir. The wells ran and ran, pulling more water out of the aquifer than ever before. In the midst of the drought of record, water flowed with reckless abandon onto fields while the river and creeks languished. The farmers pumped more water out of the aquifer than the rivers and rainfall could replace. By the 1960s, pumping was pulling an unfathomable amount of water from the aquifer each year. Hydrogeologists generally agree that in the Winter Garden area of the Carrizo-Wilcox Aquifer, rainfall (about twenty inches per year) and rivers crossing the outcrop or recharge zone add around 100,000 acre-feet of water per year to the aquifer. In 1969 alone, 255,000 acre-feet of water were pulled out of the aquifer to water crops (with public supply and industrial use adding another 24,000 acre-feet). After decades of pulling more water out of the aquifer than returns via recharge, there is a cone of depression below Zavala and Dimmit Counties where the water table has been sucked dry as far as three hundred feet below the surface. Few people even remember when the Carrizo Springs flowed or the creeks ran. The springs that fed the river are long gone, and the aquifer has retreated so far below the surface of the land that it is unlikely that any springs will ever flow again. Even the pecan trees with their impressively long taproots can no longer reach enough water to survive. The

land of wild pecans and the river of nuts survive only in history—or on irrigated land.

<p style="text-align:center">✦ ✦ ✦</p>

Recounting the boom of the 1950s, Rosalinda waves to the dance hall. "It wasn't this building but the first one. We'd have eighty workmen living here at a time. There were cots lined up everywhere and we served them lunch and dinner." Alejandro nods. "The jobs are gone. With all the technological advances, the farms don't need labor like they used to. Everything has changed." He pauses. "Except for the water; they still need the water."

"The Carrizo-Wilcox Aquifer was lowered so long ago that people have forgotten any effects it had on the river," Con Mims, executive director of the Nueces River Authority, told me later. "With the increasing demands for water by cities and the Eagle Ford Shale Play, it is unlikely the aquifer will ever refill."

Bermuda Colony

Bill found the website for Nueces' Bermuda Park by chance. Fresh from visiting Espantosa and Triple R RV Park, I am leery of the claim of "miles of river frontage along Bermuda Lake." Early spring rains have fallen, but not enough to break the heavy dog's breath of drought hanging over us. When I call to reserve a campsite, Doris Jackson tells me breezily, "Oh we've got lots of water." I hang up the phone. "I'll believe it when I see it," I tell Bill. "Let's take the kayaks anyway," he replies.

We arrive in late afternoon with a truck crammed full of kayaks, paddles, and camping gear. A rutted road leads to twin lines of dilapidated travel trailers and RVs. White oil field trucks with company logos crowd close to the dusty structures while air conditioners whine and drip. It is hot and there is no river in sight.

The line of RVs ends next to woods. The road slips into shadow between mesquites and oaks. Bill and I are debating whether we should drive down the road when Blanco, the park manager, and his dog Sam arrive.

Blanco is as thin and dry as an old cedar post. Copious tattoos on his arms blue into smudged shadows on his leathery skin. His white hair is held back with a neatly folded and tied bandanna around his forehead.

He has black eyebrows over brown eyes with a ring of pale blue around each iris. His face, neck, and arms are crosshatched with decades of sun and heat. A big metal buckle with a bronc and rider hold up his jeans—barely, since he has no belly, no hips, no butt. Sam, a black-spotted Australian cattle dog, circles us warily.

Blanco shows us the places he mowed as potential campsites and watches while we mutter to each other.

"Anything under the trees?" Bill finally asks.

We move to another spot. Then another. Blanco finally shows us down the track running into the trees. Sabal palms grow in the shadow of live oaks and pecans. The ground has a thick layer of leaves, and it is cool and quiet in the deep shade. The palm fronds rattle in the breeze. We stand in amazement. Deep, dark, and full, Bermuda Lake has water. Lots of water. A summer tanager sings from a live oak. I point to a spot beneath the tree. "Here," I say. A small smile twitches under Blanco's white mustache. He watches us unload the truck. "How long have you worked here?" I ask him. "Six years," he replies. "Did you grow up in Carrizo?" "No, Laredo. I came here to visit my dad," he says. "But when I got here they told me he had died." He looks up at me. "He was gone!" A trace of surprise colors his voice. He shakes his head and walks off with Sam at his heels.

Bill and I pitch the tent easily and without argument. A first. Soon we sit comfortably with little travel cups of bourbon and snack on chips. As dusk descends the fireflies come out and twinkle among the trees and palms. We sit quietly watching and listening. Green tree frogs, cricket frogs, and a lone groaning bullfrog color the night with calls. Armadillos snuffle through the leaves around us. It is too dark and late to fix dinner, so we fold tortillas around wedges of avocado covered with salsa for dinner, dripping lime juice, onions, and jalapeños on our shirts. We go to sleep with three barred owls sadly querying each other, "Who cooks for you?"

In the morning we slip the kayaks into the river. A rim of woods lines the impounded river. The lake is not wide—no more than a hundred feet across—but if the channel is like Averhoff or the river at Triple R, then it is at least twenty feet deep. Live oaks arc over the water with shaggy bark on the undersides of their limbs. Texas ash trees are covered with winged seeds and hysterical squirrels stuffing their mouths.

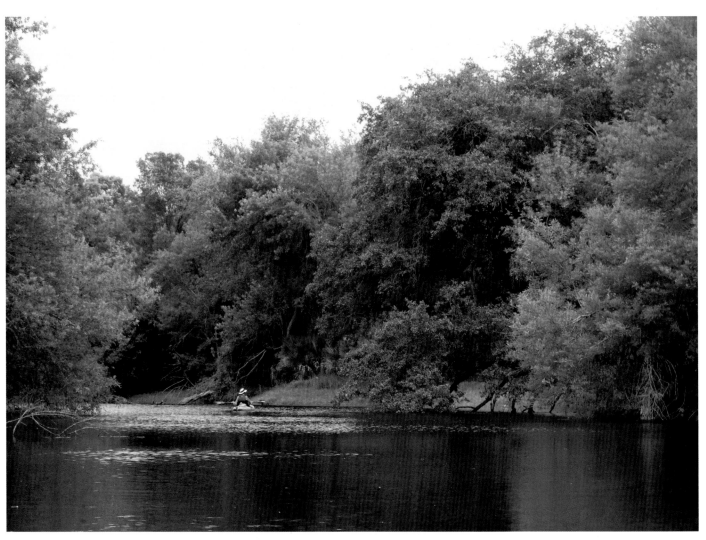

Bermuda Lake, Nueces' Bermuda Park,
Carrizo Springs, Dimmit County

Mulberry trees, both red and white, have berries hanging from beneath plate-sized leaves. Growing along the banks are the biggest buttonbushes I've ever seen; some must be fifteen feet tall. Bill remarks, "Great cover for gators." Blooming willow trees drop catkins that the breeze pushes into messy clusters. Sabal palm trees soar overhead and rattle their fronds while kiskadees squeak like giant rubber toys.

We paddle to the dam. The water is two feet below the raceway. We scramble out of the boats, walk across the concrete structure, and look down over a small pool at the foot of the dam. Yellow-green willow saplings surround the pool carved by water rushing over the dam. No water flows down the river channel below the dam. Carp or white drum lift big

pink lips out of the water to swallow willow catkins. White-winged doves coo and their voices meld into the cattle lowing in the distance. Next to the pond, blooming sage with dark red flowers smells like cat pee when I brush against the leaves. Bill casts a lure into the pool. As I hike up the spillway, I stop to peer into a hole in the center of the spillway. I can see into the heart of the dam: loose stones and soil under a thin concrete skin. The dam, no doubt repaired many times, is over 115 years old.

In the late 1890s, before the artesian wells sparked the imaginations of future land developers, Jacob Shell Taylor, often referred to as "Colonel" or "Captain," arrived in Dimmit County. Fresh off the successful development of Del Mar, California, Taylor envisioned a colony of farmers living on small plots of irrigated land along the Nueces River. To the astonishment of local residents, he bought land six miles east of Carrizo Springs and began building a dam. Then, as now, the Nueces River was not considered reliable. It slimmed down to a trickle in the summer and then leaped out of its banks when it rained. And when drought hit, the river dried to isolated pools—fine for livestock that could travel to water but worthless for farming. About that time, the first crops of Bermuda onions attracted the attention of farmers and fortune seekers across the country. The Colonel named his development Bermuda Colony, finished the dam, added irrigation ditches, and, for good measure, dug three deep artesian wells. The dam, thirty feet high, created a lake twenty feet deep and ten miles long. Taylor platted two thousand acres of "farmland" into five- and ten-acre lots and began advertising.

Bermuda Colony was the first Winter Garden development and it was a showplace. Prospective buyers (of other developments as well) toured the strawberry beds, onion fields, and apiaries, impressed by the order and fecundity. Within a few short years Bermuda gained a store, then churches, a school, and a post office.

Bermuda Colony thrived for a few years and then collapsed under the weight of drought and falling prices that crushed small farmers all over the Winter Garden region. I wonder whether the copycat reservoirs upstream impacted Bermuda. Although the project ended by 1920, a few people continued to live in Bermuda. Now Bermuda Lake and the wells are the only surviving remnants of Colonel Taylor's dream.

We paddle upstream with a breeze pushing at our backs. Bill casts

ahead and to the side. As the breeze blows the kayak upstream, he reels in the line, correcting his course with the kayak rudder. He doesn't seem to mind that he's not getting any strikes. I paddle ahead and hear his phone ring. I hear him answer and say, "I'm sitting in a kayak on the Nueces River, down by Carrizo Springs." A pause. "No, I didn't think there'd be any water either but this place is amazing. It has lots of water."

A diamond-backed watersnake swims across the river in a straight line, its body high in the water. A symmetrical V trail shimmers and flows across the narrow lake. Green jays, unseen, loudly announce their presence with a variety of noises. I play recorded calls back to them but they are not fooled and fly away in a flurry of raucous taunts. Patches of duckweed appear upstream, covering the surface in a brilliant green. The water is dark, not muddy but not clear. The woods surrounding the lake are full of birds. A palette of yellow to red flutters through the mossy dark limbs of an old live oak: yellow-green female painted buntings, sulfur-yellow kiskadees, orange hooded orioles, and red-orange summer tanagers.

I look up to see a dark gray mass in a tree. With the binoculars we look at a paper nest that must be three feet long. Barely visible in the dark entrance are what look like honeycombs. Dark insects speckle the outside of the nest. It is the hive of the Mexican honey wasp, one of the only insects, other than bees, that produce and store honey. The honey is supposed to be strongly scented and delicious, yet it can be poisonous. The honey wasps, like bees, gather flower nectar to make honey, but if the wasps gather nectar from flowers like datura, nightshades, or poison ivy, the toxins concentrate in the honey. I remember Berlandier describing honey collected in the northern brushlands as having "the singular property of intoxicating and inducing vomiting in those who have eaten a large quantity without being accustomed to it."

As we near the Highway 85 bridge, there is no current. We encounter sections of the river that are covered from bank to bank with duckweed. Beneath the duckweed, feathery aquatic plants grow up toward the surface. Bill gracefully paddles through, ending each stroke with a quick pull. I manage to fling plants over myself and the boat until I am gaudily festooned with strings of watermilfoil and clumps of duckweed showing its reddish underside. I follow Bill as he breaks trail for us. The bright green duckweed spins and swirls behind him.

On the upstream side of the Highway 85 bridge, a small park leaks trash into the river. A putrid dead feral hog and old television float in the midst of cans, bottles, and chunks of Styrofoam. We turn around and start paddling downstream.

That evening Doris Jackson, the owner of Nueces' Bermuda Park, drives down to check on us. "Oh, this is my favorite spot at Bermuda," she says. "My husband's, too." She starts telling us about Bermuda Colony and then laughs. "I'm eighty years old and I have too much information in my head! Someday I'll write it all down but I'm just too busy."

She came to Carrizo to teach school as a young woman, and although she had no plans to marry, when she met Don Jackson, she fell for him. "He was," she says, "a real John Wayne type." She laughs, a light soft sound that strips away the years. She glances at the large metal cross standing in the clearing behind us. "I put up that cross after he died." She pauses. "We put his ashes in the river here." The three of us are silent, looking at the water. Doris says, "Blanco told me that when he dies, to put his ashes in the river too." Bill nods. She looks downstream. "He wants to go back to Corpus Christi since he was stationed there in the Navy. I told him okay, but it might take a really long time to get to the coast!" She's smiling. "He said to me, 'That's okay, I'll have plenty of time! Burn me up and throw me in the river!'" She starts laughing and then the three of us stand on the riverbank and laugh at death.

I'm imagining the ghost of Blanco relaxing in the reservoir and waiting for a flood to take him down to the coast when Bill asks if there are any alligators. "Oh, just little ones," Doris replies. Then she goes on to tell Bill that both a seven-foot-long alligator gar and a five-footer were pulled from the lake on the same day. "We've got blue cat, yellow cat, bream, crappie, bass, white drum, and invasive tilapia." I recognize the look on Bill's face and know that he'll be fishing until dark. The lake isn't always as nice, she tells Bill. "When the water gets hot," she tells us, "it gets that bacteria that will kill you if you get it in your sinuses." She describes fish kills when the lake "turns over" and the water with low oxygen levels rises to the surface. "Y'all are lucky to be here now," she calls from the window of the truck as she drives off.

Black-throated sparrow

Fisherman below Bermuda Dam in flood, Dimmit County

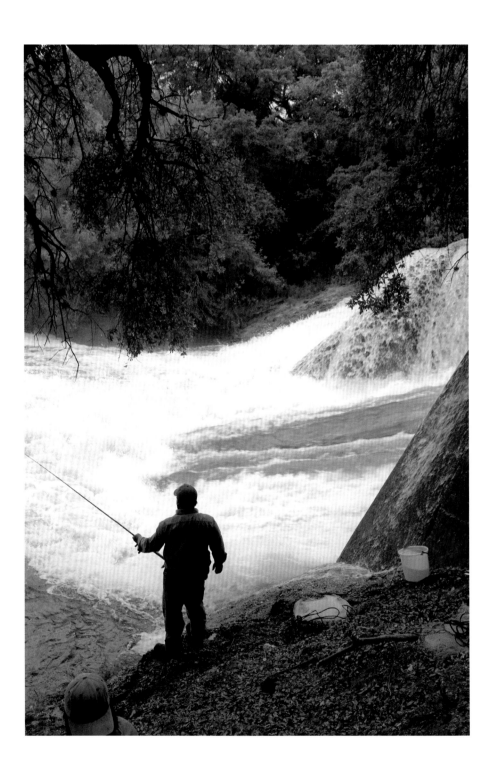

Others copied Taylor's idea. Major Alexander Boynton attempted to revive his failing Winter Garden Ranch development by building his own reservoir on the Nueces north of Bermuda Colony. The dam, originally known as the Winter Garden Dam, supplied a network of gravity-fed irrigation canals throughout the real estate development. Boynton deeded 5.35 acres to Dimmit County at the old Presidio Crossing on the Nueces and declared it should be a public park. The park still exists, greatly diminished and unmaintained, at the foot of Bookout Reservoir.[5]

The first time we visited the reservoirs, Boynton and Bookout were both steep-sided grassy canyons with little or no water. After the heavy rains that flooded the river in late May 2015, I returned to find Boynton-filled to the brim. Strangely, Bookout had no water.

I drove on to Nueces' Bermuda Park and the lake was a river again. The duckweed was gone, flushed downstream. Flowing water covered our lovely campsite. I drove down the road and parked next to a line of pickups. Unsure of my way, I asked a fisherman the way to Bermuda Dam. "My father was born in Bermuda," he tells me. We walked through the woods to the dam while a low rumble ascended to a roar. The river surged over the width of the dam. Water roared over the spillway and

Spring rains flooding through Espantosa's Rock Quarry Crossing in Crystal City, Zavala County

crashed into a churning brown pool below. On either side of the spillway, waterfalls cascaded from the dam's big shoulders. Fishermen balanced on the steep shore, casting lines into the turbulent water. The pounding of the water prevented speaking, so I pointed to my camera and then to the big white drum a lucky fisherman held, its tail weakly brushing the ground.

In Crystal City, the road was closed at the Rock Quarry Crossing. Espantosa was a muddy brown torrent flowing over the bridge, covering the rocks, and overflowing the *tinaja*. A steady parade of cars pulled up to the barricades. People of all ages walked over to stare at the flowing water and snap photos on cell phones. A young man held his phone close to the water, trying to capture the sound of the rushing current.

5 *Woollybacks and Cotton-Tops*

COTULLA

Timo Hixon signals the pilot to take us up. Like a giant dragonfly, the helicopter rises into the clear sky. I sit in the metal and plastic bubble, a primitive part of my brain babbling in terror, but as I watch the Nueces River unfurl across the brushlands, the anxiety and adrenaline transform

Cotulla

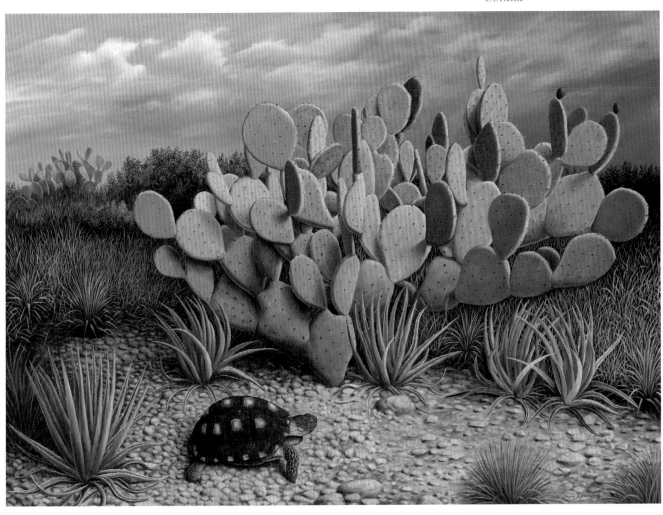

into a fierce burning joy. Suspended between heaven and earth, we are flying over the river south of Cotulla in La Salle County.

The Nueces River's silvery reflection turns to blue and then dulls to an opaque pale green as we fly over. We trace the river through the woods that line its course down to the broken Holland Dam. Built in 1904, it impounded a sizable lake for ninety years until floodwaters cracked the dam, shoved it open like a door, and left it ajar. Timo points out the former lake's shorelines. He laughs, telling us he learned to water-ski on the Nueces. "Folks would take boats from Cotulla down to the lake for picnics," Timo said. Everyone went down to the river for holidays, brush arbor revivals, and baptisms in the Nueces River. While we circle the slough and the undercut Little Dam, Bill tells him about our trips to the fish camp on the lake's shores, how we borrowed a canoe and paddled around. At the time, I thought nothing about a lake in the Brush Country; now it seems improbable, a figment of memory and imagination.

Timo points out the land between the Little Dam's slough and Holland Dam. "We call that the Island," he says. "It was prime cropland during the Bermuda onion boom but now the trees, brush, and grasses have taken back over."

Unlike the farmers in Dimmit and Zavala Counties who depended on well water from the Carrizo Aquifer, those in La Salle County got the majority of their irrigation water from the river. The groundwater is highly mineralized, so a series of dams on either side of Cotulla impounded water for the big irrigation pumps. Cotulla, after all, was the home of the first Bermuda onion crop. The following story illustrates the pervasive and fragrant relationship of the town to the onion: In 1913, the International & Great Northern train was making its regular run from San Antonio to Laredo. A worker's lunch pail fell open and an onion rolled down the aisle (onions were eaten like apples in those days), where someone stepped on it. A prankster picked up the crushed onion and held it under the nose of a sleeping brakeman. The brakeman, upon getting a snootful, woke from a deep sleep to yell, "Cotulla, Cotulla, Cotulla! All out for Cotulla!" Along with that olfactory allegory are the many recorded memories of mountains of harvested onions waiting to be shipped from the train depot—hills of onions that could transform from valuable crop to rotting black slime when the weather or the market turned. Through

the first decades of the twentieth century, the area's agricultural fortunes paralleled the Winter Garden's cycles of boom and bust. But with a difference, because the Great Depression put an end to most of the agriculture in La Salle and McMullen Counties. The land returned to livestock or, like the Island, was left fallow.

<center>✦ ✦ ✦</center>

We fly upstream, following the river's twisting course. I sit snugly strapped in, but with no doors and a plastic bubble extending from my feet to above my head, I have an unimpeded view. Piles of bark-stripped logs and limbs tangle in crooks of the channel. Grasses and plants are still flattened from the current that has since flowed downstream. Drowned brush lines the channel in grays and browns against the opaque water and the revived grasses. Ridges of mud parallel the channel, sculpted by the floodwater's fast currents. The trunks of drought-killed trees stand as pale sentinels in the dark green of the woods that fill the river's banks.

As the pilot follows the curves of the river, we see alligator gar swimming just beneath the surface. They look enormous, even from our aerial vantage. I think of Theodore Roosevelt's description of the Nueces: "Here and there were long, deep pools in the bed of the river, where rushes and lilies grew and huge mailed garfish swam slowly just beneath the surface of the water."

Just an hour earlier, I'd been balanced in a yellow plastic kayak on the surface of the river while the monsters lifted their heads out of the water in toothy grins, slapped their fins, and heaved their massive bodies out of the water. I clutched the edges of my boat as it rocked in the waves and wondered, not for the first time, "What was I thinking?" On cue, a trio of green jays flew through, calling and, I feel certain, taunting me. Just ahead a gar waved fins as big as my hands out of the water as it floated just beneath the surface. This one submerged quietly; I couldn't help but wonder where it went.

Murky water makes me nervous. I remember swimming in Louisiana bayous as a child and nearly walking on water when something large and scaly brushed against my ankle in the dark water. Those childhood fears of underwater predators have descended for a visit and sit on my shoulders, pull my hair, and gnaw on my ears. I bat at them. The kayak

shudders. A submerged branch? "No," whispers a yellow-bellied fear, "it is a giant gar that will roll and flip you out of the boat!" "They do grow quite large, you know," natters a pea-green neurosis. "A three-hundred-pound, seven-and-a-half-foot-long giant came from this very river." "It might be an alligator," another gremlin suggests helpfully. "And when it knocks you out of the boat you'll thrash around and it will think you are food and . . ." "ENOUGH!" I say. I realize I've yelled out loud when a juvenile black-crowned night-heron belly flops into the water from a low branch. The night-heron swims downstream and clambers out onto a snag. It hunches its shoulders, flips its bedraggled feathers, and glares balefully at me as I paddle past. A longnose gar the length of a yardstick swims beneath the boat. It lingers in the boat's shadow and I admire its

Nueces River, south of Cotulla, La Salle County

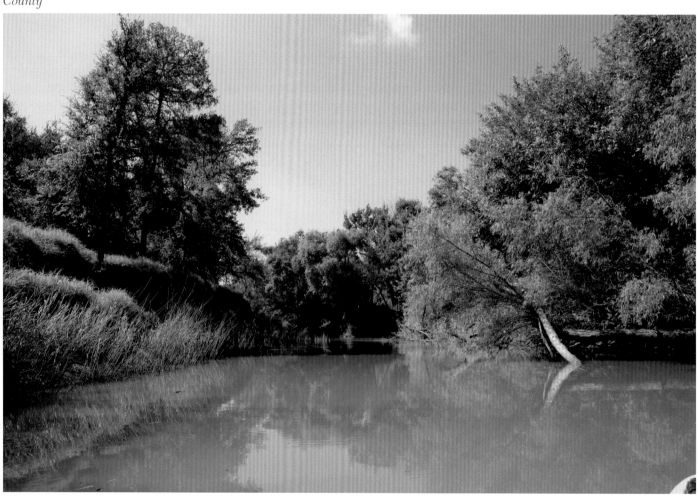

deep gold skin and leopard spots. Whirligig beetles skate over the surface, leaving V trails that they weave into complex patterns of reflected blue sky, overhanging oaks, and the yellow of the kayak hull that ripple into abstraction.

According to the USGS gauge upstream, the river is running a little over five feet deep. Just a few weeks earlier big gar, catfish, and drum were swimming among the trunks and upper limbs of the oaks, ashes, cedar elms, and other trees along the banks. The drought-busting rain that filled the channel and overflowed the first bank hit the twenty-foot mark but stopped short of twenty-two feet. At least we hope it was a drought-buster. In October 2013, in the midst of the drought, the rain-swollen river rose to a crest of nearly twenty-three feet, a full eight feet over flood stage. But this was only the fourth-highest crest recorded in Cotulla. The big flood of 1935 that filled the canyon of the West Prong rumbled downstream and the river crested in Cotulla at an extraordinary 32.8 feet. The fish would have been swimming in the tops of the trees—except that historical photos nearly always show riverbanks shorn of trees and shrubs.

The river looks placid but there is enough of a current that I have to stay alert or I'll end up tangled in a sweeper tree. Stopping to jot down notes and snap photos, I nose the kayak onto the mud bank and cricket frogs launch themselves headlong into the grasses bordering the river. A few fling themselves into the river and frantically paddle until freezing to hang motionless in the water. Hundreds of toadlets hop on the bank looking like animated earth. There is the rich dark smell of the mud, the slightly acrid smell of the hackberry leaves baking in the sun overhead, and somewhere close by, ripe and fermenting wild grapes. A spider has woven a web on a grass seed head, curved it around, and tied it down so it makes a silk-snared paddle. I look closely and it is filled with pale translucent spiders like tiny seed pearls.

In a patch of sun, I spy a congregation of baby gar. Lined up parallel and equidistant from each other, the slender eight-inch-long fish float at the surface. I wish I had grasshoppers to throw to them. They will wait, motionless, hanging just below the surface until a hapless insect or minnow gets within striking distance. Then with a sideways slashing motion, the gar will grab the prey. Across the river, a big gar lifts its head out of the water to gulp air. Gars have the unique ability to absorb oxygen through

their air bladder. By gulping air, these ancient species survive in oxygen-depleted waters during droughts, hot summers, and when algal blooms gobble up all the available oxygen. Downstream from Cotulla, low dissolved oxygen levels have been a problem for many years. Too much cow poop and municipal wastewater and not enough river flow or rainwater to dilute it all.

The current funnels into a narrow cleft, and I'm paddling vigorously to avoid getting jammed under a dead tree when I realize I've just passed the landmark for the slough's cutoff from the main river. I paddle upstream but find only a drying muddy channel, with leafless plant stems still flattened from the force of the water.

Sweating and cursing, I drag the kayak through a thicket of poison ivy, spiny aster, downed branches, and catbrier to the edge of the shallow slough. Particularly colorful language erupts when a long woody vine covered with "leaflets three, leave 'em be" smacks me across the face. I'm lifting my sandal-clad foot to step into a shadowy tangle of knee-high switchgrass (while calculating how long it will take for a faceful of poison ivy to clear) when I vividly recall the Nueces River water moccasin scene from the *Lonesome Dove* television miniseries. Balancing on one leg like a wobbling egret, I argue with myself. There are no water moccasins on the Nueces, I say firmly. I look around, and it appears to be perfect cottonmouth country—yet I know there are no records of the pit vipers in La Salle County. Author Larry McMurtry won the unremitting acrimony of herpetologists worldwide when he perpetuated the "nest of water moccasins" folktale in his popular novel. A cowboy (not the usual water-skier) falls into a tangled nest of dozens of moccasins while crossing the Nueces River (folklore usually situates it in a lake or other body of water) and dies instantaneously from the bites. Adding natural history insult to injury, the episode was filmed on a creek near Del Rio, far out of the snake's normal range. I put my foot down. Even if there were a cottonmouth here, it would have long since fled my clumsy, sweaty, and extremely verbal progress.

As I haul the kayak through waist-high clumps of switchgrass, I realize that *Lonesome Dove*'s Del Rio site did have one thing absolutely accurate: there wasn't a blade of grass to be seen anywhere, just a few puny mesquites and a grove of ash trees. Historical photos from the Brush Coun-

try Museum in Cotulla show people picnicking and enjoying the river on bare dirt banks. In one photo a group of people poses under ash trees, sitting on the exposed roots of the trees as boys in short pants wade in the river. Another photo shows a young family at the edge of the river, next to a few scraggly shrubs. A nearly treeless landscape stretches into the distance beyond the placid river.

I slog through mud dragging the kayak down the slough, sit in the boat and pull myself hand over hand through thickets of spiny aster, follow egrets and herons, and paddle when I can. A week earlier, before the river subsided, I would have had an easy paddle to the ranch house. As it is, I cheerfully (mostly) squelch my way downstream.

WONDERGRASS WONDERLAND

In the helicopter we cover my long mucky trek in moments. A gust hits us broadside and the helicopter pauses, swinging in the air like a hanging Christmas ornament, before banking into a turn. Timo directs the pilot to fly away from the river and over a new drilling pad for fracking. A

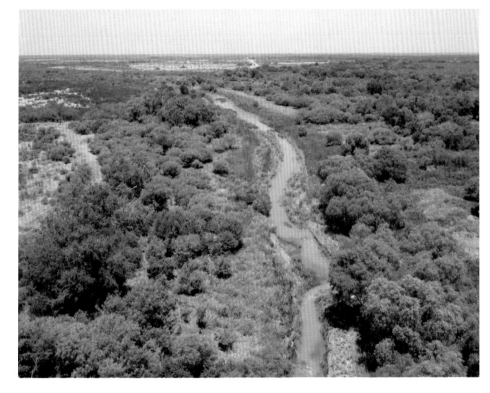

Nueces River stretching into the brushlands in La Salle County

perfectly rectangular reservoir with a black liner reflects the sky. Timo anticipates my question. "Freshwater," he says. "You'd think they could at least make it a natural shape and let some plants grow. Though that would bring in wildlife and it wouldn't be good." In the distance, a series of drilling pads are lined up in a row. "Now there's an example of bad planning. No way to efficiently reclaim or restore that arrangement," Timo remarks. We circle over brushlands incised with arrow-straight seismograph lines, *senderos*, cut through the woody brush by geologists. I think I recognize where I'd been that morning with Justin looking for quail. Off to the side broad stripes of gray-green brush alternate with strips of brighter green grass. "Is that some of your brush sculpting?" I ask into the microphone. The headphones cut out the roar of the rotors but I have to resist the urge to yell. "Yeah. That's from the eighties when they told us planting buffelgrass was a good thing," Timo answers me.

"They" are the Natural Resources Conservation Service (NRCS) and other proponents of replacing native brush and grasses with what is commonly referred to, without a hint of irony, as "improved grasses" for forage and erosion control. Yet early eyewitness accounts of the Nueces River basin don't describe endless miles of dense thorny brush, or land stripped bare and washing away with every rainfall. Just how did we get here?

Mesquite Prairies

The Spanish explorers and the *entradas* of soldiers, priests, settlers, and livestock on their way to establish missions were the first to describe the land we call Texas. Some diarists noted observations about flora, fauna, native tribes, soils, rivers, streams, and springs. Others drily recorded the number of leagues traveled per day and the weather. Notes about the presence or absence of pasturage and availability of water for the herds of livestock were common. Yet these tantalizing glimpses of the land along the Caminos Reales varied dramatically according to season and weather. A wildflower prairie in April looks substantially different on a drought-burned August afternoon or when the winds of a norther are blasting down. What historians, botanists, and ecologists generally agree on (despite what some Texas authors have asserted) is that there has always

been mesquite and thorny brush in the Rio Grande Plains. The large expanses of stirrup-high grasses existed on the Coastal Prairie and in the hyperbolical prose of *empresarios* but not, as far as experts can tell, in the area we now call the South Texas Brush Country. Descriptions from the Spanish diarists and early Anglo explorers depict a varied landscape, but the majority was mesquite prairies: native grasslands thick with a diversity of grasses and plants with mesquite trees dotting the landscape alone or in small groves with huisache, prickly pear, and smaller shrubs. There was tremendous variation on the theme. Depending on soil type and proximity to water, vegetation went from river and stream bottomlands thickly timbered with oak, ash, and pecan *galería* forests, to thorny thickets of chaparral on stony ridges, to rolling grasslands. While these same elements exist in today's La Brasada, the proportions have been flipped.

Buffelgrass

In 1908, the author of a US Department of Agriculture report titled *Change of Vegetation on the South Texas Prairies* lamented, "Very often the old mesquite pioneers, the scattered trees which made the 'open mesquite country' of other decades, are still conspicuous among their much smaller progeny and the crowds of other camp-following species which now occupy the land to the almost complete exclusion of the grasses upon which the herds of former days were pastured." He declares the brush incursion the result of overgrazing coupled with drought and lack of grass fuel for summertime fires to clear out brush seedlings. That much most people agree on. But he has one thing wrong.

He blames cattle for the overgrazing.

Long before introduced buffelgrass, before La Brasada was considered cattle country, and before the onion and cotton fields, there were sheep. Millions of sheep. Woollybacks grazed the Rio Grande Plains, the land bordered by the San Antonio River on the east, the Gulf of Mexico on the south, the Edwards Escarpment on the north, and the Rio Grande on the west.

The first flocks of Texas sheep belonged to the missions established by the Spanish *entradas*. Thousands of sheep and goats grazed in and around San Antonio along with the missions' cattle, horses, mules, oxen, and even pigs in the 1760s. A few transient flocks of sheep grazed the lands between the Rio Grande settlements and the Nueces. But those sheep disappeared after Spain closed the missions in 1790.

It wasn't until the Treaty of Guadalupe Hidalgo defined the border between the United States and Mexico as the Rio Grande that settlers—and their livestock—really began moving into and claiming the lands surrounding the Nueces River. The people of the Nueces, first citizens of Spain, then Mexico, then the Republic of Texas, were declared US citizens. They watched as the trickle of settlers flowing into the Texas frontier turned into a steady stream. The Civil War slowed immigration, but as soon as hostilities ceased, dreamers, entrepreneurs, immigrants, and farmers moved themselves and their families into Texas and the lands along the Nueces and her tributaries.

But this land, with its present-day myths of longhorn cattle and vaqueros, wasn't considered good cattle country. There was grass but not grasslands. The river and streams were not reliable, and cattle need abundant water on a daily basis. It was too far to market. Sheep, it turns out, were better adapted to a land of continual drought interrupted by periodic flooding. Plus, wool (unlike meat, tallow, or hides) was easy to store and cheap to transport, and demand was consistent.

The settlers brought in sheep. Hundreds of thousands of sharp-hoofed woollybacks flooded onto the Rio Grande Plains. Between 1860 and the early 1880s, the population of sheep exploded. An estimated 1.7 million sheep grazed through the mesquite prairies, and nearly half of all sheep in Texas were south of the Nueces River. This was the time of the free range and ranchers became speculators, buying animals to the limit of their credit, determined to take advantage of the "free" grasses.

A *pastor* (shepherd) living a virtually solitary life with a flock of dirty-gray matted woollybacks steadily munching their way across the mesquite prairie just doesn't have the same romantic appeal as a brush-popping vaquero roping and branding half-wild cattle. The wild cattle herds were missing by the 1870s and the oft-described "immense herds of wild horses" were gone too. Did they die during prolonged droughts? Were they rounded up and sold? Or were the herds actually much smaller than described? Regardless, by 1881 the herds of mustangs were also reported as missing. Yet another myth crumples when I learn that 85 to 90 percent of the cattle herded north during the short-lived Cattle Drive Era came, not from the Nueces Strip, but from the Coastal Prairies and central Texas.

Meanwhile the sheep grazed. Environmentalist John Muir famously referred to sheep as "hoofed locusts" for their rapacious and thorough exploitation of grasslands. A flock of woollybacks, tails twitching, can move together as a large efficient machine, mowing grasses nearly to the ground. What vegetation they don't eat, they tear up with their small sharp hooves. The tastiest native grasses and plants disappeared first, followed by the less palatable species. They stripped the riverbanks and streambeds of switchgrass and the other grasses that held the soil in place. The sheep nibbled and nibbled, leaving only thorny brush, hoofprints, and pellets behind.

Greed, drought, and barbed wire ended the sheep era. The land was overstocked, overgrazed, and rapidly getting fenced off. Stockmen, in a hurry to produce as much wool as possible, did not breed the sheep for resilience. Entire herds succumbed to disease and parasites. When the price of wool fell, the sheepmen tried to make up for the declining prices by increasing their herds. Then, the late 1880s managed to compress the worst elements of Texas weather into a short, devastating span. Summer droughts killed the remaining grasses. Struggling, starving cattle and sheep died of hunger and thirst. Ranchers burned the spines off prickly pear cactus and chopped up tons of it to feed a few lucky cattle and sheep. A series of bitter northers swooped down with sleet, snow, and subfreezing temperatures. Spring rains turned into floods. Sheep and cattle died by the thousands. The remaining flocks moved north to the river valleys and uplands of the Edwards Plateau. By 1900 the exhausted rangelands were emptied of woollybacks.

Mesquite Brush Miracles

Over broad sections of the Nueces's drainage, drought persisted and the grasses and leafy plants simply did not recover. The land was too abused and the soil had been stripped of nutrients. What could grow were the tough legumes: mesquite, huisache, and the acacias. Already-established thorny saplings thrived. Seeds distributed by browsing livestock and deer dug their roots into the poor soil. Because mesquite and other legumes have the extraordinary ability to absorb nitrogen from the air and convert it to nitrate (essentially creating fertilizer), they prosper in soil where few

other plants can survive. The thorny brush and prickly pear grew. Ranchers stocked the former sheep pastures with steers, which surprisingly put on weight browsing on guajillo and blackbrush, eating mesquite beans, and munching on prickly pear pads. Away from constant grazing pressure, native grasses and plants began to regenerate. The mesquite prairies were mostly gone, replaced with mesquite brush. White-tailed deer,

quail, dove, horned lizards, songbirds, and the thousands of other species dependent on the native seeds and foliage adapted as brush species slowly covered the land.

When Winter Garden fever hit, new farmers bought land and cleared the brush from the old sheep range for fields. Crops sprouted and grew in soil that biologists suspect was invigorated by the thorny cover crop of nitrogen-fixing mesquites and other legumes. For a time, farmers outnumbered ranchers. But bust followed boom and droughts followed rain.

By the time the big droughts of the 1930s hit, soil erosion was a serious problem throughout Texas. In the broad, flat valleys of the Nueces and her tributaries, fields of tilled soil butted against the river and creeks. After a heavy rain, soil ran off the fields and into the waterways, clouding and fouling the water, filling streambeds, clogging channels, and silting in natural pools and man-made impoundments. The massive floods of 1935 overflowed the fields and thin pastures, stripped off the topsoil, and sent it hurtling downstream.

Landowners and their government counterparts began campaigns of erosion prevention and brush control in La Brasada. An intractable idea took hold (despite ample historical evidence to the contrary): the Rio Grande Plains had once been extensive grasslands and were now despoiled by invasive mesquite and worthless brush. They needed grass. Grass to slow and stop erosion. Grass to feed cattle.

Ranchers couldn't bulldoze, chain, roller chop, root plow, and poison brush fast enough. The heavy machinery crushed slow-moving and burrowing animals like Texas tortoises, horned lizards, and wood rats. Birds, snakes, and mammals were displaced. The remnant native seeds in the soil didn't respond quickly enough for ranchers eager to get cattle back to grazing. Instead they planted the latest and best that science had to offer: exotic grasses.

By the 1950s seed was widely available for grasses from Africa and Asia—and often subsidized by federal and state programs. The miracle grasses were a stunningly successful solution to erosion problems as well as providing grass for cattle. In the seventh year of the crushing drought of the 1950s, buffelgrass became commercially available and a new chapter in the story of La Brasada began. It was the beginning of an era that would fundamentally change the brushlands.

Named the "South Texas Wondergrass" in a *Rangelands* magazine article, buffelgrass quickly proved its ability to survive in arid conditions by sprouting, growing, and establishing in drought-dry soil. When the rains returned, ranchers were doubly impressed. Pastures that formerly fed only one cow per thirty acres on native brush, grasses, and prickly pear could now feed three or sometimes more. Buffelgrass spread, free of charge, from pastures into neighboring brushlands.

Millions of acres of brush were cleared from the Rio Grande Plains and hundreds of thousands of those acres were planted with buffelgrass and other exotics. Ranchers made fortunes on fat young cattle at sale barns. Oil and gas roads, pipelines, and *senderos* crisscrossed the river basin. The exotic grasses ignored fences and followed roads to invade nearby native rangelands. Wildlife seemed to do just fine. After all, wasn't some grass better than no grass at all?

+ + +

Timo Hixon tells the pilot to take the chopper up and we rise into the summer sky. The trees and shrubs merge into swatches of varying greens and grays. The subtle undulations of the land level out into a broad plain that runs to the edge of the sky. Ruler-straight lines cut across the countryside. Asphalt ripples like water, white pickups raise dust clouds on the bright white gravel roads, tan dirt tracks border fence and property lines, and the dusty green of seismograph *sendero* lines darts helter-skelter across the surface. The Nueces, its edges marked by darker and taller oaks, ashes, and cedar elms, unspools across the plain before us. Loops of side channels and sloughs flirt with the main channel, twining back and forth as the river curls through the brushlands. The sun is a blinding point in the afternoon sky. We fly back toward the ranch house, swinging over a rough-edged rectangle of bare dirt on the way. A faint pattern creases the surface in rigid lines back and forth, one way and then the other. Truck tracks squiggle across the surface in random loops and zigzags. The color of the soil shifts from a pale red to a dark gray and a sandy tan. Scattered clusters of trees and shrubs interrupt the monotone soil. In the blazing July heat, it is unremittingly bleak, both from the air and, later, from the ground.

Appearances, however, can be deceiving. The heavily disked 270-acre

field is a manifestation of an astonishing optimism and belief in nature's ability to heal. It is the first step in an attempt to convert pastures completely dominated by buffelgrass and other exotic grasses into quality native habitat for bobwhite quail and other wildlife.

Buffelgrass, wildly successful for pastures, is now considered a culprit in quail's precipitous decline in the brushlands. The scientists' equations are simple enough. Take two plots. One is dense with a thick thatch of buffelgrass, a lovely deep lawn with solid grass from edge to edge. The other is rather scruffy, with bare areas around the scattered bunchgrasses, assorted leafy plants, and prickly pears, all shaded by taller mesquites and maybe a huisache or a spiny hackberry. How many quail and songbirds in the buffelgrass? How many in the native habitat? If you guessed that double the number live in the native habitat, you got it right.

✦ ✦ ✦

The tide has turned yet again: cattle are no longer king in La Brasada. Gas and oil wells bring waves of workers, revenue, and royalties into the Eagle Ford Shale Play that runs from Mexico across the state and beyond. Hunting white-tailed deer and quail brings top dollar in leases for landowners. Suddenly buffelgrass isn't the cattleman's solution but a wildlife problem.

We love a monoculture. I suppose it appeals to an innate desire for order, for things to be, well, tidy. A South Texas prairie blooming in full swing is a wonder. Even Theodore Roosevelt was charmed on a visit to South Texas to hunt javelinas:

> Here we came across wonderful flower prairies. In one spot I kept catching glimpses through the mesquite-trees of lilac stretches which I had first thought must be ponds of water. On coming nearer they proved to be acres on acres thickly covered with beautiful lilac-colored flowers. Farther on we came to where broad bands of red flowers covered the ground for many furlongs; then their places were taken by yellow blossoms, elsewhere by white. Generally each band or patch of ground was covered densely by flowers of the same color, making a great vivid streak across the landscape; but in places they were mixed together, red, yellow,

and purple, interspersed in patches and burning bands, carpeting the prairie in a strange, bright pattern. (Roosevelt 1923)

But when a native prairie isn't covered with flowers, it can be underwhelming: a dusty assortment of grasses of varying colors and heights, limp-leaved plants, thorny shrubs, and ubiquitous prickly pear.

Cotton-Tops

I'd spent the morning out tracking cotton-tops (a.k.a. scaled quail or blue quail) in brushland bordering the Nueces on the Hixon Ranch. Justin Otto, a student at Texas A&M University–Kingsville, meets me at the ranch headquarters at sunup. The pale early-morning light and cool haze work their magic on me, so I am bursting with foolish optimism—even knowing I will wilt in the oncoming heavy-handed July heat. Shadowy birds flutter through the brush and sing sunrise songs. Bobwhite whistles echo around us as we drive down a track. The thorny brush on either side looks uniformly gray-green and impenetrable. We stop so Justin can locate the radio-tagged blue quail. He stands in the back of the truck, holding an antenna aloft while scanning for the signal. I step away from the truck and the static of the radio and realize that the brush, while thick, is not continuous. Clumps of prickly pear surrounded by various plants and grasses nestle next to shrubs and under trees. I could wind my way through on the narrow paths between the spiny stuff.

I stop. The spiny stuff, as I call it, isn't all the same. Not by a long shot. True, many of the trees and shrubs have small leaves to reduce water loss to evaporation, but beyond that, the differences are remarkable. Prickly pear is nothing but water-swollen stems with only vestigial leaves appearing during the growing season. Yellow-flowered retama and paloverde have nearly dispensed with leaves altogether, instead relying on their green bark to carry on the work of photosynthesis. Mesquite, blackbrush, huisache, and ground mimosa—all legumes—have structurally similar compound leaves with paired leaflets along a stem, but the variety of sizes, colors, and growth patterns is dizzying. Honey mesquite's airy fronds are long, huisache has tiny delicate compound fronds that grow close to the branch, and blackbrush acacia's leaves are dark green

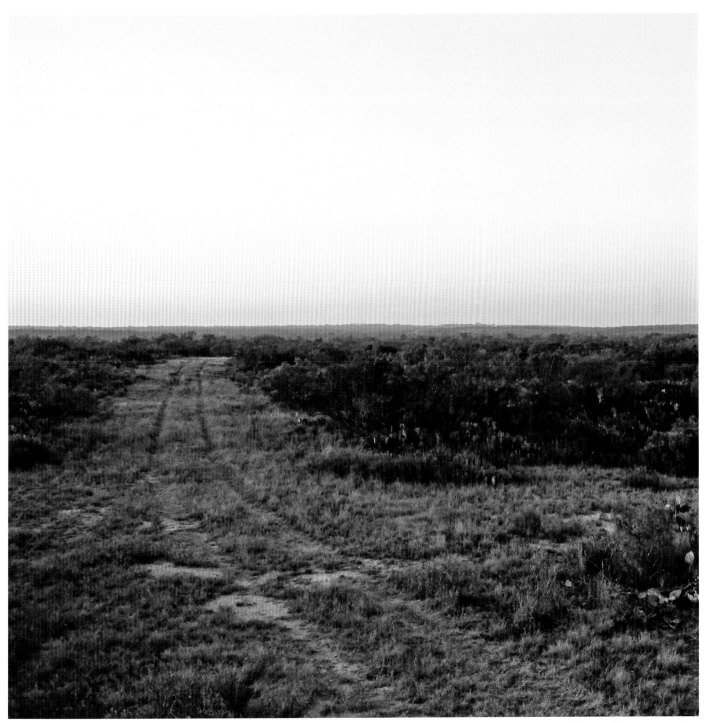

Cotton-top paradise at dawn, La Salle County

Strawberry cactus

and robust compared to those of huisache. And there are a dozen of these members of the woody legumes and possibly hundreds of other legumes in the brushlands: clovers, mimosas, sennas, and partridge peas. Indeed, a field guide to the woody plants of South Texas first divides the trees and shrubs into thorned and unthorned for identification and then subdivides the thorned plants by straight and curved thorns.

We drive to another location and stop. While Justin is busy, I kneel in the center of a grassy cove and count the obviously different plants between me and the backdrop of brush. I'm not a botanist but I easily note two dozen species ranging from cactus to grasses to leafy forbs and woody plants. I watch beetles, spiders, and grasshoppers moving around and between the plants. Harvester ants march around carrying seeds. I look for horned lizards but I'm distracted by the many sets of tiny rodent prints and beetle tracks in the fine sand between the grasses and plants. Arizona cottontop grass and bristlegrass wave their seed heads above the fray. Pale pink prickly poppies bloom next to yellow-flowered and spine-infested buffalo bur. In the shade of a gnarled *guayacán*, or ironwood, purple wild petunias nod. I move forward to admire the flowers when I see pigeon berry plants clustered below. An inch-long black and silver ant, a hairy panther ant, dashes out and crawls over several pale pink flower spikes in succession but ignores the spikes of dark red berries.

We drive down another *sendero*. A pair of blue quail dart from the shelter of the brush out into the open. They change their minds and retreat. Wait, they are coming back! This time they *will* cross the road. They zigzag back and forth and then disappear back behind a clump of grass. (It's strikingly similar to what happens when I'm trying to leave the house.) The truck is just rolling forward when the two saunter out, peer up and down the track, and then prance forward with seven chicks. The parents take dust baths while the chicks frantically ping-pong around after insects and seeds. The tiniest chick must have just hatched because it looks like an animated pompon on toothpicks. I stop giggling long enough for Justin to tell me that a female blue quail will lay an egg a day in her nest for up to three weeks. The chicks hatch out sequentially and run after their parents looking like sets of nesting dolls run amuck.

We never find the elusive radio-tagged blue quail. Instead Justin shows me prime blue quail habitat: acres of rocky ground sheltered with a

protective overstory of thorny brush interspersed with myriad plants and grasses. We see northern bobwhites dodging and running through the bunchgrasses and weedy plants of open grasslands and then taking flight to find cover under shrubs and trees. He points out the native plants that the bobwhites prefer and the species they've been collecting seed from for the restoration project. I've seen blue quail, bobwhites, all sorts of songbirds, a stunning Corona de Cristo passion vine covered with purple and white flowers, a dozen other wildflowers, a Great Plains rat snake sunning in a sandy road, many fine roadrunners, and not a single rattlesnake.

I'm a little disappointed. J. Frank Dobie's books and stories introduced me to the Brush Country. His words left me with a visceral sense of heat, sweat drying on the hides of horses and men, oiled leather, and horses and cattle stamping their hooves and swishing tails to shake off flies. I imagined tangles of brush with giant rattlesnakes coiled under every other prickly pear. The Brush Country that Bill introduced me to in the 1980s had the heat, dust, sweat, and cattle but no horses or vaqueros. Instead we spent days sitting by the Nueces and long spring and fall nights driving the quiet narrow roads looking for snakes. We weren't collecting the animals for ourselves or to sell, although some did.[1] The arid landscape and its inhabitants, so profoundly different from what I knew from my Louisiana childhood or life in Austin, intrigued me. Bill, *como siempre*, gets a kick out of reptiles of any size or shape.

Some people theorize that the snakes seek out the day's warmth that radiates from the concrete and asphalt roadways. Others say no, the snakes are searching—for prey or mates—and it is by happenstance that you both end up on the same lonely stretch of deserted highway. The magical thing is that the snakes' long, scale-covered bodies reflect light so they glow, ghostly and ethereal, in vehicle headlights. Bill would stomp on the brakes (woe to the passenger who'd dozed off) and leap out of the truck to sprint down the road. The western diamond-backed rattlesnakes were escorted off the highway. We would corral and photograph the Great Plains rat snakes, Mexican milk snakes, checkered garter snakes, coral snakes, banded geckos, and occasionally other lizards. Our nights ended in a motel in Cotulla or Freer, sleeping as late as the motel curtains and chigger bites allowed. Nowadays there are laws regard-

ing snake watching (since we weren't hunting), but worse, the roads are now glutted with traffic from the Eagle Ford oil and gas boom. White company pickups, gravel trucks, and eighteen-wheelers full of produced wastewater pound down the roads, all trying to get from point A to point B as fast as possible and at all hours of the day and night.

We wrangle an invitation to tag along with a herpetology class spending a weekend at Chaparral Wildlife Management Area (WMA), a fifteen-thousand-acre reserve of Brush Country managed by the Texas Parks and Wildlife Department for scientific research and hunting. The Chap, as it's called, is home to white-tailed deer, javelinas, rattlesnakes, horned lizards, Texas tortoises, and Texas indigo snakes. All are iconic species of La Brasada, but three of the four are listed as threatened by the state of Texas.[2]

The Chap

We arrive late in the day. The students are scattered between the air-conditioned bunkhouses and the research center. Grabbing sandwiches, we head out to drive the roads. Driving the Chap is different from driving the highways. With no traffic, we drive slowly along the dirt and paved roads. As night falls, the headlights illuminate the stark gray trunks of dead mesquites, reminders of 2008's fifty-thousand-acre buffelgrass-assisted inferno. Nighthawk eyes glow red from their roosts on the ground. They fly up with shrill cries and disappear into the night. The green jewels of spider eyes shine from the verge and tarantulas patrol the roadway. Mice scurry and kangaroo rats bound across the road, cottontails freeze, deer and javelinas appear and disappear at the edge of the light. A barn owl watches us approach and then glides away into the night. We follow jackrabbits as they lope in front us while Bill pleads in a one-sided conversation, "No, don't go that way! That's right, you want to go into the brush. No, no no! Not down the road again!" Not wanting to add to the drought-stressed creatures' anxiety any more than necessary, we stop and wait for them to finally hop off the road. We do not see a single snake. We loop around to a ridgetop and overlook oil and gas wells with their assorted drilling tanks and equipment in the rolling hills running north to the Nueces. Gas flares burn bright orange against the night sky. In-

tensely bright white lights illuminate the drill sites and the surrounding acres—lights so bright that mockingbirds sing as if bathed in the light of a full moon. We return to the bunkhouses. After more than four hours of patrolling by three vehicles, two of which were stuffed to the gills with sharp-eyed students, the tally is one garter snake, a toad, some leopard frogs, and a few tadpoles collected from a pond. Travis LaDuc, curator of herpetology for the Biodiversity Collections at the University of Texas, tells the students that the ongoing drought is to blame for the lackluster showing.

The next morning Bill and I are up early. We walk and drive the roads, but all we find are the tracks of passing snakes, lizards, and tortoises. It is past the prime wildflower season but I find no shortage. Big yellow and orange flowers festoon prickly pears, and clumps of strawberry cactus offer up nearly fluorescent magenta blossoms. True, many of the flowers

are small or tucked close to the ground, but on our morning walk, I photograph more than three dozen. Bobwhites, mockingbirds, and white-winged doves nearly drown out each other's songs. We are so busy looking at birds, spiders, insects, and wildflowers that the morning slips away.

The students had more herp luck, returning with dozens of Texas horned lizards. We walked into the research lab to find lizards in wading pools and plastic tubs covering every table and most of the floor space. A line of mesmerized students sat at a table, each rubbing the belly of a relaxed horned lizard. Bill photographed lizards while I took my turn hypnotizing a horny toad. My horned lizard is surprisingly heavy for her size but she has a very soft, finely scaled tummy. I rub her belly and she closes her eyes, her limbs relaxing. The exaggerated texture of her thorny skin is rough against my palm. I tap my finger against the eight surprisingly sharp horns on her head. Rattlesnakes are sometimes found dead with the horns of their victim puncturing their throat. Roadrunners are adept at swallowing horned lizards whole without harm, but hawks have been found dead with their windpipes punctured by the lizard's horns. I run my finger over the fringe at the edge of the lizard's flat body. A bright white line runs down the center of the back with white-bordered dark spots on either side. It doesn't look like effective camouflage, but when a horned lizard is flattened against sand and pebbles it is nearly invisible. I reluctantly relinquish my lizard to the resident biologist, who weighs, measures, and tags her. The students will return each individual to its capture site. Not one of the horned lizards used its outrageous defense of squirting a jet of blood from its eyes. But we aren't canines. Dogs, foxes, and coyotes readily provoke the defense, and the foul-tasting blood seems to repulse the predators.

I really like Texas horned lizards, as do the majority of Texans. It is oh so tempting to keep one but they are nearly impossible pets. Dietary specialists, they eat harvester ants along with other ants and termites. But not fire ants. The formerly abundant lizards are rare in the western half of the state and are almost completely extirpated from the eastern half. A perfect storm of insecticides, overcollecting, commercial sales, habitat destruction, and exotic grass invasions have left few intact populations. The good news is that horned lizards, harvester ants, termites, and bobwhites all like the same habitat with bunchgrasses, patches of open ground, lots

of different seeds from a variety of native plants, insects, and some brush for cover. As landowners work to save quail, they'll help the Texas horned lizards as well.

The second group of students returns triumphantly to the lab with a young Texas tortoise, more horned lizards, and a single reticulated collared lizard (another threatened species). After the 2008 fire toasted the Chap, biologists were relieved to discover that few animals were killed outright by the flames. With a little rain, green sprouts miraculously appeared. While the recovery didn't happen overnight, Texas Parks and Wildlife Department biologists have been pleased with how fast the wildlife and plant life have rebounded, especially after several years of drought followed the fire.

That the slow-moving Texas tortoise mostly disappeared from Chaparral WMA was disheartening but not surprising. Texas tortoises rely on prickly pear for food, water, shade, and shelter. While they don't dig deep burrows or tunnels like their eastern relative, the gopher tortoise, they do take advantage of wood rat middens stacked around prickly pears to create shallow burrows. The fire wiped out prickly pear over large sections of the Chap and surrounding countryside. It was expected that it would take time for most of the snakes, lizards, and small mammals to recover. What did surprise biologists was that the rattlesnakes disappeared and have yet to return. It seems improbable; after all, diamondbacks are tough. They survive in the harshest of environments from central Texas westward. In the canyons of the upper Nueces River, ranchers and managers told me that rattlesnakes are now rare. Most attributed their disappearance to the extended drought and the feral hogs eating everything in sight. I know some readers are thinking, "And the problem with fewer rattlesnakes is . . . ?" Most people wouldn't care one way or the other if the venomous reptile disappeared—the majority of Texans live in cities now—but I for one would lament the loss. And I'd worry about what environmental changes have brought about the demise of our iconic, ill-tempered resident.

J. Frank Dobie's disdain for rattlesnakes, after a lifetime of killing untold numbers, turned into a grudging admiration and then outright appreciation for the once-abundant snakes. Meeting a rattlesnake, he wrote that "despite my instinctive revulsion, that rusty old rattler suddenly

appeared to me as something natural, native, and honest belonging to the land that I belonged to—a fellow creature that, after all, I would not want to see exterminated."

<p style="text-align:center">✦ ✦ ✦</p>

Bill and I spend the afternoon supposedly writing up notes but actually dozing in a picnic shelter's warm shade. We overlook a field of coreopsis that bob and bow gold against a backdrop of flagrantly blooming retama. The retama's tiny leaves and long stems flutter around the yellow flowers, so it looks like yellow and green feather boas growing out of green-barked trunks. The line of retama follows the damp soil of the feeder creek and circles Blocker Pond. An aerial view of the countryside would have all the ponds and damp streambeds highlighted in retama yellow. We inch our chairs over as the sun moves down in the sky, finally getting up to walk when late-afternoon light gilds Blocker Pond.

A spotted sandpiper bobs along the shore while a turtle, a red-eared slider, grazes on the bank. We sit quietly by the pond and watch the turtle munching while painted buntings splash at water's edge. Cardinals bounce along the shore, singing, and I'm reminded of learning songs by watching a red ball bounce along the lyrics. Pink and gold ground doves waddle down to drink nervously. A line of honeybees and Mexican honey wasps sip water to carry back to their hives while mud daubers scrape up balls of mud for their nests. Red-winged blackbirds shriek and warble, bobwhites whistle, and golden-fronted woodpeckers alternate banging on dead mesquites and yelling. An Audubon's oriole flashes yellow and black to the water and then swiftly flies away. From the branch of a mesquite, a vermilion flycatcher flutters and darts after insects. It is so brilliant that it leaves an afterimage on my retina, as if I've been staring at a light. The coreopsis have turned their faces toward the setting sun. We stand up, stiff from sitting, and Bill, after the fact, wonders out loud about chiggers. I'm following Bill through hip-high plants on an overgrown track when I look down and see about twelve inches of an enormous black snake emerging from the grass. I freeze. Bill keeps walking. I yell "Big black snake!" Bill spins around. "Grab it! It's an indigo!" I'm paralyzed, listening to my heart pound while my internal Nervous Nellie—trained by a childhood in Louisiana—commands "never ever EVER pick up a black snake by water!"

The snake inches forward. What I can see is as thick as my forearm and has large glossy scales. I take a deep breath, manually override my fears, and grab the section of snake with two sweating hands. It resists, smooth scales and solid muscle pushing against my grip. Adrenaline floods my nervous system, washing away the fear. An indigo! Bill takes my place and I circle, looking for the front end of the snake. I see another loop of black and brown in the deep grass and catch hold. Whooping and laughing like we are deranged, Bill and I pull over seven feet of Texas indigo snake from the tangled weeds. The snake regally submits to our handling. No ill-tempered hissing and lunging like a Texas rat snake. No disgusting evacuating of bowels or musk glands like a watersnake. It is a magnificent creature. It calmly loops through my hands, circles around my arms, and never strikes or tries to get away. I'm the one with the racing heart and shaking hands.

Instead of being killed on sight like most snakes, Texas indigos have traditionally been left alone by ranchers and knowledgeable property

Margie Crisp and Texas indigo from Chaparral Wildlife Management Area, Dimmit–La Salle Counties

owners along the Nueces and its tributaries. Ranging from the Gulf Coast to the Rio Grande and all the way up to the Edwards Plateau, these large, handsome serpents easily reach six or seven feet in length, and giants over eight feet long are not Texas tall tales. Often called "blue indigos," the snakes are granted immunity from instant slaughter because they are ophiophagous—meaning they eat other snakes, including rattlesnakes. Who wouldn't want an indigo living nearby? They also feed on frogs, mice, rats, and other small critters. Texas currently lists the species as threatened, its populations declining as the dense riparian corridors it prefers disappear.

Bill sends a text to Travis: "7 ft. *Drymarchon* Blocker Pond." Within minutes a van arrives and students erupt from the vehicle to cluster around the indigo. From a distance we must sound like a flock of excited chickens. The indigo glides from one student to another. I take a photo of two young women and a young man standing in a row with huge smiles as the indigo languidly stretches through their hands.

Energized, we all head out to drive the Chap's roads but again find next to nothing. Sunday morning, we pack up. The indigo waits in the research center for the biologist to weigh, measure, and tag it before it is released back at Blocker Pond. The final tally for the weekend: one indigo, a single Mexican milk snake, Texas horned lizards, Texas tortoises, multiple lizard species, frogs, toads, birds, ants, and insects, plus dozens of new wildflowers and plants. But not a single western diamond-backed rattlesnake.

6 *Big Bend of the Nueces*

BRAIDED RIVER

About fifteen miles below Cotulla, near the old Holland Dam, the Nueces has an identity crisis. The river jumps out of its single channel and splits into multiple streams that crisscross and twine back and forth like quarreling siblings across a miles-wide riverbed.

Then the Nueces does something unheard of. From the Sabine to the Pecos, Texas rivers run in an orderly progression. In tidy, almost parallel lines they flow from the northwest to the southeast in a grand procession toward the Gulf of Mexico. The Nueces starts its run in the traditional

Big Bend of the Nueces and Baffin Bay

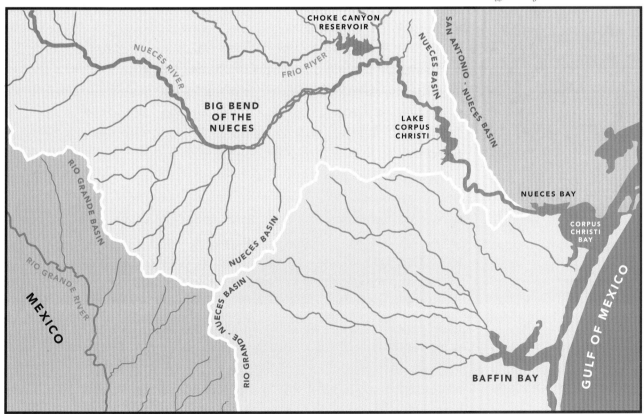

northwest-to-southeast pattern and has a couple of hiccups where it runs east for short jaunts, but just past the old Fort Ewell site in southern La Salle County, the Nueces bucks and improbably veers in a broad circular swing. The Big Bend of the Nueces swoops across the bottom of La Salle County and then turns northeast through McMullen County. By the eastern edge of Live Oak County, the river has gathered up the threads of its many streams and returned to a single channel. It continues to flow in a contrary northeast direction until making another abrupt about-face and merging with the Frio River. The Nueces, now filled with the tributary waters from the entire basin, turns and flows grandly southeast down to the Gulf, rejoining the Texas ladder.

Why does the Nueces make this rebellious swerve? There are no obvious geological answers such as hard stone escarpments or mountains to deflect the river.

Below and to the southwest of the Nueces's contrarian track, another mystery lies shimmering under the Texas sun. Baffin Bay, part of the Laguna Madre complex of hypersaline bays, is the only major bay along the Texas coast without a river feeding it. Ignore the radical turn of the Nueces and instead trace an imaginary river running through one of the many stream beds running northwest to southeast, bump over the minor hump of the Bordas Escarpment, and then slip into one of many stream courses and you'll slide right into the waiting arms of Baffin Bay.

What evidence is there to support the theory of a former tryst between the Nueces River and Baffin Bay? If it is true that the Texas bays are river valleys submerged by the gradual rise of the oceans after the last ice age, then you'd expect to find a river flowing into Baffin Bay. In my *Texas Geological Atlas*, all the major rivers and streams, including the Nueces, scrawl across the state and down to their respective bays, leaving an obvious line of alluvial gravels and soils collected and deposited in the river's path. No such line traces up from Baffin Bay. Geologist William Lindeman believes that the evidence for a Nueces River–Baffin Bay alliance is just waiting to be discovered. He believes that the intermittent streams that feed Baffin Bay are too puny to have created their valleys and at least one is an abandoned river channel. Other geologists have looked and found no definitive evidence. For now, it remains a mystery and I am denied the satisfaction of tidying up the river's errant course.

As the Nueces loops around its big bend, the riverbanks recede. While there still may be a main channel, the twisting strands course across a riverbed that broadens to nearly four miles wide in spots. Few roads cross this section of river and when I drive to the FM 624 crossing I find only a sullen stagnant pool and a dog carcass tossed on the bank, its teeth and ribcage bared.

I turn to my books. After all, William Sydney Porter, commonly known by his pen name O. Henry, lived and worked on a nearby sheep ranch in 1882, riding to Fort Ewell to pick up mail. I spend a day distracted and entertained by his stories. J. Frank Dobie worked on his uncle's Olmos Ranch on the Nueces. In his book *Rattlesnakes*, Dobie writes about "the sacahuiste that covers the Nueces River flats below Cotulla in La Salle County and is flooded when the Nueces gets on a fair rise." I pore over old topographic maps. Brush is marked with pale green dots and forest with solid green, but large areas along the river and its tributaries are an indecisive white like sand or salt running downstream. Old oil fields pepper the riverbed with capped and dry wells. Strings of forest border channels, but not necessarily the main channel. Google Earth's satellite photos reveal brush and vast, open tan areas along the river. I can't zoom in enough to see any detail. Dobie's sacahuiste can't be the same as my sacahuiste, a tough, evergreen, grasslike member of the agave family sometimes called beargrass.

I send a desperate e-mail to botanist Bill Carr. Sacahuiste, he calmly replies, is used to describe any coarse grass, but most often Gulf cordgrass, *Spartina spartinae*. "Yes," he tells me, "it's weird that a grass commonly associated with salty prairie along the Gulf Coast occurs as a dominant species so far inland. But there you have it." He included photos taken in the braided section of the Nueces: the river as a small muddy pool in drought and another of the floodplain covered with bristling clumps of spartina. I call Gus Canales, a rancher on the Big Bend of the Nueces. "Sacahuiste? Most ranchers just leave it and occasionally burn it so the cattle can eat the new shoots," he tells me. "It's nature's filter, all along that big flood zone, it slows down the floodwaters and keeps the silt in place. That soil is really fine and powderlike. It makes some really sticky mud." "Is it good for wildlife?" I ask. "Oh," he says, drawing the word out, "wildlife loves it. The does like it for hiding their fawns. It is

Immature red saddlebags

clump grass and if you look under the blades, you can see little trails and tunnels running all over the place. Rats and rabbits and mice like the sacahuiste. And, well, rattlesnakes like the rats and rabbits and mice." He pauses. "You hear the rattlesnakes more often than you see them. Kinda wakes you up."

Sacahuiste turns up again, this time in an unlikely place: a 1983 US Geological Survey conveyance report studying how much water would be lost in the sacahuiste flats between a proposed reservoir in Cotulla and the Nueces River downstream.

The Cotulla Reservoir

The Cotulla Reservoir, long a dream of entrepreneurs and water planners, is an idea that gets pulled out and dusted off every few years. As the population of Texas booms, the city of Corpus Christi and its industries (as well as San Antonio and other Texas cities) will need more water for drinking, flushing, agriculture, and manufacturing. Water planners coax the most arthritic and ill-considered of plans back into public view to totter and squint against the light. The Cotulla Reservoir is one such plan. Ten years before the Winter Garden boom, a USGS engineer proposed a series of reservoirs that linked Espantosa, Caimanche, and Soldier Sloughs near Carrizo Springs (Crystal City was not conceived yet), plus a large reservoir just west of present-day Cotulla. The goal was to turn all of Dimmit and La Salle into a vast irrigated agricultural paradise. Then in the 1960s, when it became clear that Lake Corpus Christi could not meet the city's needs, upstream planners and politicians again introduced the Cotulla Reservoir in lieu of the proposed Choke Canyon Reservoir or other downstream sites. The Cotulla Reservoir, they argued, would provide water for irrigation and control downstream flooding. When the City of Corpus Christi objected, engineers proposed selling reservoir water to the city. The project was abandoned because a local rancher, whose land would have been inundated, threatened a lawsuit.

Still, the Cotulla Reservoir is an idea that won't quit. Although way down the list at number forty-five, it still made it into the top fifty reservoir sites in the 2008 Texas Water Development Board's Reservoir Site Protection Study (as did the Caimanche Reservoir, a Crystal City Reser-

voir, and a string of impoundments in the upper river including one at Montell). Con Mims, executive director for the Nueces River Authority, believes the Cotulla Reservoir plan, as well as a plan to pipe water from the Nueces River into Choke Canyon, is finally dead. "Surface water just doesn't make sense," he tells me. Sun and wind evaporate more than twice as much water from the reservoirs as the area receives from rainfall. But more importantly, over half of the water that flows down the river's braided stretch—the Big Bend of the Nueces—between Cotulla and Three Rivers disappears into the sacahuiste flats. The grasslands that stretch along the wide floodplain are tall clumps (six feet, according to the USGS report) of Gulf cordgrass, switchgrass, and alkali sacaton that cover thousands of acres of saline soils—soils that not even the thorny brush can tolerate; soils that turn freshwater into bitter salty water. When a tropical storm dumps a foot of rain into the river basin, water spreads out into the sacahuiste flats, the bunchgrasses tangling their stems and blades in the water, filtering it as it slows and spreads out to a shallow river of grass three or four miles wide.

On Google Earth I fly downstream, the grass flats an unobtrusive tan that runs down tributaries and the strands of the braided stream. I fly over the US naval flight training area, unimpeded by access restrictions. I become a time traveler and zoom back to 2008, then forward in hops, watching as the white spots of oil and gas wells appear across the landscape like stars in the evening sky.

EAGLE FORD SHALE PLAY

If La Salle County looks like a constellation map with bright drilling pads and rig sites linked by roads and pipelines, then the Eagle Ford Shale Play is the Milky Way, a galaxy of wealth-producing infrastructure and shattered habitat stretching from the Rio Grande across South Texas and into East Texas. Most of the spots cluster in a surprisingly narrow band that runs across the basins of the Nueces, San Antonio, Guadalupe, Lavaca, Colorado, Brazos, and Trinity Rivers. A nocturnal satellite image shows the Eagle Ford glowing, an arc of lights as bright as any of the major cities.

Oil exploration started in the Brush Country as early as the 1920s, and

Green Jays in Anaqua Tree

the first carload of oil left Cotulla in 1940. There have been several peri-
ods of exploration—boom and bust—but in 2008 Petrohawk drilled the
first highly successful well in the Eagle Ford Shale formation in La Salle
County. The goal was the same, extracting oil and natural gas, but the
method was new. This well was hydraulically fractured, or fracked, a new
technology that released oil and gas from tight rock and sand formations
deep below the surface.

In 2014 the Eagle Ford Shale Play was the most active shale play in
the world. As I write this, the oil business is in a downward phase of its
boom-and-bust cycle. Currently exploration and the drilling of wells have

slowed but recent estimates indicate that we've drilled only about 10 percent of the wells possible in the Eagle Ford. If we are lucky, that doesn't necessarily mean a tenfold increase in drilling pads, pipelines, and roads. Multiple wells—dozens even—can be drilled from a single pad and utilize common roads and pipelines. I think of the four side-by-side pristine white drilling pads I'd seen from the helicopter and understand Timo Hixon's disgust at the poor planning.

Each oil or gas well requires initial exploration and seismograph lines cut through the brushlands, then roads built to the drill pads, tanks erected, and pipelines installed to carry the oil or gas across the countryside. According to a new study, in La Salle County, since 2008, wells and pipelines have gobbled up about 3 percent of the county's total area,

The Eagle Ford Shale Play at night, 2012. San Antonio and Austin, linked by the I-35 corridor, appear just above the lights of the Eagle Ford with Corpus Christi at the lower right. Courtesy of NASA's Earth Observatory.

resulting in a cross-hatching of the landscape by pipelines. While 3 percent doesn't sound like much, the number doesn't include the existing or new roads built to access drilling sites or the highways widened for increased traffic. From every drill pad a splintered ring of pipelines and roads, like a windshield cracked by gravel, slices across the Brush Country, cutting previously undisturbed wildlife habitat into smaller and smaller pieces. With nearly a quarter of the structures built in floodplains or near stream ways, erosion is also a serious consideration. The oil companies, at this time, rely mostly on the quick-growing, nearly indestructible buffelgrass and other exotics to quickly cover construction sites, pipeline rights-of-way, and roadsides. Without the property owners' insistence, few oil companies will bother to spend the extra dollars to seed disturbed areas with native seed. Highways of exotic grasses crisscross the Eagle Ford Shale across the Nueces River basin, creating pathways into native habitats. Depending on the soil type, the exotic grasses may not take over. But this much is clear: wherever buffelgrass and other exotics dominate the grasslands, quail and other native wildlife decline. The rich, complex brushlands convert into simplified systems that simply don't support the plants and insects that are the foundation of the Brush Country wildlife. White-tailed deer, horned lizards, quail, and other birds starve in a lush sea of exotic grasses.

South Texas Natives, a project of the Caesar Kleberg Wildlife Research Institute at Texas A&M University–Kingsville, is struggling mightily to turn the tide of exotic grasses. Along with the Texas Parks and Wildlife Department, it works to educate landowners about their options, develop strains of native plants and grasses for commercial seed production, and conduct research. "Is there any hope for the Brush Country?" I ask Forrest Smith, program director. "Honestly, it's looking pretty bleak," he tells me. "As we lose more native habitat to development and as exotic grasses take over more of the remaining native habitat, it impacts the wildlife—including migratory birds."

"On the positive side," he continues, "with the shift away from traditional ranching to wildlife and recreation, more landowners are restoring native habitat. But few can afford to completely go back to bare dirt and build a native habitat from the ground up like the Hixons' project. It is too expensive. Right now you or any landowner could walk into any NRCS

office and say you want to plant buffelgrass, coastal bermuda, or other exotic grass for cattle and they'd give you a substantial cost-share payment. That kind of funding just isn't available for native habitat restoration."

Forrest's last words stay with me: "We've done a lot of things to the land with good intentions that have had dramatic results. Some good, some bad. When I have the chance, I advise landowners to think deeply and act slowly. Change forward is easy but change back is often impossible."

Corona de Cristo

III : Río Escondido

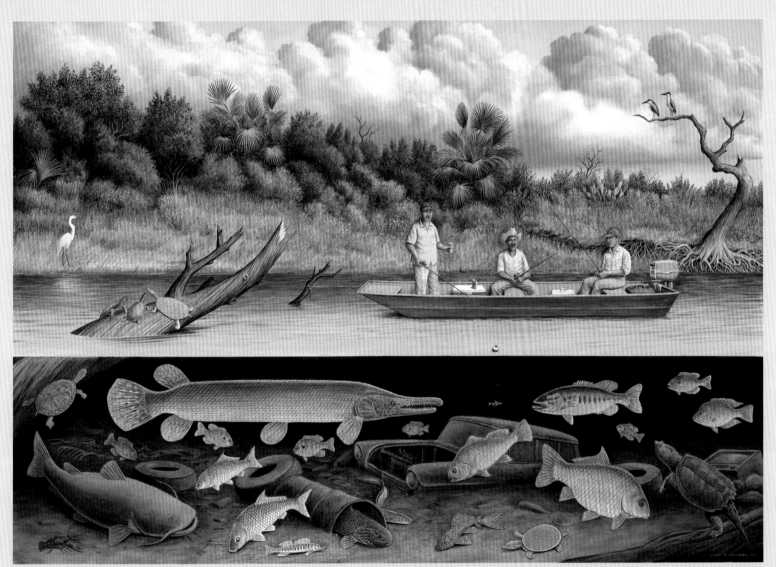

Nueces Fish Story

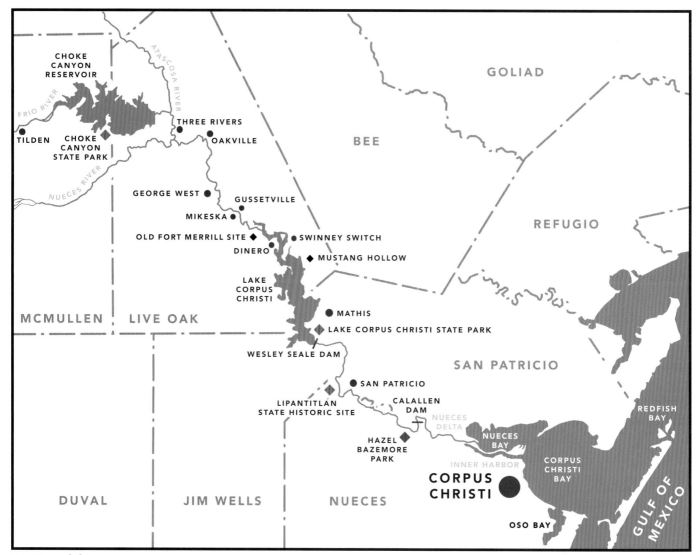

Río Escondido

By the time the Nueces and Frio Rivers formally meet below Choke Canyon Reservoir, the Frio has already collected all of the tributary rivers that run across the basin: the Dry Frio, Leona, and Sabinal, plus Hondo, Seco, and San Miguel Creeks, and, late to the party, the Atascosa River, which joins a few miles downstream of the dam. The combined rivers curl around the town of Three Rivers on their way to present themselves to the Nueces. Invigorated by the Frio and her friends, the Nueces strolls downstream, sashaying back and forth across the bottomlands and terraces, on her way to the delta and the bays.

On the surface, feathery bright yellow-green mesquites mingle with rattling sabal palms and heavy dark-limbed live oaks draped with gray Spanish moss; dark green post oaks and yaupon stand alongside prairies, long since converted to cropland and pastures. As the river moves out of the drought-tolerant, mostly small-leaved and thorn-laden trees and shrubs of La Brasada, the corridor becomes a pointillist painting of thornscrub mixing with eastern post oak savannah and the tall grasses of the Coastal Prairie, the elements fraternizing along the river's timber-clad banks. The dry hills and arroyos of La Brasada surrounding Choke Canyon Reservoir merge into the rolling hills of Oakville Sandstone as the river cuts downstream. Lake Corpus Christi, rimmed by white stone and caliche bluffs, fills the wide basin cut into the Goliad Formation. Below the lake, the river's snaking path across the nearly level coastal plain creates a broad lowland basin of floodplains and river terraces bracketed by clay and sand bluffs.

Before the city and the reservoirs, this was a land of mustangs. While it is not the location of Zebulon Pike's Wild Horse Desert, early explorers and settlers encountered herds roaming the Coastal Prairies and grazing on the abundant grass, beating paths down to the creeks and rivers for freshwater, and luring tame horses away to join the herd. Now twenty communities in seven counties—and one river delta—send pipelines to the river's reservoirs to sip water. The City of Corpus Christi operates Choke Canyon Reservoir, Lake Corpus Christi, Calallen Pool, and the river lengths between as a system, pouring water from Choke Canyon to fill Lake Corpus Christi and then to Calallen Pool, where big pumps send water to half a million people, industry, and the Nueces delta. A little

freshwater flows downstream from Calallen Dam, but much of the freshwater feeding the Nueces estuary comes from wastewater pipes releasing used and treated water into the river channel, the navigation channel, and Corpus Christi Bay.

Long before Anglo Henry Lawrence Kinney squatted on a Spanish grant to found the smugglers' roost that would become the city of Corpus Christi, Spanish and Mexican ranches dotted both sides of the lower Nueces. The river divided New Spain's internal provinces of Coahuila and Nuevo Santander, later the Mexican states of Coahuila y Texas and Tamaulipas. Then the river was the disputed border between the Republic of Texas and the Republic of Mexico, until the Treaty of Guadalupe Hidalgo established the international boundary between the United States and Mexico at the Rio Grande. By then county lines crisscrossed the state, but the Nueces retained its divisive status, slicing between San Patricio, Jim Wells, and Nueces Counties. But centuries before the River of Nuts divided counties and countries (or was even associated with its upper stretches), an anonymous Spanish map appeared, depicting a river tucked behind barrier islands. The map named it Río Escondido, the Hidden River.

7 *The Choke*

CHOKE CANYON STATE PARK

Choke Canyon Reservoir has one purpose: to collect and store the Frio River's water for Corpus Christi and other downstream users. There are no hydroelectric turbines to generate electricity, nor is it designed or managed to control floods. No one uses its waters to irrigate crops. The shimmering length of Choke Canyon Reservoir is for municipal and industrial use—and home to record-sized alligators, alligator gar, and blue catfish.

No water in sight at Choke Canyon Reservoir State Park, McMullen County. In late 2015 after a drought, the reservoir was below 26 percent capacity, nearly thirty feet below full level.

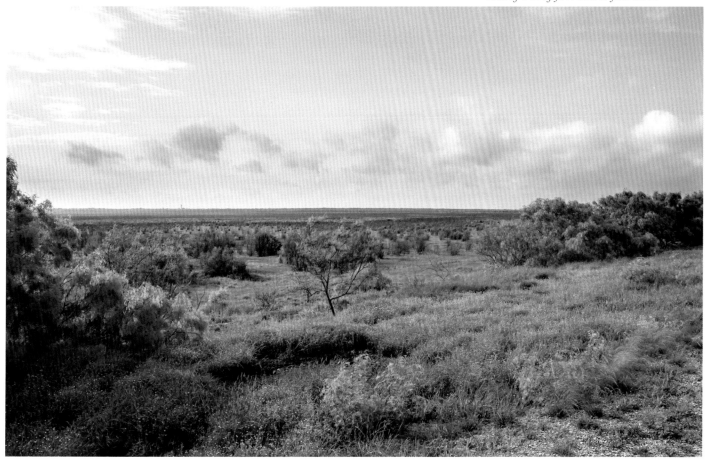

Black-crowned nightherons

I'm in one of Choke Canyon State Park's thirty-plus-year-old shelters in the Callihan Unit. The recent coats of brown paint slathered on the woodwork keep it from feeling decrepit. The luxury of a functioning air conditioner glosses over the cracked and boarded windows, the warped door, and the many initials gouged into the woodwork. Even though the drought-cramped lakeshore is a long way from the cabins these days, the location can't be beat. A flock of wild turkeys struts past my picnic table while I have my first cup of coffee. The tom eyes me and puffs up to impress the gals. They ignore him. Javelinas lazily stroll past empty shelters, the group enveloped in a cloud of musky scent that curls and twists through the air. Cottontails venture out onto the mowed clover and grass, leaving dark trails where furry paws have absorbed morning dew. Purple martins inhabit a house as broken down as the shelters; they greet the day with jubilant trills and acrobatics. Golden-fronted woodpeckers fly between the big mesquite trees and the cabins, enthusiastically banging on siding and limbs indiscriminately. Just when I think the show is over, a crowd of yellow-rumped warblers (a.k.a. butter-butts), titmice, and verdins rumble through the campground, ricocheting between trees.

I throw on my pack and grab my binoculars. Mowed, level trails wind through the brush. As I walk, I crane to catch a glimpse of the birds that call from the thorny thickets. A glimpse of yellow accompanied by rattles, harsh nasal cries, and bell-like calls: a gang of green jays. A flash of orange and black: an oriole. Both recent migrants to the area and now iconic residents. Red flutters are cardinals. Sparrows are bouncing brown shadows. High in a tree a full-throated song erupts. The vocalist no sooner finishes one song than it crashes into another, alternately soaring in beauty and mashing songs into jumbled cacophony. It hops out on a branch to look down at me and I recognize a thrasher, a rust-colored cousin of our mockingbird. A blanket of white flowers on the ground leads my eye up into the branches of a wild olive, its dark green leaves nearly hidden by large tissue-thin blossoms.

The trail releases me next to one of the park's favored fishing spots, 75-Acre Lake. The lake, formed by former State Highway 99's old roadbed, holds a few small pools, with just enough water for wading birds and a few ducks. I am the only visitor. Years ago Bill and I fished for catfish and sunfish from both sides of the highway's berm while anglers

of all ages lined the Texas Parks and Wildlife Department dock. Boats bobbed in the reservoir. The picnic ground was full of fishermen and families. I remember the wind blowing relentlessly, the posted "Beware of Alligators" signs, but especially the astonishing scalpful of chiggers Bill picked up while ducking through brush at the water's edge. Bill itched and scratched for a week, pawing at the bites behind his ears and in his hair until his skin bled.

Choke Canyon Reservoir is the City of Corpus Christi's fourth, most recent, and largest reservoir. Reservoirs are built to meet future water demands, so no sooner had the city completed one reservoir then it started thinking about the next. Over the decades federal, state, and local agencies proposed dams and reservoirs from the headwaters all the way to Corpus Christi Bay. In 1958, even as the new Lake Corpus Christi filled (submerging its predecessor, Lake Mathis or Lovenskiold), the city knew it needed another reservoir. A big reservoir. Studies and plans by the Bureau of Reclamation and independent engineering firms piled up. Finally, in the late 1960s, two sites emerged as front-runners: the Reagan & McCaughan Engineering site (R&M) twenty miles downstream of Lake Corpus Christi, and, forty miles upstream, the so-called Choke Canyon site on the Frio River (named after "the Choke," two brush-covered hills that caused the river to back up). Reclamation preferred the Choke Canyon site even though some argued that building a 700,000-acre-foot capacity reservoir on a river that contributed an average annual flow of only 171,000 acre-feet would leave the reservoir nearly empty most of the time. The R&M site, on the other hand, would intercept 100 percent of the Nueces's flow. In 1970 the voters of Corpus Christi picked the R&M site, even though it had a higher price tag and would submerge the town of San Patricio. Then federal funds for cost sharing appeared and officials had a change of heart. The voters' preferences were ignored and Congress authorized the Nueces River Project's Choke Canyon Reservoir in 1974.

Besides the obvious allure of federal funds and the deterrent of flooding historical sites, there was at least one other reason for selecting the Choke Canyon site over the R&M site: evaporation. A reservoir with tall, steep sides has less surface area; a broader, shallower lake results in more surface area. The more surface area, the more water the sun and wind

wick away as evaporation. Choke Canyon, when it is full (not very often), is more than ninety feet deep. The R&M reservoir would have created a larger but shallower reservoir.

Walking through the brush on an early June morning reminds me that this is a near-desert environment. Consider these numbers: Choke Canyon Reservoir loses between 65,000 and 130,000 acre-feet of water to evaporation every year. Lake Corpus Christi adds another 50,000 to 90,000 acre-feet to the total loss. Of course during droughts (when the stored water is especially valuable), the evaporation rate skyrockets. Nueces River Authority deputy executive director Rocky Freund told me, "Trying to explain to people why the lakes are going down is one of the most difficult parts of my job." She pulled up a report from the Authority's website. "Look at this report from August 2015. Choke Canyon Reservoir had just fifteen acre-feet of water flowing into the reservoir with twelve thousand acre-feet going out. But only about two thousand went downstream; the rest was lost to evaporation. And that was just *one* month." She pauses. "People get angry; they think we're wasting water. It is really hard to explain that it just evaporates." In 2011 the combined inflow from the rivers and creeks to both reservoirs was a meager 13,185 acre-feet, one of the lowest on record. That same year saw 228,722 acre-feet disappear into the air—about 75 billion gallons of water.

THE CHOKE

As soon as the Nueces River Project received congressional authorization, the city was ready to start on the Choke Canyon Reservoir. The Coastal Bend was growing rapidly, water demands were steadily rising, and when the next drought hit, the city wanted to be prepared. It had the money in hand but before construction could start several obstacles had to be addressed. The site, all privately owned, had to be converted to public land. Because the reservoir would drastically reduce the amount of freshwater flowing into Nueces Bay, some sort of plan was needed to avoid damaging the estuary and fisheries. Finally, someone had to figure out what to do with the more than fifty active oil and gas wells, and the unknown number of plugged wells and dry holes, in the future reservoir's bed.

Javelinas

Corpus Christi's petroleum superintendent had assured Washington that active wells would be plugged and abandoned and that even if a few old wells could not be found, the saltwater leakage would be minimal. The Bureau of Reclamation began buying up land, relocating families, and investigating the historical and archaeological sites in the reservoir area.

But meanwhile the multiyear process of securing the state-issued Certificate of Adjudication (water rights permit) for Choke Canyon Reservoir divided the residents of the Nueces River basin in a high-pitched battle. Federal and state wildlife agencies, fishermen, and environmental groups demanded freshwater for the bays. Residents in the lower basin, dominated by Corpus Christi and industry, supported the reservoir as a water supply to serve immediate needs. Farmers, ranchers, and municipalities in the agriculturally dominated upper basin felt that the Choke Canyon permit was a water grab by Corpus Christi. Because of the arid nature of the Nueces basin, they believed that the Choke Canyon permit would essentially appropriate the remaining water in the Nueces basin so

that no one else would be able to obtain sizable water rights or build future reservoirs upstream. The fight raged in newspapers, county courts, and city halls from the top of the basin to the bottom.

By 1974, state officials and the general public were, if not in complete accord, no longer actively opposing the project—everyone except the Bureau of Sport Fisheries and Wildlife, which continued to hold up approval of the Choke Canyon Project in hopes of obtaining freshwater releases from the city's reservoirs. The Nueces estuary (the delta, Nueces Bay, and Corpus Christi Bay) depends on freshwater from the Nueces River. In simplest terms, the freshwater dilutes the bay's saltwater, thereby creating the brackish conditions essential for fish and shellfish to live and reproduce. It was clear that building Choke Canyon would have a profound effect on the estuary. Under pressure from federal and state wildlife agencies, the city agreed to provide "not less than 151,000 acre-feet of water per annum for the estuaries by a combination of releases and spills from the reservoir system at Lake Corpus Christi Dam and return flows to Nueces and Corpus Christi Bays and other receiving estuaries, and maintain a minimum flow of thirty-three cubic feet per second below the Choke Canyon dam into the Frio River" (Certificate of Adjudication No. 21–3214, Section 5B).[1] The state approved the water permit needed to impound the Frio River.

While the planning and political wrangling had taken two decades, construction on the dam was finished by 1982—just as a drought loomed. With no rain and reduced river flows, it took five years for the reservoir to fill. The drought frightened the city's managers and residents, and even after rains returned, the city hoarded water. The bay grew steadily saltier and the oyster, shrimp, and fish populations diminished. The state finally forced the city into releasing the promised water for the estuary in spring 1990, eight years late. The city did so grudgingly. Then—and now—there are people who argue that freshwater is wasted in the bay. Yet the reservoir was approved on the condition that water be supplied to the bay, a promise the city did not keep.

Even before Choke Canyon was finished, plans to build additional reservoirs were being seriously considered, despite the astronomical evaporation rate. But instead of building a new reservoir, the city started looking east. A deal was struck with the owner of Garwood Irrigation

Company on the Colorado River for an option to buy thirty-five thousand acre-feet of senior water rights—even though it wasn't quite legal in 1992 to transfer water from one river basin to another. Nevertheless, engineers started drawing up plans for pipelines. In 1993, a drought parched the area again. As the rivers reduced to trickles, use and evaporation relentlessly drained the reservoirs. Area leaders contracted to purchase nearly half the annual yield from the Navidad River's Lake Texana in 1994. Two years later, with the reservoirs at a quarter of capacity, officials set out to bring the Navidad's water to the panicking city, communities, and industries. Construction started on the proposed pipeline (which by now had the state's blessing) in the summer of 1996, and, impressively, the pipeline started delivering water in September 1998. The 101-mile-long, 64-inch-diameter Mary Rhodes Pipeline was a collaborative effort with the Nueces River Authority, the City of Corpus Christi, the Port of Corpus Christi Authority, and the Lavaca-Navidad River Authority—all working together to fast-track the project. Phase II, just completed in 2015, extended the pipeline to the Colorado River. Now water from the Navidad River's Lake Texana and the Colorado River (all piped directly to treatment plants) supplements the reservoir system and helps ensure that the delta and bay receive their modest share of Nueces freshwater.

OIL AND WATER

While many worry about the quantity of freshwater, the Nueces River Authority's deputy executive director Rocky Freund also worries about the quality of the freshwater in the rivers and reservoirs. And one of her concerns is, ironically enough, chloride or salt contamination. The water flowing into Choke Canyon runs through areas with naturally saline soils so the water sometimes has noticeable levels of sodium (as does the Nueces through McMullen County). With evaporation continually concentrating the minerals in the reservoir, salty water can be an issue for downstream users. But Freund is forthright about her concerns regarding recent events. "We believe that someone illegally dumped frack water or brine upstream of the reservoir," she tells me. "It was such a sudden and large spike in the chloride levels that it clearly wasn't from a natural source."

Oil exploration started in the Nueces River basin in the 1920s and 1930s with oil fields popping up along the rivers. It took time for the state to regulate the industry and even longer for the Railroad Commission and the state to enact rules to protect water supplies. But no one foresaw the bacchanal of the Eagle Ford Shale Play's fracking boom. Today hundreds of active oil and gas wells splay across Choke Canyon and the Nueces River basin. Even more dry wells speckle the map. Disposal wells are rarer, but a number cluster along the Nueces and above the reservoir.

After a well is "fracked," the drilling company has to dispose of several million gallons of frack water—a combination of the freshwater used to carry the often toxic chemicals and sand down into the well plus the brine and oil that flow back up as the oil or gas is pumped out. The flow-back, or produced water, can be contaminated with chemicals like benzene and methanol used in the fracking process and with naturally occurring toxins such as residual oil, heavy metals, and radioactive substances.

Someone came up with a clever solution for dealing with the frack water, thinking, if we got the water out of the ground in the first place, maybe we can just put it back? Injection wells are nothing new; manufacturing companies all over the country rely on them to dispose of chemical waste. Industrial and human by-products are stored in all sorts of geological formations including salt domes, limestone karst formations, and dry or played-out oil wells. According to a source (who requested anonymity), for decades the town of Rocksprings in the Hill Country disposed of sewage by pouring it into underground karst caverns. Nowadays technology has advanced from dumping waste into a hole in the ground to high-pressure injection wells. The saltwater disposal wells (SDWs) in the Eagle Ford Shale Play utilize dry or played-out fracked oil and gas wells. Produced water is trucked (another issue) to the SDWs for disposal, where, for a fee, it is pumped under high pressure to fill the gaps in the tightly packed sands and shale that formerly held gas and oil, at a rate of a million gallons a day. While the "out of sight, out of mind" solution may come back to haunt us someday, it has helped keep our streams, rivers, and bays cleaner. Up until 1995, Texas allowed the dumping of toxin-laced produced water into some streams and all bays and estuaries.

There is controversial evidence that links SDWs with earthquakes, but the greater fear is that the toxic fluid from SDWs could escape the

Little blue heron

shale layer, either through a natural fault or via abandoned, degraded, or improperly sealed wells, to contaminate nearby aquifers—or reservoirs. Brine seeping from improperly plugged wells is nightmare enough, but I imagine used fracking fluid bubbling up to the surface through an old well to create a toxic artesian fountain. It hasn't happened in the Nueces River basin. Not yet. As one geologist told me, "You know, we really don't have a clue what goes on underground. It is a highly educated guess at best."

8 *Puente de Piedra*

ROCKY REAGAN CAMPGROUND, OAKVILLE

Hershall Seals and I stand on the banks of the Nueces River, downstream of the town of Three Rivers, watching the slow cloudy current drift below us. "The water isn't as muddy as it looks," he tells me with a wry smile. His long silver hair is pulled back into a braid; dark-rimmed glasses hide his eyes. "When you get in the water, you'll see that it is surprisingly clear." He glances at my skeptical expression and laughs quietly. "I learned to swim in the Nueces outside of Uvalde. We lived up there for a while." He pauses. "When we moved down here I was soooo excited that we'd be by the river." He laughs. "When I saw the river for the first time, I was soooo disappointed." Spanish moss flutters overhead. A fish hits the surface of the water with a splash. "I love it now," he says softly. "We all do."

Bill and I have known Hershall for years as an artist and professor at the University of Mary Hardin-Baylor. After having my requests for interviews or visits turned down by multiple landowners and ranch managers along the river, I sent out a plea for help to my entire e-mail list. Hershall confessed his Nueces connections and invited us to come down and camp at his family's place in Oakville.

I sit at the Rocky Reagan Campground under a pavilion that extends the wings of its roof toward the lake. Hershall, his father and mother, Jack and Evelyn, three brothers, cousins, and niece Jessica take turns telling me stories. Electrical outlets and light switches are placed high on the posts, above the last flood's high-water mark (from a twenty-four-foot river rise). The fire pit produces grilled dove, feral hog sausage, venison, and barbecued chicken. The lake before us, an abandoned river channel recently dredged and planted with water lilies and cattails, is full of catfish, bream, and bass. The group under the pavilion ebbs and flows with fishermen drifting back to the dock to check lines or throw out a few casts. Hershall's mesquite warrior strides toward the lake, his atlatl

Spanish moss and prickly pear cactus on the riverbank near Oakville, Live Oak County

and dart arrested in midflight. Carved from a single monumental mesquite tree, the sculpture seems to have erupted from the earth, a mythical hunter crowned with antlers, forever moving toward a fatal grace.

Family stories and history are presented to me as grandly as gifts. I bask in my imagined, albeit minor, celebrity, watching the brothers tell tales on each other, with one or more protesting or blushing in embarrassment while we laugh at youthful (and some not so youthful) escapades. Evelyn confides to me that it is a special day for her: all four of her sons have traveled to be together for this weekend at the Rocky Reagan Campground. "We've had so many good times here," she tells me. "It was my father's place; that's why the campground is named after him." Her happiness shimmers around her like light through a prism. She leans forward. "Jack was a widower with four little boys when I met him. I told a friend of mine about him and she told me, 'What could be better than four boys!' And I thought, well, she's right. What could possibly be better than four sons?" She leans back, offers a bag of potato chips to me, and pops a chip into her mouth, smiling.

I'm fortunate to have a mouthful of crumbling potato chips to cover the sudden tears that well up. While Seals brothers are pounding me on the back, handing me glasses of water, and looking on in concern, I realize that this wonderful feeling of belonging isn't about me at all. It is this extended clan's way of life. I'm surrounded by teachers, school administrators, public servants: a family whose sense of community extends far into the world.

Scott Bledsoe, a cousin, stops by for a visit. He also happens to be one of the founders of the local groundwater conservation district, on the board of the Nueces River Authority, and a member of the regional water planning commission. I pepper him with questions about the river. He speaks calmly, slowly, and thoughtfully. "The river is in better shape now with Choke Canyon Reservoir," he tells me. My surprise must show on my face; on-channel dams are notorious for disrupting and damaging river ecosystems downstream. He grins at my expression. "Before Choke Canyon, the river would dry up into pools during the summer; now it runs most of the time. Not always a lot of water but fairly consistent because of the releases to Lake Corpus Christi downstream." He looks into the distance. "Of course the kids loved building mudslides at the pools. Oh

what a mess, and what fun they had." Just like alligator slides, I think to myself. I ask what, if any, problems the river has in this section. He stops and thinks. "We don't have the problem with trash and septic or sewage like they have down south. The riverbanks are about the same. I guess we sometimes have some water quality issues, but overall it's healthy." As a member of the regional water planning commission, he's one of the group charged with considering the future of water—and the river—in the Coastal Bend region. I ask whether there are any threats to the river or the water supply. He is surprisingly quick to answer. "I guess the worst would be if there was a spill. The Three Rivers Oil Refinery is right up-stream, but we've never had any trouble with them. They're pretty good neighbors." Good neighbors or not, I think of the 1967 floods caused by Hurricane Beulah. The river reached a height of 49.21 feet at Three Rivers. Highways were flooded for weeks; bridges, like the one at the Highway 281 crossing just upstream of Oakville, were ripped out by the flood. After the waters receded, the high-water mark was visible all over town—an oil ring five to six feet high on houses, buildings, cars, and trees.

Juvenile coachwhip

As daylight fades, a campfire throws flickering orange light onto the pavilion, the sculpture, and the tangled backdrop of mesquites and prickly pear. The moon rises and fiercely illuminates the landscape. Guitars and accordions appear and we sit together and all sing along—even those of us who only pretend to know the words.

Sounder

In the morning, a sounder of feral hogs squeals and argues at the far end of the oxbow lake. A large black boar watches the group of brown and mottled females and youngsters. Are they the descendants of the herds early settlers put out to roam the forests along the Nueces and fatten on mast? Or are they more recent introductions?

The straight-tailed, slope-faced feral hogs in their coarse, bristled coats look about as much like a domestic pig as an English bulldog resembles a wolf. Remarkably, it takes only a few generations for even the plumpest, snub-nosed domestic swine to revert to the wild phenotype. The skull lengthens and the squashed, upturned snout straightens and grows strong enough for continuous rooting and digging. The curled tail

unkinks into a hairy brush. The fine bristles thicken into a coarse coat, and the interbreeding with other hogs produces a palette of black, brown, blond, and piebald piglets that scamper after the sows and boars, their colors the last remnant of their domesticity.

Some folks call feral hogs "Russian boars," believing that they might be related to porcine royalty. In the early 1930s, the first European wild boars, obtained from the San Antonio Zoo, were released into the wild in nearby Aransas County. For decades, Texas ranchers continued to release the so-called Russian boars (often just feral hogs) onto ranches, believing the European hogs to be better hunting. Regardless of their lineage, all feral hogs in Texas and the rest of the United States are *Sus scrofa* and a growing problem.

More than a few people point out, rather gleefully it seems, that the Spaniards and earliest colonists either intentionally or accidentally released cattle, horses, and pigs. The intent, ostensibly to benefit future settlers, seems unlikely in a land as rich in game as Texas was purported to be. While the Spaniards' cattle and horses survived and multiplied, no one has proof that today's feral hogs are the descendants of the first Texas pigs. We do know that in the early 1800s, settlers in central and eastern parts of the state had herds of free-ranging domestic hogs—and consequently robust feral hog populations. By the 1850s, settlers in the lower Nueces River valley also had free-ranging domestic hogs roaming the river and stream bottomlands. Cowman J. A. Doak wrote that his family had as many as three hundred hogs at a time, and "we ran the hogs on the range, same as the other stock. They fattened, mostly on acorns, but in the summertime they lived on pear-apples and on roots." The family processed the hogs and hauled the bacon, hams, and lard to nearby Dogtown (present-day Tilden) or Oakville to sell. Other years, they drove the hogs into town and sold them "on foot." Roving herds of domestic swine were common in the South Texas Plains south of San Antonio as late as the 1930s and 1940s.

I watch the hogs sloshing around in shallow water. Behind them the lake's grassy bank looks like it has been plowed by rooting hogs. When they first arrived at the lake, their coats varied from black to brown to blond, with a handful of spotted pigs. As they wallow and root, they all turn the same muddy tan. The black boar kneels down, sticks his snout into the water, and then flips his head back, flinging water over other pigs

Voracious

who squeal like they've been burned. He then flops over onto his side, a wave of muddy water splashing through the nearby flock of black-bellied whistling ducks standing near the shore. The ducks look over their shoulders and then turn back to bask in the sun. All I can see of the boar is four ridiculously tiny trotters pointing up out of a sea of mud.

Feral hog populations are booming. Five-month-old sows can produce litters of up to eight piglets twice a year. Some experts estimate that we'd need to reduce the feral hog population by two-thirds every year just to keep the population at its present level. And the current population is causing substantial damage to land and wildlife. Feral pigs eat everything in their path, happily snacking on corn from deer feeders, carrion, mast (native fruits, seeds, and nuts), prickly pear fruits (tunas), roots, birds, bird eggs, lizards, turtles, grubs, snakes, small mammals, amphibians, and

even fawns.[1] Let them near crops and they can level fields in a night by either eating the plants outright or rooting for grubs and worms. Because hogs don't have sweat glands, they spend time in wallows and mud to cool off and protect their skin from insects. Consequently, they can devastate pond and river shorelines by pummeling everything into pig-sized mud puddles. Not to mention the diseases they carry and can transmit to domestic stock, wildlife, and potentially people.

Yet feral hogs, in spite of their less-than-desirable traits, are tolerated by many because they are considered a game animal. Ranchers and hunting lease managers originally prized hogs for hunting, some as a sort of consolation prize when hunting for white-tailed deer, others as a primary target. Nowadays ranchers are starting to beg hunters to shoot hogs at every opportunity. Professional hog trappers have more work than they can handle while researchers around the world are scrambling to find a way to control feral hog populations.

In addition to their astonishing reproductive rates, pigs are smart. They learn fast and don't forget where to find food and what places to avoid. The adults have few predators, while piglets, on the other hand, are considered succulent fare by anything (and anyone) that can catch one. But the list of predators that can intentionally take down a full-grown boar like the one sloshing in the mud on the lake is short: humans, mountain lions, and alligators. Big alligators have been known to nab adult hogs as they swim across rivers, and even by stealthily snatching them by the nose at water's edge.

A pig fight breaks out, and the black-bellied whistling ducks are fed up. They rise into the air, their shrill cries momentarily drowning out the pigs' squeals. The ducks wheel overhead in a large V and circle the lake a few times before settling back down in exactly the same spot. Luckily the pigs have finally departed. I'm surprised that no one has taken a shot at them, but patriarch Jack Seals makes it clear why. He and his family believe that nothing goes to waste. Any animal they take, they use. Hog, dove, deer, alligator, and even rattlesnake and armadillo get tossed on the grill or put in the freezer. Their freezers, it turns out, are full.

Marilyn Seals pulls out the laminated front page of the *Beeville Bee-Picayune* and unrolls it with a smile. A photo of an alligator runs from the headlines to below the fold, a tall young man's grinning face not even

reaching halfway up the behemoth's hanging 14'3" carcass. "That's the gator that my boys caught in the Nueces last spring," patriarch Jack Seals tells me. "Just about broke our hoist it was so big. No idea what it weighed since we didn't have a scale that could handle anything that big."

That gator, I think, could eat a lot of pigs.

<p style="text-align:center">✦ ✦ ✦</p>

I ask Pat Seals, who manages the family ranch, about surviving the drought. He looks at me seriously and begins to tell me about losing cedar elm trees along the river, watching mesquite and huisache, long mowed in pastures, grow in spite of the drought while grasses withered and leafy plants crumbled. His brothers nod, their faces solemn. I ask whether he ever burned spines off prickly pear for the cattle. He's trying to give me an answer while his three brothers and cousin snort. "Lit the ranch on fire not once but twice," I hear while the rest of the group guffaws. "Feeding the deer and javelina is more like it," another Seals chimes in. I can't tell who. "Deer? Javelina?" I ask.

Pat nods, with a slow smile creeping across his face. "During the drought, the deer and javelina would crowd up with the cattle and follow the pear-burning rig around, just waiting for me to burn the spines off the cactus." He pauses. "We've got enough prickly pear for everyone on this place." I'm captivated by an image of cattle, deer, and javelinas standing shoulder to shoulder watching and waiting, an impatient audience, as Pat bathes cactus in flames.

Javelinas, like jackrabbits and wood rats, live on prickly pear all year round. The juicy nutritious pads supply nearly all of the water javelinas need and are the mainstay of their diet along with the flowers and the tunas, or fruits, as well as mesquite beans. Compared to feral hogs, they are dainty eaters. They stir up leaves and ground litter looking for food but they don't root underground. Since they have sweat glands, they don't need mud wallows. And unlike feral hogs, javelinas aren't competing with white-tailed deer for food. Yet these native critters keep getting caught in the crossfire. Javelinas are collared peccaries and although they are piglike in appearance, they are not related. They are small, a full-grown adult stands about eighteen inches at the shoulder, with small eyes and poor eyesight, small ears and poor hearing, but an impressive sense

of smell. Often called "musk hogs" for their pungent odor, they live in groups in a cloud of scent from the dominant male's musk gland. Covered with coarse salt-and-pepper bristles, they have a band of white bristles around the neck and a mane of longer black bristles from the back of the head and down the spine. When alarmed, they champ or rattle their tusks and raise their long bristles. They also have a long-standing, and mostly undeserved, reputation for ferocity and aggression. So much so they attracted the attention of Theodore Roosevelt, who traveled to Uvalde in 1892 with the intent of adding a collared peccary to his already crowded trophy rooms. Arriving at a ranch on the Frio River, he learned that the last peccaries had been killed nearly a year before his visit. Once abundant, the javelinas had saved many an early settler in the Brush Country. In the mid-1880s, when settlers were trying to survive the combination of drought and brutal weather in the overgrazed and overstocked land, salvation came in the shape of the javelina. Soft, supple peccary leather became the rage for gloves, bags, shoes, and other must-have accessories. Tens of thousands of javelina hides were exported from Laredo and San Antonio before interest in the hides waned. As Theodore Roosevelt wrote in "A Peccary-Hunt along the Nueces," "they were speedily exterminated in many localities where they had formerly been numerous, and even where they were left were found only in greatly diminished numbers."[2]

When Roosevelt heard from a passing cowman that a few javelinas yet survived on the Nueces, he turned his sights south. While his narrative doesn't specify exactly where he hunted, his descriptions of the river have ample clues:

> In the valley of the Nueces itself, the brush grew thick. There were great groves of pecan-trees, and evergreen live-oaks stood in many places, long, wind-shaken tufts of gray moss hanging from their limbs. Many of the trees in the wet spots were of giant size, and the whole landscape was semitropical in nature.

He found a small group of javelinas and dispatched a pair, lamenting that while "the few minutes' chase on horseback was great fun, and there was a certain excitement in seeing the fierce little creatures come to bay," he wished he'd killed using a spear instead of a gun.

Kingfisher Trifecta

I'm sitting on the bank of the Nueces, my kayak waiting in the water. Bill has run back to camp for our water bottles. I look up at the peculiar sight of long strands of Spanish moss hanging down from an oak tree and brushing the spines of a prickly pear growing beneath.

I drag Bill's kayak to the water. We're downstream of the Highway 281 crossing and close to the site of the Bureau of Reclamation's proposed Oakville Reservoir and dam. In 1952, Texas governor Allan Shivers quashed the project. Not because it would have flooded the Nueces, Frio, and Atascosa Rivers, plus required moving the town of Three Rivers, but because the governor, like the state Board of Water Engineers, feared giving control of the Nueces and its waters to the federal government.

Eroding sandstone blocks jut from the steep dirt banks. Boulders line the riverbank, the layers of stone crumbling at different speeds. A narrow forest of oaks, ash trees, hackberries, pecans, and willows crowds next to the river, an intimate gathering of friends leaning together over the water. A lone barred owl hoots and then flies through the trees. Red-shouldered

Green Kingfisher

hawks call to each other in the distance. A few insects quietly chirp but the frogs are silent. Bill returns with granola bars and water. We set off, our paddles stirring both mist and water. The sun begins to filter through the trees into the shadowy corridor.

Yesterday afternoon we'd paddled upstream with Jack Jr. and his daughter Jessica. Jack and Bill were in an aluminum boat while Jessica and I took the kayaks. Green jays and chats called from thickets of grapevines. Jack showed us the site of an old bridge with slowly disintegrating stacked concrete and riprap. A forgotten main road linked Kitty West, one of the many towns that briefly flourished along the river, and Oakville, one of the first towns in the area. Yet there is a slim possibility that it is the old Puente de Piedra, the rocky ford where the Camino Real from Laredo to Goliad crossed the Nueces. After all, we've been using the same roads for centuries—why not here?

A wide, shallow gravel riffle blocked our upstream passage. We left our boats and walked in the rippling water. Bill and Jack pulled hellgrammites out of the stream. Mussel and clam shells littered a gravel bar. I picked up what I tentatively identified as the ridged shells of southern mapleleafs and smooth giant floaters, bigger than my foot. Fresh shells, bright inside, were recent meals for determined raccoons. Other shells were older, worn smooth by the current and filled with mud and algae. Smaller Asian clams littered the ground. Jessica handed me a crawdad's sun-bleached pincher. "Cool!" I said, and she beamed.

Jessica is simultaneously one of the most direct people I've ever met and one of the most enigmatic. Dressed in baggy shorts and T-shirt, wearing wrap-around sunglasses with her hair tucked beneath a cap, she easily catches more fish than any of the guys. I watch her handle a pistol—what her grandfather calls her "snake charmer"—with a calm confidence. Yet she is also the first to jump up and help her grandmother and grandfather, seeming to have a sixth sense when it comes to them. When she'd picked up a guitar the night before, her uncles had turned to her, waiting, and then joined in as her lilting, pure voice soared above the rougher voices of uncles and cousins. Now she is sprawled in the kayak, lazily paddling downstream. I suspect if an alligator was foolish enough to approach she'd just whack it on the head with the paddle and continue on her way.

Along the banks there are thickets of something that looks like a tomato plant with papery globes like the coverings of tomatillos. I don't see any fruit, just the little green lantern-shaped pods. There is almost no switchgrass, bushy bluestem, sawgrass, or other bunchgrass along the steep dirt banks. Cattle trails skew down the steep banks. Big top-heavy clumps of flat sedge holding up bouquets of spiny pale green seed clusters seem to grow only out of reach of the cattle.

As the sun rises and we paddle downstream, the flowers open. I see pale violet trumpets of bindweed open in the early light. Corona de Cristo vines trail along one steep edge, draping bizarre flowers over the edges of a now-hidden shrub. The passion fruits, wrapped in extravagant fringed coverings, hang below the vine. Clammyweed blooms, the white flowers transparent while the long stamens burn red in the sun. Marsh fleabane nestles on the bank with its feet in the river, holding clusters of white buds and pink flowers up to the sun. We duck under the willow and ash trees leaning over the river or paddle around them. There is a subtle current from the water releases from Choke Canyon.

A series of tall sandy bluffs lean back from the river. Huisache and mesquites teeter along the top edge, their long roots exposed by the eroding soil. Bermuda grass creeps over the edge, slipping in clumps down the slope. Below the bluffs are wide shelves of gravel and stone, uncovered by the eroding bluffs and washed clean by the river. On the far bank, behind a large and healthy willow tree, buffalo gourd vines sprawl, deep gold flowers nearly hidden beneath large hairy leaves. Small green-striped gourds loll in the shadows. White morning glory flowers with deep wine-red throats wind around a shattered tree trunk.

The river runs over gravel and sand, shallow and sparkling, then slows and pools into dark, deep runs. I can't gauge the depth of the slightly cloudy water. Not muddy but, as Hershall said, surprisingly clear; yet a foot or so below the surface, the water turns opaque. I watch Bill cast a lure into the slow, deep pool. There is enough current for me to drift downstream. As I slip past, I remember that his bright orange roto-molded plastic kayak is fourteen feet from prow to stern. I imagine an alligator, just a few inches longer and wider than his boat, lurking in the dark water below his kayak. I pull my feet back into the boat.

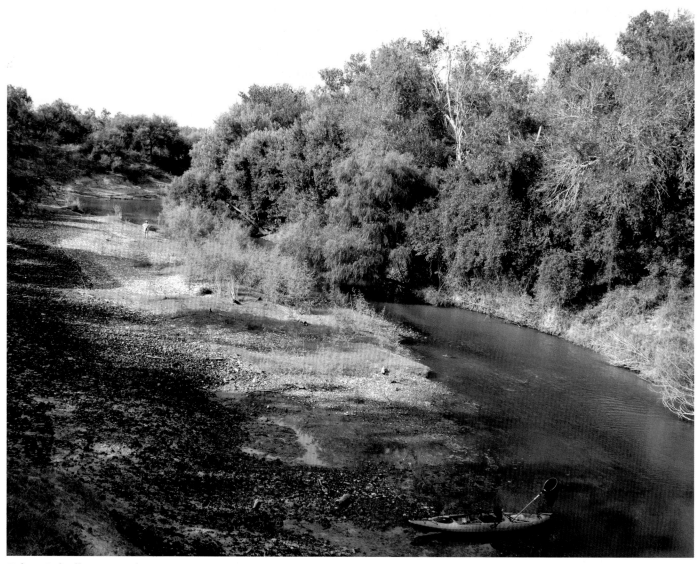

Below Oakville, Live Oak County

In my mind, alligators are coastal creatures, living in swamps and marshes. Definitely not in near-desert scrublands. But they've always been abundant along Texas rivers. In the Nueces and her tributaries, alligators are found from the coast nearly up to the Edwards Plateau. Again. American alligators were listed as endangered species from 1967 to 1978.[3] Protecting the population worked so well that not only were populations stabilized, but the gators have had a resurgence and reclaimed some of their historical territory. Hunting is allowed but tightly regulated. Tom Stoner, a ranch manager in the upper canyon and a distant relative of settler

Anna Stoner, told me that there are alligators all over the Brush Country. "Just about every tank has a gator or two," he told me. "If Texas Parks and Wildlife knew how many alligators there are out there, they'd know that they aren't in trouble anymore." He tells me that his grandfather roped and dragged a fourteen-foot alligator out of the river in the early 1900s. At the time, it was the largest alligator ever reported in Texas. William Bollaert, an Englishman traveling across Texas in 1844, wrote from near present-day George West, "When watering horse in the river this morning an alligator took my mare Fanny Baker's nose for a bait, made for it. Fanny snorted, when the alligator turned a sumerset and made off downstream."

We walk the kayaks through the gravel riffles and the shallow sandy sections, my boat nudging the back of my knees like an impatient dog. We round a bend and high above the river, in the top of a dead oak, a wood stork soaks up the morning sun. Four great blue herons are staged in the lower limbs. In the river below, roseate spoonbills swing their spatulate bills in the water while a tricolored heron, a little blue heron, and a couple of snowy egrets stand facing the sun. My kayak swings out into the current, spooking all but the stork into agitated flight. The stork remains, serene and gawky on his tall perch. Bill gives me an evil glance for disrupting what would have been a terrific photo. I follow a lovely raucous great kiskadee with my binoculars, its sulfur breast and attitude brightening the day. "Kiss-ka-dee," I tell Bill in my best squeaky rubber-duck voice. He grins and hops into his kayak, disappearing into the leaves of a large willow.

We emerge from the willow limbs unscathed and terrify a small herd of cattle. They wheel and lumber up the bank, sliding knee deep into the loose sandy soil. Spotted sandpipers and killdeer peep and shrill on the far shore. A pair of turkey vultures hunches over what turns out to be a decapitated red-eared slider turtle. The sandy banks slump into the river carrying clumps of Mexican aster and Bermuda grass. Sumpweed, cocklebur, dewberry vines, peppervine, and bindweed tangle on the bank, an unpalatable mix that the cattle ignore.

I round a sharp bend, the river swift and narrow between tall, bare banks. Two large red-eared sliders plunge into the river from a mud ledge. A double-crested cormorant basking next to the turtles tries to make a running takeoff across the river, but the channel is too narrow for

the bird to gain flight. It ends up ignobly paddling neck deep. We round the next bend and it belly flops from a log back into the river. We'll continue to unintentionally harass the cormorant as it tries, over and over, to find a spot to dry its wings in the sun so it can fly away. Cormorant feathers aren't waterproof but permeable—an advantage when diving to catch fish, but the feathers require thorough drying before the cormorant can make its running takeoff into flight.

I hear the distinctive cry of a leopard frog in distress. I paddle over to the bank, scanning and searching. Bill joins me; we can both hear the frog and suspect that a watersnake is behind the noise but we can see nothing. Bill leans over and looks like he's trying to stick his head into the water. "It's coming from one of these crawdad tunnels," he tells me. I listen, and the sound fades. A green kingfisher chases a belted kingfisher downstream, both of them yelling back and forth as they pass us. Moments later a kingfisher careens upstream. We both assume that it is the belted kingfisher returning, until it gets closer and we realize that it is much larger and has a bright rufous belly. The ringed kingfisher swoops past us—we've hit the Kingfisher Trifecta. Another bend and the cormorant plunges into the river to swim away yet again. Bill and I both see a flock of turkey vultures on the bank at the same time. "Something big and dead," Bill calls to me. I brace myself for the smell when the turkey vultures stand up and strut away, single file along the river bank. Bill and I look at each other. How did we mistake a flock of wild turkeys for turkey vultures? For the first time I understand the vulture's name. The cormorant swims downstream below them.

We reluctantly turn around to paddle upstream. Big red wasps fly over the river, the sun shining through their bodies so they glow. Dragonflies clatter past, hunting, mating, and laying eggs in the river. Damselflies flutter in the bright light, dazzling shades of lavender and azure. Paddling up a deep slow section, we look up at the big cumulus clouds and watch migrating hawks high up in the sky. Above the river corridor a pair of Cooper's hawks harass a red-tailed hawk. Vultures, caracaras, and a Harris's hawk circle in rising thermals. We walk the kayaks upstream through the shallow riffles and sandy stretches, the kayaks gently resisting the current.

9 *Third Time's the Charm*

Downstream of Oakville, the river runs past George West, the town planned, designed, and named in the early 1900s by developer George West (clearly a modest man). Family members got their own towns along the San Antonio, Uvalde & Gulf Railroad's line across the river valley. Kitty West and Ike West, like many of the towns that sprang up along the railroad, have all but disappeared, diminished by time and bypassed by main roads and highways.

In early spring 2013, in the midst of a massive drought, I drove back roads, looking for the river. I turned off Highway 281 south of George West onto County Road 151, where the map showed a thin line stretching across the river. The road pitched forward over the crest of a hill, and suddenly I could see for miles across the river bottomlands. The road plunged arrow straight, rolling down the hills and river terraces, and deposited me next to an old building, easily imaginable as a general store or café. A tall sabal palm rattled its fronds in the wind, scratching the rusting tin roof with papery fingers. A few houses and trailers still fronted the old road by the abandoned building. As I crossed the railroad tracks, the road slid down the last terrace into a brush-covered flat along the river. The bridge between Mikeska and old Gussetville (or Fox Nation) is a one-lane steel and wood structure that creaked, popped, and swayed as I drove across it. Steep banks encased a muddy, slow current twenty feet below. Thorny retama and blackbrush mixed with hackberry and chinaberry trees along the banks. Twisted live oaks lifted heavy dark limbs above the fray on the upper banks. Driftwood studded with basking turtles was knotted around the rusting pilings of the bridge. No trails or roads led down to the river. Docks were suspended a dozen feet above the water, waiting for rain.

Following the river south, I drove through housing developments on

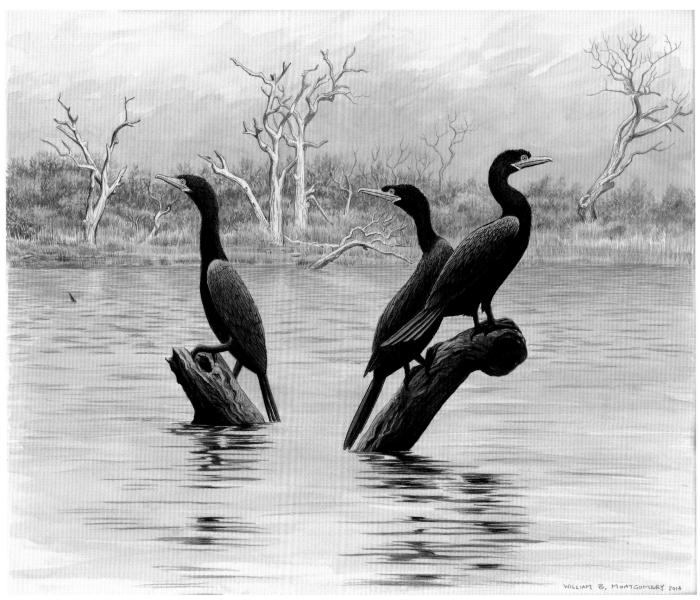

Neotropical Cormorants

what should have been the upper end of Lake Corpus Christi. There was no lake to be seen, just stranded boats and docks on grassy slopes and in thickets of willow.

A year later, rain fills Lake Corpus Christi for the first time in over four years. In late May, Bill and I drive a muddy potholed road to Mustang Hollow's primitive boat ramp on the upper end of the lake. While we launch the johnboat, a pair of great kiskadees squeak and call from a nest built on the stump of a long-dead tree in the middle of the freshly filled cove.

Out on the lake we immediately get lost in the acres of half-submerged willow thickets clogging the numerous arms, channels, and coves of the upper lake. Relying on a cell phone to navigate the tangled brush, we backtrack over and over, thrashing through brush trying to find the main channel. As fast as spiders and caterpillars fall into the boat, I scoop them up and release them into the next willow tree.

We weave the boat through the willows. Alligator, spotted, and long-nose gar swim among the saplings, rolling on the surface and striking shad and minnows. A flock of double-crested cormorants swims, looking like a ridiculous school of Loch Ness Nellies with only their heads and skinny necks above water. They paddle furiously after a school of bait fish. The birds dive and pop to the surface to fling their catch into the air, the silver fish glittering and then sliding headfirst into gullets. We pass lines of posts, the old footings of a bridge that formerly led to a ranch house overlooking the river valley. Cormorants are ranged along the posts, wings spread to the sun, with a few elegant snowy egrets standing in stark contrast. Fifty or so cormorants swim alongside us.

Somewhere below us are dozens of capped oil wells from the old Mount Lucas field, one of the numerous riverside oil and gas fields developed from the 1930s until the 1960s, when the current lake filled the valley. Lake Lovenskiold, predecessor to the current Lake Corpus Christi, was less than a quarter of the volume in a much smaller footprint, so this section of river valley was miles upstream from the lake. Even after construction of the present Wesley E. Seale Dam, the new lake was held six feet below its planned level for four years so that operators could deplete as much of the previously tapped oil and gas reserves as possible and securely cap the wells.

We emerge from a willow thicket into the main channel of the lake and power upstream. The current is dense and thick with silt. Occasionally the boat shudders from impact with a log or branch roiling in the dark current. We hold our breath and look at each other in alarm until the outboard purrs along again. Silver-gray giants line the narrowing river channel, each old oak or pecan with limbs bark-stripped and bare against the ultramarine sky. Egrets, herons, and ospreys share the tall perches. We pass beneath a railroad trestle, then a road. In the all-too-brief shade, cliff swallows cry and launch themselves from their mud nests to spin around

us. It doesn't seem fair to feel such pleasure in the colony's alarm but I lean back and watch the birds swoop and spin above me.

In our small boat we push upstream until we reach the narrow river channel. Steep wooded banks frame both sides and we fight against the current. The flow is too strong for our small outboard and although we'd like to continue up as far as Mikeska, we turn around just downstream from the site of Fort Merrill, abandoned by the US Army over 150 years ago.

Running with the current with late afternoon light slanting into the water, we can see clouds of silty water billowing wherever a creek or new channel joins the main stream. The surface of the river as it transforms into a lake looks placid at first glance, but strong currents and hidden debris shove our boat from side to side, push us into eddies, and bang against the metal skin. Bill leans back, watching the lake's surface through

Upper Lake Corpus Christi, Live Oak County

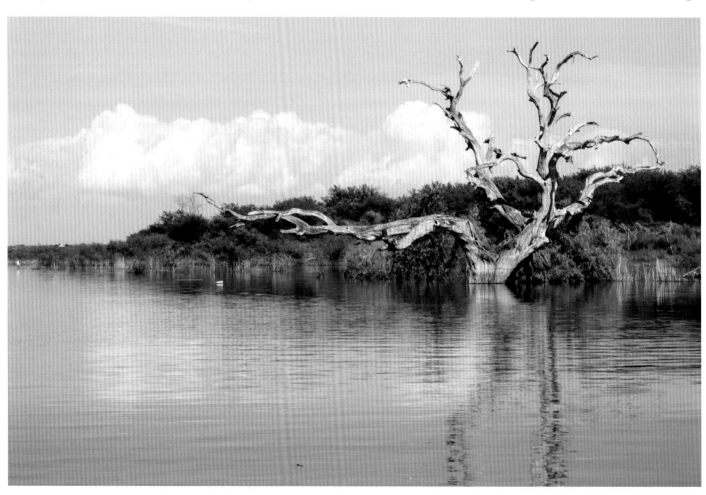

squinting eyes, and reminds me to keep a lookout for logs and branches.

We pause for a moment's respite in the shade of the County Road 534 bridge. Bill gives a long whistling exhale and shakes his head. I rotate my shoulders, feeling as if we've just exited a busy expressway. The swallows are spinning in dazzling displays, catching insects on the wing. Some swoop down to sip from the lake's surface while others line up along the shore, chattering and drinking. Above us a car rumbles on the road between the old towns of Swinney Switch and Dinero. Next to the bridge is the water intake for the town of Beeville, one of many towns that depend on the combined waters of Choke Canyon Reservoir and Lake Corpus Christi. I look around, and there isn't a water hyacinth in sight; they've all been washed downstream. Usually the upper part of the lake is choked with dense mats of the purple-flowered invasive plant. Water hyacinth has been a problem on Lake Corpus Christi since the early 1960s, if not earlier. Lake residents have petitioned the city again and again over the decades to please eradicate the floating plants clogging the lake and sloughs. The lovely flowers and bright green foliage are the reason that gardeners transported and introduced this tenacious ornamental all over the world. Native to the Amazon River basin where insects and predators, like nutria, aggressively keep the rapidly growing plant in check, it has been clogging waterways in the United States since its introduction in the early 1880s. The dense mats shade the water, choke out native plants, increase evaporative rates through transpiration, destroy water quality as dying plants rot, and clog waterways as well as intakes and pumps. In North America (as well as in Australia, Africa, Asia, and Europe), the only controls for the fast-growing plants are chemical (herbicides) or mechanical—pulling the plants out of the water. But since a single plant can produce three thousand others in less than two months and seeds remain viable for up to twenty years, it is rare for hyacinths to be eradicated once established.

Across the channel, an anhinga perched in a dead tree crooks its long neck and spreads its wings and broad tail to dry in the sun. We've seen hundreds of cormorants, dozens of herons, egrets, and several anhingas, all fishing birds. As if on cue, a big alligator gar rolls just feet away from us. Bill looks longingly at his fishing rod, then at me. The current impatiently nudges the boat downstream.

We return to our shelter (with amenities) at Lake Corpus Christi State Park. Tired, hot, and covered with crusting mud, we walk to the lakeshore and, without pausing, walk straight into the water wearing our clothes and sandals. There is a top layer of warm water, then delicious coolness with the temperature dipping so that my feet are nearly chilly by the time we are neck deep. My nylon fishing shirt and pants billow around me, and clouds of dissolving mud drift away in the clear water. The inflowing sediment-filled water hasn't reached the lower end of the lake yet. We slog out of the lake leaving a trail of dripping footsteps, yet by the time we reach our shelter, our clothes are nearly dry. We eat this trip's meal standing outside: crisp tostadas with chicken, lettuce, tomato, and heaping spoons of pico de gallo and guacamole. Juices run down our faces as the tostadas crack and we eat out of our hands, fiery peppers making my eyes run. We fall asleep as the park fills with weekend campers. Vehicles

Anhinga

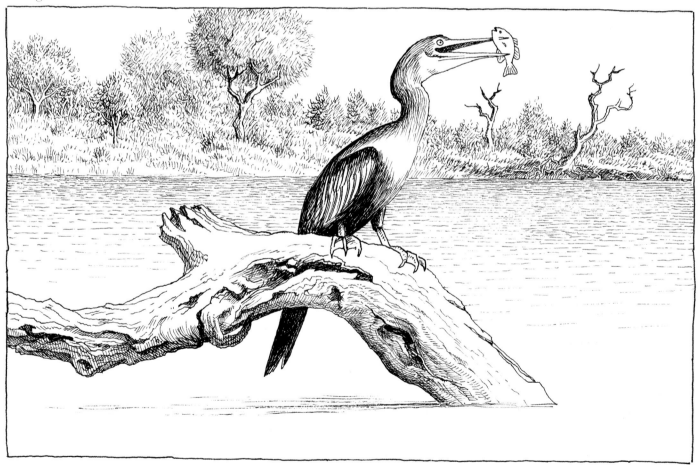

circle the sites like sharks, trying to decide which one is the best. Excited voices pierce the night as gear is unpacked, set up, and the area explored. The last thing I remember is the unlikely smell of campfire smoke drifting in the warm, humid night.

CASA BLANCA
Lake Corpus Christi State Park

Early morning is cool, quiet, and misty. Last night's campers are still asleep. Bill and I take our coffee and walk up to the refectory, what I always think of as the Pavilion. We skirt the building with its graceful repeating arches and open-air rooms perched at the end of a peninsula overlooking the lake. I love the red brick and contrasting white cast-stone walls (local caliche and cement), but the only residents are swallows, still quiet in their nests in the ceilings and along the eaves. We sit on the walls of the old staircases that once led down to the lakeshore. Now the stairs are surrounded by mesquite, blackbrush, huisache, and guajillo. A few slender paths wind through the thornscrub down to the white bluffs at the water's edge but the park maintains no trails here.

A light breeze whispers past us and the mist settles into a thick fog on the surface of the lake. All we see are the high bluffs floating above the cloud. The blank eyes of the distant houses reflect the rising sun back at us. Forty feet below us, somewhere in the mist, a fisherman tries to start up a boat, grinding the starter motor over and over, the engine never quite catching.

The Texas legislature founded Lake Corpus Christi State Park in 1934 by leasing land from the City of Corpus Christi (until 2032). During the next two years the Civilian Conservation Corps built roads, bridges, the refectory, and a boathouse on the park's lakeshore. At the time, Lake Lovenskiold (also called Lake Nueces, Lake Mathis, and, confusingly, Lake Corpus Christi) lapped at a shoreline seventy-four feet above the river's channel, twenty feet below today's lake level.

Looking out over the lake, I'm surprised—as always—by the rolling hills, bluffs, and deeply incised creek valleys that make up the land surrounding the reservoir. We're only thirty miles from the Gulf of Mexico, yet this rolling topography rises above the gently undulating coastal plain.

On the distant shore of the lake, sitting on a bluff overlooking the former Peñitas Creek valley are the ruins of Casa Blanca. Built from blocks of the local white Goliad stone, the ranch house, sometimes called a fort, housed Juan José de la Garza Montemayor and his extended family. The Casa Blanca grant, awarded to Montemayor in 1806 by the Spanish government, sprawled over sixteen leagues (70,848 acres) in the province of Nuevo Santander on the west bank of the Nueces. As with many of the grants along the Nueces, Montemayor and his family were well established by the time the paperwork was official.

In 1810 at the inception of the Mexican Revolution, Spain pulled its soldiers out of the northern provinces of Texas and Nuevo Santander, leaving her citizens to defend themselves. While the outlying provinces were spared many of the direct impacts of the revolution, the ranchos between the Rio Grande and the Nueces River did not escape unscathed. The lack of soldiers and the general unrest facilitated a wave of fierce Lipan Apache and Comanche raids throughout the trans-Nueces. Ranchos were abandoned and stock scattered as the rancheros and their families, vaqueros, and ranch hands fled to the safety of the Rio Grande settlements. Folklore has the Montemayor family murdered before they were able to escape, leaving behind wooden kegs of gold and silver buried near the ranch house. According to J. Frank Dobie, "Every old ranch in the Nueces country, every old road, every hollow and water hole has its story of treasure. But . . . the most famous resort of the treasure seekers is Casa Blanca" (Dobie 1978).

The Nueces seems to have more tales of lost treasures than other rivers. Tales about gold and silver bullion, Spanish doubloons, and other wealth buried along the roads abound. The Caminos Reales connecting the Spanish missions and Mexico, plus later trade routes, and, always, the paths taken by soldiers and armies—all of these roads have their stories of treasure. Valuables were buried for protection from thieves, hidden for safekeeping until the owner could return, or secreted away so that their master could travel swiftly and safely. Imagine mule trains, ox wagons, and *carretas* (two-wheeled oxcarts) filled with a rancher's annual yield of wool, hides, cotton, or other goods hauled slowly cross-country. The slow-moving pack trains had to travel where there was water and forage, fords or ferries for crossing rivers, and, if possible, protection from thieves and

bandits. Often slowed or stopped by weather, the long trains of mules and ox-drawn wagons had to contend with drought and flooding creeks and rivers, as well as highwaymen ready to liberate goods and profits. Are any of the old legends true? Are there casks of gold and silver moldering in the earth, marked by piles of stones and trees long gone? Or was the treasure always there, unrecognized or ignored?

<div align="center">✦ ✦ ✦</div>

In 1825, after the Mexican Revolution, the newly minted Mexican state of Tamaulipas adopted a constitution that claimed as its territory what had previously been the province of Nuevo Santander, retaining the Nueces River as its northernmost boundary. Beyond that boundary and east of the Nueces River, two former Spanish provinces were united into one state: Coahuila y Texas. In the years after the revolution, Mexican rancheros returned to settle the country, rebuilding ranchos and rebuffing Indian hostility. Mexico encouraged settlers to move to its northern states, recognized existing *empresario* grants (such as Moses and Stephen F. Austin's), and signed new grants guaranteeing land to colonists, such as the Irish McMullen and McGloin Colony (San Patricio) in Coahuila y Texas on the east bank of the Nueces. But in 1835, the Texas Revolution upended the era of relative peace and prosperity. Once again the rancheros fled, leaving everything behind to seek protection on the Rio Grande.

Mexico, not surprisingly, refused to recognize the Republic of Texas and its territorial claims. Texas passed the Boundary Act of 1836, claiming its boundaries extended to the Rio Grande. Armies from both sides raided across the Nueces Strip, trying to establish and reestablish their claims to the other's territory. But to be clear, it wasn't just grazing lands and salt lakes between the rivers that the two republics were quarreling over. The legal boundary between Tamaulipas and Texas had long been recognized as the Nueces, but the Rio Grande, with its possibilities for steamboat travel as well as its numerous ports, especially Matamoros's port of Brazos Santiago, was a desirable and strategic jewel. The contested Nueces region became increasingly dangerous, lawless, and unstable. Gangs of outlaws including Anglo, Indian, and Mexican men and boys stole cattle and horses. Traders and homesteaders, Anglos and native-born Tejanos were attacked. Comanche raided deep into Mexico

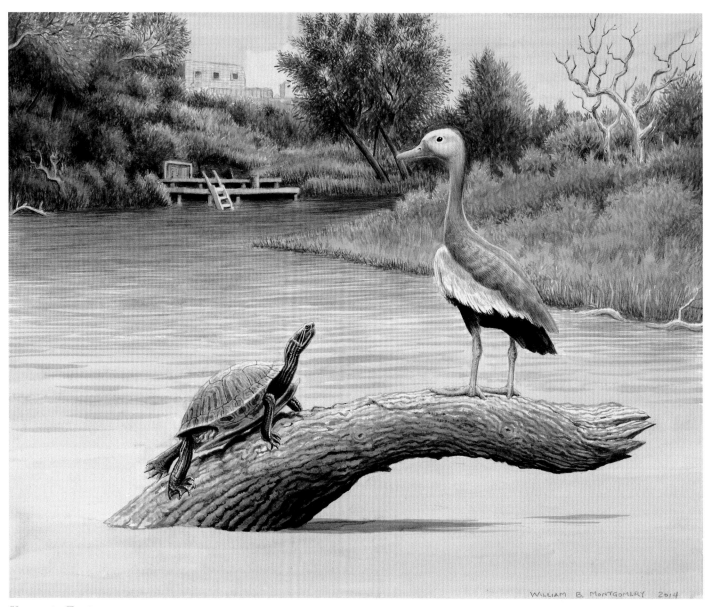

Uncertain Territory

as well as throughout the disputed area. Yet Anglo settlers continued to move in, determined to expand the frontier. Relationships between Anglo-Americans and Tejanos continued to corrode as banditry, murder, and retaliation became the norm.

The boundary question wasn't settled until after the United States legally annexed and admitted Texas as a state of the Union in 1845. As part of the annexation agreement, Texas promised to abide by the United States' adjustment of the boundary, but, uniquely, the state retained all

of its debts and public funds along with all the vacant and unappropriated land within its limits. And of course the new state declared that the Nueces Strip was already part of Texas.

War broke out. Again. This time between the United States and Mexico. The Mexican-American War lasted less than three years and ended with the Treaty of Guadalupe Hidalgo in early 1848. Mexico not only lost the Nueces Strip but surrendered claims to half its territory including present-day New Mexico, Arizona, California, Utah, and parts of Colorado and Wyoming. The border was officially set in the middle of the Rio Grande. Settlers started flooding in, the stream interrupted by a brief hiatus during the Civil War.

S. G. (Sylvanus Gerald) Miller arrived in 1859, when the territorial disputes were settled but the area was still beset with outlaws and bands of robbers. Yet he was captivated by the river valley. According to the memoir penned by his wife, Susan E. Miller:

> Before they reached the San Patricio settlement, they came to an eminence overlooking a beautiful valley. . . . Spread out before them was a fertile stretch of land, whose expanse of grass was broken here and there by occasional mesquite trees. Nearer at hand, was the Nueces River, a splendid stream of water. "This is the most beautiful spot I ever saw, and here I am going to pitch my tent," declared Mr. Miller. (Miller, Collins, and Roberts 1930)

Miller was industrious. He purchased 350 acres on the east side of the river from one of the original San Patricio grants, established a horse ranch, and then joined Terry's Texas Rangers to fight for the Confederacy. When he returned after the war, he bought additional tracts of land until his property was over five thousand acres of Nueces River valley surrounded by tall bluffs and rolling hills. He built and ran a ferry on the river on the road between Goliad and Matamoros. Miller constantly worked to improve the ranch, installing windmills, fences, and earthen tanks. At some point he found the time to meet and marry Susan East on a horse-buying trip in Louisiana. He even installed a boiler and steam-driven pump for irrigation in 1893. While the pumping plant worked and irrigated nearly 140 acres, Miller was on record saying he was dubious

that irrigating by steam would ever pay because the expense was just too great. But his irrigation experiment attracted the attention of incoming settlers to the point that his wife, Susan, regularly prepared meals for twenty-five or more visitors at a time.

Looking at old topographic maps, I can appreciate why Miller and the Montemayors built their homes on the bluffs overlooking the river valley. Near the state park, the valley is narrow—and the perfect site for a dam—but upstream it broadens into a wide basin of rolling prairies and bottomlands surrounded by rocky bluffs. Susan Miller wrote that the country was beautiful beyond the power of words to describe.

> Stretched before us was the magnificent valley that led Mr. Miller to choose this location above all others he had seen in Texas. It was a vivid green in tall, waving mesquite grass, a vast rolling prairie broken here and there with only an occasional old mesquite. Added to this was a vivid splash of wild flowers, spread like colored lace over the green. Mr. Miller and I would walk in the dusk at evening, gathering great armsful of these flowers with which we decorated our home. (Miller, Collins, and Roberts 1930)

Third Time's the Charm

It is clear from her book *Sixty Years in the Nueces Valley* that Susan Miller loved her life on the Nueces. When she arrived in 1870, she said the Nueces was a "bold, swift-running stream that was at least twenty feet deep." The rivers and creeks were lined with big timber. And there was grass, grass everywhere, waving in the breeze like vast fields of wheat. The book includes small photos of bottomland forest with tall oaks covered with swaying beards of Spanish moss and surrounded by plants and grasses. Another shows the tall grasses that she described as "more than knee-high to the wild cattle and horses." But this ranch, where she took joy in watching flocks of a hundred wild turkeys, herds of deer, and the herds, or *manadas*, of their horses grazing and running across the prairies, was destined for change.

According to Susan Miller, by the time the City of Corpus Christi settled on the La Fruta Dam site and the bluff-rimmed valley upstream for

a reservoir, the area had already changed drastically. The river, she said, had become clogged with sediment from overflows. The formerly deep channel had filled in more than twenty feet, and the river itself had diminished to a trickle. The broad expanses of prairie had been divided up and fenced into small tracts with brush growing up wherever the land was not in cultivation. Farmers plowed up the prairies and grew cotton that, for the first few crops, grew fast and healthy with fresh fertile soil and no pests to cut down on yield. Livestock—cattle, goats, and sheep—grew fat on the fine range.

Eastern amberwing

Still she lamented the loss of the beautiful valley she'd known for fifty years and the impending flooding of eight thousand acres of land for the reservoir.

In 1927, the state Board of Water Engineers granted a permit to the City of Corpus Christi for the impoundment and use of half a million acre-feet of water per year for power and municipal purposes. Over the years there had been numerous proposals for building water supply reservoirs in the lower river, some thoughtful, others astonishing. Such as the 1917 resolution by the Texas legislature requesting that the federal government begin investigation into building a dam across the dividing line between Nueces Bay and Corpus Christi Bay in order to convert Nueces Bay into a freshwater lake. As ridiculous as it sounds, it wouldn't be the last outlandish proposal concerning reservoirs on the Nueces.

In comparison, the chosen site was a logical choice, with tall bluffs circling a wide river valley that narrowed just north of the village of La Fruta. In January 1929, the earthen dam was closed and the lake began to fill. The City of Corpus Christi planned to release water as needed to flow downstream thirty miles to Calallen Pool, where big pumps would pull the water into the city's pipes.

The dam and reservoir worked as planned for about a year. The La Fruta Dam and Lake Lovenskiold spent eleven months brimful with what the engineers considered a normal amount of seepage at the toe of the spillway section. Contrary to popular belief (or superstition), most dams are not watertight and a little seepage is expected. However, the foundation of La Fruta Dam was silently eroding. On November 23, 1930, a fisherman noticed the water "boiling" at the edge of the spillway's concrete apron. Within minutes the concrete started vibrating from building

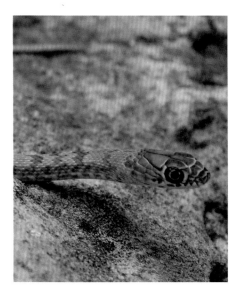

Juvenile coachwhip

pressure. The fisherman scampered up a twenty-foot embankment out of the river channel in time to see the concrete disappear beneath a torrent of water. In moments, two hundred feet of the dam washed away. The lake poured through the breach, emptying completely within a day. Downstream the river rose, but no more than what one city official deemed "ordinary flood conditions." Luckily the dam hadn't been in place long enough for the downstream river dwellers to lose their vigilance.

By 1934 the dam was redesigned and rebuilt, this time with gates to control releases over the dam, just in time for the massive floods of 1935.

The repaired dam, now called Mathis Dam (though the lake was also called Lake Lovenskiold, Lake Mathis, and Lake Corpus Christi), was not designed as a flood control structure. Reservoirs for flood control are designed to stay partially empty to catch floodwater, while water supply reservoirs are kept as full as possible. The weather patterns of the 1930s that produced massive flooding over much of the state have yet to be repeated—luckily. We've had some extraordinary floods since, but nothing like those record-breaking rises. And as Susan Miller noted, every overflow carried enormous quantities of soil downstream.

It was clear to the city that it needed another reservoir almost immediately. The new lake had held about fifty-four thousand acre-feet when it first filled (and refilled). But in just fourteen years, it had lost over a quarter of its capacity as it filled with silt. Soil running off farmers' fields, overgrazed pastures, and drought-burned land settled into the depths of the lake—sediment and nutrients that would have flowed downstream to nourish and build the delta.

The city had the permit for a larger reservoir and needed the water. Not only for the city—whose population had quadrupled in twenty years—and her industries, but also for towns like Alice, Beeville, and other residents of the Coastal Bend.

In 1952, engineers presented the city with ten possible sites for new dams and reservoirs in the thirty-five river miles between Mathis Dam and Nueces Bay. Several were sites that the US Army Corps of Engineers and other engineers had evaluated earlier. When I look at the maps of the proposed reservoir sites, they cover every bit of ground from a dam across the middle of Nueces Bay (from White's Point to Viola) all the way upstream to Mathis Dam.

The dams would all have been at least four miles in length to cross the river's bottomlands, creating wide and shallow reservoirs. The city decided on the New Mathis Site, just downstream of the existing dam, a plan that would quadruple the size of the existing lake. Construction began in 1955 on the Wesley E. Seale Dam, which would finish out at ninety feet tall and over a mile in total length. When it was completed in 1958, the rising lake water submerged the old dam (breached and usable parts were salvaged) and filled the riverbed and valley for twenty-four miles upstream, covering almost twenty thousand acres. The cast stone and brick boathouse built by the Civilian Conservation Corps at the state park disappeared as the new lake filled. The new lake, stubbornly referred to as Mathis Lake by the town of Mathis and as Lake Corpus Christi by the city, increased the city's water storage sevenfold.

✦ ✦ ✦

The sun is up and the mist is burning off the lake below us. Bill returns to our shelter to work on the boat's sticking throttle; I follow a nature path through the mesquite thickets down to the boat ramp. In the distance I hear children screaming. I've never learned to gauge the caliber of children's shrieks. Excitement or danger? Fear or joy? I hurry down the path and then the road toward the fishing pier. In the screened fish-cleaning station, five kids are shrieking and yelling. I step into the room cautiously. A bright-eyed little boy looks up at me, a Gulf Coast toad clutched in each hand. "Toads!" he squeals with ear-piercing volume. Another boy kneels on the ground, all business as he tries to corral a cluster of toads like tiny heifers. The toads are having none of it and placidly blink and hop away. The two boys no sooner gather their herd under one of the sinks when a renegade hops away, and then suddenly the toads are stampeding everywhere. The loudest shriek comes from behind me. I see a trio of little girls with long brown hair, each with her own green tree frog. The youngest girl, wearing a pink plastic tiara in her dark hair, squeals with delight as her frog slowly and stickily walks up her arm. She angles her arm toward me, her face glowing. "Is it a prince?" I ask. She and her two friends giggle and roll their eyes at me. "It's a frog," the princess tells me. "Oh, I see," I say, "a green tree frog." This causes another eruption of giggles and shrieks as one, then two frogs leap out of their captor's hands. "Frogs

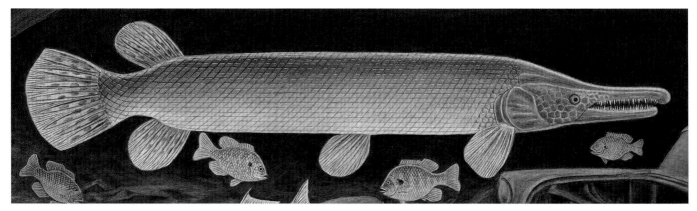
Alligator gar

don't live in trees," the princess tells me with confidence. Her frog leaps up and lands with a splat on my neck. "See," I say, "it goes up to get away," as I peel it off my bare skin and hand it back to her. The girl looks at me, brows drawn for a spilt second. With a radiant smile she turns and runs off, calling, "Daddy! I've got a frog and it lives in trees. That's why it's green!" Her sisters run after their leaping frogs. Meanwhile the toads have hopped out of the shelter, and the two boys run back to the campsites clutching a toad in each hand.

10 *The Nueces Bottoms*

LA FRUTA PADDLING TRAIL

I am sitting next to the river in La Fruta Park, just downstream of the Wesley E. Seale Dam and the 258-acre City of Corpus Christi Wildlife Sanctuary. Harry, a San Patricio County Parks employee, and Bill are off shuttling our truck to the takeout at San Patricio de Hibernia Park. San Patricio County Parks offers kayak rentals and a pick-up service, but when we learned that we'd have to make it to the takeout spot by three o'clock, we accepted Harry's offer to take our truck downstream.

I sit on my kayak in the warm light drizzle waiting for Bill to return.

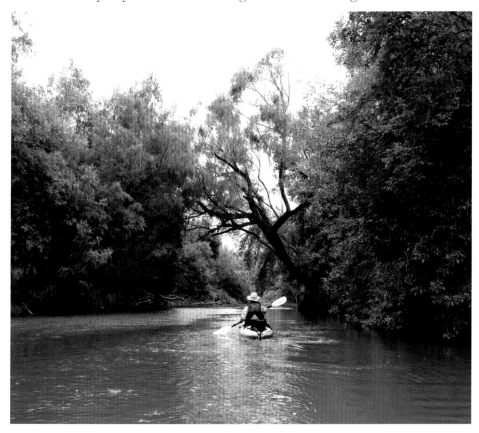

La Fruta Paddling Trail, San Patricio County

Red-eared slider

A soda bottle slowly floats downstream. A stand of bulrushes rustles next to me with a few water hyacinths tangled at the water's edge. I can barely hear Highway 359 though it is just upstream. The drizzle increases and rain starts pattering on the leaves around me. Bill phones. "It is really raining. Are you sure you want to go?" I stubbornly insist that the rain will pass.

The guys return and Harry helps us lower the kayaks down the sheer bank. "No one's gone down this year to clear the river," he tells us. "I hope there aren't too many trees in the way."

"We'll be fine," I tell him cheerfully, shoving back the nagging sense that I'm about to get us into trouble.

We start paddling. Steep banks covered with tall switchgrass encase the river on both sides. Ash trees, pecans, oaks, and hackberries lean over the river dangling long skeins of Spanish moss. Early settlers boiled Spanish moss and mixed it with mud to plaster the walls of their rough cabins. Others soaked the moss until it turned black and then dried it for stuffing upholstered furniture. Willows grow along the banks. Mist covers my glasses and turns the world soft-focus and blurry. Bill takes his glasses off while I fruitlessly squeegee water off the lens with my fingers. The water, cool from the depths of Lake Corpus Christi, smells fresh. The dark smell of the river mud combines with the rich fragrance of leaf-covered forest floor. Green tree frogs call as the river landscape disappears into mist. We may be blinded but the green jays find us and bound downstream from tree to tree, alerting the world that interlopers have arrived. Suddenly the trees are alive with yelling chickadees, white-eyed vireos, cardinals, Carolina wrens, and woodpeckers. Our entourage follows us downstream, their calls skittering off the water like skipping stones and filling the river channel. They tire of us and fly away. The river falls quiet again. The current gurgles and ripples against the banks, murmuring as it runs through water pennywort, then stands of bulrush, young willow saplings, and smartweed. The occasional slap of a fish hitting the surface breaks into the rhythm of dipping paddles and water dripping off the blades.

The water isn't crystal clear but neither is it muddy. We pass a series of low white caliche bluffs next to the river. The river is a single stream with steeply wooded banks backed by pastures and ranches. Out of sight are the rolling bottomlands that stretch ever wider as we descend the river.

We pass fishing camps, the simple shacks high up the twenty-foot banks. Aluminum ladders, rickety stairs, and a walkway made of wooden pallets skid down the incline to the river's edge where docks and chairs sit, waiting for fishermen. One camp has an elaborate setup of a long metal pole leaning over the river with a Coleman lantern attached with rope and pulleys. Bill laughs at the ingenuity. The light attracts insects, which attract small fish, which attract larger fish, and on up the food chain.

The sun pierces the mist, and within moments the clouds have lifted and we are bathed in sunlight. I take off my glasses and realize that some of the fog was actually greasy sunscreen smears on the lenses.

We pass a group of white cattle drinking from the river. Their paths down the banks are raw dirt scrapes; the river blooms with muddy water stirred up by their hooves.

Like the river between Choke Canyon Reservoir and Lake Corpus Christi, this section is not seasonal (or intermittent) and not dependent on rains to fill the stream. The perennial flow of water downstream to Corpus Christi's water intake at Calallen Dam nourishes the riparian zone—the ribbons of land transitioning from the drier uplands down to the water's edge. A functioning riparian zone is quite extraordinary; it filters and cleans water, slows down floods to reduce damage, and allows water to move back and forth between alluvial aquifers and the river—services that simply cannot be replaced by engineered processes.

The city has been protecting the watershed and the water supply for nearly a century. In 1924, the river was polluted by waste escaping from a gas well, what newspapers referred to as a "huge gasser that was running wild," in the western end of San Patricio County. The state started requiring oil companies to build levees around the wells. Yet in the 1930s, oil and gas well blowouts again threatened the city's water supply. Both north and south of the Sandia area (just west of La Fruta), blowouts resulted in overflows of large quantities of saltwater. The city knew that if a well blew in one of the many small oil and gas fields next to the river or lake, the saltwater contamination could prove devastating. The Railroad Commission adopted rules requiring blowout preventers and adequate surface casing (heavy pipe) in the area.

In the 1970s, the city, along with the Nueces River Authority, successfully opposed a proposed industrial waste dump (for steel drums of

benzene and other hydrocarbon cleaning agents from Houston petro-chemical plants) on Weedy Creek, a tributary of the Atascosa River. Engineers on either side gave diametrically opposed testimony regarding whether the proposed stored toxic wastes (up to 325 tons per day) would seep out and contaminate nearby groundwater and, eventually, Lake Corpus Christi. Ultimately the plan to site the dump on leased property dissuaded state officials from granting the permit (as did the lawsuit against the two owners—both former state representatives—for illegally dumping toxic waste into a caliche pit on a private ranch). If the company went out of business, who would assume responsibility for monitoring the pits of liquid chemical waste for the next century or more? Assistant Attorney General Rod Gorman pithily remarked that the state required more in the way of future care for cemeteries than for hazardous chemical dumps.

Nowadays Corpus Christi and the Nueces River Authority continue to work together with local landowners to protect the river. And that means considering the entire drainage area. The Texas State Soil and Water Conservation Board and the Nueces River Authority have just submitted a Watershed Protection Plan to the Environmental Protection Agency. This comprehensive plan won't instantly undo the decades of overgrazing, restore the timber-filled bottomlands, or get rid of all the leaking septic systems, but it is a start.

The Nueces River Authority is an unusual state agency. It is small—eight employees split between an office upstream in Uvalde and a Corpus Christi office. The Authority, despite its name, has no regulatory or taxing power. It doesn't own or operate hydroelectric or thermoelectric power plants, manage the river's reservoirs, hold the majority of water rights in the basin, or regulate water rights. Con Mims, executive director, laughs when I ask, "Just what does the Nueces River Authority do?" He swings into a history lesson about the origin of the Authority in 1935, the first staff members in 1961, and his employment since 1976. In the 1970s and 1980s, they fought against state-issued permits that would negatively impact the Nueces River basin (such as a low-level radioactive waste dump proposed for the Tilden area and the industrial waste dump). They worked with the city to build Choke Canyon Reservoir. They have banded together with landowners to remove motor vehicles from river-beds and have fought against San Antonio Water System's plans to pump

water in Uvalde and pipe it cross-country. "We are largely concerned with environmental protection of the resource. For years we've run water quality programs for the state, testing river water all over the basin. We're just completing our first utility project, a wastewater treatment plant in Leakey to protect the Frio River." He pauses. "But education and outreach are our priorities. We have a big education program for schools funded by the local Groundwater Conservation Districts, plus our riparian and watershed protection projects."

Every year a team of teachers and volunteers takes the Nueces River Authority's Water Stewardship Education Program to schools all over the Nueces River basin. The program, aligned with standardized testing, is customized to each school and class. I visited Jourdanton Junior High School to watch Nueces River Authority teacher Mary Bales and a class of fifth graders in action. From the start Mary is a masterful conductor, engaging the kids, letting their natural enthusiasm build until they are all leaning forward in their seats, hands shooting up, and calling out answers to questions about water catchment basins (watersheds), aquifers, erosion, conservation, and the water cycle. I'm impressed with how much these kids already know. More, I suspect, than most adults. Then the students move on to the hands-on activities. They crowd around a large, detailed, three-dimensional model of the Nueces River basin. The model disappears beneath their bowed heads as they run their hands over the canyons and river valleys, seeking their homes and places they know along the rivers and creeks. As she hands out a few small bottles of food coloring (non–point source pollution) and spray bottles with water (rain), she tells the kids, "Remember, clouds *only* rain on the Basin. *Not* on other students." I hear a stifled giggle or two and watch as nozzles discreetly swivel back to the model. Drops of pollution are placed on the model both on the rivers and far away. The clouds mist rain and the kids watch as the colors run downstream from the highlands of the canyonlands, across the South Texas Plains and Coastal Plains, and finally into Nueces Bay. They move to the aquifer demonstrations (one karst, one sand) and, again with colored water, watch the paths of water and pollution into and through the aquifers. The entire time Mary is asking questions, with the students answering, reframing what they've read in textbooks into water flowing downstream and sinking into aquifers.

Yellow-crowned nightheron

After the kids have gone, I help Mary pack up. She tells me that teachers are grateful for the program. "A science curriculum that comes to the school, free of charge?" Mary laughs. "We have trouble keeping up with the demand!" And more than one teacher has told her that the program has raised science scores on standardized tests. The program continues to grow, with nearly fifteen thousand students participating in 2015.

When I'd first visited Sky Jones-Lewey, resource protection and education director, at the Uvalde office she told me, "Resource protection through education of landowners, recreationists, and especially kids. Changing young minds, one at a time." Her delivery was fast, flat, and a little mechanical. But from what I've seen of Sky and the other employees, the Nueces River Authority's work is anything but rote. Clearly their work is fueled by a deep personal commitment to the region and its people. Not your average state bureaucracy at all.

Fort Lipantitlán

We round a large bend in the river. The broad floodplain runs eastward several miles before bumping up against the bluff at the far side of the river corridor. In the rolling bottomlands is the old town of San Patricio.

Water hyacinths near San Patricio

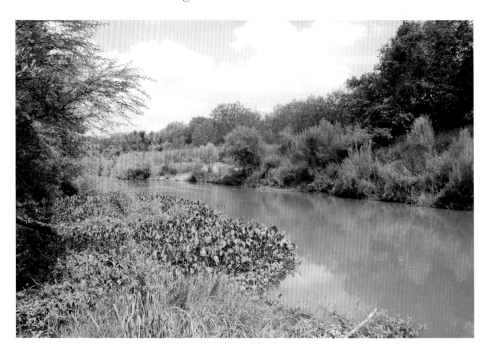

Overlooking the river is the Lipantitlán State Historical Site, the alleged location of Fort Lipantitlán. The fort, established in 1831 on the Casa Blanca grant on the west bank of the Nueces, was one of a string of garrisons built to protect Mexican Texas from unauthorized intrusions by Anglo colonists. Mexican general Manuel de Mier y Terán, in naming the fort "city or town of the Lipan," had also hoped to entice the newly arrived Lipan Apache (pushed into the South Texas Plains by Comanche) to settle in under the watchful eye of the military. Yet recent archaeological excavations show that people lived on the site long before the fort was established. Archaeologists believe this area has been continuously populated for nearly three thousand years and was the site of a large base camp of coastal Indians (not Apache) long before even Cabeza de Vaca arrived in the valley.

The location has everything needed: bluffs for camping out of the river's path, fresh water, abundant game in the bottomlands, and the Paso de San Miguel gravel ford for crossing and as a source of chert for tools. Plus there were pecans from the groves that flourished along the coastal rivers, oysters and clams from the bays, and mustang, deer, and pronghorn antelope from the coastal plains. And the Land of Tunas—the expanses of coastal prairie dense with prickly pear that drew native tribes from up and down the coast when the fruit ripened.

We know about the Land of Tunas because Álvar Núñez Cabeza de Vaca, the first European to land on Texas soil, survived to write about his experiences. After a shipwreck on a coastal island (thought to be near Galveston Island), Cabeza de Vaca and his surviving crew members were alternately saved and enslaved by different tribes. After nearly eight years, an escape from their captors, and an epic journey across the continent to the Pacific coast, they were rescued and eventually returned to Spain. Historians have used the accounts, written by Cabeza de Vaca, Alonso del Castillo, and Andrés Dorantes, to try to trace the Spaniards' route through present-day Texas. The journals are rich with descriptions of land and information about the native tribes and their customs, but there is controversy over Cabeza de Vaca's journey through the state. Texas nationalists have tried to shoehorn his path within the state's borders—even when it requires ignoring major geographical features like the Hill Country. Other historians think the route followed the coast down into

Mexico before swinging westward to the Pacific. And both camps look to the accounts to support their arguments. One of the singular descriptions is the Land of Tunas. Every year coastal tribes would travel cross-country to gather the ripe tunas of the prickly pear cactus. Also called pears, pear-apples, and figs, the fruits ripen to a dark red and black and are filled with tiny seeds.

No one knows the exact location of the Land of Tunas, but prior to 1899 prickly pears grew in superabundance near the lower Nueces River, continuing inland and southward until the vast sand plain in Kennedy County. Below the sand plain was another area reputedly thick with prickly pear along the lower Rio Grande. Did Cabeza de Vaca cross the Nueces near the Paso de San Miguel, stopping to gather pecans, before moving on to harvest prickly pears? I like to think so.

Too soon we've reached the end of the La Fruta Park Paddling Trail at San Patricio de Hibernia Park. The park is a thousand-acre tract deeded to the county with a conservation easement and the stipulation that it remain wild. The historic Dougherty home and school on the property are maintained as a museum. San Patricio, founded in 1829 by *empresarios* John McMullen and James McGloin, was a colony of Irish Catholic families on the east side of the river. Susan Miller, in her book *Sixty Years in the Nueces Valley*, recounts a story told to her by one of the original settlers. The first group of Irish families landed on the coast near present-day Rockport. The men went ashore to investigate the country and returned with their shirts full of rich purple fruits. No one knew, until the shirts were emptied and put back on, about the tiny spines that covered the prickly pear tunas. Or that eating tunas for the first time can cause violent stomach upset and brilliant pink urine. It was, she says, a memorable welcome to their new home. Within five years the colony was legally established as the Municipality of San Patricio in the Mexican state of Coahuila y Texas, and numerous land grants were confirmed. Unfortunately, San Patricio's citizens—Anglos who had sworn allegiance to Mexico—were caught in the ongoing conflicts that started with the Texas Revolution and continued for years. San Patricio's population waxed and waned as conflicts and lawlessness took over the land.

Bill spots the kayak takeout and we drag the boats onto the sandy

shore. To get to the truck, we drag the boats through neck-high sunflowers, epazote, and johnsongrass, crushing the plants into a fragrant green cloud. The long dirt road winds through old pastures grown up into mesquite and huisache brush and then passes Round Lake and the Dougherty House before dropping us on County Road 666 between San Patricio and La Fruta. It feels like we are on high ground but all of this area is high risk for floods. San Patricio County's William "Ski" Zagorski tells me that the county has limited power to impose local rules on property owners. Its solution is to buy out landowners after floods and turn the lots into greenspace and riparian corridor. We lock the gate behind us. Historical markers are the only signs of the battles and conflicts that raged along this border. And while there is no shortage of prickly pear, the Land of Tunas is gone. Extreme cold snaps in both 1885 and 1889 turned the prickly pear cactus stands into spiny green ice sculptures as the Nueces River froze over.

Common snapping turtle

EL DIEZMERO
Santa Margarita Crossing

Afternoon light slants down, illuminating the leaves and flowers along the banks so that they cast detailed reflections onto the smooth river surface. The angle of light is such that I can see past the reflections, deep into the water. A boat passes us and we nod and wave silently. One man steers while two stand poised at the prow of the boat, bows partially drawn and angled into the river as they scan for alligator gar. They slip downstream, their trolling motor barely purring, looking like strange Greek gods in South Texas.

We've motored upstream from Hazel Bazemore Park in our little flat-bottomed boat. Theoretically, we could go all the way up to La Fruta Park and nearly to the Wesley E. Seale Dam, but we turn around about six miles below the Santa Margarita Crossing. Not because of obstructions or low water but because we don't want to run out of daylight.

The gravel-bottomed ford, now crossed by County Road 666, was the northwest corner of El Diezmero, one of the original Spanish land grants in Nuevo Santander (later the Mexican state of Tamaulipas, now Nueces County). In 1806, when Don Vincente Lopez de Herrera, the tithe col-

lector for the town of Reynosa, and his three sons petitioned for the land, they described it as a place fit only for the raising of small cattle.[1] It was considered impossible to introduce gentle horses or mares because the *mestanas* (wild horses) would lure them away to run wild with the herds. And then there were the "barbarous Indians" who drove off horses and killed cattle above what had already been given to them for food. Yet just a few years later, one of the earliest pioneer women to colonize Texas, Doña Patricia de la Garza de León, and her husband, Don Martín de León, moved to the east side of the Santa Margarita Crossing. There they enclosed a pasture and built pens, capturing and breaking mustangs to sell in New Orleans. Doña Patricia and her family moved closer to San Antonio when Indian raids increased. Later the newly independent Mexican government granted Doña Patricia and her husband an *empresario* contract, and they established the town of Victoria up the coast.

I look into the deep, slightly murky water and think about English traveler William Bollaert's 1844 description of the Santa Margarita Crossing. The Nueces was on a rise and fifteen to twenty feet deep and eighty to one hundred feet wide, with "alligators and alligator gar jumping about." The field notes for the El Diezmero grant also mentioned that "the ponds and rivers abound with a great number of alligators which injure the . . . cattle." The description continued: "Along the margin of the river . . . there are various valleys and hills, covered with rather inferior pasture on account of the inundations in time of high water, which extend for about three quarters of a league to the high land and last for a considerable time."

Out of view, behind the screen of ash, oak, tallow, and hackberry trees along the banks, the river has carved a broad bottomland basin up to eight miles wide that stretches from below La Fruta Park all the way to Nueces Bay. Bluffs run along the edges that rise forty to fifty feet above sea level, making this section of Texas coast unique. Exposed white caliche or sandstone faces gave the El Diezmero grant—which extended from Santa Margarita down the river to old Nuecestown—its secondary name of Barranco Blanco. The river, slowed by the nearly sea-level bottomlands, splits into multiple channels, sloughs, lakes, and ponds surrounded by what would have been marsh. When the river rises, the entire area is, as Don Vincente remarked, subject to inundation.

Yet the inundations are no longer seasonal occurrences. The building of La Fruta Dam must have had some impact downstream; if nothing else, it collected the sediment and soil that would have flowed downstream to build the river delta. The Wesley E. Seale Dam substantially curtailed seasonal flooding but didn't entirely stop the overflows. But when Choke Canyon Reservoir started collecting water upstream, even less water flowed unregulated over the bottomlands. That doesn't mean there aren't floods—the spring of 2015 proved the river can still overflow its banks (as did floods in 2013, 2007, 2002, and 1984). It seems like the two dams and reservoirs upstream would control floods, but there are two elements at play. The first is that nearly three-quarters of the annual flow of the Nueces basin comes from the Nueces River and creeks below Choke Canyon Reservoir. So the smaller reservoir gets most of the water. And neither reservoir was designed with the capacity to catch floodwaters. To do so would have required taller dams and leaving a large border of undeveloped land around the rim with lake houses built many feet above the normal shoreline. In effect, a half-empty reservoir. Because both reservoirs were built to maximize the amount of water collected and stored for use by the City of Corpus Christi (and its customers), the fuller the lakes stay, the better their preparation for future droughts. Yet the illusion of safety instilled by the dams and reservoirs persists.

El Diezmero and the Nueces Bottomlands

Chugging along in our boat, we are in a near tunnel of lush vegetation. Sabal and Mexican fan palms hug the shoreline, tropical reminders of the nearby Gulf of Mexico. Ash trees dangle clusters of winged seeds, pale against the dark green foliage. Ashes and willows at the edge of the low bank tangle exposed roots into the soil, even as they slip sideways into the channel. Pastures and woods flank both sides of the deep channel. In the face of this exuberant display of green, it is nearly impossible to remember that this is still a near-desert environment, one of the driest river basins in the state. We slip beneath a narrow suspension bridge that connects the two sides of an oil field that straddles the river. Pipeline rights-of-way cut across the river, sudden bright spans with no trees on either side and large signs warning not to dredge or anchor nearby.

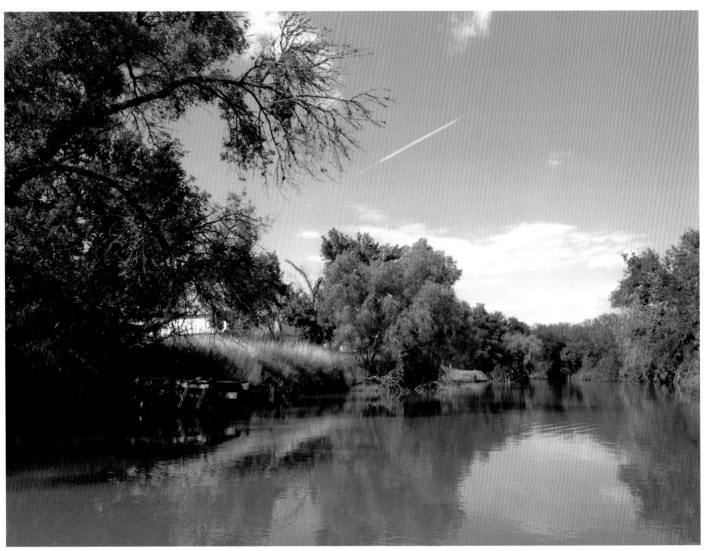

Upstream of Hazel Bazemore Park, Nueces County

A 1923 topographic map shows the border between Nueces and San Patricio Counties following the main river channel through the marsh-filled bottomlands. Unnamed channels and Dismero Slough wriggle away from the river and then back around Odem and Griffin Islands. Earlier maps show the border following the river north of the islands, but sometime in the 1930s, the river had a change of heart and veered away, cutting south to circle Griffin Island. By this time, the boundary between San Patricio and Nueces Counties was legally set, but the river is a nomadic creature and turned to flow down an unnamed channel and then Dismero Slough, leaving the political boundary far from the river.

Early descriptions of the river bottomland marshes are rare. William A. McClintock, a volunteer in the Second Kentucky Regiment on his way to serve in the Mexican-American War in 1846, described the river and the bottomlands below San Patricio.

In the west, flows the Nueces, winding its serpentine course through a dark, deep jungle of timber loaded with climbing vines, and long waving festoons of Spanish moss. To the south the prairie stretches off several miles, dotted here and there with groves of timber, and watered by lovely little lakes like so many diamonds set in emerald. (McClintock 1930)

By the turn of the twentieth century, farmers and ranchers were fencing off the marshes and prairies into pastures and cropland. Dr. A. C. Peirce, a bird hunter, described the land in the area as "divided up into pastures containing many square miles each, which are occupied by thousands of sheep, goats, horses and neat cattle." Many of which, he noted, died after bogging down in the mud. The fertile bottomlands were irresistible to farmers, and while a few industrious men put up levies to protect their fields from seasonal flooding, most were regularly flooded out.

The land is still divided up into pastures, but McClintock's "jungle of timber" is reduced to thin borders along much of the river channel. Large gravel and sand mines gouge pits in the bottomlands, creating more pools, ponds, and lakes that fill and overflow with silt-filled water when the river rises.

We pass what looks like a dry stream but is actually the old river channel. Just a few bends along and suddenly one side of the river is as populated as any suburban street. These lots strung between the river and County Road 73 were divided in the late 1950s, long before any regulations or permitting requirements. Most of the houses teeter on tall piers, hoping to gain enough elevation to put them out of the river's path. We pass a series of houses all canted to the side, relentlessly shoved by floodwaters. The ground has a scoured look from the last flood. But they survived.

A few trees shade the lots but for the most part, the underbrush and tall grasses are cleared so the owners have a view of the river—and so all the snakes and other varmints are evicted. But take away the riparian

vegetation and there is nothing to hold the banks in place. So the eroding banks are reinforced with concrete riprap, cinder-block walls, tires, pipes, and desperation. Some property owners have built docks and steps so that the native vegetation protects the banks from erosion. Others live with muddy cut banks and listing docks. Pipes extend from the riverbank, dribbling water into the river. The river no longer smells of pastures and willow trees. Now the smells of household wastewater (think dirty diaper), cut grass, and mower engine fumes waft across the water. The Watershed Protection Plan hopes to update the old septic tanks in this neighborhood—septic systems that inevitably fail when flooded.

The old septic systems aren't the only source of *E. coli* or fecal bacteria in the lower river. Bacteria counts are one of the tests that the Nueces River Authority and the EPA use to judge water quality, as are Total Dissolved Solids (TDS), which comprise everything from salt to silt. Cattle, deer, sheep, and dog turds all get washed downstream and can end up in the river. Cattle contribute most of the fecal coliform, but the feral hog population in the bottomlands is estimated at a minimum of twelve hogs per square mile (compared to the estimated one or two per square mile in most areas). And this number may be low. Not only do the feral hogs tear up riparian areas, destroy crops, and prey on other animals, but they pollute local water supplies the entire time.

Tangled discarded fishing line hangs from the trees along with brightly colored bobbers and lures. Set lines and trot lines stretch from overhanging trees into the water. Jugs bob in the channel. Some are obviously abandoned. Stands of Carrizo cane or arundo crowd the riverbank. I see patches of water lettuce but, surprisingly, no water hyacinth. Fishermen wave from docks, dogs bark from fenced yards, children's toys are scattered across yards, and I can hear trucks and cars rumbling along the county road.

Around a big right-angled bend the river cuts to the base of the bluffs. As we get closer to Hazel Bazemore Park and the boat ramp, the houses are bigger, newer, and set back a short distance from the river. Mowed lawn stretches around the houses to the water's edge to a few widely spaced willow trees. The opposite bank is still wild though, with trees and palmettos leaning over the shore. I'd paddled this section before—

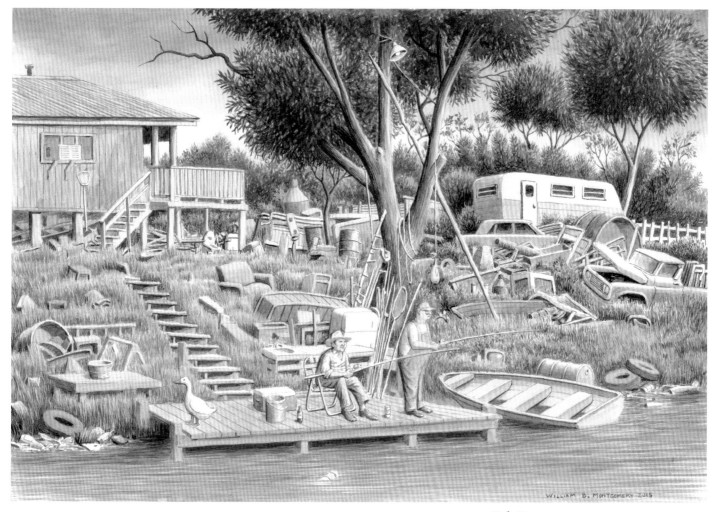

Fish Camp

the river mile upstream from the Hazel Bazemore boat ramp—for the
Nueces River Preservation Association's annual river cleanup. I'd special-
ized in extricating windblown debris from the overhanging trees: Styro-
foam worm cups, aluminum cans, chip bags, plastic bottles, plastic bags,
and tangled fishing line, bobbers, and lures. Volunteers in boats cruised
the river from the end of County Road 73 downstream, dragging tires,
a washing machine, a refrigerator, inner tubes, fence posts tangled with
barbed wire, boats, lawn chairs, and broken ice chests out of the river.
Meanwhile the kayaks and canoes filled up yellow Up2U net bags with
trash. I watched Dave, a volunteer, kneel on his paddleboard to pull up an
abandoned trot line. One hooked catfish skeleton emerged, then another.

He gave the line a final yank and a three-foot, extremely skinny catfish flopped onto his paddleboard. Dave yelped in surprise but sliced the line and watched the fish swim away. "That felt good!" he yelled to another volunteer, who gave him a thumbs up. A motorboat collected our filled trash sacks. The Dumpster began to fill with dozens of yellow sacks of trash and the big stuff hauled in by the motorboat crews. Tim McWha, president of the Nueces River Preservation Association (NRPA), told me happily that we had collected less trash than the last cleanup. He smiled, his sunglasses reflecting the river, and pointed to a new green trash barrel. "We just installed these. They seem to be working!" I looked at the open barrels. Although they are off the ground and out of reach of scavenging dogs and hogs, they look suspiciously like raccoon cornucopias to me.

The NRPA is a group of CR 73 residents and river enthusiasts who, tired of seeing the river trashed, organized to clean the area and the river. In 2013, with the help of numerous partners, the group staged a massive cleanup along CR 73 that resulted in two thousand tires collected for recycling, twenty-one Dumpsters filled with over 130 tons of trash and debris, and one Dumpster filled entirely with trash collected by volunteer boaters from the river itself.

While the cleanup volunteers eat barbecued chicken, Nueces River Authority deputy executive director Rocky Freund announces to the group that as part of the Nueces River Watershed Partnership's development of the Watershed Protection Plan, they have the funding to use side-scan sonar in the river to locate submerged appliances, cars, and other large debris. Applause drowns out her last words.

The Partnership formed in 2009 after the river water exceeded safe drinking-water quality standards. The city hired the Nueces River Authority to develop a protection plan for the drinking source for half a million people in the Coastal Bend. The Authority invited stakeholders—any individual, business, municipality, or group with a vested interest in the river's water quality—to join. Because of the interest and effort to protect the river by the Partnership's stakeholders (like the NRPA), the Texas State Soil and Water Conservation Board selected it to develop a Watershed Protection Plan (WPP). The WPP is a voluntary, nonregulatory approach to protecting water quality. In other words, the landowners, businesses, elected officials, and residents of the watershed learn how to take

care of their land and water to protect the watershed. From basic soil conservation plans for farmers and ranchers, to feral hog management, to wastewater treatment and septic system replacements, to plugging abandoned oil wells, the plan addresses the sources of current and potential pollutants to restore and maintain water quality. It is the EPA's version of teaching a man to fish: teach the residents of a watershed how to protect their land and water, and chances are they'll become advocates and stewards of the river.

Freshwater drum

Bill and I reach the Hazel Bazemore Park boat ramp just as the sun touches the horizon. Bill avoids the nasty drop-off at the foot of the boat ramp that nearly swallowed the trailer early in the day. The leathery, beer-soaked fishermen who'd watched and laughed when the trailer wheels fell into the crater are gone. We load the boat and then drive up to the top of the steep bluff past the HawkWatch platform and follow the highway upstream to our camp at Lake Corpus Christi State Park.

HawkWatch

I returned to the platform at Hazel Bazemore Park in the height of hawk migration. Four migratory flyways come together in South Texas, so in the spring and fall migrating birds—from songbirds to shorebirds to raptors—funnel through South Texas to wintering or summering grounds. The Corpus Christi HawkWatch runs from August 1 to November 15 every year and peak migration usually occurs between September 23 and 30. Three paid HawkWatch International observers work every day with a gang of dedicated volunteers to count the nearly three-quarters of a million raptors that pass overhead. I show up midmorning on a bright late September afternoon, and a smiling woman with tousled gray hair invites me to sign in and grab a chair. I join the dozen or so bird-watchers, lean back, and look up at the clouds. Lovely billowing cumulus clouds march from horizon to horizon. I stare at the sky, forgetting to look for hawks while I watch the clouds shift and change. Glistening strands of spider silk float through the air. Dragonflies, wasps, swallows, and chimney swifts dart across my field of vision. "A kettle!" someone sings out. "Where?" snaps Dane, one of the paid counters. "Over there—by the doughnut-shaped cloud." I look and see nothing like a doughnut. "No,

over there, by the pig-nosed cloud," a woman insists. A man's voice corrects her. "You mean a javelina-nosed cloud, don't you?" The banter is cut short by Dane's curt "I've got 'em." I see nothing and then I hear someone say to another neophyte that the hawks look like finely ground pepper sprinkled on mashed potatoes. It helps because suddenly I can see the hawks against the clouds. Tiny specks of birds flying far above the earth. A group streams south and then the broad-winged hawks bank into a spiral and turn into a swirling kettle of a thousand hawks. The kettle disappears as it moves into the blue. Another group streams through the clouds while the trained observers count and call out numbers and species to the person recording the data. Wood storks and turkey vultures spin in the rising thermals, confounding me but ignored by the experienced watchers. Dane spots a new flock coming through a big gray cumulus and calls it out. The bird-watchers' chatter trails off as the birds keep streaming across the sky, weaving through the clouds, breaking off to spin in thermals, and rejoining the group. Time seems suspended and I have no idea how long I've been following the mass of birds. When the last of the hawks disappears, the recorder asks in a quiet voice, "How many, Dane?" "Thirteen thousand five hundred," Dane replies. "One of the biggest groups I've ever seen." Whistles and whoops erupt—they've already surpassed yesterday's count and are on their way to a hundred-thousand-raptor day.

From the platform I can look down at the river and across the broad floodplain of the lower river basin. Our vantage point overlooking Hazel Bazemore Park is part of the clay and sand bluff that borders the river on both sides and continues along the northern and southern shores of Nueces Bay and extends to Corpus Christi. Across the river I see open pasture and possibly freshwater marsh with scattered patches of woods and a few gas wells in the bottomlands. Narrow strips of trees along the river, so important to migratory songbirds, are slim reminders of the forests Peirce described from his forays into the Nueces bottomlands:

> The river is bordered on each side by a strip of timber several miles
> in width—the Nueces Bottoms. The bottoms are dark and gloomy,
> every particle of ground not occupied by the large and magnificent
> trees being covered with shrubs and tall palmetto leaves; while the

direct sunlight is almost completely shut out by the long and flowing Spanish moss which covers every tree, weaving their twigs and leaves together into a tangled and matted web. (Peirce 1894)

Just downstream from the boat ramp is the 1898 Calallen diversion Dam (also called the Saltwater Dam). The last nine miles of river are actually a reservoir—though a narrow one with a very slight current. The bottom of the river is below sea level for twenty-three miles upstream, and the Calallen Dam prevents the brackish tidewaters from creeping upstream into the reservoir. In 1893, the City of Corpus Christi installed massive wood-fired, steam-driven pumps on the river to pull water out and send it through water mains and fire hydrants throughout the city. The pumps immediately started pulling brackish water into the system, so workers installed a temporary sand-sack dam three miles downstream on a rocky outcrop. The dam washed out with every rise, and in 1895 the city received permission from the legislature to build a low dam and reservoir.

The City of Corpus Christi pulls water from the same pool as its industrial water customers, San Patricio Municipal Water District, and the Nueces County Water Control and Improvement District (WCID) #3. While the river is no longer the sole source of water (water is pumped from Lake Texana and the Colorado River directly to water treatment plants), it is still the largest single source of water for the area.

Corpus Christi is a watery place. The city has frontage on two bays plus Oso Creek and Bay along her flanks. Easy access to the Laguna Madre and the Gulf of Mexico along with lush tropical plants conspire to make residents forget they live in a near-desert environment. The city, as the overseer of the regional water supply, struggles to retain enough freshwater in the reservoirs to supply customers; the fear of running out of freshwater in this hot, dry environment is both realistic and terrifying. As the population of the city and surrounding Coastal Bend grows and demands steadily rise, I can't help but wonder, will there be enough water for everyone?

Hidden in Plain Sight

TIDAL RIVER

Below Calallen Dam, the river doubles back on itself in a big lopsided hairpin turn before running east to join Nueces Bay. Interstate 37 and Highway 77 jump off the bluff at Calallen and then hop the river to land on a narrow peninsula jutting south. The highways cross what is the pinched-in waist of an hourglass. Historically, freshwater wetlands filled

Long-billed Curlew

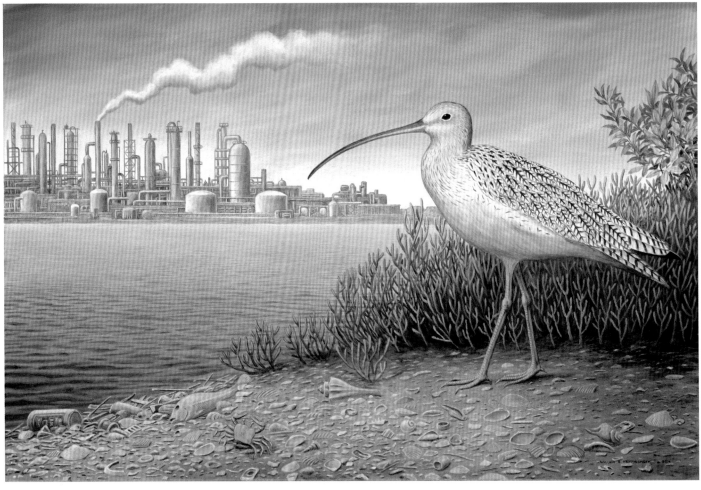

the upstream side of the hourglass-shaped basin, known as the Nueces bottomlands; downstream, in what old accounts called "the head of the bay," the area transitioned from freshwater to saltwater marshes and then into the bay.

The Nueces River is unlike most rivers in that it doesn't flow through the delta to the bay. The standard configuration is that the delta, that watery triangular transition between land and bay, is usually located at the mouth of the river where it enters the bay. Not our river. The Nueces River currently bypasses the historic delta, skirting below the southern shore of the bay to slip into it sideways like someone late to the dinner table. The delta, land of marshes and wetlands, expands from the narrows to fill the basin. Rincon Bayou, a former channel or distributary of

Nueces delta and estuary

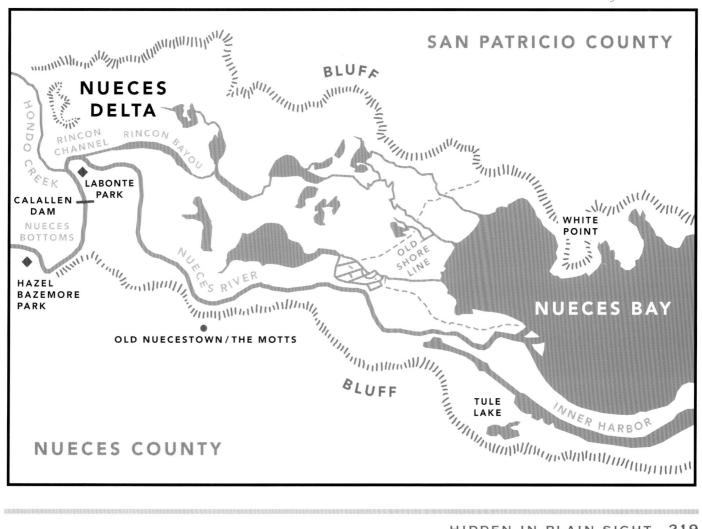

the river, curls down the center of the delta, looping into ponds and lakes until disappearing into the bay.

While the Nueces bottomlands still catch floodwaters, today's pastures don't resemble A. C. Peirce's 1890 description (likely near Hondo Creek's junction with the river near present-day Labonte Park):

> Beating our way through the deep-tangled wildwood for two or three miles toward the bay, we reached that part of the swamp where the two rivers united at an acute angle. Here there was an entire change of scene. Instead of a narrow channel bordered by steep banks, there was a spread of mire acres in extent, wherein thousands and thousands of snags and water-soaked logs were piled in confusion. More than this, hundreds of snakes were to be seen about and upon the driftwood, where they had come to bask in the sunshine and feed in the shallow pools. (Peirce 1894)

Bill, of course, would have been thrilled by the sight of hundreds of snakes. Mere mortals, not so much.

Labonte Park is a triangle of mowed playing field and picnic tables wedged between the river and the highway bridges at the end of the hairpin turn. Bill and I launch our johnboat in the shadow of the highway's concrete pillars and elevated roadbed. A glossy red and black custom bay boat launches behind us. The owner wears matching fire-engine-red nylon shirt, shorts, ball cap, and sneakers. While we watch he fires up the big outboard motors and tests the hydraulic lift, raising and lowering the engines to accommodate the shallow bay waters. I ask him where he fishes and he replies, "Way out in the bay." "What do you fish for?" I ask. "Everything," he tells me and turns away. I look up and see a pair of game wardens sitting in a truck watching the boat ramp.

Bill and I start down the river. It is immediately clear that this engineered channel has nothing to do with an old-fashioned river delta. To our north is a high dirt bank with an exposed mud low-tide shoreline at its foot, then a rim of saltgrass, followed by sea oxeye daisies and grasses, and capped with mesquite trees. The south shore is lower and lined with houses alternating with industry and open land. Every house fortifies its section of shoreline with a different type of bulkhead—concrete walls,

plastic pipes stacked like Lincoln Logs, wood, old tires, concrete riprap—whatever they can devise to slow down erosion. Just as we pass an elaborate concrete retaining wall, the red bay boat flies past, its engines churning the water and sending it into a high rooster tail. We grab the sides of the boat and rock wildly in the wake. Waves smash against the concrete. Signs from the businesses next to the highway on the bluff float above the fray, yelling WHATABURGER, PAWN, and EXXON.

 A dead brown pelican is flopped belly down with head and wings dangling over the sides of a concrete structure in the water. It is the freshwater outflow for the City of Corpus Christi's Allison Wastewater Treatment Plant. Turkey vultures stand on the sandy shore behind the outflow. Bill shuts off the engine and we slowly drift. I scan the beach and count four messy piles of brown feathers and pelican bills in varying degrees of decomposition. Brown pelicans may no longer be listed as an endangered species, but what could have killed five birds in one spot? Meanwhile Bill is counting diamondback terrapins. The curious turtles peer up out of the water at the boat. The turtles (and likely the pelicans) are drawn to the return flows (treated wastewater) flowing from the city's treatment plant into the salty tidal water of the channel. Charismatic little creatures

with their clownish black-and-white faces and boldly patterned shells, diamondback terrapins were considered gourmet fare and sold for stunningly high prices in the early decades of the twentieth century. Usually a resident of brackish coastal habitat including marshes and tidal rivers, in Nueces Bay the turtles congregate in the open bay and bask on oyster reefs and bird rookery islands. Except for the rare floods that bring in freshwater, the water in the delta and the river channel up to Labonte Park is as salty as the Gulf of Mexico.

Diamondback Terrapin

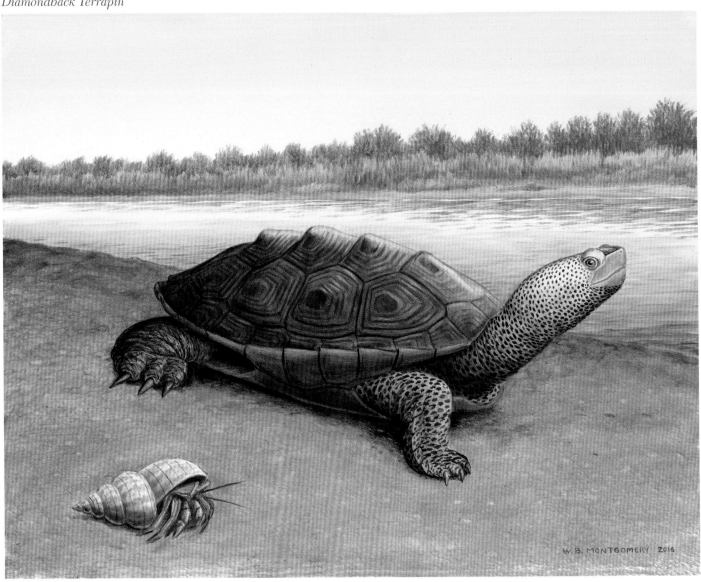

The terrapins are surviving in the hypersaline waters of the bay, but their biggest threat is habitat destruction. As coastal marshes are drained for vacation homes and shorelines are hardened with bulkheads, the turtles lose their foraging sites and nesting beaches. Crab traps, I learn, are also a serious threat. Scientist Aaron Baxter and his cohorts at the Center for Coastal Studies at Texas A&M University–Corpus Christi have been studying ways to save the terrapins from drowning in crab traps. Terrapins are opportunistic carnivores and eat blue crabs, but that isn't why they end up in the traps. The turtles eat a variety of other things: periwinkles, mussels, clams, worms, invertebrates, and dead fish. They really like dead fish. And dead finfish is the bait of choice for commercial crab traps. Both blue crabs and terrapins find it irresistible. Add their curious nature and predilection for congregating in groups and you have a deadly combination. Aaron says, "They're just curious and when one turtle goes into a trap, others follow. That's why groups of drowned turtles are often found in unbaited traps." The solution to the crab trap problem, he tells me, is stunningly simple and inexpensive. A plastic rectangle, a bycatch reduction device (BRD), fits in the entrance funnels of standard chicken-wire crab traps. The BRD allows turtles to escape, but the crabs don't leave (at least no more than they do in traps without the BRDs). Studies in the Nueces estuary (Nueces Bay, Corpus Christi Bay, and Oso Bay), as well as other studies in other parts of the country, show that traps with the BRDs catch as many legal-sized crabs as traps without the BRDs. In Nueces Bay, the terrapins are a small population and they do not readily recolonize an area. Like sea turtles, they return to their natal beach, where they hatched, to dig nests and lay eggs. If their nesting beach is destroyed, they do not move to a new beach. Once too many turtles have died in abandoned or neglected traps, they are gone forever.

We try to slip under a concrete railroad bridge crossing the river. The old creosote posts from the original San Antonio, Uvalde & Gulf Railroad trestle stick out of the water beneath the concrete piers. Too late we realize that we've chosen the wrong bay. The prop hits something, the boat shudders, and we flinch. Bill verbalizes his dissatisfaction. A brief discussion about the usefulness of maps and charts ensues while Bill pulls up the motor to check that the prop isn't cracked or damaged. We continue downstream, both silent and looking off in different directions. A school

of mullet skims past us, trios of silvery fish flying through the air. "Predator?" I ask. Bill shakes his head. "They're just goofy fish."

Fields of giant tanks and spires, twisting networks of pipes and stacks from the refineries rise from the lowlands to the south. A great ship rises, looking as if it has sailed across the prairies and docked in a grassy basin. The navigation channel and turning basins parallel the river but connect to Corpus Christi Bay. Huge sets of lights point down toward the tall, barbed wire–topped chain-link fences. The areas around the fences are prison-like, cleared and mowed to short grass. The shoreline between the navigation channel and the river mouth and Nueces Bay is entirely human made, from the last bend of the river all the way to Rincon Point. Between 1930 and the early 1970s, heavy machinery sculpted the land from spoil left from dredging the nearly nine-mile-long Inner Harbor with its deep navigation channel and turning basins. Petrochemical plants squat between the harbor and the escarpment in Refinery Row; oil docks, grain elevators, cargo docks, and shipyards line both sides of the navigation channel.

While the refineries and nearby oil and gas wells no longer legally discharge highly toxic produced water or refinery waste into the river or Nueces Bay, it was a common practice from the early 1900s until the mid-1990s. Now the oil refineries, and others, dump their cleaned wastewater (and occasional toxic spills) into the navigation channel or into Corpus Christi Bay. The Inner Harbor holds the distinction of securing a site on Environment Texas's list of Top 50 Waterways for Total Toxic Releases, with local industries dumping nearly 1.5 million pounds of toxic chemicals into the water in 2010. Refinery Row has areas where the soil is saturated with heavy metals and hazardous chemicals (including a bonafide Superfund site slated for cleanup) from the petrochemicals' tenancy. But the area has other long-term legacies. In 1994, the Texas Department of Health (now the Texas Department of State Health Services) banned the eating of oysters from Nueces Bay because of high levels of zinc, an aftermath of the billions of tons of zinc ore processed by the long-gone American Smelting and Refining Company. Operating next to the harbor, the plant discharged zinc-laden effluent along the bay shoreline and into the Inner Harbor. Nueces Bay is still closed to oystering. Decades of dredging for oyster shells, hypersaline conditions, and disease had already damaged the fishery and stunted the reefs. Today, if any oysters

thrive, the filter-feeders still extract excessive quantities of zinc from the contaminated sediments.

Yet the Nueces River is surprisingly unscathed. Except for a few unpleasant burps and small spills by the Three Rivers Refinery upstream, all the really nasty stuff bypasses the river and the delta. Even the majority of the stormwater, the purveyor of pesticides, herbicides, fertilizer, trash, oil, and dog turds from urban streets, flows toward Oso Creek and Corpus Christi Bay.

To the north (our left), turbines spin lazily from the blue rim of higher land over the bay, wavering in the heat waves shimmering above the spartina marshes. A subtle shift has occurred and the high banks have dis-

Tidal River

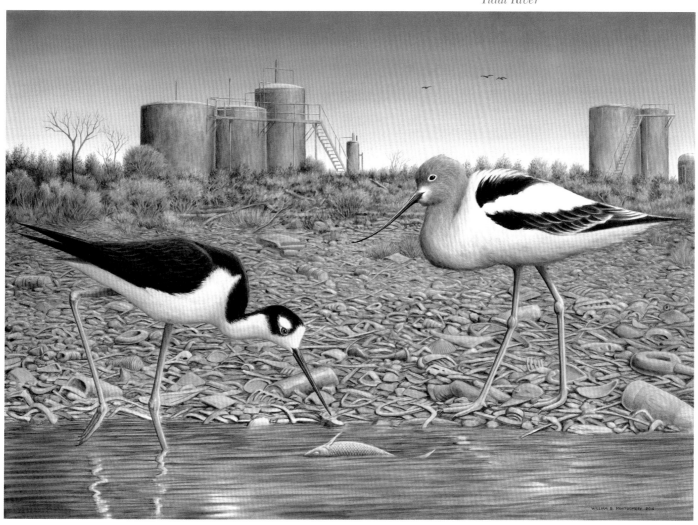

appeared. The tide is at low ebb and a strip of muddy shore rims the marshes' edges. Great blue herons and great egrets hunt through the tall cordgrass that curves off into the distance where land and water mingle. The bay opens up in front of us and through a cut to the left. Bill points the boat straight toward the open water. I'm on the verge of telling him about the infamous mudflats at the mouth of the river when the boat stutters, Bill curses, and the motor dies with a loud slurp. Seventy-five yards away fishermen calmly fish in the cut. Seems they knew how to find the channel.

The mudflats at the entrance to the bay are notorious. In 1845, a canal thirty inches deep and sixty feet wide was dug through this same shoal so that steamers could reach the US troops stationed along the river. A. C. Peirce described the mudflat as being miles in extent with only an inch or two of water. With a strong east wind, Peirce and his guide plowed a sailboat through the mile of mud with "a furrow high and dry being turned up on each side." We've got a foot of water but it isn't enough for the outboard's propeller. With an oar and the trolling motor we inch out of the mud and back toward the deeper water. At least we didn't have to use Peirce's technique of dropping over the side of the boat and paddling with our feet.

A pair of spoonbills, bright pink against the cerulean blue sky, flies overhead and distracts me from the sticky, smelly black mud.

The possibility of getting stuck on another mudflat at the mouth or out in the shallow bay discourages us. We turn upstream. An American avocet stalks the bank, posing for Bill with a black-necked stilt against a backdrop of muddy shore, discarded tires sprouting spartina, rusting metal tanks, and assorted debris.

As we slowly pass the railroad bridge (picking the obstruction-free path this time), a displaying male red-winged blackbird views us with intense curiosity, hopping down the side and leaning over the edge of the bridge to watch us slip through the legs of the bridge. I look back and he's fluttered over to the upstream side where he still watches us. A great egret serenely stands on the bridge and then destroys the tableau by reaching up a skinny leg and scratching the underside of its chin with one long toe, just like a dog with fleas.

One of the benefits of a delta at a river's mouth is that the broad,

low plain resists and slows storm surges. With the Nueces River's quirky conformation of nearly separate river and delta, dense saltwater wedges could travel far upstream—until the low Calallen Dam prevented the denser seawater from pushing upstream below the level of freshwater. Even today a strong wind out of the west will push water out of the river and into the bay (and over the mudflats). Winds out of the east or southeast push water upstream from the bay.

We know that during the 1800s marshes lined both sides of the river, with Rincon Bayou siphoning freshwater into the heart of the delta. Bayous cut from the river into the marshes even as the river clung to the base of the clay and sand escarpment that runs around the bay. Indeed, it is this unique forty-plus-foot embankment that, combined with the barrier islands, gave the leaders and residents of the young Corpus Christi a sense of invincibility. The local newspaper crowed about the location's natural superiority after the coastal ports of Siluria, Indianola, and Galveston were leveled by hurricanes. In September 1919, the landfall of a large hurricane near Baffin Bay exposed the city's vulnerabilities.

Hurricanes are a fact of life on the Gulf Coast. These storms with their high winds, extraordinary rainfall, and storm surges are frequent visitors to Corpus Christi and the Nueces River. But the 1919 storm that leveled so much of the city (primarily below the bluff) did so with a tremendous storm surge—a fifteen-foot-tall wave of water pushed by the wind out of the bays and into the city. The surge shoved saltwater eight miles overland and a reported thirty miles up the river channel—all the way to San Patricio. Then the torrential rains came, but with the river basin already filled, there was nowhere for the runoff to go. The freshwater floods eventually pushed the heavier saltwater out of the river basin and back into the bay. In 1935, the record floods that started way up in the West Prong arrived downstream, overflowed the banks, flooded the delta, and turned Nueces Bay into a freshwater lake. No wonder plans to dam Nueces Bay and turn it into a reservoir were popular at the time.

By the time Hurricane Beulah dropped her rain on the river basin, creating record floods, Rincon Bayou and the other cuts and sloughs on the river's north bank leading into the delta had been filled and closed. Over time the north bank had grown taller, raised to prevent the tidal water from flowing into the drying delta. Except for unusual overflows like

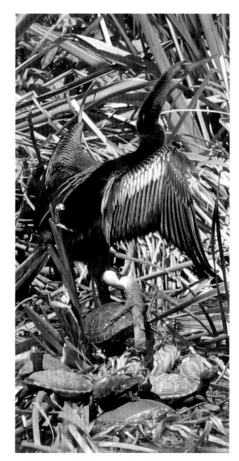

Anhinga and diamondback terrapins. Photo by Craig McIntyre

the one caused by Beulah's, the river and its decreasing supplies of freshwater bypassed the delta and poured into the bay.

The river channel Bill and I are following upstream doesn't seem like an estuary, yet the tidal river below Calallen Dam is part of the Nueces estuary, as are the coastal marshes and the bays: Nueces, Corpus Christi, Oso, and Redfish. Plus the Nueces delta. I think of estuaries as prolific nurseries of shrimp and fish, nutrient-rich water swirling with the bay's building blocks of phytoplankton and other edible microscopic organisms balancing a pyramid of predators and prey. This area doesn't seem to be exactly brimming with life, but an estuary is simply where fresh river water and tidal saltwater come together. Too much of either disrupts the balance.

In 1893, when the city first started pulling water from the river for people, irrigation, and early industry, no doubt it had some impact on the estuary. But the water was just a fraction of the half million acre-feet of river water that typically nourished the Nueces estuary.[1] La Fruta Dam's greatest impact wasn't the amount of water it confined but the sediment that collected in its reservoir. But these effects were minimal compared to what was to come. The first major blow was Lake Corpus Christi. Then twenty-two years later came the nearly fatal blow of Choke Canyon Reservoir. At the time, many people considered freshwater wasted if it flowed into the bay. The city, surrounding towns, industry, and crops claimed priority over the water.

From the beginning, there were concerns about Choke Canyon Reservoir's impact (or the impact of any large reservoir) on the estuary. The US Fish and Wildlife Service, National Marine Fisheries Service, and Texas Parks and Wildlife Department all spoke up about the dangers of reducing the amount of freshwater for the bay. While many would have preferred that the reservoir never be built, a compromise was reached whereby the reservoir could be constructed but only with an agreement to release 151,000 acre-feet of water per year to the bay and a minimum flow of thirty-three feet per second below the Choke Canyon Dam into the Frio river channel.[2] It sounds like a huge amount of water—more than the 139,000 acre-feet that Choke Canyon contributes to the water system—but it is less than a quarter of the freshwater the bay was used to receiving.

The city and the Bureau of Reclamation finished Choke Canyon Reservoir in 1982 in the midst of a drought. It took five years for the reservoir to fill. Meanwhile the city refused to release water from the reservoirs, citing the need for a plan. With the city withholding water, and with drought and higher than usual evaporation rates, Nueces Bay grew saltier, until by 1990, the bay was saltier than pure ocean water. The estuary's life diminished, and oyster, shrimp, and fish populations stunted by the hypersaline water plummeted, causing commercial fishermen to lose their livelihoods.

A lawsuit prompted the state to step in and issue an order for the city to release water to the bay. Then committees, advisory councils, stakeholder groups, scientists, and city and state officials held meetings. Many meetings. Meanwhile freshwater flowed into the bay according to the state's neatly and evenly portioned monthly schedule. Tidy but not very effective. Estuaries are living systems with cycles tied to spring and fall rains and floods. The creatures that live within an estuary breed, feed, migrate, and thrive in the seasonal variations. The strictly defined schedule of monthly inflows was deemed lacking. More meetings ensued as the stakeholders, scientists, and state agencies worked on a plan for freshwater inflows to the estuary. In early 1995, the state issued the Final Agreed Order, which reduced the minimum inflow requirement to 138,000 acre-feet per year, but the water was to be delivered in a monthly regimen designed to mimic the natural seasonal spring and fall surges. As the freshwater flowed down the river channel into the bay, it began to dilute the hypersaline waters. Fish, shrimp, crabs, and estuarine species slowly began to recover.

Yet not everyone was happy. Residents both around Lake Corpus Christi and in the city grumbled and continued to complain about water releases to the bay. Biologists fretted over the reduction of total flow to the bay. Fishermen wanted the bay to fill with fish and shrimp again.

But there was something missing. Or being missed. The freshwater was bypassing the delta, the formerly productive wetlands and marshes, the bay's nurseries for shellfish and finfish.

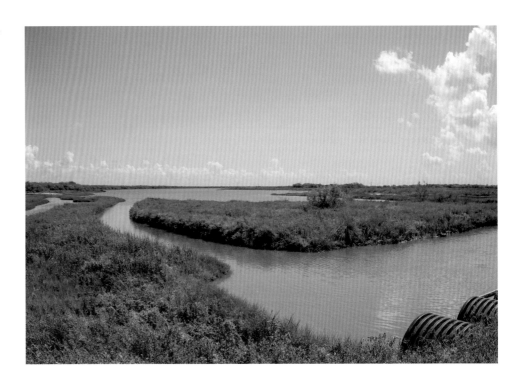

Rincon Bayou at the head of the Nueces delta, San Patricio County

NUECES DELTA PRESERVE

"It's all a bit confusing," I say to Ray Allen, executive director of the Coastal Bend Bays and Estuaries Program (CBBEP). We're standing on the banks of Rincon Bayou in the CBBEP's Nueces Delta Preserve trading my binoculars back and forth to look at a cluster of roseate spoonbills and egrets downstream. He nods, gives me an encouraging grin, and then picks up the thread of his explanation. "So finally in 1993, the Bureau of Reclamation stepped in and asked, 'What would happen if we put freshwater into a reverse estuary?' Have you seen their report?" I nod. "They were the first to try to rejuvenate the Nueces delta. By that time the salinity levels up here at the head of the delta were twice as high as ocean water and didn't get lower until way down near the bay."

I'd read the reports. To a nonscientist it seems rather obvious. Add freshwater and it will dilute the salt. Big deal. But reopening Rincon Bayou's link to the river was just the first step. The second step was to monitor the changes and collect data so future decisions could be based on science. Researchers scurried over the delta. They sampled and tested,

measured and correlated, listed species, and collected specimens. All to prove what seemed obvious: freshwater inflows could revitalize the delta.

The Bureau's study lasted just four years, but it was enough time to document the results. Clearly even a small amount of freshwater had an enormous impact on what was an unsound ecological environment. The construction of Lake Corpus Christi cut the freshwater inflows to the delta by about 40 percent; Choke Canyon Reservoir effectively cut the freshwater inflows to less than 1 percent. But realistically there was not—and is not—enough water in the river and reservoirs to restore the delta to its earlier state—not without jeopardizing the Coastal Bend's water supply.

Historically the river flowed from the head of the bay through the delta toward the bay, carrying silt and nutrient-laden water in at one end while the bay's salty waves lapped at the other end. And in between was a continuum of freshwater sliding through to brackish down to the bay's saltier waters. All expressed in assorted habitats: high marsh, low marsh, ponds, potholes, wind-tidal flats, bayous, and mudflats.

Coastal marsh is one of the most biologically productive types of habitat found on the planet, and the Nueces delta is one of the most extensive marsh systems on the Texas Gulf Coast. Deltas, as part of estuaries, create a watery half world where the primal soup of nutrient-rich freshwater galvanizes an unparalleled cycle of life starting with mud and detritus and continuing up the food chain to shrimp, crabs, little fish, big fish, and fishermen. In spite of this, it has been only in the last few decades that people have started to appreciate wetlands and see them as more than wasteland.

Peirce described the upper delta, what he called the Nueces Flats:

In hundreds of places on the north side of the river, the earth is depressed below the level of the shore; and these depressions, filled with water, are, in places, only separated from each other and the large stream by slight elevations. Replacing the land by water and the water by land, Nueces Flats would be a large lake containing countless islands, more or less connected by narrow isthmuses. Between the water and the grass-covered land, is a space perhaps twenty yards in width, which is made up of bottom-

less mud. To venture on to this mud is simply to venture into it, and as it is seemingly without limit in depth, one might better try to walk on the ocean. . . . We found wild geese and ducks in abundance; nearly every one of the small ponds was well stocked with them. . . . Gulls and terns were also plentiful.

Wetlands can be mucky, smelly, mosquito-ridden places. After collecting the waterfowl shot in the Flats, Peirce described his guide as "nothing but a pair of eyes . . . to show that the reeking mass of black mud contained a human being." Few people venture into active wetlands voluntarily—unless they are duck hunters, bird-watchers, or scientists. The Nueces delta's wetlands have not been regarded as a treasure but as an impediment, a problem to be taken care of, drained, shored up, dredged, and turned into someone's idea of productive land. In this case, cattle pastures and gas wells.

The landowners in the delta blocked off Rincon Bayou, roads and railroads were built that acted as dams, the river was channelized, and the banks raised. The big reservoirs upstream suppressed the annual spring and fall surges that used to flush over and through the bottomlands and delta from two or three a year to less than one every three years. The delta languished. As less and less freshwater flowed into the delta, saltwater crept upstream from the bay to fill the marshes, pools, and Rincon Bayou. Sun and wind turned the water into evaporating ponds, concentrating the salt in the pools and soil.

At first glance, the recovering estuary looks a lot like a cow pasture. It takes a minute for all the different shades of greens and golds to resolve into a mosaic of grasses, leafy plants, and succulents. Sea oxeyes flutter yellow flowers, dark green pompons of Gulf cordgrass (spartina, and the sacahuiste of the Big Bend of the Nueces) rub shoulders with saltgrass and patches of low-growing saltwort and glasswort. A few scattered mesquites dot the area, and clay ridges—both natural and constructed for roads—sprout thickets of thorny brush. At the edges of Rincon Bayou, a very unassuming body of silty water, pink-flowered marsh fleabane and retama are mixed in with the Carolina wolfberry and grasses.

"In this near-desert environment, our goal is to create little islands of productive habitat," Ray says. "Most years there aren't enough freshwater

inflows to reach all the way to the bay. But there is enough to enhance the delta. So when we do have rain and floods—like this last spring—those areas are ready to respond." He points upstream. "The pipeline outflow is just upstream, on the other side of the railroad tracks."

As part of a 2001 updated agreement on freshwater releases from the reservoirs to the estuary, the city reopened the Nueces Overflow Channel (filled in after the Bureau of Reclamation's study ended in 1999) and then began construction on a pipeline to deliver freshwater to the delta. The present agreement has the city pumping up to three thousand acre-feet of the water destined for the bay from Calallen Pool through the Rincon Bayou Pipeline into the upper bayou. Ray points out the solar-powered meteorological station next to the bayou. "We've got this weather station and multiple salinity stations monitored by the Conrad Blucher Institute, plus inflow monitoring by a USGS gauge. What we're trying to do is figure out how to get the biggest ecological bang for the buck by mimicking natural cycles." White ibis and a tricolored heron skirt the smooth cordgrass and wade into view. I hand the binoculars to Ray. He scans the bayou. "Our goal is to better understand the functioning of those natural cycles so we can create management systems based in *science*."

"But when Corpus Christi nearly killed the bay . . ." I start. He lowers the binoculars and looks at me. "The bay was not," he says with extreme patience, "as some claim, 'killed' by Corpus Christi, but it was profoundly changed." Feeling a little chastened by the small but sharp correction, I take the binoculars and study a trio of cormorants perched on pilings. Ray continues, "We just don't want the conditions to become too extreme. The delta wasn't flush with freshwater year round. It is a desertlike climate, after all." He sounds a little tired and I wonder what it must be like to have his job.

Ray Allen and the CBBEP are unlikely Davids to the Goliaths of public indifference and the Coastal Bend's rapid development. Yet they don't lob rocks at adversaries (except as last resorts); instead, Allen and his team of educators, scientists, workers, and volunteers haul kids (ten thousand a year) out to the preserve for hands-on science education, fund scientific studies, work with state and federal agencies, and, impressively, work with local industry. CBBEP funds and helps with volunteer projects like the Nueces River Preservation Association's annual river cleanup,

Eagle Scout projects, and marsh planting projects, and they sponsor a local Bay Day in Corpus Christi. Slowly and surely CBBEP has acquired nearly half of the land in the twenty-thousand-acre delta and established solid working relationships with the majority of remaining landowners.

Under Allen and his staff's watchful eye, pipeline rights-of-way turn into berms enclosing constructed freshwater wetlands. "Pipelines are just part of the landscape. We try to keep the disturbance confined to as small a footprint as possible," he says and points out the Mary Rhodes Pipeline's path carrying water from Lake Texana and the Colorado River to Corpus Christi customers. The city's acquisition of those additional surface water supplies made releasing water to the delta and bay not quite as painful.

We drive down through the preserve. The road humps over numerous culverts so water can flow freely across the landscape. "Mitigation," Allen says as he nods toward a stack of huisache pulled from the former pastures and piled by the road. "A few acres of wetland impacted by a petrochemical plant turn into a couple hundred acres of habitat restoration here. The delta used to flood enough to keep the brush out, but now we use fire and hand removal to keep the prairies open."

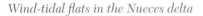

Wind-tidal flats in the Nueces delta

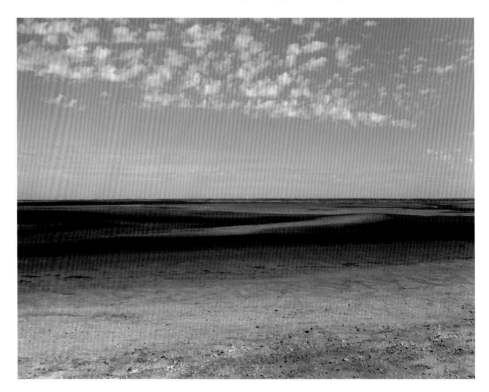

Allen stops the truck in the road. Ahead the road is rutted with churned muddy tire tracks. "Some might drive across that but I'm not one of them," he says, grinning. We walk through bright green and dark red plants to the top of a low dune. A layer of dried and cracked soil crunches underfoot. Before me is a barren swath striped with gray and white bands. The sun reflects off the bare ground and the wind is fierce. A few shallow pools gleam dark gray in the distance. Lines of dark green plants wander vaguely across the flats. The gold green of the high marshes is a thin strip behind us; before us the land dissolves into a wavering series of colored lines: pale blue pools of water reflecting the sky, dark streaks of cordgrass marsh, low wedges of red and green like our dune, and far off the low indigo streak of escarpment populated with spinning turbines. I look at Ray Allen and he is smiling, seeing something I'm missing. "This is a wind-tidal flat," he says. "Wind pushes saltwater up into the flats and it evaporates. The rest of the time the wind pushes this fine silty clay around." He scuffs his foot and a puff of dirt blows away. "Makes little dunes, then plants grow and trap more dirt," he says. He smiles broadly, squinting into the sun. "Doesn't look like anything now but when they're flooded, I've seen tens of thousands of shorebirds working these flats."

He turns toward the truck, his words trailing in the wind. "Now I've always said that there are two kinds of deltas, accreting or retreating. Our delta is retreating because the sediment we need is trapped by the reservoirs."

The silt that the river carried in to build the delta was (and is) slowly filling the jumbo settling tanks upstream. Anywhere that land and water meet, the land is either accreting as sediments are deposited, or eroding as water strips away soil, sand, and rock.

Historical maps all show Nueces Bay as having a pointed head reaching up into the heart of the delta. But in the 1800s, overgrazing, floods, and drought combined to strip topsoil off the river basin upstream and send it hurtling downstream to fill riverbeds and creek beds and build the delta. At the time, the river poured through Rincon Bayou and over the delta unimpeded. The bay's shore built up into fast land. By 1930, it reached over three-quarters of a mile from the original shoreline, a shell reef described in the survey notes of early Texas land grants. The bay's new curved shoreline sprouted with cordgrass marshes and became a prolific nursery

for shrimp, fish, and mussels while the river still flowed through Rincon Bayou. Today the delta is eroding, losing the fast land back to open water as the salt-tolerant plants die from too much salt and too little sediment. It is confusing; upstream people fight to keep topsoil from eroding into the rivers and streams because silt can compromise water quality. Yet it is a question of quantity and quality. The mixture of nutrients, soil, and bits of plants a river carries downstream feeds the delta. The cordgrass marshes capture the sediment, nutrients, and detritus. Plants, plankton, and invertebrates thrive in the muck, creating habitat and food for larval shellfish and finfish. The plants buffer the shore from the constant battering of the waves. Periwinkles graze on the grass above the tide line. Diamondback terrapins eat the snails.

But no one has come up with a way to retrieve the silt filling the upstream reservoirs and transport it to the delta. With freshwater inflows but without the silt and nutrients, the estuary and delta will survive. It will be different and maybe not as prolific, but the system will adapt.

I had visited the Delta Preserve before, joining bird-watchers on a National Audubon Society Christmas Bird Count. Our team leader and good friend, Craig McIntyre, drove Bill and me into the preserve on a warm, muggy December morning before dawn. The sky glowed, a false dawn from Corpus Christi's lights. We drove down a dark road, tires crunching on shells and gravel, looking into the tunnel of light cast by the headlights. Craig stopped the truck by the constructed freshwater wetlands. In the dark I could hear the first murmuring conversations and the rustling feathers of the ducks and geese. We heard muttered squawks as the birds began to wake up. They shifted back and forth, bumping into each other's shoulders. A few querulous imprecations were let loose; waterfowl-speak for "Watch your step, buddy." Softly at first, the susurration grew as the birds woke, querying each other, "You awake?" "Hungry?" "You hungry?" "You awake?" Movement rippled through the barely visible shapes of the birds against the water.

We left and drove to our section along the river and waited for the sun to rise. The upper delta looked like overgrazed cattle pasture to me, thick with prickly pear cactus and thickets of mesquite and huisache. The parched area looked nothing like the other coastal marshes I'd encountered along the Texas coast. The lights and gas flares of the refineries lining

the ship channel glowed, brighter than the lights of Corpus Christi or the dawn sky. In the early-morning light, we found black-crowned night-herons roosting along the river. Gulls and terns flew downstream as focused as businessmen on their way to work. The liftoff sounded, a great symphonic roar of quacks, honks, trumpeting, and beating wings. We turned and lifted our faces to the sky following the specklebelly geese, Canada geese, snow geese, and ducks as they surged into the brightening sky overhead.

"I wanted you to see that," Craig tells us. "Even though we aren't supposed to count the liftoff." I had been so absorbed in watching the wheeling birds that counting them hadn't crossed my mind.

Long-billed curlews foraged in a rainwater pool against a backdrop of prickly pear. We sneaked up on marsh-ringed pools, dark green cordgrass thick beneath ridges of mesquite, and counted mottled ducks, gadwalls, ruddy ducks, mallards, and shovelers. Every pool of water was occupied by herons, egrets, ibis, avocets, and black-necked stilts. I thought of a letter McClintock wrote describing his trip to Corpus on his way to serve in the Mexican-American War:

> The river is rapid, deep, narrow and crooked, some places the banks are high and steep. In others it is without banks, the water being scarce a foot below the level of the prairie, which is low and flat, covered in places with water and swimming everywhere with aquatic fowls, including every variety with which I am familiar and several species that were wholly new to me. (McClintock 1930)

When ornithologist Florence Miriam Bailey and her husband, naturalist Vernon Bailey, traveled through Corpus Christi in 1900, she discovered they were in, as she wrote, "a world of flowers and birds" but also in the heart of a plume-hunting district for the millinery trade. Adorning women's hats with feathers, wings, and even whole stuffed birds had become big business. Across the country plume hunters, middlemen, and milliners bought and sold the skins and feathers of hundreds of thousands of waterbirds every year to supply women with fashionable headgear. As Bailey and her husband collected bird and mammal specimens for the Biological Survey of Texas, they gained the trust of the plume hunters. One man, she said, boasted of shooting 816 birds in five days, and 1,023 terns,

yellow-legs, avocets, and willets in six or seven days. By the time she visited, she wrote to the chairman of the Committee on Bird Protection that "eggers and millinery men together had almost driven the [brown] Pelicans from the neighborhood." Roseate spoonbills were nearly extirpated. But a stop at Tule Lake, a brackish lake along the Nueces Bay's original south shore (now subsumed by the navigation channel) gave her what she called an interesting hint of the surrounding waterbird life:

> Tule Lake was alive with Grebes, Shovellers, Plovers, Sandpipers, and Terns, and a party of tall pinkish Avocets were wading out across the small waves, putting their long up-curved bills down delicately before them; while Stilts, all black above, all white below, stilted up on long pink legs, were . . . raising their black triangular sails over their backs. Rising from the lake, flocks of sandpipers would go whirling away dark before us, at a turn glancing white against the sky. (Bailey 1916)

Ducking through a mesquite thicket after a palm warbler, I felt the first searching tendrils of the coming norther. A playful little puff of cool air stirred the leaves and tossed the grasses for a second and then was gone. The air seemed heavier, denser after the zephyr passed. The mockingbirds, doves, and grackles, so active moments before, were suddenly silent. Bill stood up and turned to face north. I heard the norther barreling toward us, pushing against the warm stale air with a wall of cold wind. The first gusts were exhilarating. The glum overcast sky cleared in minutes and flocks of sandhill cranes circled overhead, calling out with that most joyful of sounds. A clumsy music that always makes me drop whatever I'm doing to run outside to stare up at the sky, searching until I spot the cranes. I stood that day as I always do, head thrown back watching the cranes, all else forgotten.

The north wind was unrelenting. The birds hunkered down. Tossing branches and whistling cold air made it impossible to either hear or see a bird—even if one was to pop its head out in the open. We fled, taking our meager count (for the delta) of fifty-six species with us. Each one of us was certain that we were on the verge of discovering a wild and hidden treasure. If we'd only had more time.

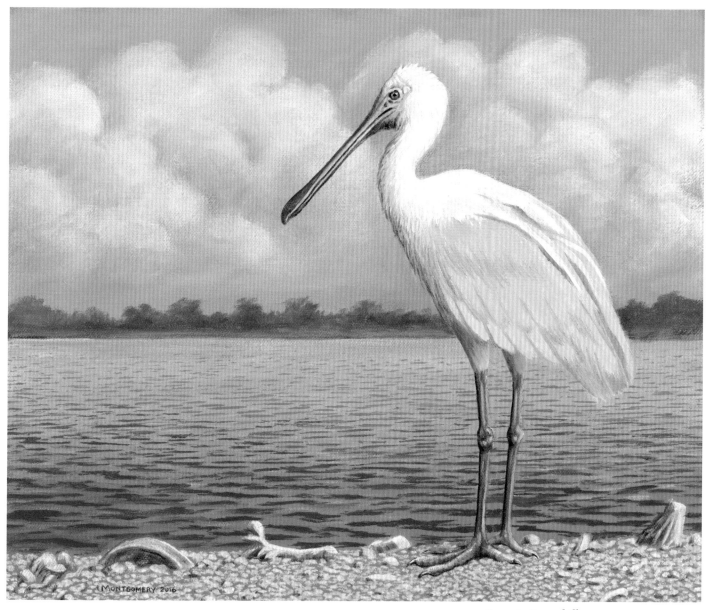

Roseate Spoonbill

TESOROS ESCONDIDOS: HIDDEN TREASURES

As we drive across the river, I crane to catch a last glimpse of the Hidden River. As the dark, quiet channel of the tidal river appears, then disappears, I think of the Nueces that I found: spring-fed pools playing hide-and-seek with the Edwards Aquifer, sparkling dancing rapids for fly fishermen and kayakers, and a river that lives both above and below its own

rocky bed. My Nueces is a river of dreams that pours into the depths of the Carrizo Sands to become the groundwater that fueled the agrarian visions of the Winter Garden and now waters corporate fields of cabbage and quenches the thirst of towns. And murky channels where prehistoric monsters splash while giant indigo snakes glide along the banks.

This canyon-running naiad that lives hidden behind locked gates is confined by downstream dams to be carefully parsed out drop by drop. Yet the same river so tediously measured and quarreled over can leap out of its banks and create havoc up and down its length—as she has always done.

Today the name Río Escondido seems appropriate. When I query my friends about Corpus Christi, they tell me sand, beaches, the Gulf, fishing, and Padre Island. Sometimes hurricanes, petrochemical plants, and seafood join the list. Fishermen and bird-watchers mention the bays, but almost no one mentions the river that is tucked off to the side, away from the city. Or the delta. As I traveled down the canyons and into the Brush Country, I was reminded that for more than a century no one connected the upper Río de las Nueces with the river flowing into a bay behind barrier islands—the river that an anonymous Spanish map labeled Río Escondido and that historians decided was the Nueces. Instead the idea persisted that the Nueces and Frio were tributaries of the Rio Grande. In a peculiar parallel, few of the people living upstream identify their Nueces as the river that loops across La Brasada to supply water to Corpus Christi, the towns of the Coastal Bend, or, surprisingly, with either Nueces or Corpus Christi Bay.

The Nueces I uncovered isn't a dividing line so much as a thread that stitches together culture, history, provinces, states, republics, and counties in unity, uneasy alliance, or outright discord. When I think of the Nueces River now, I can hold it in my mind, all the many personalities and manifestations of this river twining together, crossing and merging into a braided stream that weaves itself into a single river. A river of pecans—and cedar, honey, birds, oil, mesquite, cactus, cattle, horned lizards, and, hopefully, rattlesnakes. The waters of the Nueces are valued but in my book, the river is the hidden treasure.

NOTES

CHAPTER 1

1. The word "breaks" is generally used to describe geological faults or an interruption in continuity such as the dramatic change between the top of the Balcones Plateau and the Canyonlands of the escarpment. "Brakes," on the other hand, is used to designate an area with a thick growth of one type of plant such as a cane brake or a cedar brake. In Texas, both "brake" and "break" are used to describe a cedar forest or thicket.

2. Later research revealed that the springs were numbered in a 1958 Texas Board of Water Engineers report on Real County. Currently the springs are listed as Greenwood Valley Ranch Spring One, Two, and so forth.

3. In Texas, the land under navigable streams is legally open for public access. A stream is navigable if the bed of the stream averages thirty feet wide from the mouth up, regardless of the actual water level on a given day. Texas courts have recognized that a member of the public may engage in a variety of activities in, on, and along a public lake or stream. Besides boating, persons may swim, float, walk, wade, picnic, camp, and (with a license) fish. These activities must be confined to the waters of the lake or stream and the streambed. The public does not have the right to cross private property to get to or from public water. The Nueces River bed becomes public property approximately two miles south of the old Hackberry Community, incidentally at the point where the river becomes the line between Edwards and Real Counties.

CHAPTER 2

1. While Edwards County was created from Bexar District in 1858, it was not formally organized until 1883. Real County was formed in 1913 from parts of Edwards, Bandera, and Kerr Counties.

2. The use of acre-feet as a measurement reflects the historical agricultural basis of our water resource management. An acre-foot of water is enough to cover one acre of land with one foot of water, or 325,851 gallons. One acre-foot of water is generally considered enough water to last a family of four for up to two years.

3. This is the Balcones Fault Zone (BFZ) of the Edwards Aquifer system. The BFZ is hydrogeologically separate because there are groundwater divides in the west near Brackettville and in the east near Kyle. The Barton Springs segment surrounds Austin. There is evidence that during major droughts and periods of high pumping, the groundwater divides dissipate.

4. In Texas the land under navigable streams is legally open for public access. No state agency holds absolute responsibility for the management of freshwater riverbed lands. In effect, the Texas legislature is the land manager for most of the roughly one million acres underlying navigable freshwater in Texas. (Source: TPWD Texas River Guide)

CHAPTER 3

1. J. David Bamberger is renowned for his restoration of a devastated and over-grazed ranch outside Johnson City, Texas. His story is recounted in Jeffrey Greene's *Water from Stone: The Story of Selah, Bamberger Ranch Preserve* (College Station: Texas A&M University Press, 2007). For more information about Selah, Bamberger Ranch Preserve, visit bambergerranch.org.

2. Donald G. Schueler's book *Incident at Eagle Ranch: Predators as Prey in the American West* (Tucson: University of Arizona Press, 1991) details the trial and reviews the laws and policies in effect at the time.

3. Bald eagles are in the Hill Country but prefer riverine or lake habitat for food and nesting. Overwintering birds and nesting pairs are seen along the Llano River, Pedernales River, and Colorado River.

CHAPTER 4

1. The first group of springs arises near the municipal golf course, just north of a small municipal park. Its outflow, as well as runoff from surrounding city streets, flows into a shallow channel restricted to the park in the center of Uvalde. The park has trails, benches, and playgrounds. The city discharges its treated wastewater into the Leona. While the park is a pleasant spot, the stagnant green water looks nothing like a river.

2. In 1943, the Farm Security Administration (FSA) purchased the C & M Produce Company. The FSA organized the La Pryor Farmers' Cooperative, consisting of thirty-five farm families, each owning about 160 acres of land. The land was irrigated by wells.

3. J. Frank Dobie, *Coronado's Children: Tales of Lost Mines and Buried Treasures of the Southwest* (Austin: University of Texas Press, 1978).

4. Berlandier believed the animal to be some sort of mammal, even going so far as to suggest it was a tapir. The creature was supposedly killed in 1813 and Berlandier looked for the bones without success.

5. The four irrigation reservoirs are Averhoff or the Upper Nueces, Boynton, Book-out, and Bermuda, and their water is all managed by the Zavala-Dimmit Counties Water Improvement District No. 1 for irrigation use.

CHAPTER 5

1. Currently, it is legal to capture indigenous reptiles and amphibians on the shoulder or unpaved right-of-way of a public road provided that the person possesses a proper hunting license, doesn't kill any of the animals, and wears reflective material. It is not legal to hunt from a vehicle on public roads.

2. Chaparral Wildlife Management Area is home to four state threatened and protected species: Texas tortoise (*Gopherus berlandieri*), Texas horned lizard (*Phrynosoma cornutum*), Texas indigo snake (*Drymarchon melanurus*), and reticulate collared lizard (*Crotaphytus reticulatus*). CWMA is also home to the spot-tailed earless lizard (*Holbrookia lacerata*), a candidate for federal listing as an endangered species.

CHAPTER 7

1. The full text of the Certificate of Adjudication is included in note 2 for chapter 11.

CHAPTER 8

1. Australia also has a feral hog problem. Researchers there have determined that feral hogs can and do eat lambs and kids. While we don't have the data to prove it, in the United States, biologists believe that feral hogs are starting to impact fawn survival.

2. "A Peccary-Hunt along the Nueces" is a chapter included in later editions of the book *The Wilderness Hunter*.

3. In 1967, under a law that preceded the Endangered Species Act of 1978, the American alligator was first listed as endangered.

CHAPTER 10

1. "Diezmo" is the Spanish word for "tithe." As Administrator of Tithes for the town of Reynosa, don Vincente Lopez de Herrera would have been in charge of collecting the 10 percent tithe of all income that the church demanded until the practice was outlawed. It seems a likely source of the property's name, as Don Vincente could have been called "El Diezmero."

CHAPTER 11

1. The Texas Water Development Board's Nueces Estuary web page cites an annual average of 587,000 acre-feet of freshwater inflow from the Nueces River. The estuary

also receives freshwater inflows from Oso Creek as well as runoff from surrounding coastal watersheds.

2. Certificate of Adjudication No. 21–3214, Section SB (water right for Choke Canyon Reservoir), held by the City of Corpus Christi, the Nueces River Authority, and the City of Three Rivers, states: B. (Part) "Owners shall provide not less than 151,000 acft of water per annum for the estuaries by a combination of releases and spills from the reservoir system at Lake Corpus Christi Dam and return flows to the Nueces and Corpus Christi Bays and other receiving estuaries." E. "Owners shall continuously maintain a minimum flow of 33 cubic feet per second below the dam at Choke Canyon Reservoir." Special Condition B of CA #21–3214 further states: "Water provided to the estuaries from the reservoir system under this paragraph shall be released in such quantities and in accordance with such operational procedures as may be ordered by the Commission." The full text for the April 2001 Agreed Order can be found on the Nueces River Authority's website: https://www.nueces-ra.org/CP/CITY/pdfs/agreed_order.pdf, or the City of Corpus Christi's website: http://cctexas.com/Assets/Departments/Water/Files/2001%20 Agreed%20Order.pdf.

FURTHER READING

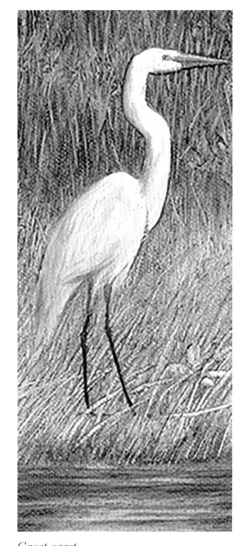

Great egret

Abbott, Patrick L., and C. M. Woodruff. 1986. *The Balcones Escarpment: Geology, Hydrology, Ecology*. San Antonio: Geological Society of America.

Acosta, Teresa Palomo, and Ruthe Winegarten. 2003. *Las Tejanas: 300 Years of History*. Austin: University of Texas Press.

Ajilvsgi, Geyata. 1984. *Wildflowers of Texas*. Bryan, TX: Shearer.

Alperin, Lynn M. 1983. *History of the Gulf Intracoastal Waterway*. Fort Belvoir, VA: National Waterways Study, US Army Engineer Water Resources Support Center, Institute for Water Resources.

Bailey, Florence Merriam. 1916. "Meeting Spring Half Way I." *Condor* 18, no. 4 (July/August): 151–55. http://jstor.org/stable/1362821.

Berlandier, Jean Louis. 1980. *Journey to Mexico during the Years 1826 to 1834*. Austin: Texas State Historical Association in cooperation with the Center for Studies in Texas History, University of Texas at Austin.

Blackburn, Jim. 2004. *The Book of Texas Bays*. College Station: Texas A&M University Press.

Blücher, Maria Augusta von, and Bruce S. Cheeseman. 2002. *Maria von Blücher's Corpus Christi: Letters from the South Texas Frontier, 1849–1879*. College Station: Texas A&M University Press.

Bollaert, William, W. Eugene Hollon, and Ruth Lapham Butler. 1956. *William Bollaert's Texas*. Norman: University of Oklahoma Press.

Brune, Gunnar M. 1981. *Springs of Texas*. Arlington, TX: G. Brune.

Burnett, Jonathan. 2008. *Flash Floods in Texas*. College Station: Texas A&M University Press.

Crofford, Lena H. 1963. *Pioneers on the Nueces*. San Antonio: Naylor.

Cunningham, Atlee M. 1998. *Corpus Christi Water Supply: Documented History 1852–1997*. Corpus Christi, TX: published by author.

Dalrymple, Tate. 1939. *Major Texas Floods of 1935*. Washington, DC: US Department of the Interior, Geological Survey.

de León, Arnoldo. 1993. *Mexican Americans in Texas: A Brief History*. Arlington Heights, IL: H. Davidson.

Dixon, James Ray. 2013. *Amphibians and Reptiles of Texas: With Keys, Taxonomic Synopses, Bibliography, and Distribution Maps*. College Station: Texas A&M University Press.

Dobie, J. Frank. 1965. *Rattlesnakes*. Boston: Little, Brown.

————. 1978. *Coronado's Children: Tales of Lost Mines and Buried Treasures of the Southwest*. Austin: University of Texas Press.

Dobie, J. Frank, and John Duncan Young. 1929. *A Vaquero of the Brush Country*. Dallas: Southwest Press.

Doughty, Robin W. 1983. *Wildlife and Man in Texas: Environmental Change and Conservation*. College Station: Texas A&M University Press.

Enquist, Marshall. 1987. *Wildflowers of the Texas Hill Country*. Austin: Lone Star Botanical.

Estaville, Lawrence E., and Richard A. Earl. 2008. *Texas Water Atlas*. College Station: Texas A&M University Press.

Everett, Dianna, and Philip A. Bandy. 1981. *Historical Resources of the Choke Canyon Reservoir Area in McMullen and Live Oak Counties, Texas*. San Antonio: Center for Archaeological Research, University of Texas at San Antonio.

Everitt, J. H., Dale Lynn Drawe, and Robert I. Lonard. 1999. *Field Guide to the Broad-Leaved Herbaceous Plants of South Texas: Used by Livestock and Wildlife*. Lubbock: Texas Tech University Press.

Falconer, Thomas. 1843. "Notes of a Journey through Texas and New Mexico, in the Years 1841 and 1842." *Journal of the Royal Geographical Society of London* 13:199–226. http://doi.org/10.2307/1798147.

Fenley, Florence. 1957. *Oldtimers of Southwest Texas*. Uvalde, TX: Hornby Press.

————. 1991. *Oldtimers: Their Own Stories*. Austin: State House Press for Sabinal Canyon Chapter, Daughters of the American Revolution.

Foster, J. H. 1917. "The Spread of Timbered Areas in Central Texas." *Journal of Forestry* 15:442–45. https://archive.org/details/journalofforestr15soci.

Foster, William C. 1995. *Spanish Expeditions into Texas, 1689–1768*. Austin: University of Texas Press.

George, Peter Gillham, Robert E. Mace, and Rima Petrossian. 2011. *Aquifers of Texas*. Austin: Texas Water Development Board.

Gray, Frank S. 1949. *Pioneering in Southwest Texas: True Stories of Early Day Experiences in Edwards and Adjoining Counties*. Austin: Steck.

Greaser, Galen D., Virginia H. Taylor, and William N. Todd. 2009. *New Guide to Spanish and Mexican Land Grants in South Texas*. Austin: Texas General Land Office.

Hart, Charles R., and Diane Bowen. 2008. *Brush and Weeds of Texas Rangelands*. College Station: Texas AgriLife Extension Service, Texas A&M University System.

Heartsill, W. W. 1954. *Fourteen Hundred and 91 Days in the Confederate Army*. Jackson, TN: McCowat-Mercer Press. http://hdl.handle.net/2027/mdp.39015027744542.

Hébert, Rachel Bluntzer. 1981. *The Forgotten Colony: San Patricio de Hibernia; the History, the People, and the Legends of the Irish Colony of McMullen-McGloin*. Burnet, TX: Eakin Press.

————. 1987. *Impressions: A South Texas Upbringing; a Picture of Life in South Texas*

during the First Quarter of the Twentieth Century. Corpus Christi, TX: published by author.

Hibbitts, Troy D., and Toby J. Hibbitts. 2015. *Texas Lizards: A Field Guide*. Austin: University of Texas Press.

Hill, Robert Thomas, and Thomas Wayland Vaughan. 1898. *Geology of the Edwards Plateau and the Rio Grande Plain Adjacent to Austin and San Antonio, Texas, with Reference to the Occurrence of Underground Waters*. Washington, DC: Government Printing Office.

Holley, Mary Austin. 1990. *Texas*. Austin: Texas State Historical Association. http://texashistory.unt.edu/ark:/67531/metapth296847/.

Howard, Margaret. 1996. *Archeological Survey of Devil's Sinkhole State Natural Area, Edwards County, Texas*. Austin: Texas Parks and Wildlife Department, Cultural Resources Program, Public Lands Division.

Huser, Verne. 2000. *Rivers of Texas*. College Station: Texas A&M University Press.

Jackson, Jack. 1986. *Los Mesteños: Spanish Ranching in Texas, 1721–1821*. College Station: Texas A&M University Press.

———, ed. 1995. *Imaginary Kingdom: Texas as Seen by the Rivera and Rubí Military Expeditions, 1727 and 1767*. Austin: Texas State Historical Association.

Jackson, Jack, Margaret Howard Hines, and Luis A. Alvarado K. 2006. *History and Archaeology of Lipantitlán State Historic Site, Nueces County, Texas*. Austin: Texas Parks and Wildlife Department.

Kellner, Marjorie. 1995. *Wagons, Ho!: A History of Real County, Texas*. Dallas: Curtis Media.

Lawson, Russell M. 2012. *Frontier Naturalist*. Albuquerque: University of New Mexico Press.

Lehmann, Val W. 1969. *Forgotten Legions: Sheep in the Rio Grande Plain of Texas*. El Paso: Texas Western Press.

Leopold, Luna B. 1997. *Water, Rivers, and Creeks*. Sausalito, CA: University Science Books.

Loughmiller, Campbell, Lynn Loughmiller, and Lynn Sherrod. 1984. *Texas Wildflowers: A Field Guide*. Austin: University of Texas Press.

McClintock, William A. 1930. "Journal of a Trip through Texas and Northern Mexico in 1846–1847: I." *Southwestern Historical Quarterly* 34 (1): 20–37.

———. 1930. "Journal of a Trip through Texas and Northern Mexico in 1846–1847: II." *Southwestern Historical Quarterly* 34 (2): 141–58.

———. 1931. "Journal of a Trip through Texas and Northern Mexico in 1846–1847: III." *Southwestern Historical Quarterly* 34 (3): 231–56.

McGraw, A. Joachim, John Wilburn Clark, and Elizabeth A. Robbins. 1991. *A Texas Legacy, the Old San Antonio Road and the Caminos Reales: A Tricentennial History, 1691–1991*. Austin: Texas State Department of Highways and Public Transportation, Highway Design Division.

McWilliams, James E. 2013. *The Pecan: A History of America's Native Nut*. Austin: University of Texas Press.

Michler, Nathaniel. 1850. "Report of a Reconnaissance of the Country between Corpus Christi and the Military Post on the Leona." In *Reports of the Secretary of War with Reconnaissances of Routes from San Antonio to El Paso, July 24, 1850*. Exec. Doc. no. 64. https://books.google.com/books?id=axQOAAAAQAAJ&dq.

Miller, S. G., and James Potter Collins, and John M. Roberts. 2011. *Sixty Years in the Nueces Valley, 1870–1930*. San Antonio: Naylor.

Montejano, David. 1987. *Anglos and Mexicans in the Making of Texas, 1836–1986*. Austin: University of Texas Press.

Myers, Lois E. 1991. *Letters by Lamplight: A Woman's View of Everyday Life in South Texas, 1873–1883*. Waco, TX: Baylor University Press.

Newcomb, William W. 1961. *The Indians of Texas: From Prehistoric to Modern Times*. Austin: University of Texas Press.

Niehaus, Theodore F., Virginia Savage, and Charles L. Ripper. 1984. *Southwestern and Texas Wildflowers*. Norwalk, CT: Easton Press.

Núñez Cabeza de Vaca, Álvar, and Cyclone Covey. 1983. *Cabeza de Vaca's Adventures in the Unknown Interior of America*. Albuquerque: University of New Mexico Press.

Oberholser, Harry C., and Louis Agassiz Fuertes. 1974. *The Bird Life of Texas*. Austin: University of Texas Press.

Olmsted, Frederick Law. 1989. *A Journey through Texas: Or, a Saddle-Trip on the Southwestern Frontier*. Austin: University of Texas Press.

O'Shea, Elena Zamora, Andrés Tijerina, and Leticia Garza-Falcón. 2000. *El Mesquite: A Story of the Early Spanish Settlements between the Nueces and the Rio Grande, as Told by "La Posta del Palo Alto."* College Station: Texas A&M University Press.

Outwater, Alice B. 1996. *Water: A Natural History*. New York: Basic Books.

Pearce, Fred. 2006. *When the Rivers Run Dry: Water, the Defining Crisis of the Twenty-First Century*. Boston: Beacon Press.

Peirce, A. C. 1894. *A Man from Corpus Christi: Or, the Adventures of Two Bird Hunters and a Dog in Texan Bogs*. New York: Forest and Stream. https://books.google.com/books?id=3W4CAAAAYAAJ&dq=a%20man%20from%20corpus%20christi&pg=PP11#v=onepage&q=a%20man%20from%20corpus%20christi&f=false.

Pool, William C., Edward Triggs, and Lance Wren. 1975. *A Historical Atlas of Texas*. Austin: Encino Press.

Postel, Sandra, and Brian Richter. 2004. *Rivers for Life: Managing Water for People and Nature*. Washington, DC: Island Press.

Richardson, Alfred, and Ken King. 2002. *Wildflowers and Other Plants of Texas Beaches and Islands*. Austin: University of Texas Press.

———. 2010. *Plants of Deep South Texas: A Field Guide to the Woody and Flowering Species*. College Station: Texas A&M University Press.

Rocksprings Woman's Club (Rocksprings, TX). 1984. *Edwards County History*. San Angelo, TX: Anchor Publishing.

Roosevelt, Theodore. 1923. *The Works of Theodore Roosevelt*. Memorial ed. Vol. 2, *The Wilderness Hunter*. New York: Charles Scribner's Sons. www.archive.org/details/worksoftheoroos12roos.

Rose, Francis L., and Frank W. Judd. 2014. *The Texas Tortoise: A Natural History*. Norman: University of Oklahoma Press.

Sansom, Andrew. 2008. *Water in Texas: An Introduction*. Austin: University of Texas Press.

Schmidly, David J. 2002. *Texas Natural History: A Century of Change*. Lubbock: Texas Tech University Press.

Schmidly, David J., and William B. Davis. 2004. *The Mammals of Texas*. Austin: University of Texas Press.

Schueler, Donald G. 1980. *Incident at Eagle Ranch: Predators as Prey in the American West*. Tucson: University of Arizona Press.

Shackelford, Clifford E. 2005. *Migration and the Migratory Birds of Texas: Who They Are and Where They Are Going*. Austin: Texas Parks and Wildlife.

Sherbrooke, Wade C. 1981. *Horned Lizards: Unique Reptiles of Western North America*. Globe, AZ: Southwest Parks and Monuments Association.

Sibley, David. 2009. *The Sibley Guide to Trees*. New York: Alfred A. Knopf.

Spearing, Darwin, and Robert A. Sheldon. 1991. *Roadside Geology of Texas*. Missoula, MT: Mountain Press.

Stoner, Anna Louisa Wellington. 1881–1900. Wellington-Stoner-McLean Family Collection. Texas Collection. Baylor University, Waco, TX.

Stovall, Allan A. 1967. *Breaks of the Balcones: A Regional History*. Barksdale, TX: published by author.

Taylor, Paul S. 1934. *An American-Mexican Frontier: Nueces County, Texas*. Chapel Hill: University of North Carolina Press.

Taylor, Richard B. 2014. *Common Woody Plants and Cacti of South Texas: A Field Guide*. Austin: University of Texas Press.

Thomas, Chad, Timothy H. Bonner, and Bobby G. Whiteside. 2007. *Freshwater Fishes of Texas: A Field Guide*. College Station: Texas A&M University Press.

Tidwell, Laura Knowlton. 1984. *Dimmit County Mesquite Roots*. Austin: Wind River Press.

Tull, Delena, and George Oxford Miller. 1991. *A Field Guide to Wildflowers, Trees and Shrubs of Texas*. Houston: Gulf.

Tunnell, Curtis D., and William W. Newcomb. 1969. *A Lipan Apache Mission: San Lorenzo de la Santa Cruz, 1762–1771; the Archeological Investigation*. Austin: Texas Memorial Museum.

University of Texas at Austin. 1975. *Devil's Sinkhole Area: Headwaters of the Nueces*

 River. Austin: Department of Natural Resources and Environment, University of Texas at Austin.

US Department of the Interior. 2000. *Rincon Bayou Demonstration Project: Concluding Report*. Austin, TX: US Department of the Interior, Bureau of Reclamation.

Vliet, R. G. 1974. *Rockspring*. New York: Viking Press.

Weniger, Del. 1984. *The Explorers' Texas: The Lands and Waters*. Austin: Eakin.

————. 1997. *The Explorers' Texas*. Vol. 2, *The Animals They Found*. Austin: Eakin.

Wrede, Jan. 2010. *Trees, Shrubs, and Vines of the Texas Hill Country: A Field Guide*. College Station: Texas A&M University Press.

INTERNET RESOURCES

City of Corpus Christi Water Utility. Comprehensive site with history, historical data, water quality reports, and regional water management information.
http://www.cctexas.com/government/water/index

Coastal Bend Bays and Estuaries Program. Dedicated to protecting, researching, and restoring the bays and estuaries in the Texas Coastal Bend.
http://www.cbbep.org

Conrad Blucher Institute for Surveying and Science. Water quality and salinity monitoring in Nueces Bay and the Nueces delta.
http://www.cbi.tamucc.edu/Nueces-BayWater-Quality-Monitoring/

Edwards Aquifer Authority. The state agency charged with management and protection of the Edwards Aquifer.
http://www.edwardsaquifer.org

Edwards Aquifer website by Gregg Eckhardt. Comprehensive information about the Edwards Aquifer.
http://www.edwardsaquifer.net

Environmental Protection Agency. Water quality, river basins, pollutants, air quality, and other relevant information.
http://www.epa.gov/

The Handbook of Texas Online. Texas State Historical Association's source for everything you ever wanted to know about Texas history.
https://tshaonline.org/handbook/online

Nueces Delta Preserve. The 8,700-acre Nueces Delta Preserve protects valuable wetland habitat and offers engaging field experiences for area students.
http://www.nuecesdeltapreserve.org

Nueces River Authority. All things Nueces including river gauges, water quality, education, and outreach.
http://www.nueces-ra.org

Railroad Commission of Texas. Information about railroads, mining, and drilling. Also

a public GIS viewer with oil, gas, and pipeline data for the entire state.
http://www.rrc.texas.gov

San Patricio County Parks. Information about parks, the La Fruta Paddling Trail, kayak rental, and shuttle services.
http://www.sanpatriciocountyparks.com

South Texas Natives. A project of the Caesar Kleberg Wildlife Research Institute at Texas A&M University–Kingsville. Information about native plants, habitat restoration, and current research.
http://ckwri.tamuk.edu/research-programs/south-texas-natives

Southwest Paddler. Basic information about paddling the upper Nueces as well as other rivers in the southwestern United States. Some information is out of date.
http://southwestpaddler.com/docs/nueces.html

Texas Aquatic Science. A guide for students from molecules to ecosystems, and headwaters to ocean.
http://www.texasaquaticscience.org

Texas Coastal Wetlands. A field guide to wetlands and where to find examples.
http://www.texaswetlands.org/index.htm

Texas General Land Office. Historic maps, old deeds, Spanish and Mexican land grant information. Also current GIS mapping systems.
http://www.glo.texas.gov

Texas Land Trends. Facts and data about changes in land use, population density, and ownership patterns.
http://txlandtrends.org

Texas Legacy Project. An archive and documentary series sponsored by the Conservation History Association of Texas.
http://www.texaslegacy.org

Texas Living Waters Project. A joint effort of the Lone Star Chapter of the Sierra Club, the National Wildlife Federation, and the Galveston Bay Foundation. Information about water conservation, environmental flows, and water planning.
http://texaslivingwaters.org

Texas Parks and Wildlife Department. Information about state parks, historical sites, wildlife management areas, lakes, paddling trails, river flow gauges, public river access points, wildlife, bird migration, fishing reports, and more.
http://tpwd.texas.gov/

Texas Water Development Board. Everything you need to know about Texas water, both surface and groundwater.
http://www.twdb.texas.gov

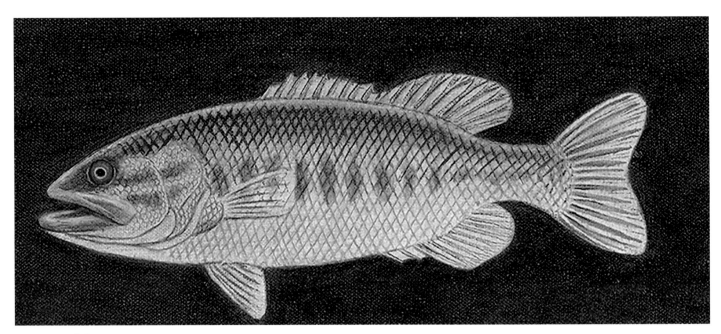

Largemouth bass

LIST OF ARTWORK

All artwork by William B. Montgomery. Photographs by
William B. Montgomery and Margie Crisp unless noted otherwise.

Camp Wood Crossing (p.1)
Oil on canvas
36" x 42"
Great blue heron fishing on the
banks of the Nueces River just
outside Camp Wood

Golden-cheeked Warbler (p.7)
Watercolor
8.5" x 11"

*Tropical Parulas on Hackberry
Creek (p.19)*
Oil on canvas
20" x 16"
Tropical parulas, migratory war-
blers in blooming Mexican buck-
eye

Senna with Coral Snake (p.22)
Oil on canvas
16" x 20"

Empress of Silence (p.27)
Line etching with aquatint

12" x 18"
Western diamond-backed rattle-
snake

American Bitterns (p.48)
Oil on canvas
36" x 48"

Laguna (p.57)
Oil on canvas
18" x 25"
During the summer or extended
droughts, the Nueces often dries
up into pools. Rio Grande cich-
lid, redear sunfish, sailfin molly,
and a common musk turtle in the
depths of a pool.

*Last Waltz of the Coppery Dancer
(p.59)*
Oil on canvas
30" x 42"
Rio Grande leopard frog and
a coppery dancer damselfly, a
Nueces River endemic

River Sentinel (p.66)
Watercolor
14" x 17"
A crevice spiny lizard surveying his kingdom

Caracara (p.69)
Watercolor
8.5" x 11"
This large falcon is also known as the Mexican Eagle.

Indigo Snack (p.83)
Oil on canvas
18" x 28"
Texas indigo snake eating a western diamond-backed rattlesnake. Texas indigos range along the length of the Nueces River from the headwaters to the Gulf.

Yellow-breasted Chat (p.93)
Oil on panel
8" x 8"

American Bison (p.96)
Watercolor
14" x 17"
Numerous accounts from before 1860 report the presence of American bison in the northern part of the Nueces River basin including on the Edwards Plateau, in the Hill Country, and in the northern Brush Country (including Uvalde, Zavala, Dimmit, and

Maverick Counties). Bison also extended well into Mexico.

Espantosa (p.104)
Oil on canvas
36" x 58"
American alligators historically ranged up to the edge of the canyonlands.

Cotulla (p.119)
Oil on canvas
36" x 50"
The Texas tortoise, a threatened species, relies on prickly pear cactus for both nutrition and hydration.

Texas Horned Lizard (p.130)
Line etching with aquatint
9" x 7"

Chaparral Cock or Paisano (p.139)
Pen and ink
8.5" x 14"
The roadrunner, an iconic member of the cuckoo family, has been called, among other things, a chaparral cock and a paisano.

Green Jays in Anaqua Tree (p.150)
Oil on canvas
21" x 28"
Green jays enjoying the fruit of an anaqua tree as an Isabella's heliconian, a rare butterfly that ranges into South Texas, flies past.

Nueces Fish Story (p.155)
Oil on canvas
42" x 60"
Above: Great egret, black-crowned night-herons, spiny softshell, red-eared sliders, *Homo sapiens*
Underwater: red-eared slider, yellow catfish, river carpsucker, green sunfish, redear sunfish, bluegill, Texas logperch, bowfin, American eel, alligator gar, freshwater drum, Orinoco sailfin catfish (nonnative), spiny softshell turtle, largemouth bass, smallmouth buffalo, orange-spotted sunfish, Rio Grande cichlid, common snapping turtle

Javelinas (p.163)
Pen and ink
6.5" x 10"

Voracious (p.173)
Oil on canvas
18" x 28"
Common snapping turtle attempting to eat a young water moccasin

Neotropical Cormorants (p.184)
Watercolor
14" x 17"

Anhinga (p.188)
Pen and ink
6.5" x 10"

Also called snakebirds for their sinuous necks, or water turkeys

Uncertain Territory (p.192)
Watercolor
14" x 17"
Black-bellied whistling duck and red-eared slider

Fish Camp (p.213)
Watercolor
11.5" x 17"

Long-billed Curlew (p.218)
Oil on canvas
28" x 42"

Diamondback Terrapin (p.222)
Oil on panel
11" x 14"

Tidal River (p.225)
Oil on canvas
30" x 42"
Black-necked stilt and American avocet on the banks of the lower river.

Roseate Spoonbill (p.239)
Oil on canvas
10" x 12"

INDEX

Up2U program, 94–95
Uvalde, 85, 242n1 (Ch 1)
Uvalde and Northern Railway Company, 36
Uvalde Cedar Company, 36–37
Uvalde County, aquifer protection, 55

Vance, 23
Vance Cemetery, 25
vaqueros, 52–53
Vaughan, T. Wayland, 34–35, 41, 61, 65, 76
vegetation: along Hackberry Creek, 18–20, 22–23; along Hackberry Road, 5–7, 28; Averhoff Reservoir area, 100–101; Bee Bluff area, 87, 88, 89–91, 93; Bermuda Park area, 110–13, 114; Big Bend of the Nueces, 147–48, 149, 152; bottomlands, 212, 216–17; buffelgrass project, 131–33; Camp Wood area, 26–27, 31, 32–35; Carrizo cane problem, 44–49; Chaparral Wildlife Management Area, 139–40, 141, 142; Choke Canyon State Park, 160; Cotulla area, 120, 121, 123, 124–27, 129–33; delta region, 232–33, 234–35, 236, 237; Dobbs Run Ranch, 71–72, 73–76; Eagle Cliff area, 12–13, 17–18; El Diezmero area, 208, 209; Espantosa Lake area, 105–106; near Friday Ranch, 51; George West area, 183; Good Luck area, 50; near Hazel Bazemore Park, 210, 211; headwaters area, 8–9, 11–12; Kickapoo Ranch, 60–62, 62, 63, 64, 65; Labonte Park area, 220; La Fruta Paddling Trail, 200, 204, 207; Lake Corpus Christi State Park, 188; Montell area, 40, 43, 44, 47–48; Oakville area,

169, 175, 176–77, 179, 181; quail tracking area, 134–37; restoration efforts, 72, 152–53, 230–36; Rocky Reagan Campground, 168–70; San Patricio area, 193; sheep grazing impact, 126–30; Silver Lake area, 77, 79; Smart Ranch, 65–66, 67, 68; Three Rivers area, 157; at unnamed location, viii, xiv; upper Lake Corpus Christi, 185, 186, 187; west/east side comparisons, 98; Winter Garden region, 98, 100, 109–10
verbena, prairie, 7, 51, 60, 71
vermilion-haired woman, 51, 57–58
Vernor, Calvin, 24
Vernor, Janet, 24
Victoria, 208
vireo, black-capped, 71, 73
vultures, turkey, 70, 80, 181, 182, 216, 221

walnut trees, 37, 43
warbler, golden-cheeked, 6, 7, 32, 35, 71, 73
Ward, Mary Lou, 43
Ward, Tommy, 43
waste dump, petrochemicals, 201–202
water rights permit, 163–64
Watershed Protection Plan, 202, 212, 214–15
Water Stewardship Education Program, 203–204
water supplies, urban, 162–65. See also Choke Canyon Reservoir; Lake Corpus Christi
Weedy Creek, 202
Wesley E. Seale Dam, 185, 197, 209
West, George, 183
West Prong: Balcones Escarpment formation, 54; Devil's Sinkhole, 59–60; Dobbs Run

Ranch, 70–76; Kickapoo Ranch, 60–65; route described, 85; Smart Ranch, 65–70; Tularosa Road, 76–77
wildfire, 33, 77, 141
wildflowers: along Hackberry Road, 7; Cotulla area, 133–34, 136, 139–40; Dobbs Run Ranch, 71–72; near Friday Ranch, 51; Kickapoo Ranch, 60; Oakville area, 179; at unnamed location, xiv
wildlife: Choke Canyon State Park, 159–60; Cotulla area, 133; illustrations, 96; Oakville area, 175–76; predator control programs, 77–78; Smart Ranch, 70. See also hunting; specific wildlife, e.g., alligators; hogs, feral; snakes
Wiley Waterhole, 69, 72
Willingham, Jim, 94
wind-tidal flats, delta region, 234, 235
Winter Garden Dam, 117
Winter Garden region: Bee Bluff area, 87–94; Bermuda Park area, 110–18; Chimney Rock, 94–95; Crystal City, 101–102; early explorers, 98–100; Espantosa Lake, 103–106, 242n4 (Ch 4); frontier development, 95, 97–98, 101–102, 107–108, 113
woodpecker, golden-fronted, 142, 160
Wooldridge, Milburn, 25–29
wren, canyon, 76

Zagorski, William "Ski," 207
zinc levels, 224–25

OTHER BOOKS IN THE RIVER BOOKS SERIES

Caddo: Visions of a Southern Cypress Lake
Thad Sitton and Carolyn Brown

Canoeing and Kayaking Houston Waterways
Natalie H. Wiest

Exploring the Brazos River: From Beginning to End
Jim Kimmel and Jerry Touchstone Kimmel

Flash Floods in Texas
Jonathan Burnett

Freshwater Fishes of Texas: A Field Guide
Chad Thomas and Timothy H. Bonner

Living Waters of Texas
Ken W. Kramer

Neches River User Guide
Gina Donovan

Paddling the Guadalupe
Wayne H. McAlister

Paddling the Wild Neches
Richard M. Donovan

River of Contrasts: The Texas Colorado
Margie Crisp

Running the River: Secrets of the Sabine
Wes Ferguson and Jacob Croft Botter

San Marcos: A River's Story
Jim Kimmel and Jerry Touchstone Kimmel

Sharing the Common Pool: Water Rights in the Everyday Lives of Texans
Charles R. Porter

Texas Aquatic Science
Rudolph A. Rosen

Texas Riparian Areas
Thomas B. Hardy and Nicole A. Davis

Texas Water Atlas
Lawrence E. Estaville and Richard A. Earl

Untold Story of the Lower Colorado River Authority
John Williams

The Blanco River
Wes Ferguson and Jacob Croft Botter

Texas Rivers and Texas Art
Andrew Sansom and William E. Reaves